Frederic Remington
and the West

Frederic Remington and the West
With the Eye of the Mind

Ben Merchant Vorpahl

University of Texas Press, Austin

Both the initial research and the publication of this work were made possible in part through grants from the National Endowment for the Humanities, a federal agency whose mission is to award grants to support education, scholarship, media programming, libraries, and museums in order to bring the results of cultural activities to the general public.

Library of Congress Cataloging in Publication Data
Vorpahl, Ben Merchant.
 Frederic Remington and the West.
 Includes bibliographical references and index.
 1. Remington, Frederic, 1861–1909. 2. Artists—United States—Biography. 3. The West in art.
I. Title.
N6537.R4V67 709'.2'4 [B] 77-25953
ISBN 978-1-4773-0521-8
Copyright © 1978 by the University of Texas Press
All rights reserved

Plates 18–23 were taken from *My Dear Wister: The Frederic Remington–Owen Wister Letters,* by Ben Merchant Vorpahl. Copyright © 1972, American West Publishing Co. Used by permission of Crown Publishers, Inc.

www.utpress.utexas.edu/index.php/rp-form

First paperback printing, 2015

For my parents

Contents

Acknowledgments ix

Introduction xi

I. Genesis
1. Solidity's a Crust 3
2. Isolato 12

II. Exodus
1. Open Country 25
2. The Tribe of Remington 34
3. Adrift in New York 45

III. The Law and the Prophets
1. The Illustrator as Parodist 57
2. Stalking the Establishment 79
3. The Strategy of Sequence 104
4. Transient 127
5. Eternal Bronze 159

IV. Armageddon

1. Archaic Man 185
2. Top of Speculation 203
3. The Real Thing 220

V. The Last Horseman

1. Letters from Another Country 249
2. Demons of the Night 266

Index 285

Acknowledgments

I am indebted to many people and several institutions for aid in various aspects of this study. The National Endowment for the Humanities financed a year of research and writing. The University of Georgia provided three summer research grants. The Frederic Remington Art Memorial in Ogdensburg, New York, allowed me to make a list of the books in Remington's library. Joe Keenan and Paul Whitmore generously shared with me their insights into Remington's native region of upstate New York, as did Mrs. Ernest Deuval and Atwood Manley. Harold McCracken took time out from a busy schedule at Cody, Wyoming, to talk with me about the backgrounds of Remington studies. Leon Howard, Phil Durham, Charles Gullans, and Walter Rideout furnished encouragement and a great deal of wise counsel. Iris Tillman Hill and Holly Carver, my editors at the University of Texas Press, were patient, meticulous, and helpful. The libraries at the University of California at Los Angeles, the University of Colorado, the University of Washington, and the University of Georgia provided both information and guidance. Through the whole process, from inception to completion, my wife, Julie, sustained her intelligence and good spirits, which she selflessly—as always—contributed.

Introduction

At first glance there would appear to be nothing more surprising in the title "Frederic Remington and the West" than there might be in titles like "Mark Twain and the Mississippi River" or "Thomas Jefferson and the Declaration of Independence." Remington and the region of the West have become so thoroughly linked in the American imagination that mentioning them together almost seems redundant, and the assumption that Remington and the West assert each other is so strong that it usually remains unstated. As is the case with many such broadly based assumptions, this one is neither wholly nor even mostly false, and yet I will argue that any formulaic linkage between Remington and the West is misleading rather than enlightening. It would of course be a mistake to claim that either Remington's work or the West has been ignored, forgotten, or neglected because of this linkage: they have not been. Both, however, have been widely and persistently misunderstood, and for much the same reason—which is why linking them seems so deceptively obvious. Most simply stated, this reason is that both Remington's work and the West appear to invite one variety of perception but require, finally, quite another. My intention here is not to reinforce the assumptions by means of which Remington's work and the West are

bound together but to examine how the linkage became established and to discover its historical meaning. Two complementary processes are involved in this enterprise—Remington's definition of the West and Remington's use of the West to define himself.

No one, so far as I know, has ever satisfactorily defined the West as a region, although many books of very many different kinds have attempted to. Willa Cather thought the region began at Council Bluffs, Iowa, where she felt a drier air flowing eastward across the Missouri River from her native Nebraska. Theodore Roosevelt alternately referred to his Dakota ranch as being in the far West and the Northwest but, when it came to locating either of these putative regions, merely shrugged his shoulders and said, the "middle of the United States." Owen Wister seemed to think the West was mostly inside the boundaries of Wyoming, although he was willing to admit parts of Texas, Arizona, Montana, Idaho, and even California as well. I have heard people refer to the Wyoming retreat where I worked on parts of the present study as being in the West, the Northwest, the far West, the Midwest, and, even, back East. The trouble is and always has been, of course, not only that the location of the West, like that of other regions, is relative but also that the shape of the West, unlike that of other regions, is intensely subjective.

During the several decades before the Civil War, numerous economic, demographic, and climatic forces operated to designate three regions within the political boundaries of the United States, each of which had its own characteristics: the North (New England and the Middle States), the South (the states that would form the Confederacy), and the West (everywhere else). Principal among the features that distinguished the West from the other two regions was that it was unknown and therefore could not be accurately charted but was known to exist and therefore invited speculation. It is this difference that Henry Thoreau addressed when, in 1854, he brushed aside the question of the West's location to ask instead, "What does the West stand for?" That Thoreau answered the question only with another question—"Is not our own interior white on the chart?"—pointed to the West not as region but as interrogative, and that he subsequently observed "we know not where we are" designated the interroga-

tive a universal condition. I will maintain in the following pages that Remington's involvement with the West was precisely the kind of involvement Thoreau articulated, for in Remington's work the West stands both for one thing and for many things—or, to put it another way, Remington began his career by attempting to apply a series of unsatisfactory templates to the West but ended it by redeeming them all with a crucial realization.

Remington's first use of the West was as a means of easy self-justification when, as a schoolboy, he drew pictures of "cowboys, Indians, villains or toughs" to relieve the monotony of classes at Highland Military Academy in Massachusetts. Later—at nineteen, in a fit of pique because Eva Caten's father had refused to let him marry her—he made a brief, solitary visit to Wyoming and Montana. Later still, when he went to Kansas in an abortive, ill-conceived experiment in livestock farming, and shortly afterward lost his patrimony as a result of the equally chimerical scheme of investing in a Kansas City saloon, Remington had the disastrous consequences of regarding the West as self-justification fully demonstrated to him: the villains and toughs he had drawn for excitement took his money away from him.

His next gambit was to regard the West as opportunity—even, in some sense, as commodity, and in this he was both more successful and more misguided. With the escalation of what eastern publications called the "Apache War" in 1886, Remington found that the pictures he had made at San Carlos Indian reservation the year before were suddenly salable and that his services as an illustrator were suddenly in demand. For the next four years he pursued western subjects with remarkable energy, drawing them, painting them, and writing about them, sometimes crudely or wrongheadedly but always with immense vigor and enthusiasm. He literally threw himself into his work—which was, he thought, the definition of the West not as a place but as a condition robust, wholesome, and in the main sensible—becoming in the process—again, literally—a household word by virtue of the popularity of his work. But the Wounded Knee massacre in December 1890, which he very nearly witnessed, proved his definition wholly, even shamefully, false.

Contrary to what is generally thought, for the re-

maining two decades of his life Remington's interest in the geographical region of the West was intermittent only. Indeed, it may be plausibly argued that the subject most urgently claiming his attention during the eight-year span that separated the Wounded Knee massacre from the outbreak of the Spanish-American War was that of civil disorder and that his discovery of the cowboy—or "puncher," as Remington appropriately preferred to call him—during this same period came about as a direct result of Remington's vehement opposition to immigration, populism, and social change. Still, these eight years were highly productive, because Remington had been forced to give up some of his sentimental, self-serving notions about the West. Even while he indulged his martial obsession, writing enthusiastic reviews of new military procedures and comparing Mexican cowherds to Norman invaders, he was discovering himself.

Self-discovery is often just the opposite of self-justification. Certainly this was true in Remington's case, and beneath the bluff, patriotic, rough-and-tumble exterior Remington presented to his public was certainly a sensitive, intelligent, and complicated consciousness fully capable of registering guilt, shame, and an awareness of personal failure. Remington had of course achieved a very considerable success as illustrator, painter, and writer by 1890—and in 1894 he added sculpting to the list of his talents—but he had allowed himself to be victimized by his subjects, his editors, and his public. By spreading himself too thin, he had attained popularity but missed artistic excellence. By pursuing contemporary topics, he had subjected himself to the evils as well as the rewards of currency. In addition, he had at least nominally adopted some then fashionable racist attitudes and had—sometimes without wanting to—served political causes that turned out to be jingoistic or foolish or both. Most important, he had not paid enough attention to his own best inclinations. His search over three continents for "types" of subjects had prevented him from fully understanding that his only worthwhile subject would have to be created by him rather than merely encountered or, even, discovered.

This is why the war with Spain constituted such a crisis in Remington's personal and professional life. Ever since his boyhood in upstate New York, remem-

bered by him as a time when his father was away, serving as a Union officer in the Civil War, Remington had hunted for a war in which he could himself participate. His 1881 visit to Montana and Wyoming followed Custer's costly blunder at Little Big Horn as quickly as Remington could cause it to, and his 1885 visit to Arizona and New Mexico preceded by only a year the escalation of the so-called "Apache War." In 1890, when units of the Seventh U.S. Cavalry turned rapid-fire automatic cannon on Big Foot's band of Minneconjous Sioux at Wounded Knee, Remington was near enough to see columns of smoke rising from the scene of the disgrace. Four years later, when the same Seventh Cavalry was called to Chicago to prevent rioting and looting related to the Pullman strike, Remington was there. When he was not hunting for battles, he was drawing, painting, and writing about them, producing what turned out to be a striking if grisly record of American killing. The point to be made from Remington's martial preoccupation is that it dominated both his view of the West and his view of himself. It thus constituted that point at which Remington's progressive definition of the West and his use of the West to define himself were joined.

Until Remington could actually witness a martial conflict extensive enough to be called a war, his own "interior," as Thoreau has it, remained "white on the chart"; once he had witnessed such a conflict in Cuba and had been staggered by the force of his own awe and dismay, his martial preoccupation vanished, and he began as never before to turn his eyes inward. What he saw then was that his subject, which had seemed multiple and diverse in its currency, had from the beginning been unitary, even universal. The effect of his new realization was the production of his final, elegiac testament, conducted in prose, pictures, and bronze, in which the West made a final, splendid reappearance not as justification or opportunity but as death.

That no single work sufficiently expresses the force of Remington's realization is a frustrating circumstance for the critic—as it doubtless was for Remington—because it means that Remington's achievement must finally be understood not in terms of its individual elements but in terms of its aggregate. This is what I mean when I say that both Remington's work and

the West seem to invite one kind of perception but actually demand another kind. For Remington and a great many of his contemporaries, the West appeared as a region susceptible to serving a wide range of collective and personal enterprises—nearly all of which involved occupying it, dividing it, developing it, and thus changing it from one material entity into another. Besides being tragic, splendid, ugly, exciting, and *immensely* useful and destructive, the change and the engagement it required also inevitably expressed the sordidness of transience. Remington's achievement was not only to include all the sordidness of the event in his recorded vision but also to expand that vision until both sordidness and transience were absorbed in a universal interrogative and the West lost its substance to emerge as perception only—the same variety of transformation Melville worked on the whaling industry in *Moby Dick*.

Examining even the best of Remington's pictures, bronzes, or literary efforts, I find myself stubbornly resisting the notion that the person who made them was a truly great artist; surveying the complex, unitary whole such individual units make when placed in conjunction with each other, I am astonished by its range, its energy, and its altogether unique harmony. Like the vision it records, Remington's work looks vivid, fragmentary, and engaging at close range but acquires an overpowering stasis if subjected to the critical and historical scrutiny required to bring it into focus at long range. In consequence, I wonder if the question of whether Remington belongs in the front rank of American painters, sculptors, or writers is quite worthwhile. Remington was surely among the most demanding and difficult of artists, because each of his works insisted on being considered together with all the others, executed in whatever medium. He was also surely among the most honest of artists—despite, or perhaps even because of, his naïveté, his frequent confusion, and his liability to various and shifting enthusiasms—for all his passionate imperfections found their way into his work. His work's sometimes embarrassing honesty and its angular, abrasively demanding difficulty give it integrity. This, I suspect, is enough to ask in Remington's case, for such integrity can be measured only against itself. Thoreau, after all, requires "first and last" of an artist "some such

account as he would send to his kindred from a distant land."

Remington's work is such an account, produced at great personal cost and smuggled across the border in a number of ingenuous and unlikely ways—and Americans may now be ready, as Remington's contemporaries were not, to regard that work with the sensitivity and sympathy these kindred are capable of giving. In any case, the signs are good, for Americans, like Remington, are in the process of shedding sentimental notions about the West. In addition, there is new and vital interest in popular culture, in interdisciplinary studies, and in the constructive reappraisal of American institutions—all of which is necessary for understanding Remington's account. In my attempt to read that account correctly, I have tried to follow where it has pointed. Remington's martial preoccupation and his involvement with popular social issues have required my use of some of the tools of the social historian; his lifelong if sometimes faltering campaign against establishment values, his ambivalent involvement with the periodical press, and his passionate exploration of the cultural event he called "that old cleaning up of the West" have compelled my attention to aspects of American cultural history. Throughout, I have tried to remain a critic of Remington's art in its sculptural, graphic, and literary permutations and to show whenever possible how each permutation is related to the other two. Such eclecticism has not been easy, but it is calculated, and Remington, himself so eclectic he seemed at times to fly apart, requires it.

Finally, I should warn readers that I do not consider Remington a "western" artist, except in the unique sense generated by his own work—the sense less of a region than of a direction. I have therefore been at some pains to show that Remington's work was a *response* to the region of the West rather than evidence of his participation in its conquest and dominion. That Remington was no pacifist is shown by the vigor with which his work persistently puts off all hints of prettiness in favor of violence; that he was no regionalist is shown both by his work's multicontinental scope and by its attention to a somber, universal theme. Indeed, when Remington died at the age of forty-eight, on the day after Christmas 1909, he affirmed his membership in what has been aptly called a lost generation. In its

least important sense, the term *lost* identifies a generational life style that in Remington's case involved excessive, perhaps even suicidal, indulgence in food and drink; in its more meaningful sense, it points out a central feature of Remington's work. For that work to have become so firmly associated with the region of the West most forcefully means not only that it echoes Thoreau's insistent demand that the West "stand for" something but also that it expresses a profound sense of the only condition capable of justifying Thoreau's demand: "We know not where we are."

I. Genesis

1. Solidity's a Crust

On the morning of April 25, 1862, New Orleans awoke to see Captain David Farragut's fleet of gunboats anchored just beyond the levee, flying Yankee colors from every masthead. The Yankees themselves stepped ashore the next day to find the Confederate garrisons already abandoned and, after overseeing an orderly occupation of the city, Farragut steamed upriver to receive similar surrenders at Baton Rouge and Natchez. A year later, Vicksburg fell, and the entire Mississippi became once more part of the Union. In July 1864, when the Eleventh New York Cavalry was transferred from Washington, D.C., to Donaldsonville, Louisiana, a river town midway between Baton Rouge and New Orleans, its mission was to perform housekeeping duties in a region where little of war's bitterness survived because little of war's violence had been suffered. As Sherman moved south from the Chattahoochee toward terrified Atlanta on the first leg of his march through Georgia, the towns along the lower Mississippi wore their occupation by Union troops with a certain easy nonchalance. Corn and cotton ripened in the summer heat; boats and barges plied the river; the smiles of Creole girls melted loyalty to faraway sweethearts. There was uncertainty at Washington, agony at Rich-

4
Genesis

mond, but at Donaldsonville the war had been over for more than two years.

Major Seth Pierre Remington, lately editor of a weekly newspaper at Canton, New York, commanded D Company of the Eleventh, comfortably garrisoned at Doyal's Plantation, a few miles east of Donaldsonville.[1] He was a slightly built man of medium height who sported a vaguely military moustache and asserted his uniform with a strut. Of all the regiment's officers, he had been the most active in the fighting, having presided the year before at the only engagement in which a unit of the Eleventh had sustained significant losses. On that occasion, Lee had entered Pennsylvania to threaten Gettysburg, detailing J. E. B. Stuart and the Sixth Virginia Cavalry to perform diversionary strikes to the south. Stuart accordingly terrorized southern Maryland and northern Virginia, at one point attacking a U.S. supply train only four miles outside Washington. Since Lee's bold tactics and Stuart's evasive sallies—both intended to confuse and demoralize the Union forces—required an informed response, there may have been a quirky fitness in selecting a journalist to discover what they were about. In any case, on June 27, 1863, Colonel James B. Swain sent Major Remington and ninety men from the regimental headquarters south of Alexandria to "ascertain the position of affairs" at nearby Centreville, Virginia, and return.[2] Remington and his squadron rode north without incident as the sun rose higher in the sky and dried the dew from roadside meadows. At about eight thirty that morning, they reached Fairfax Courthouse, west of Alexandria, where they collided with Stuart and his regiment of raiders.

Neither Remington nor any of the men in his command were experienced soldiers. The Eleventh had left New York only a year before and had spent nearly all the intervening time in garrison duty, without participating in a single major battle. Yet surely even an upstate newspaperman would have known enough to turn and run if he had been aware that the gray-coated pickets he saw at Fairfax Courthouse formed the advance guard of an enemy force two thousand strong. As it was, Remington ordered his ninety men to draw their sabers and make a frontal charge. If the maneuver was foolhardy, it was also surprising. The enemy were taken completely off guard. Momentarily, at least,

1. The Eleventh New York Cavalry, sometimes called Scott's Nine Hundred, completed its organization in October 1862 at Staten Island. D Company was recruited at Canton, Colton, Pitcairn, Potsdam, and Ogdensburg. For further information, see Frederick Phisterer, *New York in the War of the Rebellion, 1861 to 1865*, 6 vols., 3d ed. (Albany: Lyon, 1912), II, 943 ff.

2. See "Report of Col. James B. Swain, Eleventh New York Cavalry, of skirmish near Fairfax Court-House, Va.," dated June 27, 1863, in *The War of the Rebellion: A Compilation of the Official Records of the Union and Confederate Armies* (Washington, D.C.: U.S. Government Printing Office, 1889), Series 1, XXVII, pt. 1, 1038.

Remington thought he had captured about half of them, but the Confederates quickly took control, and Remington saw that he himself was the captive. As Colonel Swain's report to the adjutant general's office had it, the major and his men had to "cut their way through" in a desperate attempt to achieve the retreat they should have pursued in the first place. They left seventy-three of their number, including five officers, behind. When Swain heard the circumstances of the skirmish, he was "agreeably surprised" that even the bedraggled remnant of eighteen had managed to limp back to headquarters.³

The affair at Fairfax Courthouse was no triumph, but it was a fight and, in a regiment where fighting was uncommon, it commanded respect. "Whatever valor, coolness, and determination could perform," Swain wrote, conveniently omitting wisdom from his list of virtues, Major Remington had "accomplished."⁴ Now, however, a year later and hundreds of miles to the south, valor, coolness, and determination seemed less vital than diplomacy and discretion. There were scouting expeditions, which almost always reported "no enemy in the vicinity," minor matters of police work expedited by military sanctions—as when Remington burned a nearby "house of prostitution" on the grounds that it sometimes harbored "bushwhackers"—and a good deal of public relations work concerning the maintenance of order in the countryside, the procurement of supplies, and the preservation of morale.⁵ As the war entered its final stage, the men who had waited in Washington for a southern attack that never quite materialized found themselves in a part of the South they had supposedly conquered, where it was easy to imagine that they were guests—northern cousins come down at harvest time to sample what a combination of warm sun and rich soil could produce.

The big house at Doyal's Plantation, where Major Remington set up his headquarters in late July 1864, had every appearance of southern largesse. It was located a short distance from the south bank of the Amite River, less than an hour's ride upstream from the town of Donaldsonville and a mile or so downstream from a place called Hampton's Ferry, where the Amite could be easily forded, especially in summer, when the river was low. A grove of fine, large trees, where the men of Remington's command pitched their

3. Ibid., p. 138.
4. Ibid.
5. See the report of Colonel Cyrus Hamlin, dated August 1, 1861, in *The War of the Rebellion*, Series 1, XLI, pt. 2, 497–498.

tents, provided welcome relief from the summer heat. Beyond the grove, huge fields of tall corn stretched in every direction, bounded on the north by dense woods that lined the riverbank. Remington's force, which consisted of some two hundred "men for duty," a few prisoners of war, and some wounded, lived comfortably there for several weeks. At daybreak on August 5, however, while Remington and his men slept, Colonel John S. Scott and some fifteen hundred horsemen of the Ninth Louisiana Cavalry forded the Amite at Hampton's Ferry, placed four pieces of light artillery in the cornfields, and completely surrounded the garrison. The note Scott sent in to Major Remington at breakfast deplored "useless effusion of blood" and "respectfully" demanded unconditional surrender "within five minutes."[6]

It was careless for Remington to have left the ford at Hampton's Ferry unguarded—unthinkable for him to remain oblivious while a brigade of mounted cavalry and a battery of artillery crashed through the standing corn to encircle him. Yet an attempt to defend the garrison would almost surely have been disastrous, and its surrender might well have resulted in Remington's court-martial. The major therefore resorted to the same eccentric gambit that had served him, however indifferently, at Fairfax Courthouse—the only maneuver he had ever executed, perhaps the only one he knew. He ordered his men to "cut through" Scott's lines and head west along the levee road toward Donaldsonville.[7]

Miraculously, he succeeded. By the time Scott's artillery could open fire, Remington and his men were so near the gun emplacements that the shells passed harmlessly over their heads. The astonished Confederate cavalry stood by "like posts" as Remington rode past them. When he reached Donaldsonville, however, Remington discovered that ninety-seven of his men were missing. He quickly assembled reinforcements of about a hundred horsemen, requisitioned a Mississippi River gunboat, and returned to the garrison before noon. Scott and his artillery had vanished. So had some forty mules, a small herd of horses, large quantities of food and supplies, all the men Remington had left behind, and a number of Remington's regimental papers. Birds still twittered in the woods along the

6. Scott's note is included in Remington's report of the fight at Doyal's Plantation, in *The War of the Rebellion*, Series 1, LXI, pt. 1, 216.
7. See Remington's report, p. 216.

riverbank, the Amite still made its sluggish way to join the Mississippi, and the corn still ripened silently in the Louisiana sunshine, but something had happened to disrupt the normal order such placid appearances suggested.

Seth Remington had neither leisure nor inclination to make a response to the morning's events more profound than that contained in his spirited cursing of John Scott. However, Herman Melville—a fellow New Yorker nearing fifty, working in the U.S. Customs Office at Manhattan—kept a distance which allowed him to speculate that all the war's events were of a piece with the disruptive character of the war itself. Watching the ship of state almost four years before, while the Confederate States of America were being created at Charleston, Melville had noticed its alarming resemblance to the *Pequod*, observing that "storms are formed behind the storm we feel: / The hemlock shakes in the rafter, the oak in the driving keel."[8] In 1859, John Brown's hanging corpse had seemed to him a "portent" of events to come[9] and, when General Irvin McDowell marched thirty thousand untrained recruits south to crush the rebellion by engaging Pierre Beauregard's Army of Northern Virginia at a tiny creek called Bull Run, Melville thought the troops in their new blue uniforms looked like "preparatives of fate."[10]

For all the impressive array of political, economic, industrial, and military apparatus attendant upon it, the war itself seemed to Melville a *natural* phenomenon: beneath the reassuring hum of everyday events, it registered as the "low dull rumble" of thunder, the "winter white and dead," or "Heaven's ominous silence."[11] As a historical event, it defied the idea of historical causality to express instead what Melville called "Nature's dark side"—a tenebrous season no less natural for its blackness.[12] Melville's insight showed that John Scott's attack on Remington's garrison contained no surprise at all for anyone who sensed the impulse hidden by war's gallant appearances. Had he been present at Doyal's Plantation when Remington returned, Melville might have pointed out that the force which emerged from the cornfields to make off with Remington's men, mules, supplies, and papers was identical with the force that caused

Solidity's a Crust

8. Herman Melville, "Misgivings," first published in *Battle-Pieces and Aspects of the War* (New York: Harper & Brothers, 1866). I have here used Hennig Cohen's edition of *Battle-Pieces* (New York: Thomas Yoseloff, 1963), p. 37.
9. Melville, "The Portent," in Cohen, p. 35.
10. Melville, "The March into Virginia," in Cohen, pp. 42–44.
11. Melville, "The Conflict of Convictions," in Cohen, pp. 37–41.
12. Melville, "The Apparition (A Retrospect)," in Cohen, pp. 140–141.

the corn to grow. For the cornfield to turn suddenly into a battlefield showed merely that the force was near enough to the surface to be turned up with a plow.

Indeed, though he probably never heard of the fight at Doyal's Plantation, Melville described it perfectly:

> Convulsions came; and, where the field
> Long slept in pastoral green,
> A goblin-mountain was upheaved
> (Sure the scared sense was all deceived),
> Marl-glen and slag-ravine.
>
> The unreserve of Ill was there,
> The clinkers in her last retreat
> But, ere the eye could take it in,
> Or mind could comprehension win,
> It sunk!—and at our feet.
>
> So, then, Solidity's a crust—
> The core of fire below;
> All may go well for many a year,
> But who can think without a fear
> Of horrors that happen so?[13]

The whole phenomenon of war, said Melville, was an "apparition" that proved all else apparitional as well —an echo more closely heard of the cosmic "loomings" sensed by an abandoned Pip as God's foot pumping an ultimate treadle or by Ishmael himself as the deafening throb of a Weaver God's textile mill. Applied to Remington's experience at Doyal's Plantation, this understanding meant that, while it was easy enough to believe in the cornfield as merely a cornfield as long as everything remained peaceful, the cornfield's sudden eruption showed that it had been something quite different all along. "Thus," Melville had Babbalanja explain in *Mardi*, "Nature works, at random warring, chaos a crater, and the world a shell."[14] If such truth seemed unimportant during intervals of peace, it was because peace fostered illusion. War, on the other hand, instantly shattered all illusions. In the wake of the great battle at Shiloh, with its more than twenty thousand casualties, Melville put the matter directly, asking "what like a bullet can undeceive?"[15]

For Major Remington, of course, the affair at Doyal's Plantation taught principally that it was well to post outlying pickets, even when none of the

13. Ibid.
14. Melville, *Mardi* (Chicago: Northwestern University Press, 1970), p. 417.
15. Melville, "Shiloh: A Requiem," in Cohen, pp. 71–72.

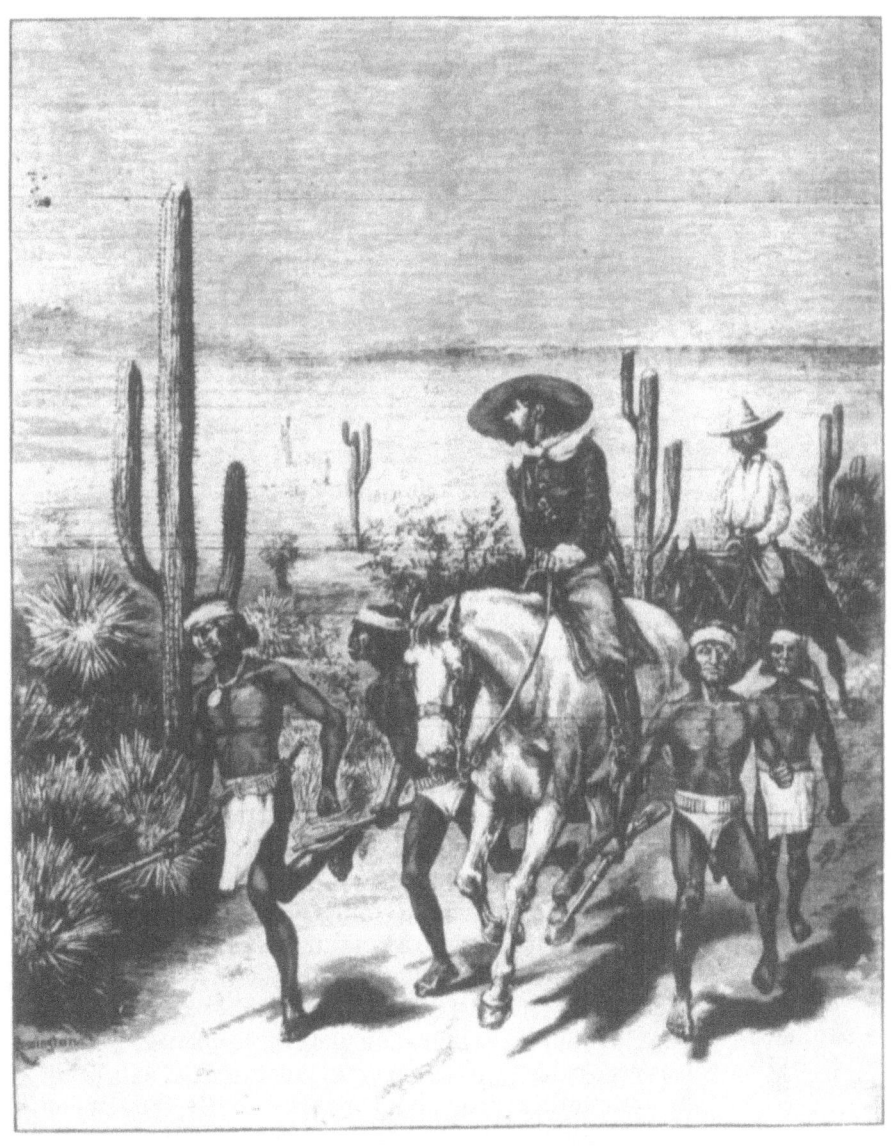

1. "*The Apache War—Indian Scouts on Geronimo's Trail.*"
*Remington's first signed illustration in a major magazine does
not represent Geronimo, the object of the search, and therefore
reflects the ephemeral nature of much of the work that follows it.*

enemy seemed near—a lesson that surely contained its metaphorical dimensions but demanded practice with far greater urgency than it invited meditation—and Melville bought his ability to penetrate the meaning of war by never having been involved in combat. The two men therefore had nothing in common except their coincidentally overlapping presence in a turbulent time. Nearly a quarter century after the war, however, Melville and Major Remington were linked in a subtler fashion when *Harper's Weekly*, the same journal Melville had read for many of the impressions that found their way into his Civil War poems, printed a curious picture on its cover.[16] Against a nightmare landscape of rocks, sand, and cacti, four Indians and two bearded horsemen, all armed, moved beneath a blank sky, out of nowhere and into nothing. The caption stated that they were pursuing the outlaw Apache chief, Geronimo—but, with or without its caption, the picture refused to serve a journalistic end, engaging instead the same principle Melville had expressed by saying that "solidity's a crust," stating the same denial of history by event Melville had caught as an undeceiving bullet. That is, both the picture's setting and its figures expressed discontinuity. Significantly, it was the first signed, commercial illustration by Frederic Remington, the major's only son, to appear in a national magazine.

During his lifetime, Remington drew and painted more than seven hundred pictures explicitly concerned with war and violent conflict.[17] Readers of *Harper's Weekly*, *Harper's Monthly*, *Cosmopolitan*, and other popular journals where the pictures appeared doubtless recognized their energetic treatment of subjects bizarre, military, or vividly grotesque. By 1890, when Remington's reputation was not only established but was firmly linked with matters western, many of the same readers may also have noticed that, while other popular illustrators like A. B. Frost, William Smedley, and W. A. Rogers drew pictures of gracefully gowned society girls and their beaux at least as often as they drew soldiers, Indians, and bearded frontiersmen, Remington seemed to ignore the former subjects almost altogether. Because the readers saw what Remington drew distributed among other materials in the pages of periodicals, however, it was easy for them to miss the extent and direction of his thrust, an un-

16. *Harper's Weekly*, January 9, 1886. Remington's cover picture bore the caption "The Apache War—Indian Scouts on Geronimo's Trail."

17. For an excellent checklist of Remington's published illustrations, see Harold McCracken, *Frederic Remington: Artist of the Old West* (Philadelphia: J. B. Lippincott, 1947).

derstandable mistake reflected in the popular image that persists today of Remington as an accurate but more or less indiscriminate chronicler of the West. In fact, the artist's eye was highly selective. Complicated, energetic, even at times prophetic, his temperament contained a zest for life bound up with a strong impulse toward destruction.

Like Melville's, Remington's perceptions were attuned to the apocalyptic and, since his life spanned the same season of interlocking storms Melville forecast in 1860 as the inevitable consequence in the chain of events that produced the Secession Convention, history challenged him to meet it with imagination. Yet the distance that yawned between the subjects Remington treated and his treatment of them always corresponded to the distance that rendered his initial *Harper's Weekly* cover anomalous as news while giving it a curious interest as potential art—a desert space that made the artist always an outsider straining to reach the revelation always beyond his range. For Melville to look back at the war as an "apparition" that had convulsed in the midst of "pastoral green" only to vanish before "the eye could take it in, / Or mind could comprehension win" was in some degree a rhetorical trick: he had seen the war coming and—albeit from a distance—had watched its progress with fully developed faculties. Yet Melville's trope designated something very much like Remington's perceptual actuality for, while it cost Melville relatively little to acknowledge that the war had destroyed his faith in historical continuity, Remington never had an opportunity to acquire that faith. Remington's illustrations, paintings, bronzes, essays, and stories all testify to how thoroughly he regarded solid-seeming order as a "crust," how passionately he sought to glimpse the "core of fire" Melville said blazed beyond it. Furthermore, although Melville's vision of the war as a dream functioned as a metaphor for the *experience* of history, his image of a fiery "core" was a metaphor for the *impulse* of history and, although Remington traveled far to find that impulse, he never succeeded. Because the impulse he sought was identical with the impulse that caused him to seek it, his enterprise was redundant, and what he discovered instead was himself.

2. Isolato

While Melville wrote poems about the battles he saw reported in *Harper's Weekly* and Seth Remington learned about tactics in a Louisiana cornfield, Frederic approached his third birthday at Canton, New York, a quiet village near the Canadian border in St. Lawrence County. Although not a good place for watching the war as a fight, it was exactly the right place for feeling the war as imaginative energy, for Canton was both exposed and insular—close enough to be anxious about the outcome of the southern fighting and far enough away to make the fighting seem romantic. Its insularity was real, because St. Lawrence County occupied a little corner of the map that belonged almost wholly to itself. Cut off from New England by Lake Champlain and the Green Mountains of Vermont, from Albany and New York City by the Adirondacks, from the great West by Lake Ontario, the "North Country," as natives called it, was less accessible from metropolitan centers of the eastern seaboard in 1864 than Mark Twain's Carson City was from San Francisco. The nearest cities of any size, and also the easiest to get to, were Ottawa and Montreal. Yet the town's insularity was also vulnerable, because the people who had settled the region were both Republican and patriotic and, notwithstanding their geographical

alliance with cities across the St. Lawrence River to the north, sent their young men off to fight in the South for the sake of a political alliance.

Among such people were the Remingtons themselves, who had come north from Binghamton, New York, in 1854, when Frederic's grandfather, Seth Williston Remington, accepted a call to preach at Canton's Universalist Church and supervise fund raising for St. Lawrence University, which would be chartered in 1856.[18] Seth Williston brought with him his wife, Maria Pickering Remington, and two sons, seventeen-year-old Seth Pierre and the younger Lamartine Zetto. The family quickly assumed a respected position in the life of the town, and in 1856 they bought a house near the university campus. That same year, Seth Pierre proudly helped start the town's first newspaper, gave it the no-nonsense name of *Plain Dealer*, and became its editor. In November 1860, when the newspaper hailed Abraham Lincoln's election to the presidency, Seth was engaged to Clara Sackrider, daughter of Henry Sackrider, the local hardware merchant and a pillar of Seth Williston's church. A snowbound day in January 1861 saw the couple's marriage, one scant month before the nation broke in half.

Between his wedding to Clara in January and his son's birth in October, Seth Remington devoted himself jointly to the newspaper and to recruiting volunteers for the Eleventh Cavalry. He was doubtless present that fall at Henry Sackrider's house on Water Street, where his son was born on October 4 while the maples outside blazed with color. But he had probably even then begun his farewells, for in December, less than a year after his marriage and when Frederic was only two months old, he accepted a commission as captain in the regiment he had helped raise. Selling the *Plain Dealer*, he took his place among the men Melville called "preparatives of fate" and departed, leaving behind an atmosphere charged more with apprehensiveness than with hope.

Had Canton been in Georgia or Mississippi, its experience of the war would have been more catastrophic but, as matters stood, the sounds of battle that reached the town through infrequently delivered letters from the South and magazines like *Harper's Weekly*—where Frederic, even at three or four years old, may have pored over W. H. Waud's vivid sketches of the fighting

Isolato

18. The best published source of information concerning Remington's family and the artist's boyhood is Atwood Manley, *Frederic Remington In the Land of His Youth* (Ogdensburg, N.Y.: Northern New York Publishing Co., 1961).

—were at once exotic and ominous. That Remington was born into tempestuous times was appropriate, because it tallied with the tempestuous subjects he later pursued as writer and artist. That the tempest he was born to lay far beyond the compass of his own sharply limited experience was not only appropriate but catalytic, for it meant that Remington would feel the force of the war always and only as hiatus. The absent father, the unspoken fears, the land that stretched beyond the Adirondacks to the battlefields were all simply voids and may be supposed to have contributed as voids to the empty spaces Remington attempted to fill with vigorous color and violent kinesis.

According to local tradition, however, Remington's growth toward maturity proceeded without notable incident. Not lurid enough to have been described by Horatio Alger, it very possibly might have been painted by Norman Rockwell. The scanty information that survives concerning his boyhood thus explains little except that Remington grew up in a thoroughly "normal" way among shabby but attractive surroundings, including his father's newspaper office, the inevitable livery stable, and the charming woods and streams of the New York countryside. The normalcy may all be verified, for Canton remains a livable and aesthetically satisfying village. The Grasse River that Remington and his playmates went skinnydipping in still runs placidly beneath a bridge at the upper end of the main street. The livery stable is gone, but the *Plain Dealer* endures, rebuilt on the same spot it occupied under Seth Remington's editorship. The woods still stretch away from the town in all directions and are still laced with streams where one may swim, fish, or canoe. Henry Sackrider's house—outwardly unchanged except for a closed-in front portico and a discreet bronze plaque installed by the local historical society—is still occupied, still stands on Water Street beneath maples that still change color in the fall. Utilizing the still serviceable rhetoric that gave the *Plain Dealer* its name, a longtime resident describes St. Lawrence County as "God's country, but cold as hell in the winter," and good-natured stories are still told winter and summer in solidly built upstate houses about Fred Remington's prodigious appetite, Fred Remington's love for fishing, Fred Remington's having been bucked off a horse in Canton's city park. There is no reason

to distrust such impressions and every reason to believe them, for they comprise colorful inevitabilities of no small value. The trouble with them is precisely their plausibility, for they touch only the credibly continuous crust of Remington's fundamentally outlandish life.

Remington's ambition as an artist was to reach beyond surface actualities and there capture qualities which could be transferred to other surfaces—clotted bronze, textured canvas, or the complex flatness of the printed page, transforming each of his subjects into a reflected facet of some aspect of himself. That the Remington who painted "Ceremony of the Scalps," sculpted *The Rattlesnake*, and wrote *John Ermine of the Yellowstone* [19] also grew up in St. Lawrence County therefore suggests that, although his boyhood appears to have been bland and featureless, his own experience of it may have been unusually intense. Remington himself much later designated the means by which this intensity might be found out when he told his friend, Edwin Wildman, that "art is a process of elimination," adding that "what you want to do is just create the thought—materialize the spirit of the thing . . . then your audience discovers the thing you held back, and that's skill." [20] Applied to an individual picture, statuette, or story, the remark meant merely that the aesthetic object derived its interest by representing impressions rather than things. A bronze horse therefore differed from a live one through having been given intentional form; a two-dimensional cowboy on canvas conveyed a "spirit" from creator to perceptor; a historical location became imaginary when included in a fictional narrative; and so on. Applied to the entire corpus of Remington's work, however, the theory that art constituted a series of controlled voids had additional significance, for whatever it was that the artist revealed by holding it back belonged to the artist. Taken as a whole, the artist's work measured vital features of his experience.

Since little is known about Remington's early life at Canton, it may be useful to identify the fundamental, recurring pattern associated with family life in his fiction for, while both of his novels and a number of his short stories were chronicles of family life that superficially fit the fashion of family reading encouraged by William Dean Howells and others, Remington

Isolato

19. "Ceremony of the Scalps," a good example of Remington's ability as impressionist, was printed in the June 1908 *Collier's Weekly*. *The Rattlesnake*, a bronze statuette that showed a rider mounted on a horse in the act of shying away from a rattlesnake, was copyrighted in 1905. *John Ermine of the Yellowstone*, first of Remington's two novels, was published by Macmillan in 1902. These three works are cited because they are representative of Remington's later preoccupations, not because they have any specific bearing on his early life.
20. Remington, quoted by Edwin Wildman in "Frederic Remington, the Man," *Outing*, March 1903, p. 715.

almost always regarded family groups as organic units rather than as social institutions, placing them far beyond the reach of that nineteenth-century modernism men like Howells counted on to rub rough edges smooth and give the nation good manners. The reason was that, as a collective enterprise, modernism depended upon its participants to make themselves over in its own image, while Remington insisted that the most American feature of America was its susceptibility to tempests like the Civil War. Remington's model of American family life thus contained none of the sturdy domesticity that sustains Silas Lapham even after his paint business has failed or the amiable bickering that leads the Marches on their zigzag course toward social truth in *A Hazard of New Fortunes*. Instead, without exception, Remington represented marriage as one of several ways to achieve sexual gratification and, whenever the parties to such an arrangement stayed together long enough to be called a family, grief was the inevitable result.

A good example of the only kind of family portraiture that interested Remington may be found in "The Story of the Dry Leaves," written while he recovered from malaria contracted in Cuba during the Spanish-American War. The tale, Remington averred, was told him "long ago" by a "very old Indian" in Manitoba and concerned people "long since gone" who lived at a place "of which no name is saved," so far away in time that the "very trees they lived among are dead and down this many a year."[21] It was a family narrative, curiously modified by the rigorous application of its title and setting as metaphors for character and incident, for Remington designated both the characters and the family they briefly form as identical with the forest where they live, allowing them a single season of automatic greening before the organic unit they comprise disintegrates. He even described the story's hero, a young Ojibway brave named Ah-we-ah, as one who "grew up or *came up*" (italics mine) where numerous "deadfalls" allowed only the strong to achieve maturity, and he later included "Dry Leaves" in a collection he called *Men With The Bark On*."[22]

While a popular organic metaphor had served books like Walt Whitman's *Leaves of Grass* and Henry Thoreau's *Walden* by allowing them to focus on a unitary movement toward rejuvenating springtime,

21. Remington, "The Story of the Dry Leaves," *Harper's Monthly*, June 1899, pp. 95–104.
22. Remington, *Men With The Bark On* (New York: Harper & Brothers, 1900).

the arboreal metaphor Remington used in "Dry Leaves" was thoroughly autumnal. Rather than revealing how all phenomena are linked in a family of the living, it showed how quickly death causes such a family to decay. Therefore, at the beginning of the story, it was with appropriate nonchalance that Remington noted the slaughter of Ah-we-ah's mother, father, brothers, and sisters by the Sioux—an occurrence he called merely "very common." The scene of the slaughter—which Ah-we-ah misses by the lucky chance of being absent on a hunt—offered Remington ample opportunity to represent in prose the vividly realized carnage he captured in many of his best-known pictures, but he wisely bypassed the opportunity, writing only that, when Ah-we-ah returned from his hunt to come upon a litter of "charred and wolf-eaten" corpses, "he found himself utterly alone" —or, again, "the very last kinsman Ah-we-ah had on earth was dead." [23] In this instance, Remington "held back" the battle and the killing. The "spirit" summoned into being by his restraint was Ah-we-ah himself, the offspring of perfunctory forebears who showed Ah-we-ah what maturity meant by being killed when he entered manhood: to be a man and to be "alone in the country" were two sides of the same condition.

Had the pattern defined by "Dry Leaves" occurred in that story only, it might be explained in a variety of ways but, wherever Remington's work touched family life with more than a passing reference, the pattern was duplicated. For example, in *The Way of an Indian*, Fire Eater clings to the corpse of his infant son in much the same way as Ah-we-ah's wife in "Dry Leaves" later clung to hers; [24] in *John Ermine of the Yellowstone*, Ermine, like Ah-we-ah, declares that he has "no relation anywhere on earth"; [25] in the stories from *Sun Down Leflare*, Sun Down's involvement with stolen squaws and white prostitutes makes a crazy quilt of amorous encounters, producing a number of offspring but no home; [26] and so on. Conceived in trouble, orphaned by the time of their majority, frequently lustful but never domestic, the heroes who figure in Remington's family portraits either have no family ties to begin with or soon lose whatever ties they had. It will not do to push the analogy between these men and Remington himself too far or to suggest that Rem-

23. "The Story of the Dry Leaves," p. 96.
24. *The Way of an Indian* (New York: Macmillan, 1906). This novel was also published serially in *Cosmopolitan* between November 1905 and March 1906.
25. *John Ermine of the Yellowstone*, p. 161.
26. See *Sun Down Leflare* (New York: Harper & Brothers, 1899). Several of the Sun Down episodes appeared in *Harper's Monthly* during 1898.

ington's boyhood in upstate New York contained a series of calamities like that which overtook Ah-we-ah, but since the family life represented in Remington's works so consistently fits a single template—and since that template does indeed tally with certain features of Remington's boyhood—an unavoidable inference is that the family pattern Remington produced in fiction had meaningful connections with the family pattern he experienced.

Remington was nearly six and could not remember having seen his father when Seth, who had spent the year following his discharge at the end of the war as editor of the Bloomingdale, Illinois, *Pantagraph*—possibly to get enough money to make a start at civilian life—returned to Canton. There is no record that Canton afforded the colonel a hero's welcome—it probably did not, since he came home so long after the fighting was over—but Frederic must have both welcomed him and expected much of him, for a victorious soldier who had faced down Jeb Stuart could surely be counted on to make a success of whatever he chose to undertake. What neither Seth nor Frederic understood was the truth contained in Melville's irreverent contention that "all wars are boyish and are fought by boys"[27] and, whatever the end of the war meant for Seth himself, it also involved a readjustment of his stature in the eyes of his son, for St. Lawrence County contained no Jeb Stuarts, and the St. Lawrence *Plain Dealer*, which Seth bought back soon after returning, did not resemble a transcontinental arena of combat. Having experienced a brief and mostly unpleasant excitement about the war, the North Country participated not at all in the explosive industrial and economic growth that followed it. While the rest of the nation moved rapidly into what Mark Twain and Charles Dudley Warner aptly christened the Gilded Age,[28] Canton returned to its old ways, its fears in part replaced by nostalgia. The condition was not an advantageous one for a local newspaper and, although Seth Remington pursued his editorial duties energetically, the *Plain Dealer* made indifferent progress.

Indeed, even a thriving business would have been shaken by the event that occurred at three o'clock in the morning on August 14, 1869, just two years after Seth's return: the building where the *Plain Dealer* had its office and presses burned to the ground. All Seth

27. "The March into Virginia," in Cohen, pp. 42–44.
28. See Mark Twain and Charles Dudley Warner, *The Gilded Age* (Hartford: American Publishing Co., 1873).

could salvage were his accounts and subscription lists. Seven-year-old Frederic may, as one biographer argues, have found the event "soul-stirring, thrilling, tremendously exciting"[20] but, even if the fire warmed him as a spectacle, it also chilled him as a disaster.

Furthermore, what may have looked like merely an unfortunate accident took on the aura of persistent bad luck when the *Plain Dealer*, temporarily established in another building, burned down again the next year. Frederic never came home from a hunting trip to find his family slaughtered, but by his ninth birthday he had experienced anxiety and tension stemming from history's first modern war, had been forced to rapidly recast whatever images he had formed during the war years of his absent father, and had twice witnessed the destruction of the family business. Dating from at least as early as the second burning of the *Plain Dealer*, he had an uncommon awareness of "deadfalls."

Although Remington later drew landscapes and character studies that touched features of life in St. Lawrence County, it was therefore understandable that he never turned back with the intention of recapturing his boyhood. If he had, he might have discovered, as Mark Twain did in *Huckleberry Finn*, that beneath nostalgic justifications lurked a complex tangle of fear and denial—or, like E. W. Howe in *The Story of a Country Town*, he might have been stricken dumb with amazement at how ambivalent the idea of "growing up with the country" became when examined closely.[30] As it was, he sought to get away from Canton and the values it represented with more determination than he sought to get back to them. His submerged impressions of a Canton boyhood were in some sense identified in his first oil painting, purportedly executed in 1875, when he was fourteen. Entitled "The Captive Gaul," the work showed a large blond figure, stripped to the waist and bound hand and foot with disproportionately massive chains fastened to iron rings embedded in a stone wall.[31] Like the figure in the painting, Remington wore manacles—as soon as he could, he left them behind with few regrets. Meanwhile, two lesser journeys helped define the direction he would take when circumstances left him looking for a place to go.

Shortly after the *Plain Dealer* burned for the second time, Seth Remington fortunately managed to be appointed Collector at the Port of Ogdensburg, a town

29. Manley, p. 12.
30. Howe's curious novel (Boston: Houghton Mifflin, 1883) collapses into burlesque shortly after midpoint, as it becomes apparent that the author has raised issues far beyond his power to control as form. See especially Howe's apologetic preface, an honest confession of inability valuable for its implications concerning autobiographical fiction in the United States.
31. "The Captive Gaul" hangs in the Frederic Remington Art Memorial at Ogdensburg, New York. It has not been reproduced for publication.

some eighteen miles northwest of Canton on the south shore of the St. Lawrence River. Even during the summer his duties were not arduous, and the port shut down altogether for about four months of every year because of ice. Seth used his spare time to take up horse racing, leaving Lamartine Zetto, his younger brother, to preside over the *Plain Dealer*'s convalescence. The result was what seems to have been a profitable partnership with Walter Van Valkenberg, a trainer of trotting horses from nearby Hermon. When Seth sold the *Plain Dealer* in 1873 and moved his family to Ogdensburg permanently, Van Valkenberg moved there too. In something like the way youthful Sam Clemens watched for side-wheel riverboats to steam past Hannibal, Remington avidly pursued the harness races at all the surrounding county fairs. As family fortunes improved, there was less worry and more fun, and the shadow the war had cast on the Remingtons grew less distinct as Frederic began to explore his natural talents—horsemanship, woodcraft, and drawing.

Indeed, the family was affluent enough by 1877 to begin planning a bright future for its only son and, that year, Frederic was sent to Highland Military Academy at Worcester, Massachusetts, to finish his preparation for college. At Highland, Remington disliked having to participate in spit-and-polish drill like that he later ridiculed as inimical to the training of officers—whose business, he thought, was to fight [32]—but he enjoyed the military atmosphere. He drew pictures of soldiers and horses and described himself as a rough-and-ready sort with "short ... stiff" hair, "good" muscle, and a big appetite.[33] The few letters he wrote expressed verve and an ironic self-awareness rare indeed for a seventeen-year-old, suggesting confidence in himself and the palmy times that seemed to be ahead. The summer of 1878 he spent at home in Ogdensburg. That fall, he bypassed the family connections with St. Lawrence University at Canton to enter Yale at New Haven.

Besides reflecting the Remingtons' new prosperity, Frederic's matriculation at Yale was a debut from the North Country's backwater into the mainstream of history Seth had left in 1867. The plan was for Frederic to enroll in a business course that would prepare him for making money, but the only figures the newly created freshman had any use for were not numerical, and they did not appear in columns except when they

32. Among Remington's many essays and articles on this subject, see especially "The Essentials at Fort Adobe," *Harper's Monthly*, April 1898, pp. 727–735; "Vagabonding with the Tenth Horse," *Cosmopolitan*, February 1897, pp. 347–354; and the following, all from *Harper's Weekly*: "Indians as Irregular Cavalry," December 27, 1890, pp. 1004–1006; "A Day with the Seventh Regiment," July 18, 1891, pp. 536–538; "The Galloping Sixth," January 16, 1892, pp. 57–64; "Troop A Athletics," March 3, 1894, p. 206; "A Model Squadron," June 9, 1894, pp. 539–542.

33. Remington in a letter to a friend, written from Highland Military Academy, quoted in McCracken, p. 28.

wore uniforms and marched. Therefore, Remington overrode parental objections and enrolled in the recently formed art school, electing to bury himself in a cluttered basement studio rather than prepare for economic advancement in the orderly classrooms above.[34] He proved a poor student and quickly developed an intense dislike both for John Niemeyer, his professor, and for the subject Niemeyer taught.[35] Years later, Poultney Bigelow, who occupied the basement studio at the same time Remington did, recalled Remington as a "big, burly blond undergraduate who ... cursed Praxiteles and left Yale disgusted with art and its New Haven exponents."[36] Remington went to Yale instead of St. Lawrence because Yale might open doors for him that St. Lawrence could not. Yet his subsequent disenchantment with art school designated both ambition in general and Yale in particular as illusory goals, for neither offered anything he thought worth the trouble of pursuing. The result of a Civil War infancy, a boyhood in which two disastrous fires figured prominently, and an adolescence organized around county fair horse racing was a kind of paralysis.

The only facet of college life that attracted Remington was football, an activity that offered the chance for violent locomotion without threatening to move a player beyond the limits of the football field. Because football was strenuous, it appealed to Remington's urge toward vigorous engagement. Because it was a game, it required only limited commitment and presented only benevolent perils. When Remington joined the varsity team as forward in 1879, Walter Camp, later famous as the game's "father," was captain—years afterward, when reformers pressed to make the game less dangerous, Remington wrote to Camp asserting that "football ... is best at its worst," adding that what he liked most about it was "its destructive quality."[37] Yet what Remington saw as "worst" was the cheerfully battered condition he depicted for the *Courant* in an 1879 drawing—possibly a self-portrait—in which a bandaged hero recuperates from injuries that only affirm his status. Although Remington enjoyed it while it lasted, the contest contained but the barest suggestion of the terminal conflict he later represented over and over again as a last stand.

Ironically, however, a scoreless football game with Princeton, played on Thanksgiving Day 1879 at Hobo-

Isolato

34. Founded in 1864, Yale Art School occupied a many-turreted building named Street Hall. The basement classroom remembered by Bigelow (see note 36 below) was probably a drawing studio.
35. John Henry Niemeyer (1839–1932) was born in Germany and grew up in Cincinnati and New York. From 1866 until about 1870, he studied in France with Jean Léon Gérôme, Adolphe Yvon, Sébastien Cornu, and Jacquésson de la Chevreuse, meanwhile tutoring Augustus Saint Gaudens. He was appointed professor of drawing at Yale in 1871.
36. Poultney Bigelow, *Seventy Summers*, 2 vols. (London: E. Arnold & Co., 1925), I, 302.
37. Remington, *Frederic Remington's Own Outdoors*, edited by Douglas Allen (New York: Dial Press, 1964), p. 17.

ken, New Jersey, signaled the end of Remington's academic career. It was the football rusher's own last stand as teammate against the forces that hounded him out of the North Country and the East, sent him across shimmering deserts, and brought him finally to death, producing in the meantime a recorded vision of outlandish people engaged in bizarre pursuits. Shortly after the game broke off because of injuries on both sides, and darkness, Seth Remington became seriously ill at Ogdensburg. Frederic was called home before the end of the term and did not return after Christmas vacation. On February 18, 1880, Seth died, leaving Frederic "alone in the country" at nineteen. The solid crust had broken, and the captive was free to become an Ishmaelite.

II. Exodus

1. Open Country

"Artists," Remington asserted in 1905, "must follow their own inclinations unreservedly," and he confessed that such practice was "more a matter of heart than head, with nothing perfunctory about it."[1] He was, of course, speaking about himself. A recognized success as sculptor, painter, journalist, and novelist, he responded with amiable arrogance to requests from editors and interviewers that he share with an admiring public the wisdom responsible for his success. Quite rightly, he attributed his accomplishments to aptitude rather than calculation, yet he neglected to add in 1905 that the "inclinations" he spoke of had been difficult to discover, almost impossible to pursue. Indeed, only by looking backward was it possible for Remington to perceive that such inclinations had sent him anywhere. Sitting in his cluttered studio at New Rochelle, New York, he therefore conjured up a point twenty-four years in the past and designated it the beginning of his career. Night had overtaken him, he remembered, in the Montana Rockies. The time was September 1881, he was not yet twenty, and he was alone. As dark thickened, and a tingling in the air promised snow, he rode by chance into the solitary camp of a "wagon

1. Remington, "A Few Words From Mr. Remington," *Collier's Weekly*, March 18, 1905, p. 17. Reprinted in *Collier's Weekly*, January 8, 1910, p. 12.

freighter" who cooked "bacon and coffee" over an open fire. Here, he wrote, he had found his vocation.

The wagon freighter Remington remembered was, like Remington, a New Yorker. Like Remington, he had gone west at "an early age," following the "receding frontiers" Remington had read about in "Catlin, Irving, Gregg, Lewis and Clark, and others." He had moved to Iowa, from Iowa to Montana. If the freighter had seen sights, loved women, fought Indians, killed bears, however, Remington thought none of it worth mentioning in 1905. All that survived of the old man's nomadic life, when Remington wrote about it years after their Montana meeting, was a single sentence: "Now," Remington remembered being told across the embers of the fire, "there is no more West." From this pronouncement Remington dated his birth as an artist for, realizing, he said, that "the wild riders and the vacant land were about to vanish forever," he began "without knowing exactly how to do it . . . to try to record some facts" about their extinction.[2] Remington's account was plausible enough as an anecdote but would hardly do as an explanation for his career. What stared out from *Collier's Weekly* was no statement, but a question: how did nineteen-year-old Remington, erstwhile admirer of trotting horses and more recently a football player and unenthusiastic student of art at Yale, happen to be wandering at nightfall in the Montana Rockies?

On the surface, Remington's answer was simple. "I was in the grand silent country," he maintained, "following my own inclinations"—that is, doing exactly what art required of the artist. Looking back from 1905, he regarded his sojourn in Montana and his frugal supper with the wagon freighter as nothing less than fated. Yet it was not only Remington himself who made the trip, and Remington himself who talked with the freighter, but Remington himself who welded Montana and the freighter into a single design. The artist's inclinations derived significance only by being forged into art, and whatever destiny informed them was produced by the artist's imagination. Although it was probably misleading as autobiography, surely insignificant as history, Remington's anecdote therefore became valuable as fable. In it, Remington acknowledged history by admitting that his work rang down the final curtain on "three American centuries of

2. "A Few Words From Mr. Remington," p. 17.

smoke and dust and sweat," but he also affirmed art by calling the termination thus accomplished a "living, breathing end" and a turning away from historic progression, which had produced "quite another thing" at the same geographic place. His assumption was that the end of the West as historic event identified the beginning of the West as art. By placing himself in the fable at precisely the point where end and beginning were the same, he identified himself as creator of both. His inclinations were to make himself the central actor in the drama he chronicled, and the most significant feature of the fable he told concerning his birth as an artist was that no other ontogeny mattered. Since the fable functioned to designate the artist as creator, the question of how the artist got to Montana neither required nor permitted an answer.

Remington was not an artist when his father died, and his inclinations were vaguely artistic at best. Therefore, it was no search for art that sent him west the following year but a series of mostly unpleasant events. Immediately following Seth's death in February 1880, Frederic and his mother had returned to Canton to live with the Sackriders, who had sold the house on Water Street and moved into a larger place several blocks away. Although the family was not without resources, the loss of Seth abruptly ended the financial security that had been unsteadily building since 1870. As a result, plans for Frederic's further education were abandoned in favor of efforts to find him employment. Since Remington had disliked study from the start, it was not difficult for him to give up Yale. Finding a job, however, was quite another matter and, during the year that followed, he drifted in and out of several unpromising occupations, including a junior clerkship in the state capitol at Albany and waiting on customers in a grocery store at Canton. Ironically, he spent much of his time at the old Sackrider house on Water Street, now occupied by Walter Van Valkenberg, the horse trainer who had gone into partnership with Seth ten years before. Having left Canton's backwater with high hopes for success at Yale in 1878, Remington now found himself back at the point of his earliest beginning. If the significance of "The Captive Gaul" had escaped him when he painted it six years before, he now surely saw that the clumsy work stated a personal dilemma.

Of course, there were several obvious avenues of escape, none of which Remington took. Although it lacked Yale's glitter and prestige, St. Lawrence University—within easy walking distance of the house where Remington now lived—offered courses in the practical disciplines the Remingtons had urged Frederic to pursue in the first place, as well as religious training. Although the *Plain Dealer* had passed out of family control, Seth's contacts would have made it relatively easy for Frederic to become a journalist or to enter politics, both on a small scale. Although his means were limited, Remington might even have used his inheritance to continue his father's partnership with Van Valkenberg, buying and training trotting horses for the racing circuit. All the avenues had advantages, but all were unsatisfactory because they depended upon close ties with Remington's own past. None offered an opportunity to make the break that would free the wanderer of Remington's 1905 fable to follow his own inclinations.

The impulse that sent Remington veering westward in 1881 was thus quite literally *outlandish*, for yielding to it meant repudiating the sensible values Canton cherished. Remington was not rich enough to make the Montana trip for fun, because his inheritance, which amounted to just over ten thousand dollars gross,[3] was not available to him until his twenty-first birthday, and even the small advance that financed his trip eroded the patrimony he was expected to invest in some profitable venture. Neither did he go west to set up business there, as Theodore Roosevelt did shortly afterward, or—by his own admission—to paint. Instead, he left Canton in a fit of temper.

In the fall of 1880, Frederic had met Eva Caten, a pretty girl from Gloversville, at the county fair in Ogdensburg. Shortly after he began a courtship that lasted through the winter and the following spring. In the summer of 1881, he proposed marriage, only to be firmly rebuffed when he sought permission from Lawton Caten, Eva's father. Youngest of five children, Eva needed a husband who would support her and, although Remington at nineteen had certain accomplishments, they were all the wrong kind. His knowledge of horses and racetracks, his brief football career, even his talent for making sketches all combined with his large, adolescent appearance and his unsteady,

3. At the time of his death, Seth Remington's estate was valued at $21,791.40. The will divided the estate equally between Frederic and his mother. For further details, see Manley, pp. 20–22.

sometimes boisterous manner to give those assets he possessed a vaguely sordid look—which Remington immediately confirmed by his erratic response: instead of trying to prove himself to Lawton Caten, he tried to become a Horatio Alger hero. When the *Plain Dealer* for August 10, 1881, announced that "Fred Remington, son of the late Col. S. P. Remington, expects to start on Wednesday of this week for Montana," there was no pretense of praising the young man or wishing him good luck. Instead, the newspaper was noncommittal to the point of skepticism: "We understand that he intends to make a trial of life on a ranch."[4]

Whether Remington took any active part in the business of raising livestock before returning east, he did have the chance to observe it and, for the first time in his life, was profoundly impressed. Cattle ranged free in pastures bounded only by the horizon, and the work of maintaining them seemed casual and intermittent. Most important, the men who worked on the ranches appealed to those same qualities in Remington's temperament that had made him unacceptable as a son-in-law. Picturesque, congenial, and profane, they, like Remington, were drifters and delinquents. Most were young, and nearly all were fugitives from some tangle of failure or misfortune. There was also the astonishing *scale* of the country where such men seemed to play at working. While St. Lawrence County's woods and water expressed a certain reassuring continuity, and the Adirondacks could always be counted on to turn green in spring, red and yellow in autumn, and white in winter, the Rockies defied all homely rhythms. In this sense at least they were for Remington apocalyptic for, by breaking so sharply the pattern he knew, they justified the temper tantrum that had shot him out of Canton. In the North Country, Remington was regarded as a young man without a future. In the Rockies, he suddenly discovered that he was without a past. It was the right place for revelations.

Characteristically, however, Remington was slow to recognize the signals that pointed him in a new direction. While it was easy enough for him, more than twenty years afterward, to look back at the Montana experience as the beginning of a lifelong dedication to the demands of art, it formed part of a pattern which, in 1881, had every appearance of personal disaster.

4. St. Lawrence *Plain Dealer,* August 10, 1881, quoted in Manley, p. 22.

Begun in pique, undertaken recklessly, finished without significant result, the trip marked Remington as improvident, puerile, cranky. Instead of applying himself to unriddling the riddle he much later recognized in the experience, Remington returned to New York when his money gave out and marked time with a trivial political job at Albany until his twenty-first birthday. Meanwhile, his western sojourn bore its absurdly meager fruit—a single illustration, redrawn by staff artist W. A. Rogers from a hastily executed Remington sketch and printed in the February 25, 1882, *Harper's Weekly*.[5]

Editors commonly ordered the modification by staff artists of graphic works sent to them—especially when such works were unsolicited—usually for the purpose of bringing them into conjunction with some feature of a text as illustrations. Remington's picture of the Wyoming cowboys he encountered on his way to Little Big Horn therefore acquired an ironic if appropriate jointure with an article about Arizona outlaws. In its magazine version, five figures, roused from sleep by a mounted companion, emerged from blankets on the ground and hastily prepared to break camp. One buckled on his gunbelt, two clutched rifles, and two wore large bowie knives at the waist. All were drawn with the obvious intention of indicating that they had been caught in midmotion and were placed against a conventional background that vacillated between the romantic and the homespun rustic. Yet the picture's most interesting feature was the disjunction between what Remington probably drew and what appeared in *Harper's Weekly*. There is no way of knowing how or to what extent Rogers altered the initial sketch, but Remington's models were almost surely herdsmen, people whose innocent business it was to raise and care for cattle. The earnestness and capability for movement Remington admired in such models, however, were translated in the published illustration—shaped to fit a shrewd assessment of popular taste—into violence and laughable craftiness.

Whether it derived from Remington's ineptitude, Rogers' perceptiveness, or a simple matter of editorial necessity, the transformation was appropriate, for Remington could never bring himself to regard the cowboy as pastoral, and his own first sojourn in the West was a desperate enterprise that defined Reming-

5. Entitled "Cow-boys of Arizona: Roused by a Scout," this illustration accompanied an article concerning a band of outlaws who called themselves "cowboys" after the terrorists who burned and looted isolated farms in New England and the Middle States during the Revolutionary War.

ton himself as desperado. Small wonder then that, shortly after coming into his patrimony, the young man quit his job at the state capitol and set out to seek his fortune—this time in Kansas, where he bought a quarter section of prairie land near the town of Peabody and halfheartedly applied himself to raising livestock. Everything about the venture was anachronistic, for Kansas lacked both the comfortable continuity of the North Country and the hard, millennial glitter of the Rockies—and for Remington to fancy himself as a livestock farmer was grotesque. Had he had the money, he would doubtless have preferred to go in for large-scale ranching farther west but, by the time he left New York, his inheritance had shrunk to less than half its original size and, even though his Kansas investment cost him less than sixty-three dollars per acre, he still had to borrow two thousand dollars to make it. Besides his badly eroded patrimony, Remington brought with him only bitterness, self-doubt, and the impression—acquired in Montana—that stock raising was easy.

The Kansas version of what Remington later called "the wild riders and the vacant land" he claimed to have discovered in Montana was a dreary business and, although he tried to mask his disappointment when he wrote about it in an autobiographical essay called "Coursing Rabbits on the Plains"—his only published account of the venture—unhappiness and frustration everywhere poked through the work's thin upholstery of heartiness.[6] The essay told the story of several aimless young men, all of whom had come to Kansas for adventure but encountered boredom instead, who are humiliated by losing their horses in a bet with a fatherly squatter. The work had no artistic pretensions and contained few signs of talent, but its very transparency revealed secrets a more mature work might have hidden.

A strongly felt counterpart of the perception half fictionalized in "Coursing Rabbits" made Remington want to leave his farm only months after he arrived for, like the vagabonds of his narrative, he ached with boredom and smarted with humiliation. As a farmer, said one of his Kansas acquaintances of 1883, Remington was "moody beyond anything I have ever seen in man."[7] Yet what caused his desire to move was no new self-knowledge but an extension of the same petu-

6. Remington, "Coursing Rabbits on the Plains," *Outing*, May 1887, pp. 111–121.
7. Quoted in G. Edward White, *The Eastern Establishment and the Western Experience* (New Haven: Yale University Press, 1968), p. 96.

lance that had first sent him away from home. Therefore, he merely wanted to go "somewhere else."[8] Having failed at everything he attempted, he was ready to try "anything."[9] Early in 1884, he succeeded in selling the farm and made a brief visit to Canton, where he somehow managed to give the *Plain Dealer* the impression that he was "an enthusiastic admirer of Kansas, not as a home, but as a place to make money."[10] Then, before his credibility grew thin, he departed for Arizona and New Mexico to escape March on the prairie and try for the first time to draw pictures for money. Late that spring, he turned up in Kansas City, where he painted oils from some of his sketches and sold them to whomever would buy.

The rough paintings Remington made brought small profits, but apparently he felt at last that, out of the "anything" he wanted to try, he had hit upon something he could do. Instead of spending the money that still remained from the sale of his land, he therefore used it to buy a small interest in a Kansas City saloon and, abandoning for a time the search for adventure, he drew and painted. The change was wholesome and, under its influence, Remington's self-doubt and recrimination gave way to confidence, as he began to think once more about returning to New York and again asking permission to marry Eva Caten. That summer, he made plans to go east. Before he left, the saloon moved to a new location in a better part of town. The expensive wild-goose chase to Montana and Wyoming, the dead-end job at Albany, the anachronistic misadventure of the farm at Peabody, all seemed culminated in an enterprise whose future was secure. Shortly afterward, however, Remington discovered that the saloon he had bought into no longer existed. By moving to a new location, its owners had dissolved their connection with Remington, established a new business, and freed themselves of any legal obligation to recognize Remington's claims. This meant simply that, within two years of receiving it, Remington had lost his inheritance.

A persistent tradition maintains that, when Remington found out he had been swindled, he took a pistol and went hunting for the men who had cheated him, only by chance encountering a friend along the way who convinced him that adding murder—either his own or someone else's—to his list of follies would be

8. Quoted in McCracken, p. 37.
9. Ibid.
10. St. Lawrence *Plain Dealer*, February 27, 1884, quoted in Manley, p. 23.

unwise. The tradition is plausible, because Remington had by then repeatedly demonstrated a dangerous tendency to be ruled by fits of temper, and being rendered a pauper was after all the most serious misfortune he had yet encountered. Something, however, transformed the catastrophe into revelation. The shock of being penniless seemed to leave Remington with the ability to be himself. Four times he had set out from Canton to conquer the possible: to Yale, where dull lectures confined him; to Montana, where he may or may not have been told that what he sought was no longer there; to Peabody, where, as the last sentence of "Coursing Rabbits" had it, he seemed pointed only "up the road and into the darkness"; to Kansas City, where a single stroke of derisive fortune shattered his fantasy of the West as "a place to make money." The possible had simply evaporated: all that remained was the absurd.

2. The Tribe of Remington

Almost immediately after losing his money at Kansas City in 1884, Remington departed for the North Country to resume his courtship of Eva Caten—and somehow the aspiring artist with neither financial security nor a single proven talent managed to succeed where the ex-football hero about to come into ten thousand dollars had failed just three years earlier. Lawton Caten this time added his consent to Eva's. On October 1, three days before Remington's twenty-third birthday, Eva and Fred were married at the Caten house in Gloversville. There is no record of why Caten finally agreed to accept Remington as a son-in-law, but Eva must have influenced his decision, for Remington demonstrated little about himself between 1881 and 1884 except that he was even more untrustworthy than he at first appeared. Eva, on the other hand, had ample opportunity to turn other suitors away during Remington's absence, and she apparently did so. The marriage therefore came about as much through Eva's constancy as Remington's persistence—but Remington's persistence would have to sustain it. Both newlyweds were accordingly back at Kansas City by the time snow flew, founding their domestic establishment on the foggy hope that Remington's pictures could supply them with a livelihood.

Remington tried hard but came nowhere near succeeding. Remembering the Wyoming cowboys who had appeared as Arizona desperadoes in *Harper's Weekly* two years before, he slaved all that winter on sketches for eastern magazines. The disappointing result was acceptance of a single illustration, redrawn by T. de Thulstrup and printed on the cover of *Harper's Weekly* for March 28, 1885.[11] Works like this wagonload of Oklahoma "boomers" lacked both polish and enthusiasm. Instead of opening windows on the scenes they represented, they limited the scenes to the hermetic space of a page. They looked as though they had been drawn at Kansas City, in the winter, by someone who preferred not to be there.

Just as Eva was largely responsible for saving Remington from indigence, she was symptomatic of the paralysis that afflicted his work that winter, for Remington still associated her with all the North Country respectability that had made it so difficult for him to win her. It was unimaginable that the nineteen-year-old wanderer in Remington's fable of the artist should ever settle down to conventional married life, because the artist's inclinations required an identification with some family otherwise composed—a clan that mirrored his own eccentricity. By 1886, when the artist sent a photograph of himself to Ella Remington of Canton, whom he addressed as "my old maid cousin," he had found what he needed. Looking out of the picture with confident eyes was a handsome, heavyset young man who signed himself "Frederic of the tribe of Remington."[12] Like Crèvecoeur's American farmer of more than a century before, he had joined the Indians.

Crèvecoeur's husbandman united with the tribe to achieve "a state approaching nearer to that of nature," where he would be unencumbered with "voluminous laws or contradictory codes."[13] In support of his decision, he observed that Indians "live without care, sleep without inquietude, take life as it comes, bearing all its asperities with unparalleled patience, and die without any kind of apprehension for what they have done, or for what they expect to meet with hereafter."[14] Remington's red men, however, were somewhat thornier, and the complicated identification Remington began with them in 1885 was far more difficult to discover. Part of the reason was historical, part personal,

11. This work was called "Ejecting an 'Oklahoma Boomer.'" Remington's hand was evident only in the depiction of a black trooper, who made one of the eight figures crowded into the picture.
12. The photograph and its inscription are printed in Manley, p. 9.
13. J. Hector St. John [Michel de Crèvecoeur], *Letters from an American Farmer* (New York: Dutton, 1957), p. 205.
14. Ibid., p. 210.

for Remington was born on the very verge not only of the war between North and South but also of the war between red and white—and, just as surely as the former conflict beat plowshares into rifles and made battlefields of peaceful farms, the latter turned those people Crèvecoeur called impervious to "the stings of vengeance" into warriors. Furthermore, Remington thirsted not for the withdrawal that sent Crèvecoeur's farmer into the woods but for the engagement that had sent his own father to Virginia and Louisiana. Time, place, and event all conspired to make the tribe of Remington a brotherhood of conflict, a family where creativity and a talent for annihilation were always the same.

Abrupt as an idea, Remington's transition from newly wedded husband in 1884 to tribesman in 1886 was explicable enough in its occurrence. In spite of Frederic's efforts that winter, the Remingtons recognized that they could not live on the income from illustrations editors refused to buy. Understandably, Eva grew homesick, a condition that brought Remington's old restlessness, now returned with new intensity, into sharp relief. There may or may not have been quarrels, but there was a lack of money, and surely there were doubts about both Remington's ability and the ability of the marriage to survive. As a result, one day during the summer of 1885, Eva boarded the eastbound train for a solitary journey back to Gloversville and an extended visit with parents who doubtless not only consoled her for being unhappy but reminded her that they had known she would be. Remington, on the other hand, was by himself again after the affair of little more than half a year, the period that seemed to define his staying power in almost any enterprise, even under the best conditions. Legend has it that he lingered briefly in the little western city, enjoying his bachelorhood—then chanced one afternoon to meet a local housepainter named Shorty Reason, from whom he bought a tough gray mare for fifty dollars, riding her out of town the next day at dawn, pointed west. In any case, he did leave Kansas City, and he did spend most of that summer in Arizona Territory, where a Chiricahua Apache named Geronimo had been engaged in sporadic guerrilla warfare with various units of the U.S. Army since 1881.

Fort Thomas, where Remington arrived sometime in July, squatted on a treeless, gravelly plain overlooking the Gila River. Because of its ugliness, its violent heat —a desert sun raised temperatures nearly every day to well over a hundred degrees—and its isolation in an area where Indians responded to government mistreatment by raiding settlements and killing travelers, the garrison attracted few tourists. Remington's reason for going there was Geronimo himself. In 1884, General George Crook had convinced Geronimo to stop his raids and settle down to raising livestock at San Carlos, the Apache agency across the Gila from Fort Thomas. But, without warning, Geronimo escaped from the agency on the night of May 17, 1885. He took with him some thirty men and more than twice that many women and children, cutting the telegraph wires as he left. Crook, an experienced Indian fighter, recognized that the size and composition of Geronimo's band marked it as no war party. Tired of life on the reservation, the Indians wanted merely to cross the border into Mexico and take up residence again in the Sierra Madres, where they had lived before Crook brought them north. Part of the band, however, made the mistake of changing their minds before the border was reached and attempting to return to San Carlos. On the way back, they were attacked by soldiers, whom they fought off, and reversed their direction a second time, leaving a trail of sharp, violent encounters behind them before joining Geronimo in the mountains. This, of course, alarmed white settlers and generated a flood of frightening accounts in newspapers and magazines across the country. Remington responded to the screaming headlines by getting as close as possible to their source. The response was a desperate one, and only a desperado would have attempted it, but it was also artistic in a unique way—and it therefore marked the spot where Remington's hitherto catastrophic inclinations began to point the artist toward his proper subjects.

The dazzling sunshine that beat down on Fort Thomas was no help at all in discovering what the subjects were or how they should be treated and, having come several thousand miles to meet the Apaches face to face, Remington discovered that the task he had set himself far outstripped his ability. In the first place, the Indians he had come to see were scattered across

the huge reservation. Even when they gathered at the agency to collect their government rations, and Remington prepared himself for a "feast" of journalistic detail, they "vanished like quail" whenever they noticed he was sketching them, bringing a rebuke from the supervising officer, who admonished Remington that, "if you desire to wear a long, gray beard, you must make away with the idea that you are in Venice."[15] Second, the people Remington saw at San Carlos bore little resemblance to newsworthy Geronimo. As one observed these "agency Indians," the savage warriors of the newspaper accounts shrank to demoralized wards of the state, who depended on periodic doles of stringy beef and inferior flour and took their family quarrels to an infantry captain who doubled as social worker. Since they would not stand still to be sketched, Remington hoped they would move about so he could watch them, or speak so he could hear them, but the only movements he saw were guarded gestures that revealed nothing; the only talk he heard, a murmur drastically modified by the obtrusive context of the agency. He was told that "among these people men are constantly killing one another, women are carried off, and feuds are active at all times," but he saw only "physical suffering and the anguish of old age," which life on the reservation bred—sensed that the Indians "eyed one another with villainous hate" but encountered only creatures who "seemed a sympathetic part of nature." Throughout the whole frustrating process, his expectations clashed violently with his experience.

Two years earlier, Remington might have shrugged his shoulders and left the problem to swelter toward some resolution of its own. Now, personal necessity demanded that he somehow come to terms with it. Since the appearances that confronted him were visible but opaque, he therefore complemented them with speculations that were translucent but invisible. The officers at Fort Thomas became "as entertaining in their way as poets," and the Chinese cook who presided over the mess where he dined performed what Remington called "culinary miracles" with army rations. In the same vein, the domesticated Apaches at San Carlos could be "almost imagined" as "Millet's peasants," and the wash of moonlight that submerged the agency at night reminded Remington of "the great

15. Remington, "On The Indian Reservations," *The Century*, July 1889, p. 396.

strength of chiaroscuro in some of Doré's drawings." Even the bleak landscape was not without its promise, for juxtaposed against the "great flat plain" severed by the Gila were rows of canvas tents and squares of low adobe buildings—drab properties transformed into tropes for conquest by Remington's sense of the military presence they stated. Everywhere Remington looked were blank surfaces that invited form. What made Fort Thomas and San Carlos exciting was not the presence of details to be recorded but the challenge of joining a usually monotonous actuality with his vivid expectation of it to produce a pattern that had imaginative meaning.

At the center of the challenge were the Indians themselves, who supposedly justified both Fort Thomas and Remington's presence there but in fact looked tame, harmless, and disagreeable. Remington's comparison of them with French peasants solved nothing, because its pretentiousness fit neither Remington nor the Indians. His inability to either find the Indians he wanted to see or sketch the Indians he found led finally to his admission that Indians in general were "incomprehensible to the white man's mind." While this admission expressed Remington's failure as historian, it also augured his success as artist, for it defined the almost universally interrogative quality that later distinguished his best works. The pale, empty skies of his oils, the mingled elation and wistfulness of his bronzes, the curious density achieved by his prose when it crossed and recrossed the hairline between history and fiction—all stated questions without giving answers, repeatedly expressing a bewilderment much like that which Remington felt at Fort Thomas in 1885. If the Indians were "incomprehensible," Remington's task was to show how it felt to collide with verities that could not be accounted for.

An incident of Remington's journey to Fort Thomas contained the whole process in capsulated form. Descending the southern slope of the Pinaleño Mountains toward the Gila, Remington camped one night with two wandering prospectors, who regaled him with tales of the recently escaped Geronimo and his band of raiders, speculating that if the Apaches could vanish without a trace—or, as Remington put it, "usurp the prerogatives of ghosts"[16]—they might also be expected to appear at any moment out of nowhere. Sometime after

16. Ibid., p. 394.

nine o'clock, the talk tapered off, while Remington and his companions lay about the fire on their backs, gazing skyward. As Remington engaged in "sluggish" calculations concerning "the time necessary for the passage of a far-off star behind the black trunk of an adjacent tree," he suddenly felt "moved to sit up." Facing him across the embers of the dying fire were three motionless Apaches, "with rifles across their laps." Despite Remington's "unbounded astonishment and consternation," the Indians remained unruffled, stating with disarming directness that they "no want fight—want flour." After the rattled whites had satisfied their request "in generous quantities," the Indians "stretched themselves out and went to sleep." Remington "pretended to do the same" but watched fearfully through the night for "more visitors" that never came, tensed for the impact of an Apache warrior he imagined must be waiting to leap on him with scalping knife ready. After the Apaches had applied a "blessing" to their hosts the next morning and departed, he "mused over the occurrence" of their visit to derive from it a "warning": always "mingle undue proportions of discretion with ... valor" in dealing with Indians.

His musing, of course, was more or less futile, his warning useless, for experience had shown him that Indians were quiet and peaceful but apt to show up unexpectedly. Short of calling off the Arizona excursion altogether, no amount of discretion on Remington's part could have kept the three visitors away from his campfire, and nothing that occurred after their arrival required valor. Both Remington's presence in Arizona and his belief that Apaches were dangerous stemmed from the same source—a thirst for excitement. What puzzled him about the Indians who visited his camp was that they were *not* dangerous—that is, they failed utterly to fulfill his expectations.

Therefore, his later warning that a student "must not penetrate" an Indian's "thoughts too rapidly, or he will find that he is reasoning for the Indian and not with him" [17] made more sense. Remington thus ignored the former warning and abided by the latter, acknowledging in one sentence that "the thing about our aborigines which interests me most is their peculiar method of thought" and asserting in the next that "no white man can ever penetrate the mystery of their mind." The "mystery" Remington recognized explained

17. Ibid., p. 400.

the reason for Fort Thomas and San Carlos, for the rows of military tents, the poetic soldiers, and the miracle-working mess cook. Indeed, as far as Remington was concerned, it explained the reason for Arizona Territory itself. The only way Remington could resolve it was to become an Indian and, since it was impossible for him to change his skin color, bone structure, and background, the task seemed hopeless. The series of insights that rapidly followed, however, gave Remington a way to found his tribe. First, he discovered that skin color became irrelevant when separated from history; second, that in the desert bone structure expressed function rather than caste; third, that background was less a matter of who one was than of what one had left behind.

From Fort Thomas, Remington drifted south to Fort Grant, another military outpost, where it occurred to him that any resistance to the sand drift and sun glare of the desert was "as hopeless ... as sweeping back the sea with a house broom."[18] Despite the threadbare metaphor he used to express it, his perception was accurate, for the most significant feature of Fort Grant was not its buildings, its officers, or its men but the intrusive environment that contained them all. It therefore made far less difference than it would have in the East that the Tenth Cavalry, which made its headquarters at the fort, was composed of men who were black. Remington found the troopers hardy and self-reliant, amiable and imaginative, just as he had found the white soldiers at Fort Thomas. One entertained him with stories of travel and adventures so luridly embroidered he thought they "would have staggered" Baron Münchhausen. Others were said to have performed spectacular feats of bravery in battle with the Indians. All in all, nothing separated them in Remington's mind from their white counterparts except color—and even that vanished when Lieutenant John Bigelow, white commander of the regiment's K Troop, allowed Remington to come along on an eight-day scouting expedition north to the Gila, then west into the Mescalero Mountains.

As the column of black horsemen moved across the alkali flats with the two white men at its head, Remington noticed that he and Bigelow had become indistinguishable from the column they led. Describing the transformation, he observed that the "great clouds

18. Remington, "A Scout with the Buffalo-Soldiers," *The Century*, April 1889, p. 900.

of dust choke you and settle over horse, soldier and accoutrements until all color is lost and black man and white man wear a common hue."[19] At first, the phenomenon appeared to be a matter of surfaces only, for the dust could be brushed off, the glare shut out, leaving all the old differences in the open again, as strongly evocative as ever of the historical agony they had fostered. Yet, as Remington examined it, he found to his surprise that the phenomenon went deeper, for the dust that indiscriminately powdered black and white to a common gray expressed not only a common environment but also an intensely shared experience.

At the time of Remington's birth, black men and white men had been separated by cruel traditions, but now they seemed united under law against all those of whatever color who remained outside the law. In some degree, this comfortable realization compensated for the stinging dust that triggered it by suggesting that traditional categories of black and white had merged in an imperial design. Very shortly, however, Remington received another jolt, when he rode with Bigelow's dusty column of lawkeepers into a bedraggled camp half hidden by a thicket of mesquite. There, he saw "two or three rough frontiersmen" lounging in a scrap of shade about a campfire. Because they were "veritable pirates in appearance," Remington half expected Bigelow to arrest them. He felt "intense astonishment" when the men leaped to their feet at the column's approach to "stand in their tracks as immovable as graven images" and execute perfect military salutes "in the most approved manner of Upton." Despite their "rough flannel shirts, slouch hats, brown canvas overalls and unkempt air," the men were soldiers sent to keep watch over the Indians at a "post of observation" on the Gila. It was not an imperial design but, rather, the desert sun that melted black soldiers and white soldiers together into merely soldiers and made soldiers indistinguishable from pirates. Therefore, it was not law that governed the metamorphoses that astonished Remington, but weather and landscape. Since the special context formed by weather and landscape seemed independent from the conquest he had seen signs of at Fort Thomas and Fort Grant, Remington wondered whether that context might challenge the assumptions that justified the conquest. The next morning he had his answer: K Troop rode out of camp

19. Ibid.; p. 907.

accompanied by a white lieutenant who had spent "the best part of his life" in "rough country" with Apache scouts, acquiring habits that were "exactly those of an Indian." The officer "only needed breech clout and long hair," Remington remarked, "in order to draw rations at the agency."[20]

Yet even though the desert could change the way people looked, and modify their habits, it could not alter events that had already occurred. For all the alkali dust and the heat, the lieutenant who acted like an Indian still drew his pay from a government founded on principles devised by European philosophers in the eighteenth century, and the presence at Fort Grant of a regiment of black enlisted men with a handful of white officers to oversee them gave the place an uneasy resemblance to some antebellum plantation, incredibly set down where nothing would grow. History thus seemed secure—until Remington noticed, as he rode up the dry washes with K Troop, looking for Apaches, that "all along the Gila Valley can be seen the courses of stone which were the foundations of the houses of a dense population long since passed away." They eventually came to another camp, where a "jolly" captain from Syracuse in true "frontier style" offered him the use of his field tent for the night because, as Remington put it, "I too was a New Yorker." If seeing the ruined foundations had not shown Remington how the desert robbed history of its meaning, being welcomed to a field tent as a fellow New Yorker should have. The essence of what Remington called "frontier style" was an accommodation to having been stripped of the past.

Remington summed up the process in a picture he drew to illustrate his account of it.[21] There, black trooper and Apache brave stood face to face, against no background at all, while the Indian gesticulated with his left hand. The trooper's features were Negro, the brave's Apache; while the trooper wore a regulation cavalry uniform complete with boots, gauntlets, wide-brimmed hat, and neckerchief, the brave was dressed in breechclout and buckskin leggings, his shoulder-length hair bound by a wide band that spanned his forehead. Both, however, were armed, and both wore identical cartridge belts. Both were soldiers who sojourned in an inhospitable region. Whether their dark skin bound them together more closely than their

20. Ibid., p. 908.
21. Ibid. The picture bears the appropriate caption of "The Sign Language."

common calling was not really a question, because both skin and calling expressed displacement.

As a result of this displacement, the "dry, parched, desolate" country of "rolling hills ... covered with cactus and loose stones" which suggested "Nature in one of her cruel moods" was a region where nobody really appeared to belong, which could not conceivably belong to anybody for, as Remington put it, "the land displayed ... mastery over man." The red, black, and white antagonists, all of whom came from somewhere else, were thus united by their exile even while they quarreled about who would lead it. Accordingly, they took over parts of each other as circumstances demanded. The Africans wore American uniforms and served an American cause with Europeans who acted like Indians in order to conquer land the Apaches had never, in the European sense, pretended to own—and the Apaches fought back, mounted on Spanish horses and armed with weapons marketed in New York City.

All this had the effect of blurring the sharp distinctions Remington had been prepared to make between himself and the Indians he had come west to see. As he looked back at it, his initial encounter with the three Apaches in the hills above Fort Thomas became more enigmatic than ever for, the more closely they were regarded in the light of Remington's subsequent experience, the more the three Apaches resembled Remington. When they leaped into focus as mirror images, the tribe of Remington would be achieved.

3. Adrift in New York

When K Troop at last arrived home at Fort Grant, saddle-weary Remington supposed that "soldiers, like other men, find more hard work than glory in their calling."[22] After resting, he departed into the desert and crossed the Mexican border, sojourning briefly in Sonora, where he made sketches of subjects more willing than the Apaches—Mexican horsemen, common soldiers, and a remarkably slothful line of prison guards at the frontier town of Hermosillo.[23] From there, he headed east and north again to Texas, where he found the "green stretches of grass and the cloud-flecked sky"[24] near Henrietta a welcome relief. In Indian Territory, at Fort Sill, he saw Cheyennes, Kiowas, Cherokees, and even Apaches—all more or less domesticated and unexciting, except for the rugged handsomeness of most of the men and the special beauty of "good looking" Cheyenne women, who fulfilled his conceptions of Pocahontas, Minnehaha, and "other heroines of the race."[25] For the journey that had begun with an unnerving visit from three Apaches in Arizona to end with an admiration for pretty women at Fort Sill was appropriate. What remained was the hard work of responding with the grace, intelligence, and insight demanded by the challenge of integrating reality and expectation.

22. Ibid., p. 912.
23. Remington, *Harper's Weekly*, August 7, 1886, p. 509.
24. "On The Indian Reservations," p. 400.
25. Remington, "Artist Wanderings Among the Cheyennes," *The Century*, August 1889, p. 539.

As Remington said good-by to Indian Territory that fall, his portfolio bulged with angular sketches that Poultney Bigelow, who had suffered with him in Yale's art school, shortly afterward called the "real thing."[26] Here, exclaimed Bigelow, were "no stage heroes . . . no carefully pomaded hair and neatly tied cravats; these were men of the real rodeo, parched in alkali dust, blinking out from barely opened eyelids under the furious rays of the Arizona sun." Since Remington had spent much of his stay in Arizona living with soldiers at military garrisons, nearly all the sketches in his portfolio represented military subjects. There were numerous facial studies of black and white soldiers in frontal, profile, and three-quarter views, larger pictures of groups of soldiers riding together, saddling and unsaddling their mounts, shooting and being shot at by Indians—even some studies of the Indians themselves. Bigelow's comment that the figures in the sketches had unruly hair and dusty clothing was correct, for all were men caught performing violent actions. Bigelow was equally correct in noting that they were not "stage heroes," because none of the actions they performed had the look of being planned. Even his contention that the sketches and the subjects sketched were "real" had some validity, for Remington captured details of posture and expression that to a degree compensated for the crudeness with which such details were combined, giving an impression of verisimilitude that tended to be more powerful in slight works like the facial profiles than in more ambitious ones. Yet it was the rhetoric of Bigelow's praise, rather than the praise itself, that identified the most arresting feature of Remington's portfolio: by contrasting the "real thing" he saw in Remington's pictures with carefully groomed "stage heroes," Bigelow designated the theater a benchmark for measuring actuality. The attractiveness of Remington's 1885 sketches derived not from their accuracy but from their sense of drama.

Therefore, although Bigelow thought the figures peered out from a blaze of Arizona sunshine, the drawings in fact represented Arizona only to the extent that Arizona represented movement. In the entire portfolio, there was not a single landscape study. Many of the drawings lacked a background altogether. Others represented it as merely a single line separating featureless earth from empty sky. Still others filled the

26. Poultney Bigelow, p. 304.

space behind the moving figures with herringbone patterns, impressionistic leaf shapes, or the evenly textured face of an adobe wall. Although they were *made* in Arizona, Remington's sketches depicted neither Arizona nor any other place—which meant that they were historical in none of the usual senses, scenic in no sense. What Bigelow's perception of them as "real" finally meant was not that they were actual but that they were *physical*. Their subject was energy.

In 1885, Remington probably lacked the maturity of insight to understand that putting kinetic figures against abstract backdrops—or no backdrops at all—suggested the remarkable ability of his imagination to turn Arizona into a stage, rather than the far more mundane achievement of evoking Arizona as a place. Yet, when he boarded the eastbound train at Fort Sill, he demonstrated an instinctive awareness of what the sketches were about by showing the conductor a ticket to New York City, for New York—as Herman Melville, Henry Adams, Mark Twain, and even William Dean Howells had by then recognized—was the energy capital of the continent, perhaps of the world. Canton, Ogdensburg, New Haven, Kansas, Montana, Wyoming, Arizona, and Indian Territory each had unique attractions that Remington had tasted, but all were provincial, even peripheral, compared to the city where decisions concerning them all were made, images that shaped them all were molded. Whether Remington knew it in 1885, he had already embarked on a career of giving visible form to vague national fancies. Before the Civil War, he might have pursued this career almost anywhere; after the Columbian Exposition of 1893, he might have chosen Chicago. For now, however, New York, with its museums, its art galleries, and—most important of all—its great publishing houses and the printing presses they nourished, was the place. He therefore stepped off the train that fall in the city Walt Whitman, before joining the Bureau of Indian Affairs at Washington, had celebrated as "Mannahatta," its Indian name. His as yet unformulated goal was to win the metropolis back for those orphans, wanderers, and warriors of red, black, brown, and white whom he had collected into a single tribe and christened after himself.

The tradition that Remington arrived at New York with three dollars in his pocket and the dust of Indian

Territory still on his clothes conveys enough figurative truth to render the question of its "factual" content hardly worth the trouble of debate. Whether the twenty-four-year-old vagabond wore soiled linen, he carried a bundle of earthy pictures; whatever the amount of money he carried, it was small, and his chances for success seemed smaller still. In the West, Remington had ridden his pony across deserts and mountains to receive the generous hospitality of officers at military outposts. Now, he took the ferry across the East River to Whitman's "Paumonauk," or Long Island, where he rented a meager, one-room flat in a Brooklyn tenement. His loneliness was eased when Eva came down from Gloversville to join him shortly afterward, but the elation he had carried back from Arizona rapidly diminished as he attempted to sell his drawings to New York publishers. Editors looked and frequently admired, but only in a discouragingly qualified way. They thought the drawings attractive but felt that printing them would be inadvisable, and therefore they refrained from buying.

The trouble was just that hiatus Poultney Bigelow noted by saying that the pictures did not contain stage heroes, for what Bigelow called stage heroes were trademarks of the tradition George Santayana later derisively christened "genteel" [27] and Howard Mumford Jones somewhat more kindly defines as an "operative fusion of idealism and the instinct for craftsmanship." [28] Whatever one called the tradition, it was, as Jones points out, the "cultural norm" in the United States between the end of the Civil War and the beginning of World War I and, when Remington came to New York in 1885, he discovered that his pictures did not belong to it. In pictorial art, the norm demanded either sweetness or elaborate allegory. Samuel Isham, a respected painter and critic, affirmed the former quality by proudly claiming for American artists in general that "our annual exhibitions tell of the joy and beauty of life with hardly a discordant note," adding that "art is still so new an interest with us that we have not yet had time to weary of simple, natural things of life." [29] The latter quality informed Thomas Cole's description of the cycle of patriotic landscapes he called "Course of Empire" as a "series ... that should illustrate the history of a natural scene, as well as be an epitome of Man—showing the natural changes

27. See George Santayana, *The Genteel Tradition at Bay* (New York: Scribner's, 1931).
28. Howard Mumford Jones, *The Age of Energy* (New York: Viking, 1970), p. 216.
29. Samuel Isham, *The History of American Painting* (New York: Macmillan, 1905), p. 561.

of landscape, and those affected by man in his progress from barbarism to civilization."[30] The norm's most articulate spokesman, William Dean Howells, summed up gentility as "the large, cheerful average of health and success and happy life" which he thought "peculiarly American."[31]

Just because "sin and suffering and shame" could not be wholly eradicated any more than "death ... and a great deal of disagreeable and painful disease," Howells argued, did not mean that they should be celebrated. Indeed, "the smiling aspects of life," which were also "the more American" and therefore preferable to "certain nudities which the Latin peoples seem to find edifying," proved such unpleasantness unworthy as a subject. To be "true to the facts," it was necessary for a clear-eyed artist to recognize the dominance in American life of "honest work and unselfish behavior." Remington thus found himself rejected by publishers in 1885 for essentially the same reasons Lawton Caten had rejected him in 1881. Neither he nor his work measured up to the "genteel" standards that required literature and the graphic arts to avoid unpleasantness and observe the proprieties. Remington's subjects were uncouth, his treatment of them unpolished. Like Remington himself, they sought crisis and expressed desperation—hardly proper fare for families that preferred nibbling daintily at "culture" to devouring open space and violent action.

Isham, Cole, Howells, and their fellows were joined in their sentiments by the editors of large national magazines—genial, intelligent men like Richard Watson Gilder of *The Century*, Henry Alden of *Harper's*, and F. J. Singleton of *Scribner's*—to make an evidently impenetrable front against Remington's entry. The public, they insisted, had every right to require of art that it cater to refined sensibilities. "Historical" landscapes, edifying fiction and essays, and instructive portraits of great men and significant actions must all be infused with lofty idealism and moral purpose. Remington, on the other hand, had not only failed to master techniques for elevating appearances to an ideal plane—practices Professor Niemeyer had tried to teach him at Yale—but felt no desire to do so. To people who hungered for assurance that industry, democracy, and decency were justified by enduring spiritual and religious guidelines, Remington offered only energy itself

30. Quoted in Louis Legrand Noble, *The Life and Works of Thomas Cole*, edited by Elliot S. Vesell (Cambridge: Belknap Press of Harvard University Press, 1964), p. 129.
31. William Dean Howells, *Criticism and Fiction* (New York: Harper & Brothers, 1891), chap. 21.

—which, as one historian correctly observes, is "both amoral and ambiguous."[32] When editors refused to buy what he offered them, Remington discovered that none of the avenues he had previously followed away from failure was now available to him as an escape route. His financial resources exhausted, his youthfulness losing plausibility at twenty-four as an excuse for arrogance, his independence swallowed up in the responsibility of supporting himself and Eva, he surrendered to the times. Borrowing a small amount of money from his uncle, he enrolled as a common pupil at the Art Students' League.

If he had been born five years earlier, Remington might have stayed in Ogdensburg and Canton and painted North Country landscapes and local color that would have been acceptable to the large New York magazines from the outset. If he had persevered in his studies at the Art Students' League, instead of leaving at the end of 1885, something similar might have happened, with the additional possibility of his becoming a successful portraitist in the mode of John Singer Sargent or James McNeill Whistler. Both hypothetical courses were far indeed from the one Remington eventually took but, if he had arrived at New York City ten years *after* he did, yet another course would have been open to him: instead of accommodating to the genteel establishment, as he appeared to do in 1885, or attempting to subvert it, as he shortly began to do, he would have been able to openly attack it. In May 1894, the first issue of *The Chap-Book*, inspired by Henry Harland's famous London *Yellow Book*, appeared at Boston and was quickly followed in San Francisco by *The Lark*, in New York City by *M'lle New York*. All three affected a *fin de siècle* decadence, replaced obedience to Gilder, Howells, Alden, and the others with allegiance to Edgar Allan Poe and Oscar Wilde, and carried fashionable, wispy illustrations in the manner of Aubrey Beardsley. There is no way of telling whether Remington's rejection by the genteel editors might have led him into bohemia if the way to bohemia had been clear—no possibility of knowing what hybrid offspring might have resulted from a union of *M'lle New York*'s tired francophilia with Remington's vigorous and curiously complex nativism. What actually happened in 1885, however, was even

32. Howard Mumford Jones, p. 105.

more bizarre than what might have happened ten years later: by blind luck, Remington managed to maneuver himself into the single, shabby corner of the publishing industry not within the genteel domain, discovering at almost the same time that something had occurred to cause the genteel editors to begin seeking him out.

The readers of *Outing Magazine* were accurately bracketed by one contributor as "out-of-doors, plain, uneducated, shrewd-minded men of sport."[33] Because the magazine aimed at an adult male audience, it could afford to be less delicate than the "family" magazines in treating supposedly sensitive subjects. Because it aspired to neither art nor moral edification, it paid tribute to neither "culture" nor religion. To be sure, it was no *Police Gazette* and contained precious little of the Latin nudity that caused Howells to turn away his eyes, but it was no soldier in the march of nineteenth-century progress either. Its unpretentious subjects were dogs, horses, hunting, fishing, and other outdoor sports, and it pursued them clumsily, with indifferent good humor and a short attention span. In 1885, it occupied a dingy suite of offices in Nassau Street, where business crept along from day to day, half buried in disorderly litter. So casually was the magazine run that even bankruptcy failed to stop its publication, because the staff found financial matters mysterious. At its cluttered helm sat Remington's sometime classmate, Poultney Bigelow.

Bigelow felt tired, overworked, and cross when Remington wandered into his office with a bundle of pictures. Five years had added flesh to his frame, filled out his face, and aged him, and Remington apparently made no connections between the man at the desk and the classmate at art school. The meeting in Bigelow's office thus had none of the characteristics of a reunion but, instead, seemed charged with a vague, potential hostility. For Remington, who appears not even to have recognized Bigelow's name on *Outing*'s masthead, Bigelow was cast in the role of Editor—one of those who held the keys to success but refused to surrender them. For Bigelow, who did not even bother to look up as Remington entered the room, Remington was merely another Petitioner—a unit in the troublesome, though usually polite, army of unemployed who wasted his time. When Bigelow saw the picture Remington pushed at him, however, he felt the thrill of an "electric shock"

33. Letter from Owen Wister to Sarah B. Wister, May 31, 1901, quoted in Ben Merchant Vorpahl, *My Dear Wister: The Frederic Remington–Owen Wister Letters* (Palo Alto: American West, 1972), p. 300.

and looked again, this time at the signature—which recalled the football player and the basement studio. Because the work before him contained nothing to suggest the work of his "homonymous fellow-student," he thought he had discovered an "odd coincidence." As he looked up to explain, Editor and Petitioner melted, and the office that contained them vanished: "Hell! Big," Remington roared, "is that you?"[34]

The late 1885 meeting in Nassau Street began an alliance between Remington and *Outing* that proceeded intermittently for the next eighteen years, both ending Remington's insolvency almost at once and providing the struggling journal with an asset that helped it to a sound footing. On the spot, Bigelow bought every picture Remington had and assigned him as illustrator to "every manuscript" that might interest him. The result was spectacular and in its way prophetic, for in March 1886 *Outing* began serial publication of a diary written by Lieutenant John Bigelow, whose "homonymous" name did not indicate a family relationship with Poultney Bigelow but did identify the same cavalry officer with whom Remington had ridden out of Fort Grant in the summer of 1885. Lieutenant Bigelow's diary was made up for the most part of detailed, day-by-day accounts of marching through the desert at the head of K Troop on both sides of the Arizona-Sonora border. Remington's pictures gave faces to the nameless troopers, drama to the plainly stated descriptions of acts like loading pack mules and saddling horses. Both pictures and account derived urgency and direction from a deftly chosen title: "After Geronimo."

As it happens, the army's pursuit of Geronimo in the Southwest provided the catalyst for Remington's success in New York. Shortly after Remington's departure from Fort Grant in the summer of 1885, General Crook received orders from Washington that Geronimo and his band were to be taken captive or killed. Similar orders issued from Mexico City, with the result of turning the Apaches' sanctuary into a trap, where they were sought by two armies instead of one. In March 1886, shortly after *Outing* began publication of Lieutenant Bigelow's diary, Crook succeeded in locating the Apaches and talked with Geronimo in a peaceful meeting, urging him to give himself up and return to the reservation at San Carlos. He told the Apaches that

34. Poultney Bigelow, p. 304.

they must expect to be punished for breaking the law but assured them as well as he could that the punishment would not be vindictive or unjust. Geronimo agreed to surrender, with the condition that the term of his imprisonment should not be longer than two years. When Crook telegraphed news of this meeting to Washington, however, he received the stern reply that Geronimo's condition could not be met. To make matters still worse, Geronimo and his band became suspicious and broke away from the column of cavalry that was escorting them to the fort. Crook was reprimanded and in April surrendered command of the District of Arizona to Brigadier General Nelson Miles, effecting a sharp escalation in what eastern magazines and newspapers called the "Apache War." However shabby the escalation was as an episode of national history, it elevated Lieutenant Bigelow from diarist to war correspondent, gave his daybook the thrust of an imperial record—even if it did appear in a sporting magazine—and draped Remington's pictures of amoral energy in patriotic bunting.

What Poultney Bigelow felt as an electric shock when he looked at Remington's drawings was energy more or less undraped—and, because it was undraped, editors mistrusted it as Howells mistrusted Latin nudity. Amoral and ambivalent as it might be by itself, however, it took on an altogether different look when clothed in the dignified uniform of national purposes. Therefore, where Remington failed at translating the physics that fascinated him into the metaphysics genteel standards required, history succeeded. Geronimo's escape from San Carlos, Crook's subsequent pursuit, the inflexible policies made at Washington, and Miles' ambitious aggressiveness all contributed to Remington's respectability by creating a vividly definite political, nationalistic, and even religious context for his thoroughly ambivalent art. Within such a context, violence looked like heroism, the featureless desert like a battlefield.

Overnight, gentility's outcast became one of its oracles. Remington gained a successful hearing with Henry Alden of *Harper's*, and his first signed, commercial illustration appeared on the cover of the January 9, 1886, *Harper's Weekly*. During the year that followed, three more numbers of the same journal bore Reming-

ton's pictures on the cover.[35] Beneath each picture was a more or less inconsequential caption that referred to some aspect of the intermittent clashes in Arizona. Above, an ornate design joined emblems of science with emblems of the arts and justified the prickliness of Remington's subjects by heralding their appearance in "A Journal of Civilization."

35. August 21, September 4, October 9.

III. The Law and the Prophets

1. The Illustrator as Parodist

Applied by *Harper's Weekly* to Remington's pictures, civilization appeared to principally mean embellishment. The January 9, 1886, cover illustration—although refusing to serve a journalistic end in itself—was thus supplied with a journalistic dimension by several internal paragraphs of anonymous journalistic prose that alluded to Geronimo, General Miles, and Arizona Territory. Several weeks later, the magazine carried another picture by Remington and upholstered it with a similar fabric of background and description. A third picture followed in April, a fourth in May, and so on through the year until fourteen sketches and combinations of sketches had appeared, all in the "illustrated newspaper" format *Harper's Weekly* used.[1] Along with Baker's Breakfast Cocoa and Ayer's Sarsaparilla —guaranteed to "restore physical force and elasticity" to sufferers from "liver and stomach troubles"—Remington's name was on its way to becoming what one student quite accurately calls "a household word."[2] Like the names of those products advertised in columns adjacent to it, it acquired a marketable value in direct proportion to its popular notoriety.

Yet, while *Harper's Weekly* pictures may be said to have launched Remington's career as an illustrator, there is some question about what they illustrated and

1. The *Weekly*, founded at New York in 1857, was the most popular among several similar American publications that aspired to the standards set by the London *Illustrated News*.
2. Manley, p. 24.

how they performed an illustrative function. That is, even though events had made Remington acceptable to gentility, his pictures tended to resist the genteel context provided them by *Harper's Weekly*, which declared itself a "picture history of our own times," also claiming to print, "*besides* the pictures" (italics mine), serialized—and sometimes expurgated—versions of the "best novels of the day, finely illustrated, with short stories, poems, sketches and papers on important live topics by the most popular writers," adding the assurance that it intended to be a "safe as well as a welcome visitor to every household."³

If calling the magazine a "picture history" bared private parts of gentility in an unintentional and not altogether becoming way, it also identified at least some of the pictures printed as representations of events supposed to be historical rather than illuminations of texts supposed to be meaningful. The picture history might have been precisely a picture history—that is, a pictorial representation that suggested the scope and sequence associated with historical narratives. By itself, it might even have been said to objectify and thus in some sense "illustrate" certain historical tendencies but, when joined with prose narratives that identified its component pictures as objects rather than objectifications, it became a vehicle for replacing history with myth. As the picture took over functions of events, the event that allegedly lay behind it dissolved.

A good example was Remington's January 30, 1866, picture, which bore the caption "The Apaches are Coming" and was accompanied by a five-paragraph narrative of the same title.⁴ In the picture, what appeared to be a family group stood in postures of surprise and dismay before a rural adobe dwelling, while a vaquero—complete with gunbelt, spurs, and wide-brimmed straw hat—kept his seat on a rearing and absurdly disproportioned horse and pointed into the distance. Supplying little information, the picture itself—caught between the vaquero's supposed encounter with the Apaches and their supposed approach—took on the look of a single frame in a series of cinematic exposures.

What the accompanying text did was summarize the frames that went before and those that were to follow. As readers of *Harper's Weekly* looked at the text, the picture's indeterminate location emerged as a "New-

3. This advertisement was printed in each issue of the *Weekly* during the 1880s.
4. "The Apaches are Coming," January 30, 1886, p. 76.

Mexican 'ranch,' " its single architectural feature became the rancher's humble "shelter of ... sunburnt brick," and the cluster of buckets, tubs, and pulleys in the background was defined as a well—which showed the ranch to be located in the desert, "where no reliable run or spring can be found." The ranch, readers were informed, was even more "exposed" than a "lonely mining enterprise among the mountains," because the "properties of a mining outfit, other than the scalps of the hard fighting miners, offer less temptation to an Indian marauding party." In case the readers wondered why anyone would live in such a dangerous position, they were informed that cattle ranching required isolation from other herds—and hence from other people—and that "each separate venture is made under an impression that reasonable safety from savage inroads has been attained," because the "most dreaded bands are understood to have been broken up by cavalry, or are securely corralled upon government reservations, or have been driven across the Mexican border to stay." It was just such an understanding, said the text, that made the people inside Remington's picture easy prey for the Indians outside. Invisible though they were, the "predatory bands" were always ready to victimize the "unsuspecting, unready, unprotected outreachings of civilization," and among those Indians, "friendly enough in appearance and conduct," who had visited the pictured ranch were "one or more ... of GERONIMO's or some other similar band, in search of 'business' for their chief and kindred." The people in the picture had been isolated, lulled into complacency, spied upon, and singled out for extermination. So much for the picture's past.

Having applied one of history's chronological dimensions to the picture, the text proceeded briefly to the next: "One day long afterward a cowboy with one of the herds, whose business it was to have his eyes about him, saw enough to send him racing ranchward at the utmost speed of his fleet mustang." The "cowboy," of course, was the mounted figure in the picture, and his sighting of the approaching Indians supplied the picture's caption, designating the text's second concern as that of the picture's present dimension. In order for the picture to function as "fact," and therefore be subject to inclusion in a "historical" account, however, it was

necessary to represent its events as having been accomplished, even resolved—that is, for the picture's present dimension to become the past dimension of the text.

Accordingly, the text observed that the vaquero's "terrifying shout" came "too late" and concluded: "The best mounted cowboy did what he could, and then rode his horse to death in bearing the news to the nearest settlement. All the rest fell into the hands of the utterly merciless." In other words, the figures represented in the picture were now dead, victims of an Apache raid. Rather than illustrating the text, the picture itself supplied the event the text reported and elaborated on. That neither picture nor text was anchored to any specific incident other than the one the picture typified allowed both to disregard the Indian raids that actually occurred in the Southwest, except as such raids appeared to symbolize what the text suggested as an imaginative construct—the "unsuspecting, unready, unprotected outreachings of civilization" beset by "utterly merciless" savages. Strictly speaking, the result was neither art nor history, but it was advertised as both, and among many of the subscribers to *Harper's Weekly*—by no means an unintelligent or insensitive company—it doubtless passed for both. As an element of popular myth, it celebrated a brief episode of defeat in the ongoing conquest of barbarity by "civilization," thus justifying the conquest as not only necessary but in some sense right. As an episode in his career, it expressed Remington's dilemma: even when historical events enabled skeptical perceptions to slip into genteel magazines, the skeptical perceptions were forged into a picture history that contained no shred of skepticism.

At first, the dilemma seemed insoluble. All fourteen of Remington's 1886 contributions to *Harper's Weekly* were smothered in a context that was anecdotal and journalistic by turns. In the April 24 issue, a sparse, acute study of horses and men strung out against a jagged backdrop of desert mountains—Remington's best effort to date—served merely to show how a particular cavalry maneuver was customarily executed. A month later, the moral wrung from "The Apaches are Coming" was repeated by a Remington sketch, romantically redrawn by T. de Thulstrup, of which the accompanying text concluded that the "Indian's hour has come, and he may be there somewhere, behind something, and he may be taking aim." In July, there was a

picture that showed the method used by isolated military units for "signalling the main command"—in August, some comparisons between frontier soldiery in Mexico and the United States, and so on.[5] The pictures testified to Remington's commercial success but augured a personal and professional failure in his lifelong pursuit of integrity. In the last analysis, they had as much, or more, to do with Ayer's Sarsaparilla as they did with the difficult vocation Remington later claimed to have discovered at nineteen among the wild riders and the vacant land of Montana.

As the "war" against Geronimo dragged on in Arizona, however, and was rendered both more ludicrous and more urgent by the newly ordained presence there of a full five thousand regular army troops, along with large numbers of militia and Indian scouts, there was a significant change in both the pictures Remington contributed to *Harper's Weekly* and the relationship such pictures bore to their accompanying texts. The first signal of the change occurred on August 21, when the *Weekly*'s cover featured Remington's picture of two soldiers, one black and one white, who dragged a wounded comrade across the face of a steep incline during an Indian battle. Because of its ability to suggest movement and its specificity of characterization, the work was more arresting than any Remington had yet contributed to the *Weekly*. In the same number, the *Weekly* carried another demonstration of Remington's talent that was even more striking—a montage of "types from Arizona" that included thirteen figures in various attitudes, all invested with a sardonic ranginess that marked them as members of the tribe of Remington.[6]

Both the cover picture and the montage were treated in a brief article entitled "Our Soldiers in the Southwest," which named the wounded man on the cover as a Corporal Scott and one of his rescuers as a Lieutenant Clark, both of the Tenth Cavalry. The article also identified several of the "types" that made up the montage and commented on the "heroic mood" of the southwestern fighting.[7] While the article was framed with a certain pomposity in striving to show how the pursuit of thirty or forty Apaches by five thousand soldiers was "heroic," it also admitted that the soldiers were not genteel. One enlisted only after bankruptcy left him not knowing "what else to do"; another "got his mili-

5. The April 24 picture appeared on p. 268; Thulstrup's redrawing (May 29) on pp. 344–345; "Signalling the Main Command" (July 17), p. 452; "Mexican Troops in Sonora" (August 7), p. 509.
6. "Our Soldiers in the Southwest," August 21, 1886, p. 532, including "Types From Arizona."
7. "Our Soldiers in the Southwest," p. 532.

2. *"Types From Arizona."* This is an early example of Remington's talent for combining—in a single expressive design—sketches which would be relatively undistinguished by themselves.

tary training in the Prussian service"; a third was characterized as an "Irishman who kept going West without knowing why." Even General Miles was stripped of pomp to reveal "buttons that do not glitter, boots that do not shine, a uniform the color and weight of which have been changed by many undisturbed deposits of dust."

Finally, the battlefield itself was differentiated from places like Brandywine and Yorktown, Bull Run and Vicksburg, by the admission that it would never "become historic." Whoever wrote the article doubtless forgot that it was supposed to contribute to a picture history, but this forgetfulness highlighted the unintentionally ironic cast the article acquired by attempting to justify the Apache "war" as national policy with details that proved the "war" to be anomalous and bizarre. Remington's own concern with national policy was intermittent, his attraction for the bizarre and anomalous continual. The rift that separated substance from intention in the August 21 article therefore became Remington's means for expressing ambivalence in contexts that seemed to promise certainties. Whereas his earliest pictures had been robbed of their potential skepticism by the prose that accompanied them, Remington now began to enliven credulous narratives with pictures that belied credulity.

At their best, the individual pieces that resulted were vigorous and often humorous, and their collective force was broadly parodic. A second installment of "Our Soldiers," printed in the *Weekly* for September 4, waxed strident and almost hysterical in patriotic support of government policy, claiming with no vestige of ironic intent that, when the well-fed, well-clothed, and well-armed soldiers rode out of their forts and "chased the Indians to their own ground," they looked for "anything . . . but a fair fight" from the small bands of starving Apaches they sought to kill or capture.[8] As though the Apaches' tactical ability were dishonorable, the text observed that "these Indians prefer not to fight when their enemy has an equal chance" and hinted that it was somehow less than fair for them to resist the invasion of "civilized men" who could not be "trained or inured to anything like the same endurance at once of hard work and meagre fare." It was "such difficulties as these," argued the text, "that have made the prolongation of the Apache war necessary in spite of its

8. Ibid., September 4, 1886, p. 567.

vigorous prosecution at favorable opportunities by both our troops and the Mexican troops, and by both combined."

Surely this was a remarkably elaborate detour around truths that became relatively simple when faced head-on. The Indians, who knew how to survive in the rugged country, did not want to be captured or killed. They therefore refused to surrender and fought stubbornly and cleverly, according to the best military traditions, using every advantage they had as thoroughly as they could. The soldiers, who had nothing to do with establishing the policies that sent them to Arizona, for the most part followed orders but could ill afford the highfalutin notion of a "fair fight" or the effete distinction, conferred upon them by the *Weekly*, of being "civilized men." Remington therefore attacked the spongy stuff of the text with a sharp pencil, producing a picture that exposed the text as solemn nonsense. To represent the legions of colorless but ethical patriots suggested by the text, he created two chunky black troopers, dressed in rumpled, ill-fitting uniforms and engaged in saddling two knobby, big-headed horses of vaguely unwilling appearance.[9] The picture possessed the same sardonic angularity that had distinguished the "types from Arizona" the month before but, because of its context, it was even more striking. The more swollen the accompanying texts became, the more sharply pointed was the potentially parodic function of Remington's lean, terse pictures.

Coincidentally, also on September 4, Geronimo surrendered to Captain Charles Gatewood, one of General Miles' staff officers, in a dry canyon between Tombstone, Arizona, and the Mexican border. Popular sentiment—encouraged by clever politicians and expressed in some degree even by the relatively temperate *Harper's Weekly* articles—was strong in favor of hanging the Apache leader, but General Crook and others prevailed upon President Grover Cleveland to have him confined at Fort Marion, Florida, instead. It was an anticlimactic conclusion to the shabby episode the *Weekly* had advertised as thrilling drama, a proof that Remington's drawings had been shrewder in their persistent suggestion of grittiness and sweat than the accompanying texts had been in their defense of "civilization." Accordingly, the bombast of "Our Soldiers" ceased with the September 4 number and was replaced

9. "Saddle Up," September 4, 1886, p. 567.

the next month by a brief notice that acknowledged what had previously been dignified with the title of "war" to be a series of "wearisome and sometimes hazardous campaigns."[10] Two of Remington's pictures—one on the cover and one printed with the text—graced the issue, and both were distinguished by their non-martial air.[11]

These two pictures made a fitting close for the series begun in January with "Indian Scouts on Geronimo's Trail" and "The Apaches are Coming," for they successfully communicated a sense of how ephemeral the conflict with the Apaches had been as chronicled in *Harper's Weekly*. There were no pictures of Geronimo and his fellow captives peering out from the enclosures of a prison camp or being loaded onto railroad cars for the long journey east—no triumphant portraits of Captain Gatewood or General Miles. Indeed, the series passed from alarm and slaughter through search, engagement, and capture and finally to some sort of "victory"—all without the appearance of a single hostile Apache. It was thus no picture history in the sense the *Weekly* claimed, but it did reflect Remington's own experience, for his Arizona sojourn of the previous year had shown him no Indians who even *looked* as though they might fight. However credulous its context, Remington's record of the Apache campaign was the statement of an unbeliever.

If the picture history chronicled anything, it was Remington's fundamental skepticism concerning the actual occurrence of a war in any region save the rarefied domain of historical theory—where it might be supposed that, since results like burned homesteads, murdered settlers, dead Indians, and military casualties could be observed, events had happened to cause them. Even the text that accompanied Remington's pictures admitted that the Indians, who supposedly *were* the cause of this war, could seldom if ever be seen and seemed to accept their existence pretty much as an article of faith, arguing at one point that following the tracks they and their horses made in the desert sand had much in common with the science of the "egyptologists."[12] Neither Remington nor the *Weekly* pursued this analogy, but both seemed to act by it, following the hypothetical Indians along a trail littered with all manner of artifacts, rumors, theories, reports, and gossip and—since the Indians themselves could not be

10. "Our Soldiers in the Southwest," October 9, 1886, p. 655.
11. "The Couriers," p. 655; "In From the Night Herd" on front cover.
12. "Our Soldiers in the Southwest," September 4, 1886, p. 567.

seen—asserting their potential presence precisely by virtue of their observable absence. Despite its obvious flaws, the method had a tendency to stimulate imagination.

There *had*, however, been a war in Arizona, or at least a series of "wearisome and sometimes hazardous campaigns," and it did not seem unreasonable to expect that someone who had participated in the campaigns might be able to give a coherent account of them, perhaps even including a glimpse of the Apaches tantalizingly invisible in Remington's pictures. Therefore, when the diary of Lieutenant John Bigelow, with whom Remington had ridden along the Gila River the previous summer, began serial publication in *Outing* in March 1886, readers doubtless supposed that the savages who always stayed just out of range in *Harper's Weekly* would at last find their way onto the page, for Bigelow had been in Arizona and was still there, actively involved in the business of hunting the Apaches down.

The diary's first installment was dated May 19, 1885, from a place called Bailey's Wells, a short distance northeast of Fort Grant. Geronimo's departure from San Carlos had occurred during the night of the seventeenth, and Bigelow had heard about it the next morning as he supervised K Troop's daily "target practice." During the course of the morning, several more or less definite details concerning the escape emerged. The number of adult males in Geronimo's party was said to be thirty-four, the number of women and children "about ninety." The "prevalent belief of the garrison" was that troops would soon be detailed to engage in pursuit.[13] Before retiring on the night of the eighteenth, Bigelow thus made his "preparation for taking the field." He realized that "laurels were scarce along Indian trails, and ... grew in difficult places," but it was still "principally for the practice of looking and reaching for them" that he wished to be included in the search party.[14]

By midmorning on the nineteenth, a contingent of some one hundred fifty men, consisting of five troops of cavalry, one of them led by Bigelow, rode off in a southeasterly direction, halting at a ranch about six miles away to rest and gather information. The ranch people, among whom Bigelow saw "only women and children," exhibited no signs of alarm concerning Geronimo's es-

The Illustrator as Parodist

13. *Outing* printed Bigelow's diary in thirteen consecutive installments, beginning with the March number for 1886 and ending with the April number for 1887. Immediately following its serial appearance, the diary was published, using the same plates, as *On the Bloody Trail of Geronimo* (New York: Harper & Brothers, 1887). For the sake of convenience, page references will be made to the book version. P. 1.
14. Lt. John Bigelow, p. 3.

cape, but Bigelow apprehensively observed that "hardly do I see a woman on a ranch but some Indian atrocity springs up in my mind too horrible for description here."[15] While the lieutenant stoutly refused to describe his vision—which presumably had something to do with sex—he wished that more of his eastern readers had direct experience of the conditions from which the vision supposedly derived. It had been a "mistake," he argued, "ever to remove westward the Indians that had settled on reservations east of the Mississippi" because, if such Indians had remained in the East, easterners "should now have samples of Indian life and character." As it was, Bigelow thought that "people in the East can not know the horrible particulars of Indian murder, torture, and outrage" because "there is no public organ to give them utterance." The "revolting indecency" of such acts, he wrote, excluded accounts of them from "every respectable paper and the lowest publication of sensations and horrors" alike, for "the most morbidly-depraved imagination would be sickened by them." The lieutenant indicated that "Indian atrocity" was an affair of horrors but left it up to his readers to imagine the worst, assuring them that their worst would not be nearly bad enough. As for himself, the merest glimpse of an Arizona ranch wife caring for her children in the usual domestic way plunged him into lurid, incommunicable reveries.

For the next twelve months, *Outing* carried an installment of Lieutenant Bigelow's diary in each number, beginning the use of Remington's pictures as illustrations in December 1886. Most of the pictures came from the portfolio Remington had brought back with him from Arizona in the fall of 1885. Others appear to have been drawn later, for the purpose of illustrating Bigelow's text. All asserted the sharp angularity of line and the vigorous, kinetic configurations that were rapidly becoming Remington's trademarks, and none made any concession to Bigelow's habit of seeing what he imagined rather than what was before him. Failing to encounter any hostile Indians, Bigelow lapsed into extensive accounts of the Arizona landscape and its history—interesting enough, even engaging in their own way, but hardly the heady combination of sex and violence promised by his opening remarks. He also enumerated matters of military ordnance, discipline, and training and told of Mexican serenades and

15. Ibid., p. 4.

holiday dances, held in isolated settlements and adorned by pretty girls in their best gowns—all conducted with decidedly antiseptic propriety. Remington, however, stuck to the troopers—making sure to show that most of them were black, which Bigelow's narrative tended to overlook—and the horses—putting in all the bones, stringiness, saddle sores, and sex organs that Bigelow's prose was too delicate to mention. Twenty-nine of the thirty-four pictures were studies that accentuated the least courtly aspects of the experience Bigelow's journal recorded. Five attempted to represent scenes Bigelow heard about and relayed secondhand. Only two, both in the latter category, contained hostile Apaches.[16]

Remington's drawings thus emphasized the most striking property of the lieutenant's diary: not one enemy Indian had come within range of the lieutenant's vision during the thirteen months chronicled by the diary. To be sure, there were numerous alarms, all of which turned out to be false, and several long rides to places where Bigelow's initial vision of "revolting indecency" promised to be ratified but never was. Seven months after Geronimo's September 1886 capture, however, when the *Outing* for April 1887 printed its last installment of the diary, some measure of the glory Lieutenant Bigelow had glimpsed at the outset of his venture seemed about to be fulfilled.

The date of the entry was June 5, 1886. The previous day, the commanding officer of Bigelow's detachment had received a dispatch from the adjutant general's office, stating that Indians had murdered a rancher named Davis who lived in the nearby San Pedro Valley and that Indian signal fires had been sighted in the Rincon Mountains. During the year since he first "took the field," however, the lieutenant had become less gullible. He dismissed the signal fires as "burning woods ... observable to us ever since we came here" and supposed the rancher's death "quite as probably the work of a Mexican or an American as of an Indian."[17] Nevertheless, at one o'clock on the morning of June 5, a frightened rancher rode into camp with news that a band of Apaches had raided his homestead the previous evening, stealing a small herd of livestock. Shortly after daylight, Bigelow and his troop of black riders were ready to take the field one more time.

Not long after leaving camp, they encountered a "trail of from fifteen to twenty animals heading for the

16. Ibid., pp. 190, 216.
17. Ibid., p. 202.

Whetstone Mountains." Bigelow's "regular guide" expressed appropriate excitement, as did the three "citizen volunteers" picked up along the way. Bigelow, keeping his imagination in check, noted only that "I push steadily along at a good four-and-a-half mile walk." Suddenly, however, the "trailers" ahead of Bigelow were seen to stop and confer. A soldier then came galloping up to report that Indians had been sighted. Bigelow's account of the sighting contained tension but no vivid fantasies:

> After making a few remarks to my men upon my intended tactics, I set out in two platoon-columns of fours at a brisk trot. About a mile from my objective point, I halt to let the men tighten their girths, and then push on, alternating between a trot and a gallop, across the railroad track in the bottom, and up the long, rolling slope fringing the point of the Whetstones. As I surmount the swells in the ground, I strain my eyes to distinguish the figures, or perceive some movement of the enemy. I make out nothing but a fused, glistening line, as if of gunbarrels resting on the ground, and to the right rear of this what seems to be a herd of horses.[18]

In full command of his faculties, Bigelow realized that the enemy position did not invite a frontal charge. He therefore ordered his second platoon to remain in place and galloped off at the head of the first in a flanking movement. When he had arrived near enough to attack, he looked again and discovered that the enemy's "line of gun barrels is a surface of smooth rock, and his herd of horses a clump of small trees." Whether or not the lieutenant realized it, this was merely the opening scene of his journal seen from the other side. "My enemy," he at last admitted, "is but an optical illusion."

The sentence was susceptible to several interpretations, for it might be argued that, if Bigelow had experienced fewer illusions, he would have seen more Indians—or that the lieutenant participated in illusions by believing that the Indians he sought laurels for capturing were illusory—or even that the laurels he hoped to win were illusions and therefore potentially an enemy. Remington's picture of the episode, however, suggested the most intriguing possibility. The harder

18. Ibid., p. 205.

3. "Sir, They Are in Sight." In this pictorial joke, Remington, by leaving the horizon blank, calls attention to Lieutenant John Bigelow's difficulty in finding Indians.

one looked at the picture, the clearer it became that what was in sight for the lieutenant and his companion was precisely and literally *nothing,* for Remington had omitted even the usual perfunctory skyline or abstract pattern from the background, leaving the lieutenant to gaze beyond the courier into a blankness wholly unrelieved. According to Bigelow, the Indians he chased across the desert were so elusive that he could not capture them, so fundamentally shifty that they seemed interchangeable with the landscape. According to the picture, Bigelow saw neither the Indians nor the landscape. Both were invisible because both were identical, and the unity they formed threatened Bigelow because he remained unable to grasp it.

Remington's ambivalent picture diagnosed Lieutenant Bigelow's fits of optical illusion as a simple case of

blindness. The ailment was so widespread among participants in the Apache campaign that few were even aware of its existence, and accounts of the interminable marching and intermittent fighting in the desert almost universally displayed the same symptoms. Captain Leonard Wood, later surgeon general in Theodore Roosevelt's administration, treated the Apaches exclusively as pieces in a sometimes exasperating tactical puzzle, naming a few and counting many but never describing one.[19] General Miles did somewhat better—noting that the captive Indians had "masses of grass, bunches of weeds, twigs or small boughs... fastened under their hatbands very profusely, and also upon their shoulders and backs," further observing that "when lying upon the ground in a bunch of grass or at the head of a ravine... it was impossible to discover them as if they had been a bird or a serpent"—but he still insisted that Geronimo, at the time of his surrender, looked like "General Sherman in the prime of life."[20] Even physical proximity did not make the Indians visible. Thus, early in 1887, weary of vacant abstractions and pregnant vacancies, Remington set out again to find the Indians.

The circumstances were far different from those that first sent him to Arizona in 1885 for, during the interim, the *Harper's Weekly* pictures and the illustrations for John Bigelow's diary had established his reputation on a national scale and satisfied his pressing need for money. A comfortable Manhattan apartment had replaced the meager Brooklyn flat, Eva was back now, on a permanent basis, and even the North Country began to show faint signs of thawing. Most important of all, Remington now had a sponsor—*Harper's Weekly*—and the sponsor had a purpose: to celebrate the triumph of gentility. Remington, however, had other objectives, even though they had yet to be directly articulated. Two years before, while the newly married Remington struggled to become an illustrator at Kansas City, Mark Twain had ended *Huckleberry Finn* with Huck's avowal to escape the "sivilizing" ardor of Aunt Sally by a scheme to "light out for the Territory." Remington, having begun to make his mark in a "Journal of Civilization," now attempted the same gambit.

Back in Arizona again, he drew domestic studies of the San Xavier Papagos, assembling twelve sketches into a single, attractive composition that represented

19. Leonard Wood, *Chasing Geronimo; The Journal of Leonard Wood: May–September, 1886*, edited by Jack C. Lane (Albuquerque: University of New Mexico Press, 1970).
20. Nelson A. Miles, *Personal Recollections and Observations of General Nelson A. Miles* (Chicago: Werner Co., 1897), p. 525.

4. "Sketches Among the Papagos of San Xavier." This deftly arranged composite is a more sophisticated application of the combining technique that may be seen in the earlier "Types From Arizona."

varying facets of Papago life.[21] He caught the Indians caring for livestock, making bread, threshing grain, carrying burdens, justifying the text's description of them as a "law abiding and peaceable people ... friendly to whites." The text, however, also noted that the Papagos were "not benefited by civilizing influences" because they found the property laws they abided by "perplexing" and were therefore often victimized by the whites they befriended.[22] Moreover, since the Papagos were not "wards of the American people," they were not eligible for government generosity like that which had driven Geronimo and his followers away from San Carlos.

The plight of the people Remington drew was tragic and shameful, but whoever wrote the text labored under a stupefying weight of genteel arrogance that made it impossible for the writer to understand what the drawing communicated. The author thought that, because several horses appeared in the composition, the sketches showed "how important a part the horse plays in [the Indians'] daily life" and closed by loftily observing that, "in an ethnological sense, as recording a phase of aboriginal life in a semi-civilized condition, these sketches are of great interest." What the author missed were the perception of despair that pervaded the sketches and the fabric of irony that held them together. "Home, sweet Home" was an open shelter of mesquite boughs supported by leaning posts; "Threshing Wheat," a strangulation of five wild-eyed horses bound together with ropes about their throats; "An old Man," the shriveled face of bitterness; and so on. At the hub of the vicious circle they composed, Remington had placed an architectural study of the ornate Mission San Xavier del Bac, an emblem of that religious force which had brought the Papagos to their present state of what the text called a "semi-civilized condition." Even Lieutenant Bigelow, who mistook features of the landscape for Apaches, could probably have seen the mission—and, if he had, he could probably have seen the Indians in Remington's picture as well, for it was the mission that brought the Indians into focus.

Calling it an "adobe church erected by the Franciscan order in 1797," and adding with a predictable condescending malice that services were no longer held there, the text noted that the interior of the mission was "rudely decorated" with "altar ornamentations ...

21. Published in *Harper's Weekly* as "Sketches Among the Papagos of San Xavier," April 2, 1887, p. 244.
22. Ibid., p. 243.

taken from biblical sources"—this to explain the appearance in Remington's sketch of a detail from the decorations that adorned the sanctuary's altar rail. Remington labeled the oddly sinister carved head a "dragon," but it also suggested a lamb—with all the attendant religious and pastoral implications—and balanced the profile of an old man that occupied the space below and to the right of it. Dismissed by the text as evidence that the "Franciscan fathers employed native talent, whose idea of art was but crude," the bestial head with human features and divine insinuations signaled a vital shift in the nature of Remington's western interest, for the head was a precursor of what he later perceived as "spirit." To call the head "crude" was probably accurate but surely irrelevant, and to explain it as "ethnological" was simply to miss the point of Remington's perception: the unused church that baked beneath the desert sun near a river the Spanish fathers had christened Santa Cruz contained demons that obscurely resembled the indigent farmers who sweltered in the heat outside. Since the resemblance failed to fit the template of a picture history, *Harper's Weekly* chose to ignore it, but Remington—who correctly sensed that the resemblance exposed the idea of a picture history as nonsense—pursued it.

The enterprise carried him east from San Xavier into New Mexico, then north across the plains and mountains into Canada. Before leaving the Southwest early that spring, he sketched seven white poker players apparently teetering at the edge of violence over an episode of cheating—a work *Harper's Weekly* advertised as a "typical gambling scene" and treated in a manner unmistakably derived from the combination of prose, pictures, and piety that had occurred a century before in *Hogarth Moralized*.[23] In Montana, he watched Crow Indians perform a buffalo dance while firelight smeared the walls of their tents with spider shadows. On the prairies of Saskatchewan, the contrast made by hungry Blackfeet families, huddled over stewpots improvised from discarded tin cans, compared with the spiffily uniformed troops of the Mounties created to guard them showed him how fragile—even spiritual—a unitary tribal structure became when confronted with the massed material diversification that expressed itself as the Canadian Pacific Railway.[24] The deserted chapel and its demons at San Xavier, the

23. William Hogarth, *Hogarth Moralized*, explanations by Rev. John Trusler (London: Henry Washbourne, 1841).
24. "A Quarrel Over Cards," *Harper's Weekly*, April 23, 1887, p. 301; "The Buffalo Dance," May 7, 1887, p. 332; "In the Lodges of the Blackfeet Indians," July 23, 1887, p. 521; "The Canadian Mounted Police on a 'Musical Ride'—'Charge!'" December 24, 1887, p. 945.

Crow buffalo dancers in Montana, the Blackfeet at the Bow River were all moribund. Having been sent by *Harper's Weekly* to chronicle triumph, Remington drew pictures of defeat. The text printed with the pictures utilized a rhetoric that took for granted allegiance to genteel attitudes and institutions, but the pictures themselves seemed to suggest that the Indian's buffalo dance was less nasty and more intelligent than the white man's poker game—the accomplishments of "native" artisans at San Xavier far greater than those of the imported Mounties in Saskatchewan.

By late spring, Remington had returned to the East, and he and Eva spent most of the summer together at Canton while his pictures came out in *Harper's Weekly*. He painted and vigorously set to work on illustrations for Theodore Roosevelt's *Ranch Life and the Hunting Trail*, which began serial publication in *The Century* the following February. In October, *Harper's Weekly* printed the final unit in the series begun half a year before—even though two pictures of Mounties followed in December. It was a composition on the order of the opening study of Papago life at San Xavier, utilizing the same bulletin board technique and achieving a similar balance.[25] Here, however, the focus was military, and the sketches that made up the composition represented aspects of the practice maneuvers being performed by General Nelson Miles' command along the Gila.

The daily round of domestic chores at San Xavier was accordingly replaced by horsemen who scrambled up one side of the page and down the other, and instead of a wrinkled old man there was a determined-looking trooper who had supposedly been in military service "since '61." An Apache couple and their three children, all horribly emaciated, were designated the "innocent cause of this pomp and circumstance." In place of Mission San Xavier del Bac and its lamblike dragon, two cavalrymen galloped across the center panel, melting together into a single hybrid beast with eight legs and four heads. Since more than twenty numbers of *Harper's Weekly* intervened between the Papago studies and the practice maneuvers, it is unlikely that many subscribers placed the two compositions side by side, but doing so produced a curious effect. Instead of the "outreachings of civilization" proclaimed by the text, the continuous whole showed an ancient adobe

25. "Training U. S. Troops in Indian Warfare," October 1, 1887, p. 713.

5. "Training U.S. Troops in Indian Warfare." Clearly intended to complement "Sketches Among the Papagos of San Xavier," this montage shows how Remington used composite works, themselves made up of multiple sketches, as units in yet larger composite designs.

church encircled by farmers and besieged by monsters and uniformed barbarians.

As usual, such irony escaped the writer of the text, who described each of the martial studies with relish and refused to even notice the "innocent cause of this pomp and circumstance." The maneuvers were "designed to train... troops for the pursuit and capture of raiding Indians."[26] Post commanders all along the valley alerted their garrisons, and then a "well mounted raiding party of two officers and twenty men, with extra horses," rode out from Fort Huachuca into the desert. They, of course, were the "Indians," and the job of the other soldiers was to find them. The activity was harmless because caution was exercised "to avoid over exertion, breaking down the animals, or injuring the property of settlers." On the whole, the writer thought it a "novel device... combining practice of the highest value with something resembling the excitement of a competitive field sport." Yet what the writer missed was precisely what Remington saw: the activity *was* a competitive field sport. However indispensable the maneuvers were, Remington's pictures exposed them as a game for which the squalid Apache family, huddled in the dirt before a straw hut, was the merest excuse. The vigorous composition that closed the first period of Remington's professional career pointed out that —even when blind men like John Bigelow could find no Indians suitable for fighting—bearded, dish-faced worshipers of the eight-legged satyr could invent them.

26. "Field Service in Arizona," October 1, 1887, p. 707.

2. Stalking the Establishment

The next period of Remington's career opened with
a flourish when the February 1888 number of *The
Century* punctuated a first installment of *Ranch Life
and the Hunting Trail* with eleven Remington illustrations. None of the pictures was so articulate as the
Papago composition or its companion study of the
Arizona war games but, taken as a group, all eleven
represented an improvement over Remington's contributions to the picture history. One reason was *The
Century* itself, which, by never aiming to perform the
function of a newspaper, resisted the allure of currency
and was thus freed from the urgent need to print
material before it aged. The other was Roosevelt's
uneven but usually workmanlike prose, which ordained
a rapid shift in both the nature of Remington's pictures
and the function the pictures performed as illustrations. By *Harper's Weekly* standards, the *Ranch Life*
series was enormous in scope and leisurely in execution,
consisting as it did of six long episodes printed over the
space of nine months. Moreover, it was not a project
which, like John Bigelow's diary, depended upon some
supposedly newsworthy event for its form or hung, like
the picture history, on a set of well-established and
self-indulgent assumptions concerning race, national
origin, and caste. Because Remington's pictures were

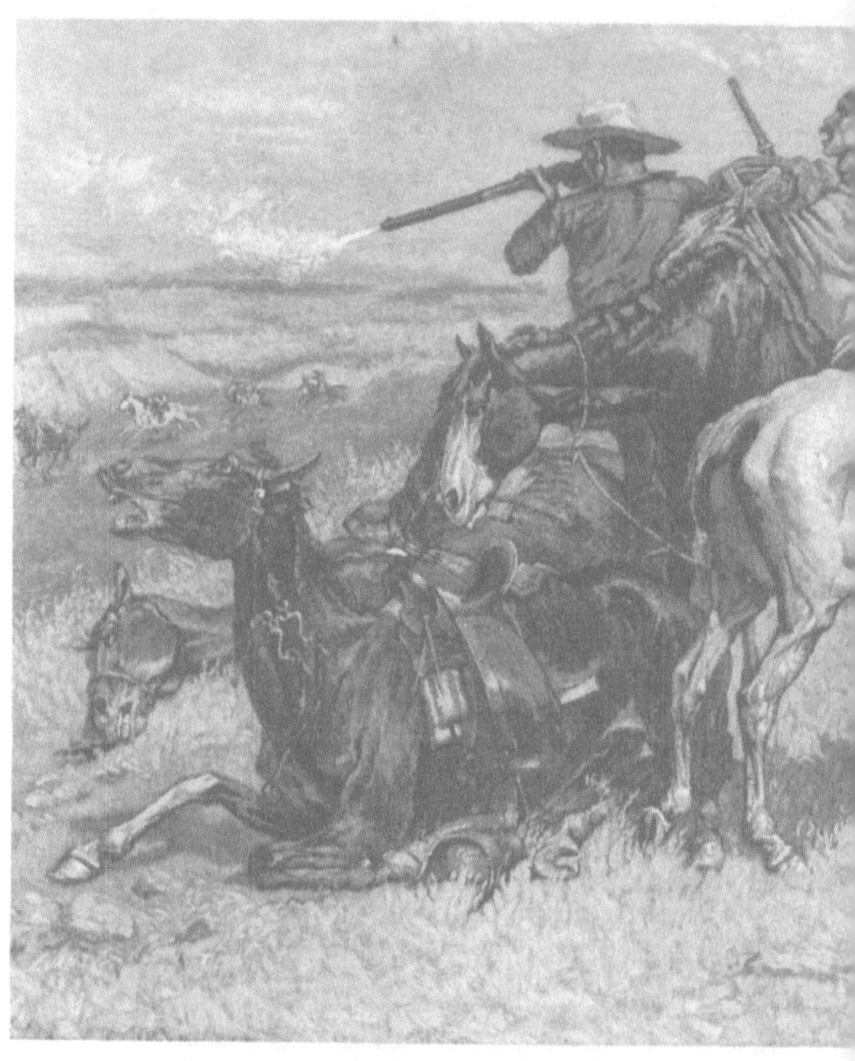

6. "*An Episode in the Opening Up of a Cattle Country.*" Printed with the first installment of Roosevelt's Ranch Life, *this picture shows how Remington used composition to establish focus and movement.*

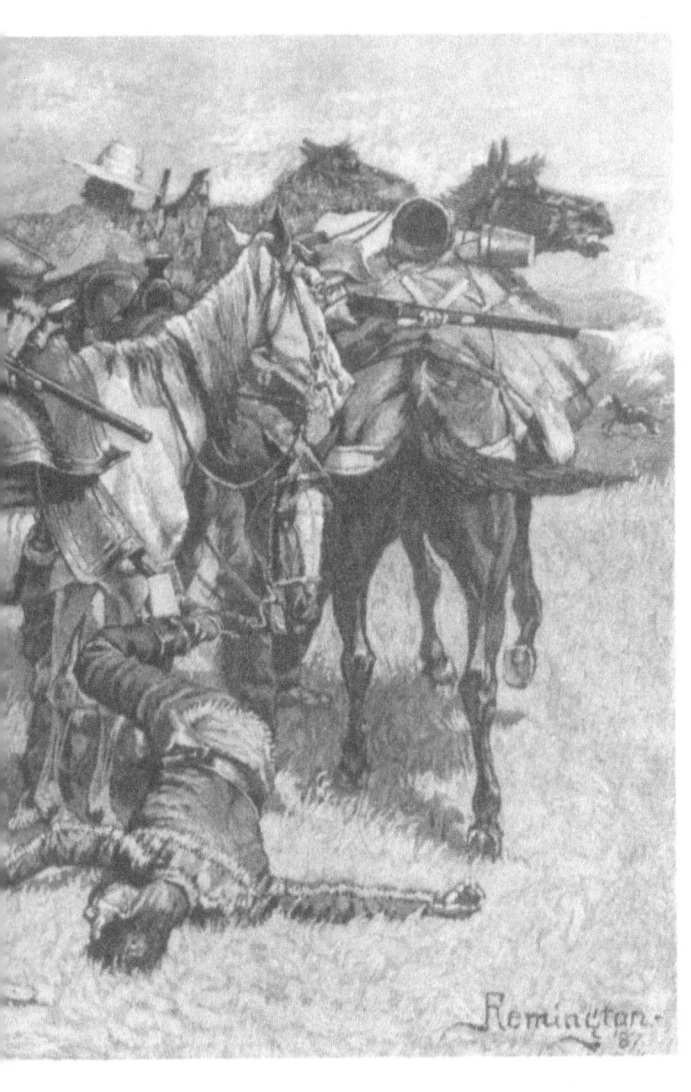

fundamentally at odds with *Harper's Weekly* picture history, they fairly bristled with denial of the text that accompanied them. Because the mode and organization of *Ranch Life* were fundamentally akin to Remington's own perceptions, the pictures Remington drew and painted for the series reinforced it without mocking.

Roosevelt combined geographical, technical, and demographic concerns in his first installment to produce what seemed intended as a description of the essay's subject—"ranch life in the far West." His manner throughout was curiously hesitant and apologetic, from the first paragraph—which asked the reader to understand that the "far West" actually meant the "middle of the United States" and admitted that fewer livestock were raised there than in the East—to the last—which stated with "real sorrow" that "stock raising on the plains is doomed."[27] Remington's pictures, however, measured the prose by giving it specific optical coordinates that ignored apology and supplanted description. The drawing of an "old-style Texas cowman" showed at a glance that the "middle of the United States" could not under any circumstances be confused with the Middle West and that the number of livestock raised in the "far West" was ancillary to the presence of an arresting human type who deserved to be celebrated. Likewise, the painting "An Episode in the Opening Up of a Cattle Country" gave Roosevelt's assertion that the "final overthrow of the Horse Indians opened the whole Upper Missouri basin"[28] a location at the interface where history—which required a historian to describe it—met drama—which designated even the actors who performed it as functions of the artist who imagined both actors and actions. In short, Remington's pictures not only "illustrated" Roosevelt's prose by matching its generalities with details but also identified its principal function by providing a contrast between graphic and literary modes.

The graphic mode functioned by occupying space, and all the relationships it represented were spatial. Any of a hundred titles might be applied to the picture printed as "An Episode in the Opening Up of a Cattle Country" without modifying the picture's meaning even slightly, for the meaning was contained in the lines of firearms pointed outward from the center, the angular corona of horses' heads, the human figures

27. "Ranch Life in the Far West," *The Century*, February 1888, pp. 495, 510. *Ranch Life and the Hunting Trail* was published as a book by the Century Co., New York, in December 1888.
28. Ibid., p. 497.

connected by invisible but unmistakable lines of force to the eyes of their comrade, who glared out of the picture at something located behind the perceptor. The picture was far more geometrical than it was historical, and the geometry it stated augured threat. In a similar fashion, the six men seated on the ground and the two approaching riders all faced the coffeepot carried by their standing companion in "The Midday Meal"—which balanced the centrifugal "Opening Up" with a centripetal closing in—and "The Outlying Camp" achieved its sense of loneliness by focusing on the central campfire, while the two cowboys and their horses pointed off to the left, away from the hillside soddy's door. Each work possessed its own controlling vectors. Some, like "A Row in a Cattle Town," had their elements drawn together by converging lines of gunfire, hurled furniture, or other unifying patterns. The rest, like "In a Bog-Hole," "Pulling a Cow Out of The Mud," "A Dispute Over a Brand," and "Bronco Busters Saddling," were stretched taut across the page by lariats, straps, etc., that grew stiff and rectilinear as they became vehicles for transmitting force. All represented men, animals, objects, and settings as spaces transformed by an energy that expressed itself by changing locations.

The literary mode, however, did not necessarily occupy space, and it functioned not by stretching, shrinking, or otherwise modifying shapes and locations but by enumerating sequences and assigning them significance. As Roosevelt practiced it, its principal function was economy—the operational linkage that joined energy with form to produce function. Roosevelt therefore pointed out that, in the "arid belt" he called the "cattle country," "cowboys and branding irons take the place of fences." The lariat Remington drew as a straight, connecting line was the "one essential feature of every cowboy's equipment"—it could be "used for every conceivable emergency."[29] The cowboys who watched over cattle were in turn watched over by "stockmen," or ranch owners—who made possible the "after settlement of the region," putting the entire country in their debt. Every object, creature, and circumstance had a proper use and, if the use was not immediately apparent, this usually meant that it was larger and more important—perhaps even somehow spiritual or metaphysical—in inverse ratio to its

29. Ibid., pp. 495, 506.

visibility. The "great, dreary solitudes," "melancholy, pathless plains," and "lonely rivers" set in beds of treacherous quicksand, for example, might at first seem disadvantageous, but Roosevelt thought they encouraged the "abounding vigor and... bold, restless freedom" that informed the "pleasantest, healthiest, and most exciting phase" of American existence.[30]

Life in the arid belt, according to Roosevelt, appeared to compensate for physical hardship by granting genetic favor. If herds of cattle played some role in the enterprise, it seemed to Roosevelt a minor one, for the "stock" that captured and held his attention was human. Once this focus was understood, the "great Montana Stockraisers' Association" meeting at Miles City acquired new significance, as Roosevelt called it a "typically American assemblage," remarking of the "certain number of foreigners" present that they had "become completely Americanized" and adding that "on the whole it would be difficult to gather a finer body of men."[31] Like Remington, Roosevelt regarded the landscape as a stage. Yet, while he seemed to trust the accuracy of his senses, he also relied upon what the senses showed him to collapse and fall away, revealing something different and better underneath. In this sense, he was very much an idealist whose perceptions were formed by antecedent expectation. The "dust, noise and confusion" he *saw* from his vantage point above a cattle roundup, for instance, contained the "rapidity and certainty" of the work he *knew* was happening "in reality." Translated into the realm of his own work, this meant simply that the fragments there recorded were individually opaque but collectively transparent. The order of their arrangement mattered little, but their presence in a single amphitheater augured icons in the backstage chamber where the playwright labored and, behind the icons, gods.

Most simply iconic were the wild beasts that derived significance by being hunted. According to *Ranch Life*, the ranchman typically spent much of his time in the slaughter of wild game, shipping his cattle east for the benefit of lesser and more domesticated palates. Venison of various kinds made a staple, but any wild creature that came near enough to be shot or captured seemed almost sure to be gobbled up. "Wall eyed pike, ugly, slimy catfish, and other uncouth finny things" had no adverse effect on Roosevelt's appetite—prairie

30. Ibid., pp. 498–499, 510.
31. Ibid., p. 500.

chickens, avocets, and geese and ducks of all varieties were consumed with gusto. On one occasion, he even succeeded in stealing up on a flock of sandhill cranes—engaged in "queer antics" of "dancing and posturing to each other"—and shot a "full-grown female," later finding "its breast, when roasted, ... very good eating."[32] Whether or not a reader found them agreeable, these accounts made their point: there was more than food value involved in eating a quarry that had been stalked and killed, for Roosevelt called the hunter the "arch-type of freedom."[33] The hunter asserted his freedom by preying—which for him also seemed to be a variety of prayer. His way of participating in the power that dotted the prairie with bog holes one day and blanketed it with wild roses the next was literally to consume it.

If Roosevelt had moved to Dakota Territory several years earlier, he might have hunted Indians as well as elk and deer, and they too served as icons. Roosevelt's attitude toward the Indians did not at first glance appear to be worshipful. Indeed, he even offered the sensible opinion that the "chief trouble" between Indians and whites derived from an unfortunate "tendency on each side to hold the race, and not the individual, responsible for the deeds of the latter"—he further remarked that he and his men got along "particularly well" with the "perfectly meek and peaceable" Indians who sometimes visited Elkhorn Ranch by resolving that "they shall be treated as fairly as if they were whites."[34] Yet Roosevelt recognized that he and other whites had dispossessed the Indians and preyed upon them, even admitting that his own ranch—where he, like an Indian, regarded cattle as a "nuisance to the hunter"—had until 1880 been part of the "last great Indian hunting-ground." Because of this recognition, he regarded the Indian in a special way. Even within the boundaries of his own property, ruts cut in the sod by the ill-fated Custer's supply trains a decade before —scars Roosevelt called "well known landmarks" which remained "as distinctly to be seen as ever"—reminded him of "bloody campaigns" that set the Indian apart.

Roosevelt's account of his only encounter with Indians was charged with peculiar force, although he called it "very mild." He was riding alone, northeast of Elkhorn Ranch in an area of "practically unknown"

32. "The Home Ranch," *The Century*, March 1888, p. 666.
33. "Frontier Types," *The Century*, October 1888, p. 832.
34. "Sheriff's Work on a Ranch," *The Century*, May 1888, p. 39.

country. Topping a rise, he found himself on a plateau about half a mile in diameter, a raised counterpart of the sunken amphitheater where he had watched a cattle roundup. Just as he reached center stage, five mounted Indians entered from the wings, popping up "over the edge," and approached him at a run, "whooping and brandishing their weapons."[35] Roosevelt "instantly reined up and dismounted," shielding himself with his horse. When the Indians were about a hundred yards off, he conspicuously raised his rifle and took aim. "The effect," he said, "was like magic"—the supposed attackers "scattered out as wild pigeons or teal ducks sometimes do when shot at." By pointing a rifle at them, Roosevelt had changed the Indians into game. Doubtless without intending the full force of his remark, he confided to his readers that "I never saw the Indians again."

Ranch Life persistently identified Indians with the land that produced and nurtured them and repeatedly suggested that, even when the Indians themselves had been hounded onto reservations, something of their essence remained in, on, or under the region they had left. If the Indians had made their entrance by seeming to rise out of the ground, they must have made their exit by seeming to sink back as they rode away. Roosevelt thus contended that in "lonely, uninhabited country" there was always danger of meeting a "band of young bucks," never, evidently, considering how the Indians might come to be there if the country was truly uninhabited.[36] Once such curious rhetoric was sorted out, it made a certain kind of sense for, if the Indians were identical with the land, they could hardly be said to inhabit it, except in a special way. Roosevelt showed what the way was by comparing the Indians with pigeons and ducks or avowing that "even the best Indians are very apt to have a good deal of the wild beast in them."[37] Like the animals he killed and ate for midday dinner, the Indians were for Roosevelt fragments spun outward from some primal center of power. Even though they seemed to spring up out of the earth, it was not practical to farm them and, even though they might be hunted, it did not seem right to eat them. Roosevelt clearly saw, however, that there was another way of participating in the power the Indians exemplified.

For well over a decade it had been relatively common

35. Ibid.
36. Ibid.
37. *Ranch Life*, p. 107 (deleted from serial version).

practice in parts of the West for white frontiersmen to take scalps from the Indians they killed, and sometimes these sigils were prominently displayed in such public places as saloons and store windows. Only half a year before *Ranch Life* began serial publication in 1888, there was considerable support in Arizona for a scheme to offer bounties of five hundred to one thousand dollars for each Apache scalp, and "no impertinent questions ... asked."[38] Roosevelt nowhere condoned such practices but, characteristically, seemed to recognize an aspect of their utility. With exactly the same matter-of-fact nonchalance he used to describe his hunting trophies, he noted that a Powder River rancher of his acquaintance had sometime before bagged "one scalp, belonging to a young Sioux brave."[39]

Yet, while trophies commemorated a significant act, they also tended to contain and localize its significance. Breeding, on the other hand, bore comparison with eating as a direct, intimate, and elemental means of absorption. "Here on the border," Roosevelt observed, "there is a certain amount of mixture with the Indian blood."[40] One of his "prosperous" neighbors, he said, was a "Chippewa half-breed." Two others had Indian wives. "Several of the most thriving North-western cities" contained citizens of high standing who possessed a "strong dash of Indian blood." All in all, he thought, the phenomenon occurred "much more than is commonly supposed" for, although admitting it sometimes occasioned "shame," a "couple of generations" usually sufficed for it to be "forgotten."[41] Eating wild game was a hunter's mode of assimilating the strength of the wilderness by way of his digestive tract; miscegenation a predatory culture's mode of assimilating people who contained a "good deal of the wild beast" by way of the womb.

Without ever successfully invoking chronological progression, *Ranch Life* established a chain of interlocking physical relationships. The Indian, who fed upon wildness produced by the land, was in turn fed upon by the white culture and, in the process, a third icon appeared—that of the white frontiersman, or man of the border. Like the wild beast and the wild Indian, this figure was marginal in the sense that it occupied an edge where one identity touched another—indeed, it was the white frontiersman who made the border into a border for, among the three icons of *Ranch Life*, he

38. Arizona *Sentinel*, June 25, 1887, quoted in Lt. John Bigelow, p. xiii.
39. *Ranch Life*, p. 104 (deleted from serial version).
40. Ibid., p. 108 (deleted from serial version).
41. Ibid. (deleted from serial version).

was the most aggressively kinetic. Consequently, Roosevelt never said where the frontiersman lived but always seemed interested in where he came *from* and always noticed when he left signs *behind* him. "The trapper and the miner ... the hunter and the cowboy," wrote Roosevelt, were "all of the same type."[42] In other words, their kinesis defined them. This made them marginal in another sense as well for, since movement could only occur in space, the frontiersman was unconditionally limited by the boundaries of the space he moved through.

Utilizing rhetoric subsequently become a dubious asset of the National Park Service, Roosevelt characterized this space as a region where "mighty rivers twist in long reaches between the barren bluffs; where the prairies stretch out into billowy plains of waving grass, girt only by the blue horizon,—plains across whose endless breadth [a frontiersman] can steer his course for days and weeks and see neither man to speak to nor hill to break the level; where the glory and the burning splendor of the sunsets kindle the blue vault of heaven and the level brown earth till they merge together in an ocean of flaming fire."[43] Elsewhere, however, Roosevelt observed of frontiersmen that "there is no plain so lonely that their feet have not trodden it; no mountain so far off that their eyes have not scanned its grandeur."[44] Both statements were bloated, but they did contain the meaning Roosevelt assigned to the man of the border. The latter proposed that the frontiersman had exhausted available space by traversing it. The former, although it might be mistaken for a reference to the biblical lake of fire, suggested the crucible Roosevelt supposed the frontiersman must tumble into as he stepped across the horizon. If the hunted could become food for the hunter, and Indians might secretly enrich the genetic structure of the race that conquered them, then it seemed plausible that the frontiersman—who moved through space to escape the state—should demonstrate his utility by becoming a statesman when space ran out.

Roosevelt's insistence on the cowboy as statesman was obviously necessary for, without such insistence, his book would be deprived of its principal focus, the physical continuum within which beast, Indian, and frontiersman were all linked with each other—which, in order to be credible as a continuum, needed coor-

42. "The Ranchman's Rifle on Crag and Prairie," *The Century*, June 1888, p. 204.
43. "Frontier Types," p. 843.
44. "The Ranchman's Rifle," p. 204.

dinates beyond itself. Roosevelt's strategy was to apply coordinates derived from American political history and theory, and the reason the strategy failed is that the physical continuum Roosevelt identified was incapable of supporting his genteel assumptions concerning utility. Remington, on the other hand, was able to show in pictures what Roosevelt could not bring himself to say in words: the relationships among units in the physical continuum were those of deadly enemies; in order to make the cowboy useful to the state, it would be necessary to kill him.

While Remington's contributions only occasionally succeeded in resolving the problems presented by Roosevelt's prose, they did make *Ranch Life* far more attractive than it would otherwise have been, modifying very considerably the impact of the finished work. Without the pictures, *Ranch Life* would have been humorless, vague, and often self-contradictory; with them, it achieved points of sharp specificity, an intermittently powerful ironic awareness, and a persistently visual dimension where Roosevelt's stuffiest passages could not enter, where they were thus rendered more harmless—or at least less noticeable.

Yet what Remington gained from *Ranch Life* was finally more important than what *Ranch Life* gained from Remington. Commercially, the work linked Remington's name with ideas less foolish and far more potent than those espoused by the picture history. Artistically, it presented him with complex subjects and required that he deal with them in ways that were more symbolic than journalistic. In terms of his continuing career, it identified concerns he never left off pursuing and avenues of approach he followed until they ran out. From *Ranch Life* on, white man, red man, and wild beast functioned for Remington—as they had for Roosevelt—as icons, and in 1888 the processes of mutation and assimilation which linked all three in a single continuity looked like a viable alternative to the genteel religion of Culture.

As might be expected, however, the focus of Remington's vision differed markedly from that of Roosevelt's. Remington shared neither Roosevelt's gastronomic enthusiasm, his confidence in miscegenation as a means of invigorating European bloodlines, nor his belief in the cowboy as most prominent among types of the white frontiersman. While still at work on pictures for

Ranch Life, Remington wrote his first essay since the apprentice "Coursing Rabbits" of 1887. It was a polished, knowledgeable work of surprisingly wide suggestive range, called "Horses of the Plains" when *The Century* published it in January 1889. All but two of the ten pictures that accompanied it had been printed in the book version of *Ranch Life,* which had appeared just a month earlier. It was therefore clearly intended by *The Century* as a continuation in the series the *Ranch Life* essays had begun, and the continuity between Roosevelt's work and Remington's was established in it graphically, topically, chronologically, and with regard to method and approach.

Just as Roosevelt had attempted to define frontier types, Remington treated five varieties of American horses. Just as Roosevelt had traced the origins of cattle ranching and predicted ranching would make a significant contribution to American culture in the future, Remington occupied himself with the "development" or "gradual adjustment" of the Spanish "Barbary horse" to American conditions, speculating that it was "destined to become a distinguished element in the future horse of the continent." Yet "Horses of the Plains" constituted much more than an equine version of the genetic and political theories advanced by Roosevelt, for it augured a different set of relationships among the three icons of *Ranch Life.* As a species of historical narrative, it concerned the same time, the same region, and even the same phenomena dealt with in Roosevelt's series. As a demonstration of historiographical assumptions, it identified different causes, promised different results, and constituted in some sense a rebuttal.

Remington disavowed Roosevelt's hunting metaphor and replaced it with a martial one. The Barbary horse or "barb," from which the American horse had descended, had been "bred for the purpose of war" in northern Africa and was still, in its American avatar, what he called the *"ne plus ultra* for light cavalry purposes."[45] Despite its aristocratic origin, this horse, having escaped in considerable numbers from Spanish conquistadores making their way across the continent, had quickly rubbed off any veneer of domesticity. A hostile environment worked more effectively than selective breeding to perfect a strain that was hardy, strong, and persistently self-assertive. Yet the power of this

45. "Horses of the Plains," *The Century,* January, 1889, p. 341.

horse was not to be absorbed by eating, even though Remington observed that some Indian tribes enjoyed it broiled, roasted, or boiled. Instead, Remington ascribed the Indians' success with the horse to knowing enough "not to combat nature."[46] Like a typical white man, he had tried to "regenerate" one of the horses into a "pretty little cob" by combing, feeding, housing, and otherwise pampering it. As a result, the horse acquired a "paunch . . . distended to frightful proportions" but retained its "cat hams, ewe neck, and little thin shoulders . . . as hard and dry as ever."[47] Having descended from stock of Moorish invaders of Spain, the Spanish barb had joined the Spanish invaders of America and, having descended from the Spanish barb, the American barb had joined the Indians. When a white man rode it, the horse made less of a surrender than the rider.

In other words, the bronco could be captured and even mounted, but it refused to be assimilated. "The Moor, the Spanish conqueror, the red Indian, the mountain man, and the vaquero"—in short, everyone who had ridden the bronco and its ancestors—thought Remington, had passed or would pass away, but the bronco balked at following, remaining behind as a "living protest against utilitarianism." That the bronco could be harnessed with the "collar of the new civilization" and forced to "enter the new regime" proved only that the horse was versatile as the new regime was not.

Ostensibly a humble treatment of equine temperament and anatomy, "Horses of the Plains" may therefore be said to have skeptically countered the eagerly nationalistic belief of *Ranch Life*. A certain timidity restrained it—as when Remington protested that it expressed only "personal views" or called his idea for training broncos to be cavalry mounts a "particular fad which I would like to demonstrate"—but the essay was first in a considerable series of works where Remington vigorously set about the task of rearranging genteel assumptions. By suggesting that wildness possessed virtues which often failed to tally with utilitarianism, it implied that utilitarianism might not always be a virtue.

Next in the series were the three Indian essays Remington wrote after having been sent west by Richard Watson Gilder, editor of *The Century*, in the summer of 1888 to retrace his less purposeful but more exciting journey there of three years before. Throughout these

46. Ibid., p. 339.
47. Ibid., p. 335.

pieces ran a steady skein of resistance to consensus that grew more pronounced as Remington unwound it. In the first essay, he was content merely to chronicle his visit to Fort Grant, Arizona, and his impressions of the black soldiers there, concluding without bravado that the fort was a difficult place to live and that the soldiers were hardy, self-reliant, and cheerful. This, of course, was harmless enough, and Remington's narrative was as amiable as the pictures that went with it, proposing to demonstrate how it felt for an eastern city man to encounter the desert and executing the demonstration with a healthy measure of humorous self-ridicule. Yet comparing the essay to the *Ranch Life* series—in the vein of which it supposedly continued—put it in a rather different perspective. Roosevelt's "lonely lands where mighty rivers twist" became a "great stretch of sandy desert" where the fleshy Remington experienced "hot work."[48] The threatening Indians Roosevelt never saw again after flushing them from the stagelike plateau near Elkhorn Ranch reappeared as a "very small and very dirty little Yuma Apache," who gazed with "sparkling eyes" at Remington as at a "very strange object." The cowboy Roosevelt called the "grim pioneer of our race" was replaced by a happy-go-lucky black trooper, who stowed chewing tobacco in his boot and called Remington "Whitey." While Roosevelt asserted the frontier's utility to the establishment, Remington insisted on recognizing that, whatever values establishment writers might assign to it, the frontier remained principally alien to establishment values.

The second *Century* essay, printed in July, was both more explicit and more acerbic in its denial of establishment values and the consensus attitudes that formed them. In the same issue, an open letter from Indian Commissioner Hamilton Mabie[49] defended current Indian policies on the grounds that, by means of education, support, and motivation, they were leading Indians along a course Mabie called the "white man's road." Although Mabie did not say so, the road made a beeline toward the institutions, styles, and habits of perception that caused Roosevelt to call the cowboy a grim pioneer. The Indians who followed it would ideally become identical with the white men who built it—which meant that as Indians they would become invisible.

Remington, however, could not help noticing that the

48. "A Scout with the Buffalo-Soldiers," p. 907.
49. "Indians, and Indians," *The Century*, July 1889, p. 471.

Indians he saw at the reservations near Fort Sill were just as visible as any white man and far more distinctive than many of them. Very much to the point as usual, he thus observed, when he visited a Comanche agency, that the Fourth of July was not known among the captive Indians as Independence Day but as one of the "white man's big Sundays" when the Indians were allowed a "regulation celebration," the main feature of which was an enlarged measure of agency beef.[50] It is impossible to know whether it also occurred to Remington that there was something ironic in chronicling this regulated festival only months after drawing pictures for Roosevelt's essay celebrating white hunters feasting on game harvested from the vanishing hunting grounds of the Indians. He contented himself with saying that the Comanches should never be allowed "to lose their blankets, their horses, their heroism, in order to stalk behind a plow in a pair of canvas overalls and a battered silk hat." Remington felt that the "good white man who would undertake to make Christian gentlemen and honest tillers of the soil out of this material would contract for a job to subvert the process of nature." His metaphor explicitly stated that assimilation was *not* natural and implied that utility was even less so. He saw clearly what participation in the establishment consensus altogether obscured for men like Mabie and Roosevelt: the white man's road was identical with the wagon tracks gouged in the Dakota prairie by Custer's supply trains. Although others might suppose that it ended at respectability, Remington remembered that it began at Little Big Horn.

Remington's third and final *Century* essay about the Indian question focused on the Cheyennes, who, over two decades earlier, had been herded from the Great Plains of Roosevelt's arid belt to a reservation along the South Canadian River in Oklahoma. These people, thought Remington, were more attractive and shrewder than the Apaches he had seen at San Carlos or the Comanches he had watched at Fort Sill. A young Cheyenne woman laughed prettily when she learned that Remington had drawn her picture. The Cheyenne tongue, spoken with the "pleasant sound" of "soft, guttural ... pronunciation," he found "charming."[51] The camp he visited contained "young fellows ... stretched on the grass in graceful attitudes," a friendly old warrior named Bull Bear, "children ... playing

50. "On The Indian Reservations," p. 402.
51. "Artist Wanderings Among the Cheyennes," p. 539.

with dogs," "women ... beading moccasins," gamblers playing monte in the shade of a wagon, dancers preparing for a tribal ritual—even a medicine man in the act of treating a "young buck who seemed in no need" of sympathy. Remington left a long talk with the tribal chief convinced that the "old Indian knew more about Indians, Indian policy, and the tendencies and impulses of the white men concerning his race than any other person I had ever met," and he observed that among the Cheyennes some men had "respectable" herds of cattle that testified to their economy and industry. As Remington had earlier said he hoped they would be, the Cheyennes seemed "far along on 'the white man's road.' " What it meant for them to be taking such a journey thus became an important question.

By way of defining the progress they had made, Remington sensibly proposed to discover where the Cheyennes had started from, choosing as a benchmark not the 1861 treaty that ceded their northern lands to the United States or the epic march away from Oklahoma that ended in the bitter winter of 1879 with the killing of Dull Knife and his band but, rather, a tribal legend of the Cheyenne "medicine arrows"—a narrative of the mythic disaster to which many Cheyennes attributed historical misfortunes like the 1861 treaty and the 1879 Dull Knife fight. Not only did Remington see the Cheyennes, he tried to see them through their own eyes. The measurement he chose for demonstrating their movement along the white man's road was one they themselves had devised, and no special talent was required to see that, thus measured, the movement was in the direction of defeat rather than triumph.

It was therefore with appropriate sensitivity to its ironic features that Remington recounted the issue of beef rations at the Cheyenne agency. Cowboys, whom Remington stripped of all romance to call merely "cattle contractors," assembled a motley herd of steers in a tumbledown enclosure a short distance from agency headquarters. While soldiers of the garrison conducted target practice at a firing range nearby, the hungry Indians gathered "in twos, and threes, and groups, and crowds ... converging on the beef corral." A cursory inspection by the business-suited Indian agent and a nattily uniformed army officer preceded the branding of each of the animals—intended to identify the hides and thus protect the Indians who used them from ac-

cusations of cattle rustling. Then, the Indians chosen to receive a ration were called forward one by one and, selecting an animal from among those in the holding chute, marked it by cutting off an ear, gouging an eye, mutilating a tail, or making some other mark to show that the animal was theirs.

Finally, these animals were released onto the open prairie, and the Indians pursued them in a madcap chase, shooting at them with revolvers until they fell. Remington observed that the Indians "could not handle the revolver" but also noted that they "greatly enjoyed" the pursuit. His comment that "it was buffalo hunting over again"[52] expressed his recognition that the pathetic spectacle represented a loss of freedom.

It also involved a loss of faith, for the hunt had become a supervised skeet shoot, symptomizing the moribund condition Remington sensed beneath the agency's colorful exterior. "Tribal traditions," Remington noticed, were "not known thoroughly," and only a "very few old men" could correctly tell the "tribal stories." When Remington asked the reasons for these lapses, he was forced to conclude that "no one seems to know." His own speculation was that the "Indians have seen and heard so much through the white men that their faith is shaken." This was not to concur with Mabie and others that formal education had induced the Indians to give up their old beliefs but, rather, to assert that white treachery and mismanagement had created conditions in which the old beliefs appeared to be meaningless. Remington thought sending Indian children off to schools where they learned "English, morals, and trades" a scheme of "absolutely . . . no consequence" for, as soon as the children returned to the reservation, their English gave way to Cheyenne, genteel morals seemed irrelevant, and trades were useless without the opportunity of practicing them. Real education might have resulted in exchanging one set of attitudes for another. Token gestures of what Remington called extreme "imbecility . . . fostered by political avarice" had the dreary effect of withering the old attitudes without offering viable alternatives to them. Power had somehow departed from the medicine arrows, and the medicine practiced by white men was either weak or vicious or both.

Remington saw that the converse of *Ranch Life* was reservation life—for those whose hunting grounds had

52. Ibid., p. 544.

been preempted, the hunting trail led only to a holding chute. He also refused to believe that assimilation, by either social or genetic means, would substantially reduce the injustice that outraged him. He did, however, have "views . . . on the subject," and he took advantage of the series' last essay to express them. Rather than helping Indians "become a part of our social system," he thought, the "white race" was "slowly crushing them out of it."[53] While he did not accuse his fellow whites of being purposely cruel, he did charge that the "great body of our citizens are apathetic." Those who lived far from the Indians found it difficult to see them, and Roosevelt had inadvertently shown in *Ranch Life* how easy it was for those who lived nearby not to look at them. Remington therefore supposed that if Indians were to cease being trivial they would have to become visible. Roosevelt had conjured the cowboy into a hero by presenting him as a fighter, stating that "under a man like Forrest [cowboys] would become the most formidable fighting horsemen in the world"—a contention he later attempted to prove in the Spanish-American War.[54] Remington accordingly matched Roosevelt's gambit piece for piece, asserting of the Cheyennes that "they are naturally the finest irregular cavalry on the face of this globe, and with an organization similar to the Russian Cossacks may do the United States a great good and become themselves gradually civilized."[55] Because he believed the Indians were "made of soldier stuff," Remington thought they might spring into view at last if they were given uniforms to wear and rifles to carry.

Remington asserted that all Indians "like to be enlisted in the service, universally obey orders, and are never disloyal." He was sure that, with a competent officer to lead them, they could "ride around the world without having a piece of bacon, or a cartridge, or a horse issued by [the] Government"—as for "police work," he observed that the "corps of Indian scouts do nearly all of that service now." After indicting the callous politicians who used "theoretical Indian regenerators" as tools and applauding the Indians as potential patriots, he decided that the only truly significant factor in the Indian question was a hopelessly incurable "public apathy." He therefore broke off with a furious shrug, declaring that "nothing will be done," rhetorically asking "why continue this?" Having once asked

53. Ibid., p. 540.
54. *Ranch Life*, p. 108 (deleted from serial version).
55. "Artist Wanderings," p. 541.

the question, however, it was impossible to walk away from it.

In 1888, Remington had invaded the American Water Color Society's annual New York exhibition with his painting "The Arrest of a Blackfoot Murderer," a "spirited bit"[56] displayed among boxer puppies, little girls, Dutch landscapes, and the inevitable cliffs with whitecapped waves. The next year, which saw the printing of his even more spirited *Century* essays, also carried the Indian question across the Atlantic, when "The Last Stand"—Remington's large oil of embattled troopers huddled about the standing figure of General George Custer—was awarded a silver medal at the Paris Exposition. The award was given in July, meriting a tiny notice in the St. Lawrence *Plain Dealer*—which regarded Remington with less alarm than it had eight years earlier—and a more extensive and enthusiastic account in *Harper's Weekly*, where the picture itself was reproduced in January 1891.[57] Between the time the picture of Custer gained recognition at Paris and the time of its printing in the *Weekly*, Remington felt the final consequence of the event the picture recorded.

Shortly after the exhibition of Remington's painting began at Paris in the summer of 1889, General George Crook convinced representatives of the Sioux Nation at their reservation in Dakota Territory that they should agree to the division of their lands into seven parcels, in the bargain selling nine million acres to the United States government at a price of $1.50 per acre. The previous winter, a Paiute mystic named Wovoka declared himself messiah of all Indians. Early in the fall of 1890, Kicking Bear, a Sioux from the Cheyenne River agency in South Dakota, went west to listen to the new messiah. He returned to the Cheyenne River with a blueprint for millennium.

Wovoka had promised that the next spring, 1891, would see the end of white treachery in America. When the grass was knee-high, a new landscape would roll over the face of the old one, burying the white men and all their works far beneath a hunting ground where life was pleasant and all varieties of wild game abounded. Indians who learned to perform what later came to be called the "Ghost Dance" would be magically raised into the air while the renewal occurred, and when they returned they would live forever. Dead Indians would

56. "The American Water Color Society," *Harper's Weekly*, February 4, 1888, p. 79.
57. The *Plain Dealer* conceded in July that "news comes from the great Paris Exposition that Frederic Remington has carried off second honors in his class in the art exhibition" (see Manley, p. 25). "The Last Stand" was reproduced in *Harper's Weekly*, January 10, 1891, pp. 24–25.

rise and live among them, and in the fall of every year the youth of each good Indian would be restored. By late October 1890, thousands of Indians on the Dakota reservations were performing the new dance, and many said that Wovoka had conquered time and space to appear to them in visions and instruct them. Sitting Bull —who had left his Canadian exile nine years before, since then acquiring genteel prominence by appearing at public ceremonies, making a tour sponsored by the Department of the Interior, and even joining Buffalo Bill's Wild West Show with Annie Oakley—declared that he had eaten buffalo with the messiah and talked with his old friend Black Kettle, whom Custer had killed in 1876.

White settlers, who preferred occupancy of the arid belt to burial under Eden, wished that the dancing would stop. Officials on the reservations and at Washington were alarmed that the dancing seemed to bring progress along the white man's road to an abrupt halt, for agency classrooms and trading posts became empty, and work on the agency farms and ranches ceased. Military officers, who sensed a dangerously assertive surge of racial consciousness beneath the religious imagery, feared an uprising. In short, consensus decreed that the dancing must come to an end, and military units were dispatched to execute the decree. In response, Indian leaders told dancers that—if they wore specially designed "Ghost Shirts"—they would be protected from any harm the soldiers might attempt, and—if they performed certain incantations—they would become invisible to everyone except their fellow dancers. This was an appropriate and even logical answer to decades of white blindness, but the trouble with it was that it contained a challenge capable of penetrating even the public apathy Remington had identified the year before. If the Indians said that they were invisible, consensus became determined to examine them and, if they claimed to be bulletproof, they invited consensus to shoot them. Accordingly, before the beginning of November 1890 Nelson Miles, now a major general, left his headquarters at Chicago to make a personal inspection tour of military garrisons attached to the Dakota agencies.

Remington made part of the general's entourage as a war correspondent for *Harper's Weekly*, a role he accepted with alacrity and performed with relish.

Journeying from Chicago to Rushville, Nebraska, by rail, the party mounted horses waiting for them at the depot and rode twenty-eight miles north to the Pine Ridge agency on the Sioux reservation, where Remington sketched a Ghost Dance in progress among the Ogallala Sioux and talked with soldiers and Indians concerning its significance.[58] Several days later, the group arrived at Fort Keough, Montana, on the Yellowstone River. There, Remington admired the trim, soldierly corps of Cheyenne scouts assembled and trained by Lieutenant William Casey of the Seventh Cavalry. Another breakneck ride of some sixty miles took them to the Eighth Cavalry camp on the Tongue River, site of an 1877 battle where Casey and Miles had fought with relatives of some of the same Cheyennes who now formed Casey's corps of scouts at Keough. Next day, they inspected the battlefield at Little Big Horn and dashed on to nearby Fort Custer, where Remington heard troopers sing Indian "medicine songs" with an Irish accent. One more ride of thirty-five miles, taken at night, brought them to the railroad and a train that waited to tow them east.

Miles' inspection tour was an immediate prelude to swift, positive action aimed at crushing the Ghost Dance, making an example of the Sioux, and restoring the Indians to their place in the center of the white man's road. It was supposed that the arrest of Sitting Bull might appropriately set the stage for such action and, since Buffalo Bill Cody knew the chief, he was sent to bring him to Chicago for a "conference" with Miles. When this maneuver failed, military reinforcements were moved to Pine Ridge from Fort Keough and Fort Custer, and Remington speculated in a December 6 article for *Harper's Weekly* that "before this matter is printed the biggest Indian war since 1758 will be in progress, or ... the display of military force will have accomplished its object, and the trouble gone."[59] Nine days later, on December 15, Sitting Bull was awakened at dawn by a lieutenant named Bull Head, who had been sent from Pine Ridge with a force of forty-two other Indian police to arrest him. In the brief altercation that followed, the chief was shot and killed.

The man who pulled the trigger was Red Tomahawk, one of the Cheyenne scouts Remington had seen little less than two months before at Fort Keough. These scouts were among the men who exemplified for Rem-

58. See Remington, "Chasing a Major General," *Harper's Weekly*, December 6, 1890, pp. 946–947. See also Lieutenant Marion P. Maus, "The New Indian Messiah," *Harper's Weekly*, December 6, 1890, p. 947.
59. "The Art of War and Newspaper Men," *Harper's Weekly*, December 6, 1890, p. 947.

ington the best product of a military alternative to the bungling civilian administration of Indian affairs. "Six months before," asserted Remington in an article written shortly after his visit to Fort Keough and shortly before the death of Sitting Bull, "all these men were down at the Lame Deer Agency doing nothing, unless to go out gunning for a ranchman's cattle." [60] Now, after Casey had "brought them up to the mouth of the Tongue River [and] uniformed and equipped them," they were "fine Indian soldiers, who stood like bronze stones . . . who looked a soldier, and felt a soldier"—in fact, these were the "finest" soldiers Remington had ever seen. They proved that Indians and whites could work together and that Indians could prosper. "Under a just administration" like that at Fort Keough, Remington asserted, "there would be no more chances of the Indians breaking out than there would be of the people of Deadwood or Helena." Indians, like whites, could employ their special talents and reap appropriate rewards, dispelling the threat of violence and eliminating the need for government support and regulation. Remington even predicted that, "if the Crows, Cheyennes and Sioux became wealthy, industrious and contented, the First Cavalry will not be at Fort Custer, but in New York." Men like Red Tomahawk were evidence that a "practical scheme of regeneration" could yet "preserve the native American race." Something, however, had gone dreadfully wrong, for on December 29, 1890, just two days after *Harper's Weekly* printed Remington's essay on the Fort Keough scouts, they and the white military units to which they were attached killed more than two hundred hungry Sioux, mostly women and children, at a small Dakota creek that by some quirk of ironic understatement bore the name of Wounded Knee.

The well-known event itself was relatively simple in outline. Since Kicking Bear's October return to the Cheyenne River, Big Foot, chief of the Minneconjous Sioux, had enthusiastically supported the Ghost Dance and was thus labeled a dangerous fomenter by the War Department. Two days after the death of Sitting Bull, he was accordingly ordered arrested, but news of the killing and of the increasing military presence had already prompted him to move his band of some four hundred fifty followers to Pine Ridge, about seventy miles off, to avoid a fight with the soldiers. December

60. "Indians as Irregular Cavalry," *Harper's Weekly*, December 27, 1890, p. 1006.

28 found him well on the way, when he encountered four troops of the Seventh Cavalry, commanded by a Major Samuel Whitside. Whitside ordered the Indians disarmed and moved them to his camp at Wounded Knee Creek, a few miles away. That night, more units of the Seventh Cavalry arrived, under the command of Colonel James Forsyth, and several pieces of rapid-fire automatic cannon were added to the units already surrounding the Indians. In the morning Forsyth detailed soldiers to search the Sioux for weapons, finding a rifle that belonged to a young man named Black Coyote. Because he had paid for the rifle, and prized it, Black Coyote did not want to give it up. Following orders, the soldiers tried to take it from him by force—and someone, perhaps Black Coyote, fired a shot. Intense rifle fire and a brief period of hand-to-hand scuffling followed. As soon as the soldiers could get safely away from the Indians' tents, the artillery opened fire, and Indians who attempted to follow them were cut down "like buffalo," as an Indian survivor who probably never heard of *Ranch Life* noted.[61]

For half of the men and women in Big Foot's band, the event was fatal, and for the white soldiers and Indian scouts it was at once a terror, an agony, and a triumph. Although Remington was not present when calamity engulfed the Sioux camp, he played each of the roles and eventually experienced all the responses, although it took him nearly two decades to do so.

Shortly after the killing of Sitting Bull on December 15, Remington had left New York for South Dakota. While Ghost Dancers gathered at Big Foot's camp along the Cheyenne River, he had camped in the badlands with the Sixth Cavalry, noting that the region seemed an appropriate place for "stratagem and murder, with nothing to witness its mysteries but the cold blue winter sky."[62] Christmas found him at the railroad depot in Rapid City, waiting for the arrival of Lieutenant Casey and a detachment of the Fort Keough scouts —who had been in the field for a month and thus surprised him by their bedraggled appearance. After joining them, he rode down the rail line a short distance to the village of Hermoso, where he and Casey "brewed a little mess of hot stuff" in Casey's tent and toasted the strange occasion with "three fingers" of it gulped steaming from large tin cups.[63] The next night, they camped along the Cheyenne River, and a trooper sent

61. Louise Weasel Bear, quoted in Dee Brown, *Bury My Heart at Wounded Knee* (New York: Bantam, 1972), p. 417.
62. "Lieutenant Casey's Last Scout," *Harper's Weekly*, January 31, 1891, p. 85.
63. Ibid.

out to locate Big Foot's camp, supposed to be nearby, rode in late to report that "they are all gone." Casey's detachment moved into the abandoned camp on the morning of the twenty-eighth and watched with field glasses from a bluff, while the Sioux crept away toward Wounded Knee.

Two Brule Sioux stragglers who visited the camp that night must have recalled for Remington the event of five years earlier—in the Pinaleño Mountains of Arizona—that had begun the tribe of Remington, for Remington now gazed across a similar fire at one of the two Brules, finding eyes this time to see the Indian and words to describe what he saw. What looked back at him was a "perfect animal . . . replete with human depravity, stolid, ferocious, arrogant, and all the rest —ghost shirt, war paint, feathers and arms." Revolted and suddenly frightened, he decided the following morning to set out for Pine Ridge agency and Miles' field headquarters, some twenty-five miles distant. Lieutenant Casey obliged him with the loan of a supply wagon and assigned three men, two of them Cheyennes, to go along. Soon after leaving camp, Remington and his companions saw "two black columns of smoke" which they "did not understand" rising in the distance, where Big Foot's tents were burning. Sometime not long before noon, a young Sioux warrior dashed over a hill and, hovering just outside pistol range, made the "danger sign." Then, six of his fellows "rose out of the ground" alarmingly nearby and held a conference with Red Bear, one of the Cheyenne scouts.

Red Bear returned to the wagon in an agitated state and delivered a message in Cheyenne—very possibly some account of the incident at Wounded Knee Creek. The only portion translated for Remington, however, was a terse injunction that it would be necessary for him and the others to attempt a return to the relative safety of Casey's camp, now about ten miles behind them. As they deliberately turned the wagon around for the retreat, two of the Sioux rode up, and Remington offered a handshake but was refused. The Sioux watched as the wagon slowly set out, sticking close to it as it moved. When the wagon gradually increased its speed, they spurred to keep up; when it slowed down, they slowed too.

The four men of Remington's party lifted rifles from the wagon bed in preparation for a fight, but these

Indians refused to become part of the landscape—like those John Bigelow had chased in Arizona—or disappear—like those Roosevelt had encountered near Elkhorn Ranch. Instead, they looked as though they would attack, when "five fully armed, well mounted cowboys" appeared at the top of a neighboring rise. The Sioux opened fire but did not follow as the wagon rattled over the prairie at a full gallop, accompanied by its unlikely reinforcements. "It was," said Remington, "a regular rescue scene from Buffalo Bill's show."[64]

The flimsy metaphor expressed a certain breathless relief and the temporary sensation of idiotic incongruity that relief may have fostered, but it also somehow bore an enormous weight of pathos. The chief who had ridden with Buffalo Bill was dead, tragically shot by another Indian in the historical drama that sometimes resembled an opéra bouffe. Big Foot was dead, along with many of his followers, and the smoke from his burning tents was an omen Remington did not understand—at least for a time. The Ghost Dance was dead, crushed by men who professed the Christian faith from which it seemed to have drawn its Edenic imagery and millennial fervor—one of the dying Sioux at Wounded Knee had even begged a soldier to carry him to the side of Yellow Bird, a Ghost Dance medicine man, so he "might die with his knife in the old conjurer's heart."[65] Each had threatened the establishment, and the tinsel and calliope music suggested in Remington's metaphor showed how thoroughly the establishment had destroyed them all.

64. Ibid., p. 87.
65. From the account of a wounded Seventh Cavalry officer, quoted by Remington in "The Sioux Outbreak in South Dakota," *Harper's Weekly*, January 24, 1891, p. 61.

3. The Strategy of Sequence

The last day of 1890 dawned on the Sioux reservation through a mist of low, dark clouds and veils of driving sleet. Before noon, a glaring, salt-colored lambency suffused the atmosphere, as wind from the north steadily strengthened and the rattle of sleet was replaced by the roar of a blizzard. While the canvas walls of his tent at Lieutenant Casey's Seventh Cavalry scout camp billowed and slapped about him like the sheets of some disabled sailing vessel, Remington huddled over a small kerosene stove, contemplating his personal crisis of two days before. He probably recalled with hurt and puzzlement the shock of encountering hostility where he had expected friendship or respect, and it may have occurred to him, as he later wrote, that nothing less than the "great beauty of the American Character"[66] had rescued him from the threatening Brules. However, most insistent among the thoughts that challenged the weather for his attention was a belief that the worst was over. Therefore, even in an army tent that shook with the wind of a South Dakota blizzard, New Year's Eve seemed "comfortable" when it arrived, for to experience the occasion with a whole skin was to spend it, as Remington observed, "in a proper manner."

In addition, beneath the outrage and dismay Reming-

66. "Lieutenant Casey's Last Scout," p. 87.

ton felt concerning the fight at Wounded Knee and its attendant events, there ran a current of elation for, if the Seventh Cavalry's massacre of the Sioux exposed as simplistic his own earlier theory that a universal remission of the Indian question could be achieved by turning the Indians into a military class, it also fully confirmed his indictment of the bungling, bureaucratic policies and public indifference that had in large part been responsible for the conditions under which the fight occurred. Moreover, if Wounded Knee was the worst consequence of mishandling the Indian question —just as the affair of the supply wagon seemed to Remington personally and immediately the worst consequence of Wounded Knee—then something better might be expected to follow it, just as New Year's Eve among friends at the scout camp succeeded anxious waiting among enemies on the prairie. For the next three years, Remington accordingly formulated and tested an optimistic hypothesis: he hoped the convulsion of race, politics, and religion in South Dakota would provide the imbalance necessary to move the genteel establishment off dead center and begin its progress at last toward the imperial design he had first glimpsed in 1885. His formulation and testing of such a hypothesis required the development of a strategy different from any he had yet practiced, turning his attention away from energy—which had served him as subject—toward sequential order—which he quickly began to regard as both subject and context. Had Remington known how perilous the strategy of sequence would prove for him, even Wounded Knee might not have been enough to cause him to begin developing it. As matters stood, however, the affair of the supply wagon could be explained only by being brought into scale, and it could be brought into scale only by being perceptually linked with other events in a linear sequence.

The hypothesis that allowed such a linkage was deeply rooted in the Western European assumptions that informed the republic's founding, constructed the white man's road, and shaped American politics and culture until at least the end of World War I. To problems of government it brought the chronological perspective that allowed Thomas Jefferson to speak of the "course of human events," as though time had direction as well as duration, and gave Thomas Hart Benton,

Theodore Roosevelt, and other supporters of Manifest Destiny a way of justifying the present and celebrating the future by joining them both with extrapolated lines of immanence that issued from the past. In literature and the arts, it produced countless monuments, equestrian and otherwise, that represented people who were evidently *going* somewhere, as well as written discourses that one way or another seemed to acknowledge what Walt Whitman in "Passage to India" called a "worship new"—the belief that "God's purpose from the first" consisted in ordaining the "oceans to be cross'd, the distant brought near." [67] Although Remington did not subscribe wholeheartedly in 1891 to either the "progress" supposed to be a universal virtue or the "evolution" applied in popular journals to everything from country clubs to cowboys, he could not as illustrator, journalist, and painter of supposedly historical pictures sidestep the pervasive notion of linear movement that both progress and evolution expressed. The two events with which he linked his adventure in Casey's supply wagon therefore seemed not only to clarify a puzzle, they ordained a new perspective for his art.

The first event began at Casey's scout camp on the prairie, sometime between New Year's Eve and dawn of the next day. Having received news of the killing at Wounded Knee on December 29, the same day of its occurrence, General Miles had immediately dispatched a courier from his field headquarters at Pine Ridge to bring Remington back as soon as possible. Without knowing either that Miles had sent for him or that a massacre had occurred, Remington had gratefully performed the rituals attached to New Year's Eve and retired, only to be roused from a sound sleep and informed that he must ride to Pine Ridge before daylight. The enigmatic columns of smoke he had seen from the supply wagon acquired new meaning as he heard the reason Miles was recalling him, and the affair of the supply wagon shed its aura of coincidence to become an episode in the destruction of Wovoka's millennial hope and an incident in the linear progression Roosevelt had called the "onward march of our people." If Remington had been rescued from the Sioux not by cowboys but by the "great beauty of the American Character," he had been ambushed not by the Sioux but by the notion of linear sequence—assuming, as he now

67. Walt Whitman, "Passage to India," Section II. From *The Portable Walt Whitman* (New York: Viking, 1945).

seemed automatically to do, that the cowboys were American as the Indians were not, because their nationality *superseded* that of the Indians. Attempting to come to terms with an actuality that was stimulating, dangerous, and fragmented, he found that "progress" had outflanked him. When the affair of the supply wagon was linked with the affair of the Wounded Knee massacre, it became a serious threat to the tribe of Remington.

Perhaps because he remained unaware for the moment that his tribe was threatened, Remington "cheerily" managed a farewell with Casey, who promised to meet him soon in New York, and rode away with the weary messenger, arriving at Pine Ridge the next morning to hear "vague reports of the Wounded Knee fight" flitting about among cold, uncomfortable soldiers. Members of the Seventh Cavalry, newly returned from the former site of Big Foot's camp, showed him their wounds and regaled him with grisly "small talk" concerning the "military process of killing men." Yet, even while he sympathized with the wounded troopers and paid properly patriotic tribute to their martial skill, the vividness of his own brush with danger obscured his perception of the larger pattern they occupied. He was therefore able to leave the Seventh Cavalry, Miles, and South Dakota in a verbal tableau that expressed detachment rather than involvement:

> The dead were for the time forgotten, and the wounded were left to fight their own little battles with stitches and fevers and suppuration. The living toiled in the trenches, or stood out their long term on the pickets, where the moon looked down on the frosty landscape, and the cold wind from the north searched for the crevices in their blankets.[68]

If Remington had been a true participant, the mental contortions necessary to suppose that the moon might look down on him or the wind might search for ways to freeze him would simply have not been worth the trouble. Only a man who felt he had been given a special perspective on what was past could draw so long a bead as Remington.

This altered perspective was further altered by a second event, which began as Remington—with a new appreciation for the amenities of travel by Pullman—

68. "The Sioux Outbreak in South Dakota," p. 62.

boarded an eastbound train at Rapid City on January 3. Clean, warm, and freshly dressed, he watched the midwestern farms whip past his window as he breakfasted next morning in the dining car after a night of restful sleep. Then, moving to the smoker, he lit the day's first cigar and settled himself comfortably with a Chicago morning paper. Ironist though he was, he could hardly have perceived that the aura of success that now hung about his person had been purchased at the expense of precisely that realization of the vanishing West he had sought to discover in Montana ten years earlier. The spendthrift compulsion that had pulled him away from friends, family, and security in 1881 now seemed not only remote but foolish, and the West itself had been rendered both more accessible by the Pullman car and less desirable by Wounded Knee. As Remington traveled east from Pine Ridge, resorting as he did so to a Chicago newspaper for accounts of the battle at Wounded Knee Creek, the technology that had produced the train and the newspaper asserted itself as a barrier between him and his subjects. Even though he had so recently ridden with Casey and the Cheyenne scouts, his presence in the smoker rendered implausible his aspirations to be a tribesman. For the moment, indeed, he was neither tribesman nor clubman but, apparently, a curiously detached observer. What met his eyes when he opened the newspaper, however, was a headline that reported Lieutenant William Casey's death at the hands of the Sioux. Its effect was immediate and explicit: the Indians for whom Remington had confidently prophesied a future of patriotic prosperity became suddenly and collectively a "hater of the United States." [69]

Casey's death linked Wounded Knee and the affair of the supply wagon in a way that was impossible for Remington to miss—in a way that also required an end to his brief detachment from his subjects and a beginning of an altogether new variety of involvement with them. Nothing measured the new involvement or defined the subtly changed attitude behind it so well as the pictures Remington drew of the Sioux campaign. Individually, many of these pictures looked much like Remington's earlier treatments of similar subjects. The same concern with details of posture and costume found expression in much the same way as it had in his first southwestern drawings, and the same vigorous

69. "Lieutenant Casey's Last Scout," p. 87.

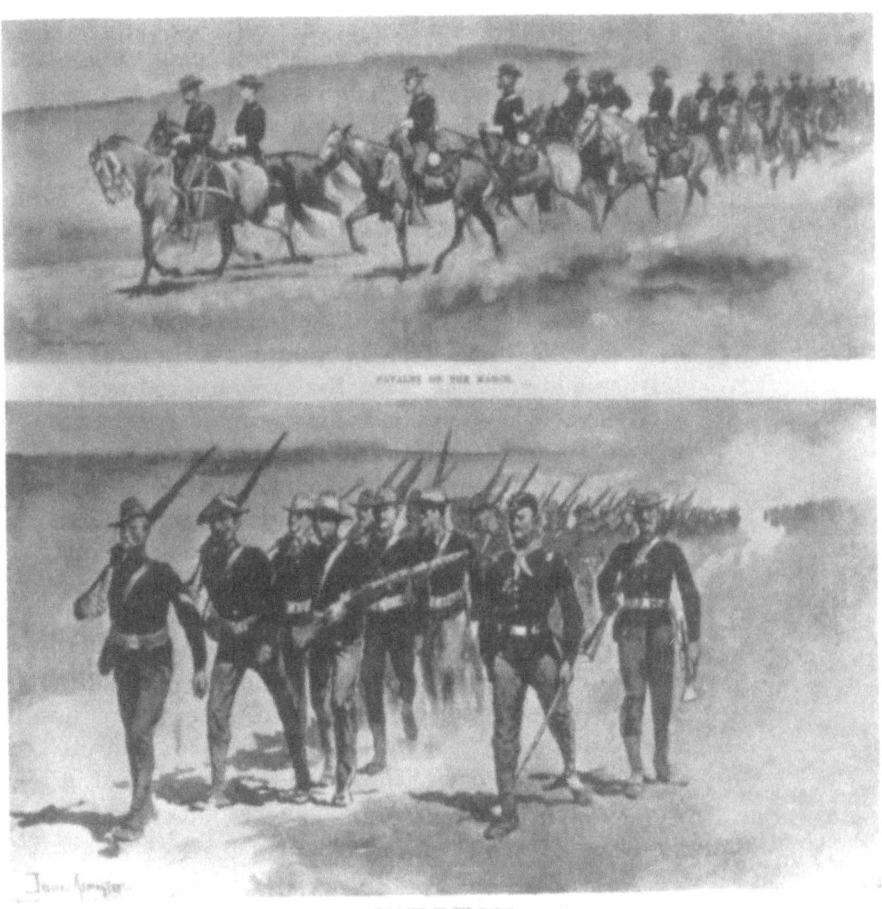

7. *Pictures like these, drawn just before the Wounded Knee fight, demonstrate Remington's freedom from the prescriptive point of view that his experience of Wounded Knee very soon imposed on him.*

The Law and the Prophets

angularity marked all twenty-two of the South Dakota pictures with the properties that had caused Poultney Bigelow to identify the rough Arizona sketches of 1885 as "real." Collectively, however, the pictures were different for, while troopers still peered out into bright sunlight through half-closed lids and colorfully decorated Indians still put on a warlike look, Remington's *place* in the processes he depicted had changed. All eight drawings made from General Miles' inspection tour, conducted before fighting broke out in South Dakota, implied the artist regarding his subjects from the usual angle—the front. Six army mules towed an ambulance wagon out of the picture, toward the perceptor; a column of infantry marched out of the background and into the foreground. General Miles aimed his horse as though to ride Remington's palette into the dust; even the Ghost Dancers at Pine Ridge obligingly showed their faces and the cadence of their dance, as though Remington had sat at the center of one circle and looked out from there to others. So long as the artist remained invisible, he could place his palette wherever he liked without fear of being shot or ridden down, because his identity as recorder protected him from involvement in what he recorded—but, after the affair of the supply wagon on December 29, the invisible artist appeared. The change in the artist's attitude, brought about by Wounded Knee, had caused the artist to become his own subject.

In one picture, he stood with his hands in his pockets while Lieutenant Casey, holding field glasses, stared grimly after Big Foot's retreating band of Sioux. In another, he raced toward Casey's scout camp with the supply wagon itself. In all the rest that pretended to be anything more than fragmentary studies, his presence was signaled by a consistent and clearly defined point of view. "The Wounding of Lieut. Hawthorn" displayed the broad posterior of a gunner being examined by the lieutenant and another soldier in a way that might have been funny but that also stated, in no uncertain terms, whose side the artist was on; the "final review" of infantry at Pine Ridge located Remington in the solidly respectable reviewing platform beside the general; and so on.[70] In "The Last Stand," exhibited at Paris in 1889, Custer and his men faced every point of the compass from their embattled position, and Remington correctly supposed that they looked most dramatic

70. "Watching the Dust of the Hostiles from the Bluffs of the Stronghold," *Harper's Weekly*, January 31, 1891, p. 89; "A Run to the Scout Camp," January 31, 1891, p. 88; "The Wounding of Lieut. Hawthorn," January 24, 1891, p. 61; "Final Review of General Miles's Army at Pine Ridge," February 7, 1891, pp. 108, 109, 112; "The Last Stand," January 10, 1891, pp. 24–25; "The Opening of the Fight at Wounded Knee," January 24, 1891, p. 65.

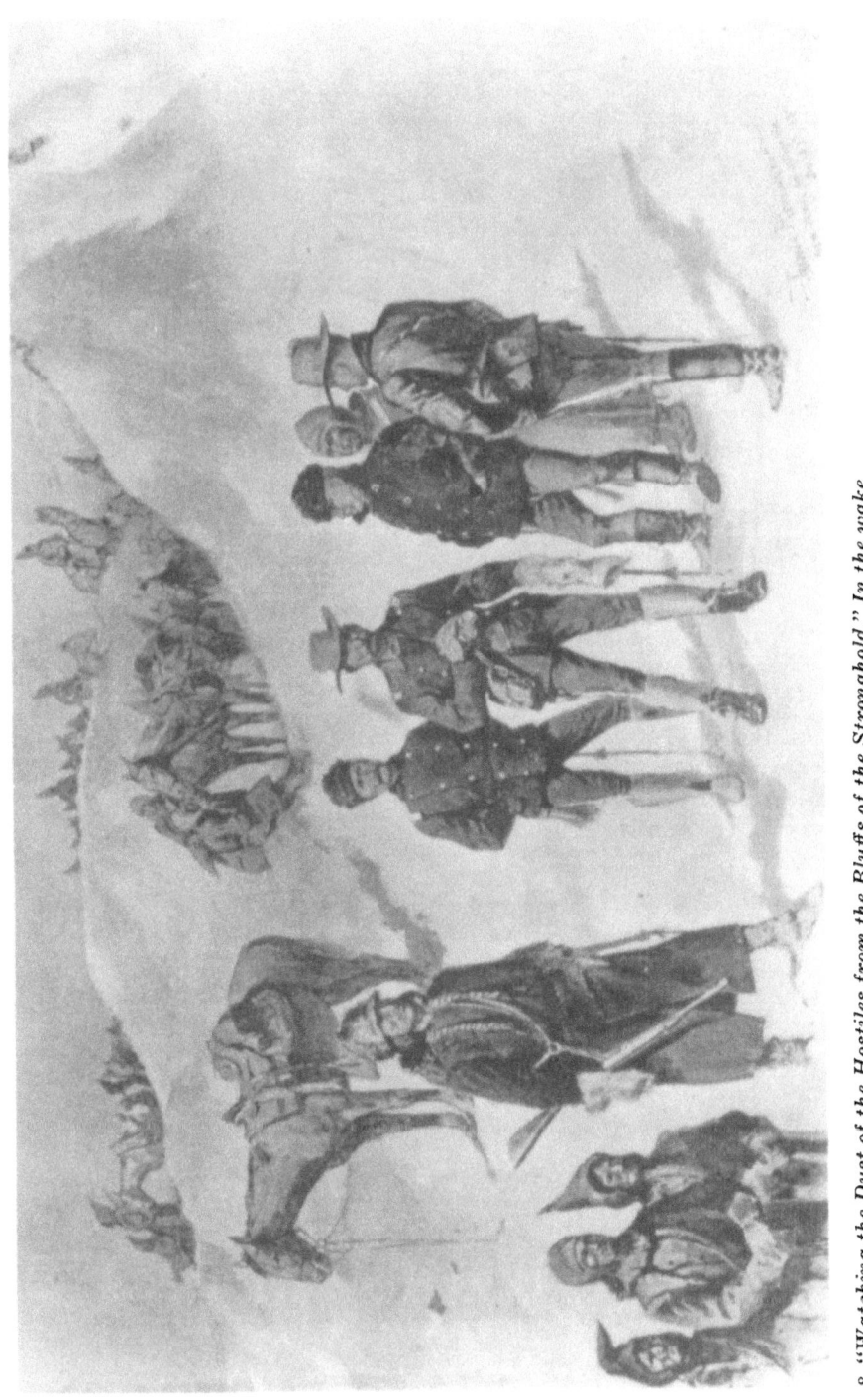

8. *"Watching the Dust of the Hostiles from the Bluffs of the Stronghold."* In the wake of Wounded Knee, Remington sometimes put himself into his own pictures. Here he appears in the foreground, third figure from the right, in a fur cap.

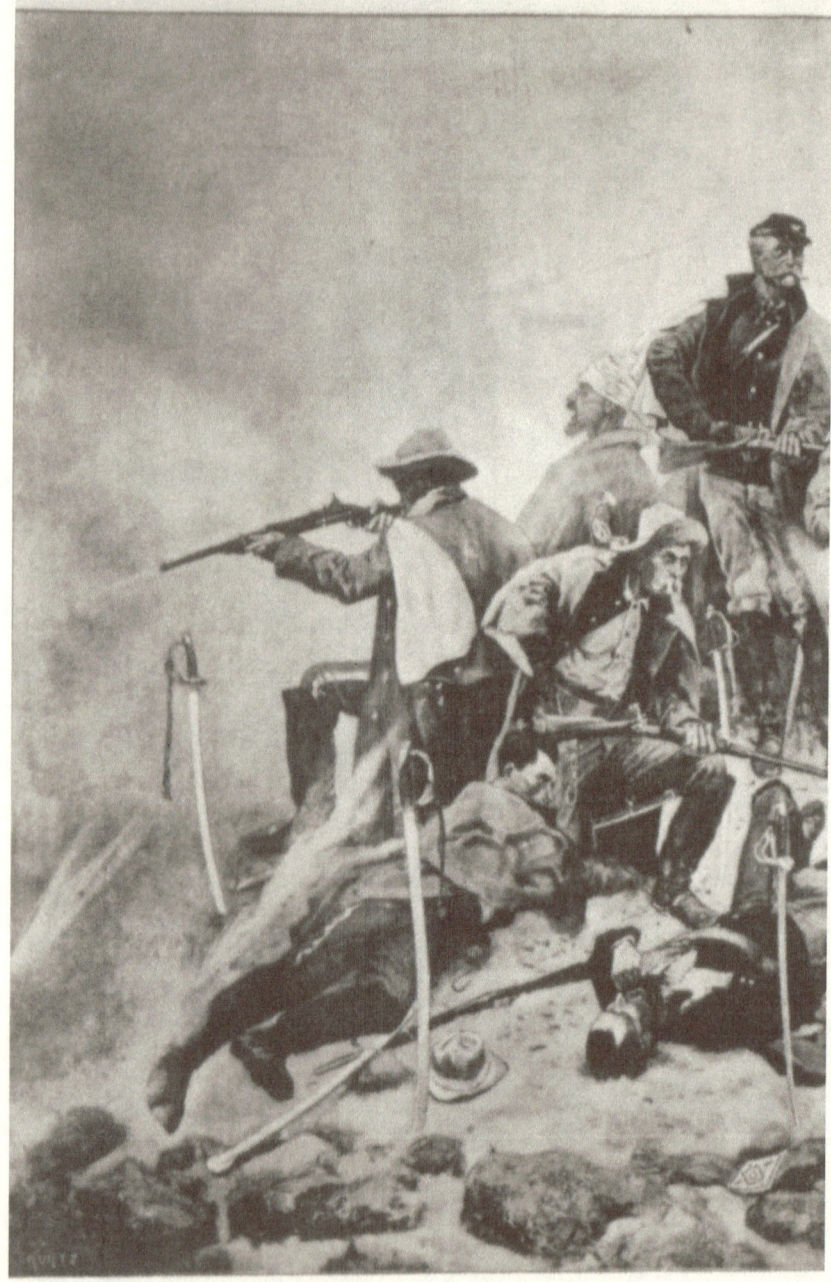

9. "The Last Stand." Custer and his men are represented as seen from the front, as is usual in the paintings and drawings made by Remington before Wounded Knee.

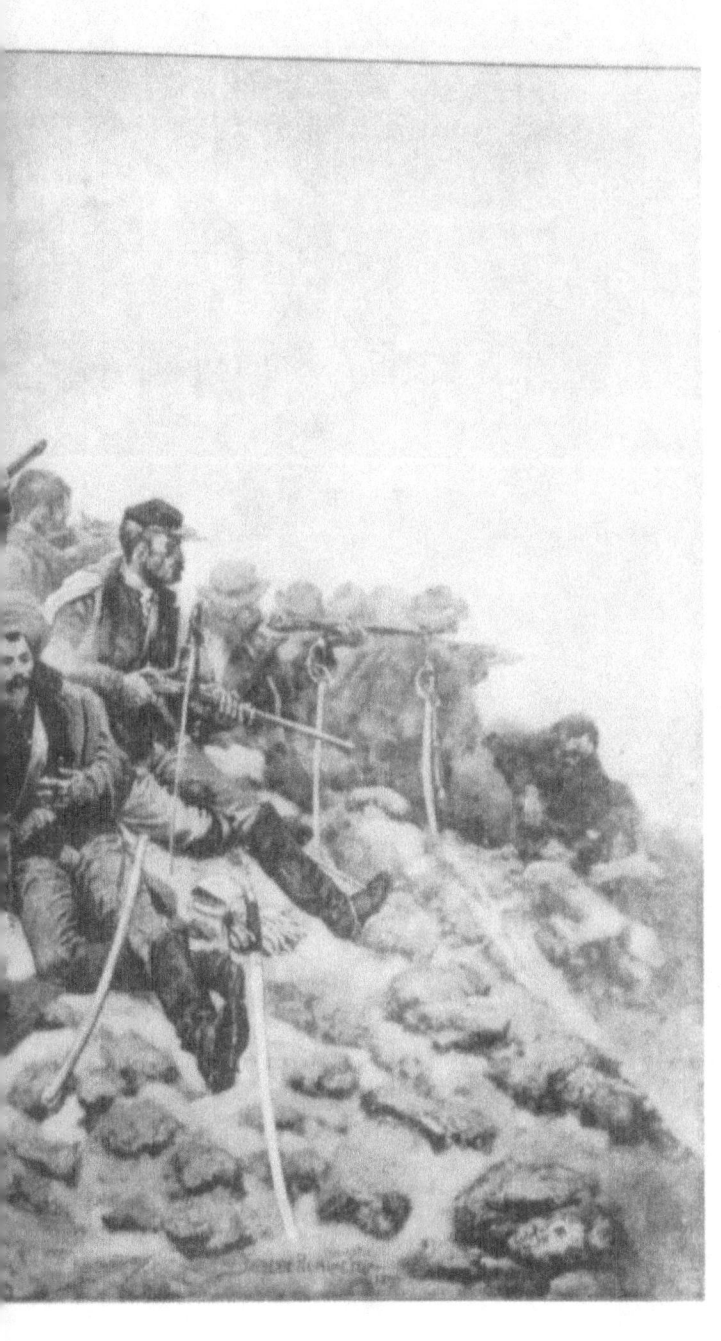

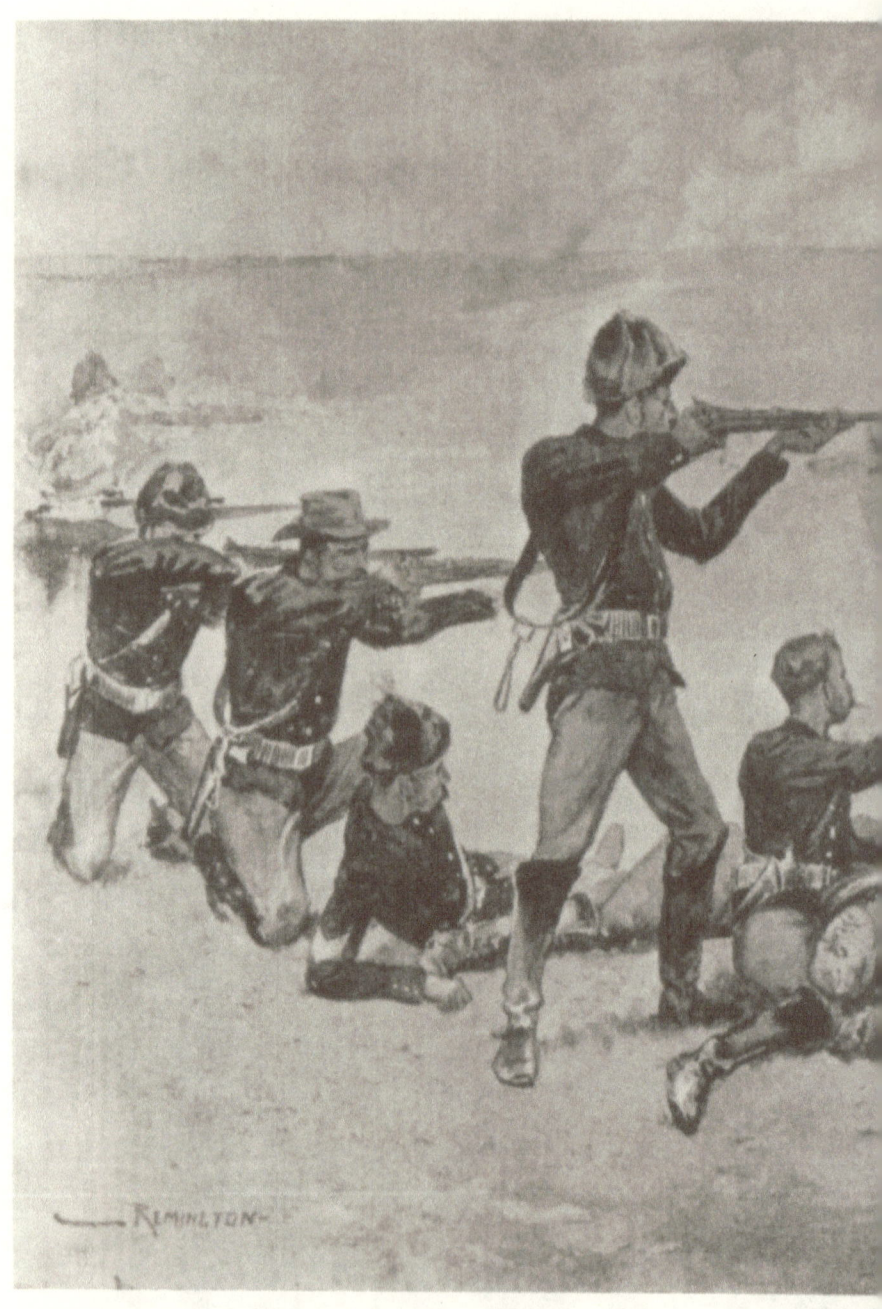

10. "The Opening of the Fight at Wounded Knee." The line of soldiers is represented as seen from the rear, a frequent occurrence in the works Remington produced just after Wounded Knee.

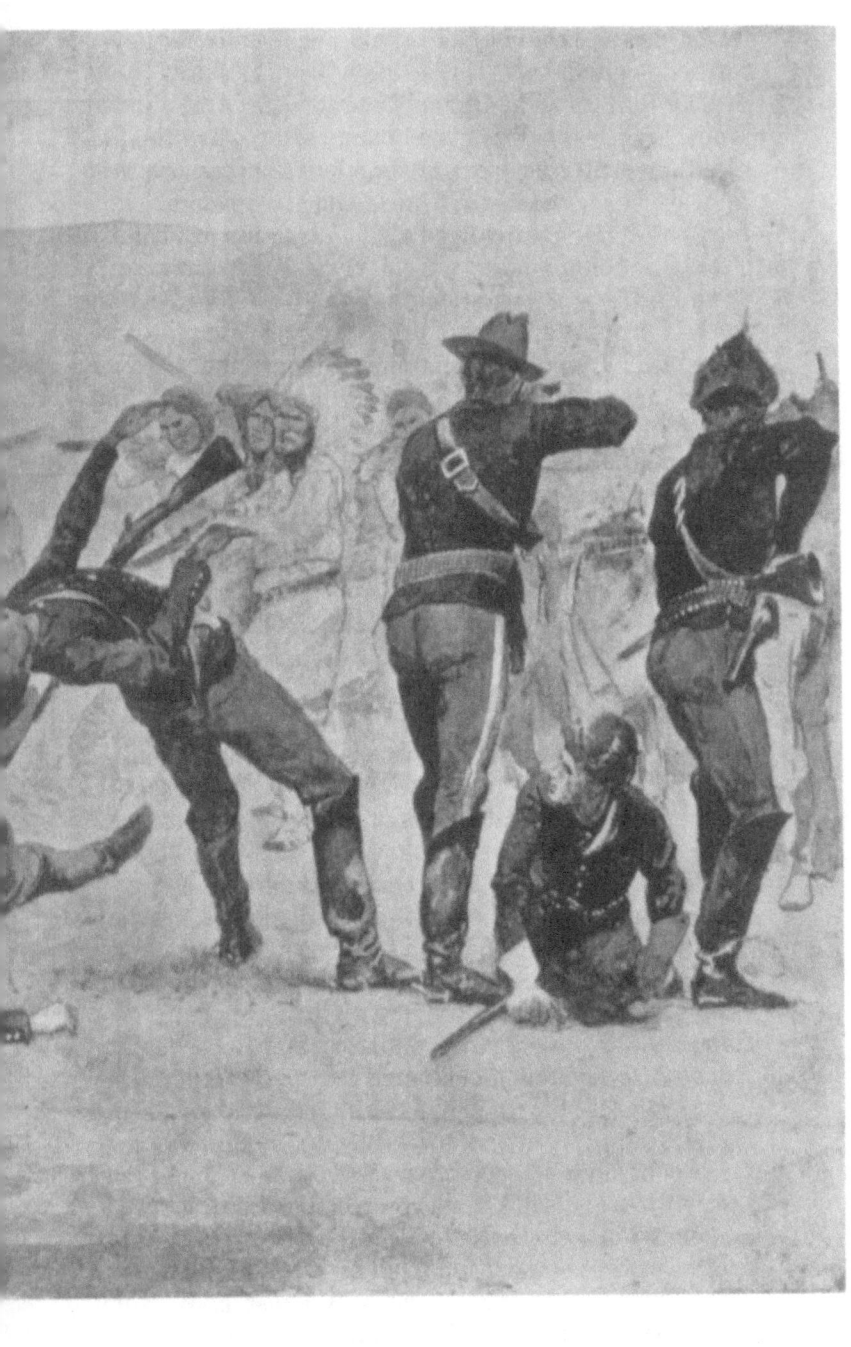

when viewed from outside the defensive circle they formed—which was also the view they presented to Sitting Bull. In "The Opening of the Fight at Wounded Knee," faceless troopers fell backward toward the palette they protected from Sitting Bull's successors, who appeared as a ghostly outline in the background. The new point of view involved a new direction of vision.

No title could modify the clearly stated meaning of "The Last Stand," and the question of whether Remington had produced it "from life," locating himself at some unlikely spot between the defenders and whoever it was that attacked them, was simply irrelevant—but the Wounded Knee picture was meaningless without its caption, and its content consisted exclusively of the sense that the artist who drew it had done so from the dangerous but plausible position of a point just behind the line of troopers. The difference between the two pictures was important because it identified the profuse diversity of conception and execution that was ultimately responsible for much of Remington's unevenness as an artist, prophetic because it augured Remington's new role.

From the beginning of his career, Remington had been an "illustrator" in the sense that his pictures were all thoroughly topical representations of specific actions. Indeed, even the sketches he made at Highland Military Academy in 1878 consisted exclusively of pieces that illustrated aspects of academy life, and he clearly intended to produce a sense of having been present at the scenes they represented. Later, his illustrated essays for *The Century* and his disjunctive participation in the *Harper's* picture history and Roosevelt's *Ranch Life* series demonstrated that pictures could reinforce a prose narrative by balancing literary continuity with graphic immediacy—even when pictures and prose contradicted each other. Yet, when he anchored himself to a spot that prose or circumstance dictated as a likely window onto the scene he represented, he lost control of the composition. Had his work been of the same order as that of men like A. B. Frost, E. W. Kemble, or Rufus Fairchild Zogbaum, the consequences might have been to fix him in the self-effacing role of staff artist. As it was, the peculiar verve of the pictures he produced had the effect of calling attention to the places from which the pictures were perceived and, ultimately, to himself. By abdicating authority over his

pictures, Remington entered them, and from the metamorphosis that took place at Wounded Knee emerged the figure of the artist as celebrity. Remington became a national figure simply by making pictures of himself for national magazines.

Yet Remington's new alliance with the makers and chroniclers of popular national attitudes was complex and decidedly conditional. On one hand, since 1885 magazines like *Harper's* and *The Century* had discovered that Remington's subjects and techniques, once regarded as lacking in refinement, attracted an indisputable interest from the genteel public. On the other, Remington had acquired experience, confidence, and facility as both writer and graphic artist since his earliest *Outing* pieces, and as a result he had a great deal more to offer than energetic, roughly executed sketches of uncouth subjects.

Remington's presence at the Pine Ridge reservation during the Wounded Knee massacre demonstrated the advantage of being in the right place at the right time. His manner of utilizing this advantage demonstrated the intensely personal bias of his work. Together, these two factors operated to designate him as a correspondent who sought the exotic and was sought because he treated the exotic with unique vigor. From now on, neither the accuracy of detail he usually achieved in his graphic works nor the wrongheadedness that often afflicted his writing mattered as much as the rigorous impressionism that informed both. Remington probably believed that, by faithfully drawing what he saw and honestly writing about what he thought, he was forging a record of events—and his publishers surely shared the same belief—but readers who followed his published work and regarded Remington the celebrity as its creator should have known implicitly what may have escaped Remington and his publishers altogether: the only event the works recorded was Remington.

For all its complexity, the event was continuous and, during 1891, its continuity was expressed in Remington's record by elements that recalled the continuum of the Ghost Dance, the affair of the supply wagon, and Lieutenant Casey's death, reflecting as they did so Remington's efforts to piece these experiential units into a pattern where both sequence and sequel could occur. As the process worked itself out, it became increasingly evident that the martial, the American, and the west-

ern—the three areas of Remington's most urgent concern—were acquiring chronologically sequential dimensions not previously associated with them in his work.

The first writing Remington did after returning from South Dakota in January dovetailed neatly with his last pictures of the Pine Ridge agency. In February, *Harper's Weekly* printed three drawings of "The Sioux War—Final Review of General Miles's Army at Pine Ridge"; in July, it printed Remington's account, with an accompanying drawing, of "General Miles's Review of the Mexican Army."[71] The Pine Ridge pictures showed units of cavalry, infantry, and artillery whose members wore heavy winter caps, overcoats with collars turned up against the cold, and whiskers that needed trimming. The picture with the Mexican account showed Miles and his staff impeccably groomed and decked out in full dress uniform, complete with glossy boots, gold braid, and epaulets. There was a contrast between the two spectacles, but Remington's account of the Mexican review identified the contrast only obliquely, for instead of comparing the American soldiers at Pine Ridge with the Mexican troops reviewed by Miles in May 1891—or even explicitly noting the change the latter occasion made in Miles' appearance—Remington insisted that the review at Pine Ridge and the inspection in Mexico were part of the same process. Of the officers and men in South Dakota, he had noted that they were gentlemen and soldiers, however much their hair might want cutting; of the Mexicans, he wondered how they would "act under fire" and concluded that, should they be confronted with an enemy, they would "fill that enemy with bullets and favorable opinions." In South Dakota, Remington had at last seen something that approximated war and, since the Sioux war was over, what dominated his work in prose and pictures was a military sequence.

This meant not only that he perceived the obvious difference between the way soldiers looked when they had been fighting and the way they looked when they were on parade, but also that he understood both appearances as subordinate to one governing impulse. In June, he observed the New York National Guard's Seventh Infantry Regiment—a unit famous for being composed exclusively of wealthy socialites from New York City—at its annual encampment near Peekskill,

71. "The Cavalry," "The Infantry," "The Hotchkiss Cannon," *Harper's Weekly*, February 7, 1891, pp. 108, 109, 112; "General Miles's Review of the Mexican Army," *Harper's Weekly*, July 4, 1891, pp. 494–495.

caustically remarking that the "militiaman's pride" was an "obsolete" matter of the "faultless line" interesting only to "women and children."[72] Although he apologized for stating "certain impressions of my own," the point he made concerning these impressions was clear and revealing. Remington liked the idea of a national guard and the actuality of the Seventh Infantry, because both reinforced the ideal of the citizen soldier. Yet he also felt that, because citizen soldiers often cherished traditions, they found accommodation to new ways of fighting difficult. New ways of fighting were made inevitable, he argued, by the dynamic imbalance between human capabilities and technological potentialities. As a consequence, technology and the human species played ceaselessly at military leapfrog.

Searching for something to explain this sequence, Remington saw not the figure of a Teutonic or Anglo-Saxon warrior which provided sufficient justification for many ideas of national and racial ascendancy but, rather, *man*, who proved by fighting not that he was ascendant but that he was atavistic. Remington supposed that "there will always be a small army of refined minds who are firm in the hope that because they do not like fighting, all other men will be of the same mind shortly," but he declared himself unable to discover "any difference between a modern man and a fellow of the stone age." He was willing, he said, to modify his stand "when the canine teeth in man become square and not pointed." Meanwhile, he suggested that—while weaponry and tactics existed to serve man—man, by virtue of his physical nature, existed to serve war. His attitude toward the gentlemanly Seventh Infantry was summed up in his observation that "they need a little killing."

The Seventh Infantry comprised what Remington called "military seed corn"—the best substitute for real warriors that a nation at peace could hope to possess. In declaring his wholehearted agreement with the maxim "you can't have soldiers without fighting," Remington stated the fear that overtook him after Wounded Knee: with the fighting finished, the soldiers who had done it might wither and, without soldiers to nurture it, the seed corn would surely spoil in the bin—an event which threatened to halt the military sequence.

Seven years afterward, Remington would respond with elation when the sequence seemed operative once

72. "A Day with the Seventh Regiment," *Harper's Weekly*, July 18, 1891, p. 536.

more, in the face of imminent war with Spain. Now, he clutched at straws to convince himself and others that units like the Seventh Infantry might soon have a chance for the killing he thought they needed. He may or may not have recalled that a superficial but operative association of his work with nationalistic pursuits and sentiments had rescued his earliest Arizona pictures from obscurity in 1886, allowing their publication as patriotic and grounding his own popularity on a solidly respectable base—but he does appear to have recognized that public awareness of some threat to the sequence of nationality might have the effect of bolstering the military sequence he felt was threatened by disuse. After his May 1891 excursion into Mexico and a side trip, taken on the way home, to Havana, he recalled that he had accompanied Julian Ralph along the Canadian border to Vancouver four years before. In early 1891, Ralph published "The Chinese Leak," an arid, statistical essay about illegal Chinese immigration from the north.[73] In November 1891, Remington welded Ralph's tame warnings with a recollection of his own to produce the remarkable document he called "Coolies Coaling a Ward Liner—Havana."[74]

Remington made full use in "Coolies" of the well-defined point of view that had emerged suddenly and with such peculiar force from the Sioux campaign in South Dakota, for the accompanying picture regarded its subjects from an elevation, effectively blotting out the coolies' eyes by means of shadows and hat brims and focusing on their stooped shoulders, bony arms, and misshapen bare feet. Likewise, the essay itself made much of Remington's actual presence at the scene the picture represented, identifying the steamer that took Remington into Havana Harbor as an emblem of the wealth and power that produced it, which granted those on it a lordly perspective. No magnanimity obtained, however, when the coolies, sent out aboard a coal barge to refuel the liner, hove in sight as a "most astonishing array of physiognomy" that blotted out Remington's awareness of the harbor, the ships, the coolies' colorful hand-me-down costumes—even the "rest of the world." Here, he thought, was an equivalent of "ten years' experience in the sketch class at the Art Students' League."

Remington applied an absurd catalog of analogies to the coolies but dismissed them all as inadequate because

73. "The Chinese Leak," *Harper's Monthly*, March 1891, pp. 515–525. Illustrated by Remington.
74. "Coolies Coaling a Ward Liner—Havana," *Harper's Weekly*, November 7, 1891, p. 877.

he thought the coolies a "new genus."[75] Bearing down hard on his reputation as observer, adventurer, and correspondent, he confessed that "I experienced every thrill, every shudder, every horrible emotion of which I am capable." The hollowest and yet most significant note of the whole incredible business was Remington's declaration that the coolies filled him with fear of the "terrible man—a thing which might taint my people; a thing which I knew that the political machinery of my country could not keep at a distance."

Less than a year before, Remington had bitterly complained that Americans were apathetic, misguided, and self-interested concerning vital matters related to Indian policy and the West. Now, he echoed Lieutenant John Bigelow's pious veneration for genteel tenderness, lumping the "people of America"—by which he presumably meant people more like those about him on the steamer at Havana than those who had attacked him in South Dakota—into an aggregate he called "clean, wholesome and industrious," confiding that they would surely "understand" his horror if only it were possible for him to tell them the "half dozen things which I cannot tell, because it would not be printed in a decent journal." Readers were thus left to fend wholly for themselves against the Yellow Peril and, while Remington may have intended to suggest that such a prospect was frightening, he succeeded even less than Lieutenant Bigelow had in his similar insinuation of five years before. Developing a point of view in South Dakota had suddenly left Remington staring, like Bigelow, into a void.

The "terrible man" Remington confronted at Havana was truly terrible because truly invisible, and Remington's desperate attempt to somehow fill the moral and perceptual vacuum left by Wounded Knee was expressed by naming the apparition a "new genus," for the designation prefigured his next application of his sequential theory—the attempt to discover a meaningful sequence associated with the region he later identified as "vacant land." In addition, it showed very clearly that the optimistic hypothesis Remington had begun to formulate as a counter to gentility ran aground every time it encountered the political bias Remington had earlier voiced by calling Indians a "hater of the United States."

From "The Captive Gaul" onward, Remington's

75. Ibid., p. 881.

work had shown a tendency to typify its subjects, noting the racial, occupational, and regional variations in, for example, the "types from Arizona" he drew for *Harper's Weekly* or the "horses of the plains" he executed in prose and pictures for *The Century*. In the wake of Wounded Knee, however, the typifying impulse suddenly acquired new force, bending Remington's work to new purposes. It was one thing to observe the distinctions between broncos and Indian ponies or to note that Cheyenne women as a rule looked more Caucasoid than their Apache counterparts, quite another to systematically set about the task of dividing the whole of experience into appropriate categories, drawing or otherwise describing the features by which these categories were distinguished, and then placing them in an album like a collection of butterflies. The former process involved projection, imagination, and judgment; the latter demanded accuracy, assumed that experience comprised a divisible continuum, and depended upon authority. Furthermore, when the last "new genus" was pinned neatly to the page and labeled, the process would be over. Stung by Wounded Knee into a new consciousness that judgment and imagination were dangerous, Remington began almost at once to subordinate confidence in his creative abilities to reliance on a reassuring multiplicity of subjects. The distressing result was that his subjects became specimens as soon as they were collected and generated a hectic search for new specimens that could end only by exhausting either Remington or the supply, whichever gave out first.

The three "western" projects Remington pursued in 1891 therefore all moved to the same cadence. In *The Century*, a series of essays by several authors concerning the development of the West marched steadily from John Frémont's California expedition of 1845 through the 1849 gold rush to the White River massacre of 1879, accompanied the whole way by a string of Remington's pictures, which emphasized chronological continuity by faithfully noting the changes in costume and appearance wrought by the decades covered by the narratives.[76] *Harper's Monthly* carried four of Colonel Theodore Dodge's "papers," aided immeasurably by Remington's pictures in designating the progression of equestrian types from buffalo-hunting plains Indians of the early nineteenth century to modern jockeys who

76. *The Century*, March 1891, June 1891, July 1891, September 1891, October 1891.

hurtled across a manicured suburban turf.[77] *Harper's Weekly* printed a serial novella by Howard Seely that chronicled the growth of a small Texas settlement from youthful lawlessness to middle-aged priggishness, punctuated with Remington's drawings stating both the growth and the rigor mortis it predicated.[78] All were not only sequential narratives but narratives *preoccupied* with sequence. All chronicled the replacement of old orders by newer ones, assuming that the newer ones would become old and be jostled aside in turn. Dodge, Seely, and the others who contributed segments of the chronicle stayed well within the boundary of the segment each contributed and, for readers who perused the segments as they appeared, the chronicle may have seemed diffuse. Yet for Remington—who welded the segments together with pictures—the chronicle was unitary, powerful, and personal. Each of the three projects that made up the chronicle showed how some aspect of the West had become obsolete. Seen whole, the chronicle itself stated only obsolescence.

Nearly all the pictures Remington made for this chronicle were conceived with vigor and executed with skill, and some made spectacular displays of the "painterly" erudition editors had missed in Remington's work at the outset. Indeed, a few outstanding pieces like "The Coup"[79] and "A Fantasy From the Pony War Dance"[80] even foreshadowed the burst of power that, some ten years later, would carry Remington's career to its uniquely arresting conclusion, following the artist's discovery of what it meant to be his own subject. Unfortunately, however, these were striking exceptions to the malaise that afflicted the chronicle's totality. Unquestionably attractive though they were, works like "An Indian Trapper," "A Mexican Vaquero," and "United States Cavalryman" had a posed appearance, as though the subjects had reluctantly consented to sit for portraits not of themselves but of some demographic category to which they belonged.[81] Statuesque, isolated, even splendid, they thus abandoned angularity and individuality for the sake of being cleaned up and made to look like representatives at an equestrian congress or participants in a historical pageant. Being represented as typical prevented them from being specific, and the point of view that had captured Remington at Pine Ridge subtly operated to suggest that they were no

77. "Some American Riders," *Harper's Monthly*, May 1891, June 1891, July 1891, August 1891.
78. "The Jonah of Lucky Valley," *Harper's Weekly*, October 3, 1891; October 10, 1891; October 17, 1891; October 24, 1891.
79. "An Old-Time Northern Plains Indian—The Coup," *Harper's Monthly*, May 1891, p. 851.
80. "A Fantasy From the Pony War Dance," *Harper's Monthly*, December 1891, p. 39.
81. "An Indian Trapper," *Harper's Monthly*, May 1891, p. 855; "A Mexican Vaquero," *Harper's Monthly*, July 1891, p. 209; "United States Cavalryman," *Harper's Monthly*, June 1891, p. 5.

longer so relevant as the Oriental coalmen who had inspired Remington to nonsense at Havana Harbor. In a word, they were passé.

Remington's technique was not at fault, for it had made remarkable advances since the low-intensity sketches made in Arizona gave Poultney Bigelow a sense of the "real thing." What damned the subjects was precisely their identity as subjects—as though Remington, abandoning his pursuit of the *real* thing, had perversely chosen to paint the *wrong* thing. In Arizona, he had sketched energy, which for him was the *right* thing, in crude but expressive outlines; after Wounded Knee, he drew and painted nostalgia, and the union between an increased technical ability and a diminished level of perception made a formula for sentimentality. One way of diagnosing the difficulty might be to say that the "spirit" had departed from his pictures for, while his technical achievements were sufficient to make a number of the individual pieces valuable, all the pieces together betrayed a lack of enthusiasm that amounted to tiredness.

The main difference between "The Patient Pack-Mule"—done in 1891 for John Bourke's "General Crook in the Indian Country"—and "Saddling a Pack Mule" —done in 1885 for Bigelow's diary—was that the troopers in one picture were white; those in the other, black. Either "Lieut. Ross's Attack," for Bourke's essay, or "Long-Tom Rifles on the Skirmish Line," for "General Miles's Indian Campaign" by G. W. Baird, could have been substituted for "The Opening of the Fight at Wounded Knee." While "The Indian Method of Breaking a Horse"—for Colonel Dodge's third "American Riders" paper—had glamor, it also had the same taut lariat, more frayed and less effective, that had stretched across several of the *Ranch Life* pictures. "Captain Dodge's Colored Troopers to the Rescue," for E. V. Sumner's "Besieged by the Utes," hardly differed from pictures Remington had made in South Dakota, and the "Utes" essay closed with Remington's double-page drawing of a cavalry column identical with the picture that had closed the final installment of "After Geronimo." Likewise, no attempt whatever was made to disguise the "Gentleman Rider in Central Park," one of Dodge's "American Riders," or the "Ladrone" who slouched in A. C. Ferris' "Through California to Mex-

ico," although both had appeared in Remington's 1889 "Horses of the Plains."

As usual, Remington blamed his subject, which he thought was the West, rather than himself, assuming that, because it had taken only ten years for his treatment of the West to become redundant, the West itself had been exhausted as a focus for his work. His editors may well have been partly responsible for both Remington's attitude and the redundancy attendant on it, for their policy regarding western subjects was founded on redundancy and executed in pursuit of a single formula that grew rapidly stale. *Harper's Weekly*, *Harper's Monthly*, and *The Century* all derived their interest in the West from the series of convulsions that ended at Wounded Knee in 1890. Even Roosevelt's *Ranch Life*—which claimed that Indian fights and brawling cowboys were less significant than hard work at a cattle roundup or the political promise of a cattlemen's association meeting—regarded the cowboy as a warrior, the hunter as a marksman, and the ranch itself as an outpost against the weather, Indians, and outlaws —and, however alien much of Roosevelt's thinking was to Remington, Remington agreed that the West was yoked to violent conflict, insisting in his *Century* essays that Indians were "natural" cavalry, broncos untrained war horses.

So long as Apache wars and Sioux uprisings remained plausible, such views appeared to contain an element of truth, because spectacular events like Custer's stand at Little Big Horn could still be used to justify them—but the Ghost Dance, the death of Sitting Bull, and the rapid-fire cannon used against the Sioux in South Dakota rendered Little Big Horn as stale as yesterday's news and instantly blurred the image of the West as an arena of heroic conflict.

Along with the blurring went a drastic shrinkage that effectively robbed the West of its geographical dimension and reduced its chronological extent to a truncated millennium between the California gold rush and Wovoka's revelation—two apocalyptic events that together stated the initiating impulse and catastrophic conclusion of what Roosevelt appropriately called the border. As the idea of vacant land became less compelling, the idea of the West as a place faded in the popular imagination and, as the West lost its identity as a

place, it acquired increasingly specific boundaries in time, becoming less and less a continuing event, more and more an episode of history. *Harper's Weekly* thus proceeded from its 1891 treatment of the Wounded Knee battle to an 1892 serial publication of *The West from a Car Window*, by Richard Harding Davis, and then gave up the West altogether, except when something that constituted a "current live topic" happened there.[82] After Julian Ralph's essays on the Canadian frontier ended in 1892, *Harper's Monthly* likewise looked westward only now and then, except when it could use the West as fiction—as it began to do in 1892 with regular publication of Owen Wister's cowboy stories.[83] *The Century* took a final excursion to Montana in 1892 with E. S. Godfrey's essay "Custer's Last Battle"; it found the prospect so uninviting that it did not return in earnest until 1901, when it began a repetition of the cycle by printing Emerson Hough's *The Settlement of the West*.[84] Once it was decided that the West was an episode of history, and that as such it had clearly delimited chronological boundaries, the episode of the West could either be left behind or retold.

That no other alternatives seemed possible for Remington was shown by his last published work of 1891, a picture and brief essay entitled "Merry Christmas in a Sibley Tepee," printed by *Harper's Weekly* on December 5.[85] The picture showed nine pleasantly tipsy officers gathered with Remington about an army tent's stove. While others proposed a toast, one of the officers poured whisky punch into Remington's tin cup from a coffeepot. Clearly, the scene was derived from Remington's sojourn of the year before in South Dakota, and the man who held the coffeepot was Lieutenant William Casey. The event was far more distant than might be suggested by the mere passage of the months between its occurrence and the picture's publication, but the picture would still do for a Christmas card and, while the first sentence of Remington's accompanying essay may have made one of the toasts about the camp stove in 1890, it surely made part of Remington's thinking at the end of 1891. It also lucidly articulated a sequence that touched each of the areas of Remington's interest and therefore constituted a concise statement of where the strategy of sequence would certainly lead: "Eat, drink and be merry, for tomorrow we die."

82. "West from a Car Window," *Harper's Weekly*, March 5, 1892; March 26, 1892; April 9, 1892; April 23, 1892; April 30, 1892; May 14, 1892; May 28, 1892.
83. "Hank's Woman," Wister's first published western story, appeared in the August 1892 number, initiating a pattern that continued for more than a decade.
84. Beginning in November 1901, Hough's essay ran into the next year, bearing some of Remington's most political illustrations.
85. "Merry Christmas in a Sibley Tepee," *Harper's Weekly*, December 5, 1891, p. 973.

4. Transient

For Lieutenant Casey, the death toasted in the Sibley tepee had meant the end of life. For Remington, it meant the end both of the West he had entered at nineteen and of the tribe he had founded there some five years afterward—as well as the beginning of his search for something else. Instead of losing his identity by the event, Remington therefore acquired a new one, a postmillennial selfhood more suited to his age and to the postmillennial spirit of the 1890s than his earlier self-imposed role as desperado had been to either his first youth or to the years that youth occupied.

By the beginning of 1892, far from serving him as hope, Remington's belief that the worst was over at Wounded Knee had rendered him hopeless, and the artist's pursuit during the next two years of his sequential strategy might have been ruinous had it not been for one thing: Remington's involvement in the massacre at Wounded Knee had had the effect of calling his attention to himself as subject, and the new strategy he began to develop immediately after Wounded Knee revealed nothing more clearly than the sequence of changes undergone by Remington. Whether or not Remington intended it to do so—as he probably did not —the strategy of sequence was informed by a sub-

merged but luminous and persistent enthusiasm for the discovery of self.

The roles of desperado and celebrity Remington had assigned himself thus became suspect as he began to test them. Using rewards earned by the desperado, the celebrity left New York City and bought a large, comfortable house overlooking Long Island Sound at the suburban town of New Rochelle. The restlessness that had carried the former figure in and out of Peabody, Kansas City, and scores of western settlements and military bases seemed likely to be dispelled by the latter's acquisition of something so substantial as a residence, complete with grounds and a studio—indeed, trips to the West were for a time supplanted by fishing and hunting expeditions into the Adirondacks, where Remington spun yarns with North Country friends from his boyhood days. Yet the placid alternation between suburban gentility and genteel rusticity could not survive for long. By June 1892, Remington was in St. Petersburg, waiting for permission from the czar of Russia to make a canoe trip along the Baltic coast to Berlin. The new identity thus flamboyantly advanced as a substitute for the now questionable identities of desperado and celebrity was that of *seeker*.

Remington's presence at the Russian capital expressed his new identity in two ways. First, it was an official presence, ballasted with a "special passport" signed by Secretary of State James G. Blaine and decked out with the letters of introduction, protocols, and other apparatus attendant on officialdom. Second, it was the altogether personal presence of an artist who doubted his creative powers and thus sought exotic subjects he hoped might confirm his identity as an artist without challenging his ability to create. The former presence was a sign of the degree to which Remington seems to have caved in to gentility. The latter was evidence of his determination to identify and record that which he increasingly referred to as "new."

The Russian trip's planning had begun early in the year, when Poultney Bigelow—having left the editorship of *Outing* for the more exciting vocation of world traveler—wrote Remington at New Rochelle with a scheme for making a tour of Europe and North Africa, financed by the house of Harper, for the principal purpose of producing a series of illustrated essays with a military focus. Colorful desert tribesmen, Russian Cos-

sacks, German hussars, and whatever other types of the military animal that might turn up would, he thought, add pages to the album Remington had begun to fill with types from Arizona—which by then had been enriched by types from the Orient as well as Canada, Texas, New Mexico, South Dakota, the North Country, and elsewhere. On January 11, Remington wrote back that he agreed.[86] So long as Harper's furnished the money and promised to print the results, he was willing to begin the search for a new tribe.

By the end of March, the compact was complete. In addition to the commercial sanction of a publishing house, Bigelow had managed a contract with the U.S. government, which commissioned him and Remington to make a report on methods used in Russia and Germany to check erosion along their northern coastlines—thought to resemble sandy regions of Long Island and New Jersey. Bigelow's letters to European officials styled Remington the "first artist of America," a designation which would seem to secure both his respectability and his talent,[87] and the documents the two travelers carried called on all concerned to permit the bearer to "pass *freely* without let or molestation and to extend to him all such friendly aid and protection as would be extended to like citizens of foreign governments resorting to the United States." In addition, the two bore guidebooks, firearms, art supplies, and clothing for all weathers. Crowning their equipage and proclaiming their nationality were two specially built, expensively crated cruising canoes, each proudly emblazoned with the pennant of the New York Canoe Club.

All this, of course, was decidedly and rather unpleasantly official, but the personal side of the enterprise powerfully asserted itself in Algeria, where Remington and Bigelow were surprised to meet an Arab chief who had never heard of America, although the region where they met him reminded Bigelow of Colorado and seemed to Remington "Arizona all over again." This refreshing perspective allowed Remington to make pictures with a vigor that had not been present in his work for years. "A Revolver Charge" of Arab tribesmen captured the sense of being set free from subjects that demanded his justification and afflicted him with guilt. Two Turcos, Arab irregular troops in the French Algerian forces, had all the promise of the Cheyenne scouts he had drawn at Fort Keough but required none

86. See Manley, p. 24.
87. Poultney Bigelow, "Why We Left Russia," *Harper's Monthly*, January 1893, p. 300.

of the recrimination. Indeed, Remington's opinions about the American West, regarded with suspicion by many in the United States, were more frequently vindicated in French Africa than they had ever been at home. In the landscape that resembled Arizona, there were French military bases analogous to the outposts at Fort Thomas and Fort Grant, and among the men of these outposts were officers anxious to demonstrate the skill of native soldiers, whom they thought of as corresponding to the Indian corps they had heard of in America.

Having put his Arab troops through an impressive exhibition of mounted drill, a French officer even told Remington that "you would have equally good results with your North American Indians if you treated them as justly as we do our Arabs,"[88] and Remington began to feel that, insofar as North Africa released him from patriotic nationality and allowed a more universal application of his perception of energy, it was indeed analogous to Arizona. Once more he began to see his subjects from whatever angle he chose and to represent his perception rather than his allegiance. Although the pictures he made in Algeria were for the most part "typical" in the same sense as his military studies of the year before had been, they contained a verve and a style that identified them as types newly encountered, escaping the photographic by virtue of the excitement they expressed. Being freed from all the icons that demanded his veneration in America allowed Remington to use his eyes again in Africa. The result was a burst of enthusiasm like that which had carried him west to start his tribe in 1885.

The enthusiasm lasted for about a month, while Bigelow and Remington traveled out of Africa and north across Europe to Berlin. It began to fade as the pictures of Arab tribesmen gave way to studies of German officers consuming luncheons and pacing among businessmen and young ladies on tree-lined avenues. Remington's Berlin sketches were interesting as observation and decidedly humorous as comment but reverted rather sadly to enervation. Nearly all the soldiers they depicted wore the same elaborate moustache and the same opaque pince-nez affixed to Teutonic features that varied but little among individuals. Like so many mannequins, they were distinguished principally by the clothes they wore and by the peculiar shapes of their

88. Poultney Bigelow, "French Fighters in Africa," *Harper's Monthly*, February 1895, p. 372.

11. *"Drawing of a German Officer." Remington's pictures of German soldiers, unlike his pictures of frontier types, are characterized by attention to the niceties of dress uniforms and formal postures.*

legs, arms, paunches, and torsos.[89] Part of the reason was doubtless that the German soldiers presented to Remington exactly what Remington drew—a hard surface of polished brass, colorful fabrics, and glossy leather—part, that they appeared to Remington less as individuals than as elements in a pattern of political maneuvering that threatened to require his alignment with one of its several participants against the rest. Dining with a cavalry captain whose main business was espionage against the Russians, he was regaled with exciting tales that demonstrated German cleverness and daring. Another officer explained the superiority of German uniforms; yet a third, the advantages of combining a rigid code of discipline with a strictly democratic system of military justice. None explicitly compelled Remington to take up the German cause, but all implied that the German cause was distinctly preferable to any other, especially the Russian. With the line of riflemen he drew from behind at Wounded Knee replaced by what Bigelow called the "border land of Czar and Kaiser," Remington found himself locked as firmly as ever into a pattern that could not be seen except from one side or the other. Consequently, his sketchbook again turned into a photograph album of officialdom, and Bigelow appropriately called the illustrated essay that recorded the Berlin episode "Sidelights on the German Soldier."

The illumination on the other side of the frontier was no more satisfactory, with the result that Remington called Russia the "sad gray land" and drew it accordingly.[90] He and Bigelow crossed the border into Poland at Posen and were immediately confronted by two officers of the Russian "third section," or political police, who closely compared them with the pictures on their passports. At Warsaw, they encountered another Russian functionary, who burst uninvited into their hotel room, questioned them, and at last offered to act as their guide. Remington wanted to return to Germany instantly, but Bigelow, who remained confident in the protective powers of his special passport, urged persistence. While in Paris, he had met a wealthy Polish aristocrat, since returned home to Warsaw, who wanted to talk with him further. Taking the reluctant Remington in tow, he now proceeded to arrange the interview. It was necessary to communicate with the Pole through an intermediary, who told Remington and Bigelow that

89. Poultney Bigelow, "Sidelights on the German Soldier," *Harper's Monthly*, July 1893, pp. 213–232.
90. Poultney Bigelow, "In the Barracks of the Czar," *Harper's Monthly*, April 1893, pp. 771–785.

they must enter a certain nearby café at "exactly 3:50" that afternoon, also warning them that, when their Polish friend joined them "five minutes later," they were to take every care to make the meeting look accidental.

Followed by the same spy who had offered to act as their guide, the Americans kept the appointment and tried their best to preserve the illusion that no appointment had been made. The Pole, to whom Bigelow gave the name of Zerowski, arrived on schedule, delivered a warning that two secret service agents were watching and listening, and whispered an aggrieved account of Polish suffering at the hands of an oppressive Russian government while Remington—whom Bigelow thought had preternaturally "quickened" his senses by "mixing paint among the huts of Cheyennes and Apaches"— kicked Bigelow under the table whenever the Russian spies seemed to take notice. Remington's picture of the event showed the spies in the background, Bigelow and Zerowski in the foreground, and a vacuum where the artist should have been, for Remington neither placed himself in the picture—as he had on several occasions at Pine Ridge—nor left himself out of it—as he had at Little Big Horn and in Algeria. Instead, he placed his *absence* there. At the picture's center was Remington's empty chair, with Remington's untasted drink before it on the table.[91]

While this curious device was an intensification of photographic technique, stating the photographer's presence behind the camera by his explicit absence from the photograph, it also identified as a major feature of such a technique its power to dissociate the illustrator from his subjects. By setting up his palette between Custer and Sitting Bull Remington had achieved a sense of excitement, and by drawing Wounded Knee from behind a line of Seventh Cavalry riflemen he had stated both presence and patriotism, but by putting a camera between himself and the various schemers who sat in a Warsaw café he achieved only a dubious protection. The last resort of objectivity was not invisibility but self-effacement.

On the evening after their café rendezvous, Remington and Bigelow set out for St. Petersburg and the Baltic coast, taking time along the way to stop at a military base near Moscow, where one of Bigelow's acquaintances commanded a regiment of Russian infan-

91. "In the Cafe Tomboff," in "Why We Left Russia," p. 297.

try. The acquaintance happened to be a Pole who, despite his nationality, had managed to reach the rank of colonel. His troops, however, were thoroughly Russian, and he readily acknowledged their shortcomings, admitting that they were illiterate and consequently difficult to train, except in the performance of routine duties. Partly because of this imperfection, and partly because of what Remington called their "sporting blood," he represented the Russian soldiers more sympathetically than he had their German counterparts. He was refreshed by their rangy appearance, which reminded him of frontier troops in the United States, and found their ability to feed themselves by foraging for wild game wholly preferable to the German habit of requisitioning supplies from farms and taverns. Except for the shape of their caps, many of the infantrymen Remington drew at the camp near Moscow might have passed for members of Nelson Miles' command in South Dakota.

Remington's enthusiasm for them was thus both pronounced and ambivalent. As frontiersmen, they recalled the excitement of his own early experiences in the American West. As sojourners in a sad gray land that Remington could not bring himself to compare with Arizona or Montana, and as participants in a rigid process of regimentation that had little in common with the democracy he had witnessed at Fort Thomas and Fort Grant, they depressed him. His pictures of them were vigorous without being animated, bearing more resemblance to "The Captive Gaul" than to "The Last Stand."[92] If Remington had still truly believed in his tribe, he might have recognized a kinship between himself and the men who, as Bigelow put it, had "lost the power of thinking consecutively." As it was, he preferred the thoroughly sequential order expressed by the literate Germans, even though the Russians appealed to his senses by means of the same eccentricity expressed by Indians on the American plains or Arab horsemen in Algeria. While the pictures he drew of the Germans expressed his reluctant admiration of military efficiency, those he drew of the Russians were, for the most part, condescending.

The single exception was the figure of the Cossack, whom Bigelow significantly styled "cowboy, soldier, and citizen" and whom Remington drew with all the energy that pervaded his best treatments of subjects

92. "Advance of Russian Infantry," "Dragoons, Mount!" "A Bold Dragoon," "One of the Czar's Body-Guard," "Cossacks Scouting," "Shoeing Cossack Horses," "The Soldier's Song," "A Hair-Cut in a Cavalry Stable," "Kuban Cossack, Imperial Guard Corps," "The Russian Military Gendarme," "One of the Czar's Pirates," in "In the Barracks of the Czar."

12. "The Blue-China Cossack." The types Remington found in the borderlands of Russia bear a strong visual resemblance to the types he had earlier found in the American West.

that most appealed to him.[93] Like the soldiers he had drawn in Arizona, the Cossacks all wore perpetual squints and, unlike either the meticulously proper Germans or the usually abject Russians, they always made parts of compositions arranged to express emphatic kinesis. The "Cossack of the Guard" sat lightly on a mount poised for action; the "Blue-China Cossack" leaped outward toward some imperative intent; "Cossacks of the Amoor" paused briefly during an urgent journey; and so on. Although all were clearly types, they avoided being specimens in the same sense that the German officers drawn at Berlin had been, for they fit the paradigm of marginality Remington had sought in Montana, briefly found in Arizona, and lost at Wounded Knee. That is, they appealed not to the ascendant celebrity Bigelow called "first artist of America" but to the submerged seeker who did not yet understand that what attracted him to the "new" was a tantalizing transiency that invited his art. The key to understanding the vitality in Remington's pictures of the Cossacks lay in Bigelow's remark that they were "doomed to disappear . . . as irresistibly as the cowboy and the Indian."[94] The urgency they held for Remington derived from the perch they occupied at the edge of obsolescence.

Bigelow's friend at the infantry camp near Moscow observed that Kuban Cossacks looked as though they had "just come from some butchering expedition in Central Asia," and Bigelow said of himself and Remington that, "between nihilists and Amoor Cossacks, we preferred the nihilists." That such savages should be assigned to guard the czar's palace in St. Petersburg he thought so incongruous that its like in the United States could only be achieved if a president appointed a "band of Apaches" to guard the White House. Yet when he compared the Cossacks with cowboys he also supposed that, if there were any reason to anticipate a large-scale war within the United States, the government might "artificially arrest the disappearance of the cowboys" in order to enrich the military structure with "regiments of cowboy cavalry."[95]

As Indian, the Cossack seemed to Bigelow anomalous because he occupied a region just *beyond* the frontier of the state—the same functional outer darkness Roosevelt saw as an invitation for the "onward march of our people." As cowboy, the Cossack pressed the

93. Poultney Bigelow, "Cossack As Cowboy, Soldier, and Citizen," *Harper's Monthly*, November 1894, pp. 921–936.
94. Ibid., p. 921.
95. "Why We Left Russia," p. 293.

frontier outward toward geographical and chronological boundaries that augured stages in the growth of the state as well as the end of the Cossacks. Throughout Bigelow's discourse, a commitment to utility prevented him from ever imagining that time constituted anything but a measure of irresistible linear progress. When the "next great war," which Bigelow assumed must lie somewhere along the vector of such progress, arrived, the Cossacks—having achieved the limits of their usefulness—would be officially obsolete. Remington, on the other hand, drew the Cossacks as a vigorous exception to Russian dreariness and German formality because whatever sequence might engulf the Cossacks still, at the moment of his perception, left them a unique identity.

The exhilarating freedom Remington sensed in the Cossacks intensified the unpleasant shock he experienced immediately afterward for, on June 6, he and Bigelow encountered a swamp of opaque formality that threatened to sink them just as surely as the colorful Cossacks had promised to buoy them up. A week before, Bigelow had mailed a letter to the American embassy in St. Petersburg, advising the ambassador of the mandate he and Remington had from Washington and requesting aid in obtaining the necessary permission for their planned canoe trip down the Baltic coast. Confident that the ambassador had routed their request through official channels, and mindful of Zerowski's warning about police spies, they therefore went to the American embassy as soon as they had deposited their luggage at a hotel. The American chargé, however, received his countrymen with distinct coolness. Remington's title of first artist did not impress him, and he was not afraid of being criticized by Bigelow in *Harper's Monthly*. Furthermore, he had received the letter Bigelow sent the week before from Paris but had not taken any action concerning it and intended to take none. Asked by an outraged Bigelow why he had not seen fit to make a request to Russian officials for the planned canoe trip, he replied that "diplomatic usage" prevented him. Remington, wrote Bigelow later, "looked ready for a fight," and Bigelow—sensing the failure of his name, his title, his mission, or his argument to impress the chargé—resorted to the signature of James G. Blaine, producing with appropriate fanfare the special passports and other official papers that

had served during the whole of the journey up from Africa to exact the respect of whomever saw them. In the chargé's parlor at St. Petersburg, such documents were impotent. The chargé casually leafed through them and remarked that they were "lacking in diplomatic form."

Three days later, after a brief but frightening dispute with customs officers, the two Americans departed for Berlin. Their route took them by rail to Kovno on the east bank of the Niemen River, then down the Niemen by steamboat to the point where it crossed the German border near Tilsit. During the first part of the journey, one of Bigelow's Russian friends told them that the permission they had been waiting for would never arrive and that, if they persisted in seeking it, their death would be quietly arranged by the government. Remington and Bigelow, he noted, should not be surprised by such a procedure, because the Russians had merely copied it from the American lynch law.

Feeling more apprehensive than ever, and possibly even a little chastened, the Americans began the second leg of their journey by boarding a small steamboat, where garrulous Bigelow soon made friends with a Russian passenger and Remington lounged about the deck with a sketch pad. Since the personal seemed for the moment less perilous than the official, Bigelow assured everyone who would listen that "we were merely American tourists visiting [this] beautiful country in search of the picturesque."[96]

Yet they soon discovered that even the picturesque was denied them. Bigelow's Russian friend noted Remington's sketch pad with alarm, pointing out that two Russian officers were watching the artist suspiciously. Without a protest, Remington packed his sketches in a suitcase and spent the rest of the journey trying not to look at anything. The experience was a peculiarly lucid demonstration of how freezing the artist's angle of vision diminished the artist's ability to see for, as Bigelow's friend observed, the secret police made "no distinction between sketching a peasant's nose and pacing off a fort front" and, while Remington later took revenge on the police by sketching his impression of them, he could not escape the consequence of having had his vocation confiscated. The Arab Turcos and wild Cossacks still rode across the pages of his sketchbook

96. Ibid., p. 310.

and still kept a grace that could be sensed by others, but for Remington himself they were retrospectively clouded. Consequently, he turned his back on them and the freedom from allegiance they represented. "I'm going to do America," he shortly afterward declared, "it's new."[97]

Like Mark Twain, Henry James, and other prominent Americans who made America their subject in the nineties, Remington appears to have credited the notion that, because the continent harbored a "young" nation, it would provide "new" models of experience for art. Yet, just as Huck Finn, Lambert Strether, and others repeatedly discovered that youth was the most ancient of all possible subjects, Remington belied his search for "new" experience when he turned westward again from Russia in 1892. In June, discouraged by the frustration and fear of his experience at St. Petersburg, he accompanied a crestfallen Bigelow on a brief visit to the kaiser's hunting lodge and breeding stables at Trakhenen, near Konigsberg, in eastern Prussia. Then, he left Bigelow in Germany and made his way alone to England, where he saw Buffalo Bill's Wild West Show at London and watched British soldiers execute training maneuvers at Aldershot.

Of the Aldershot maneuvers, he remarked that "miserable machinating staff and ordnance officers and inventors" had ruined the art of war by introducing the "pitiless, all penetrating, rapid-firing rifle."[98] Similarly, the Wild West Show assembled on a single stage most of the types, including even Cossacks, Remington had ranged far to discover, eliciting his half-ironic comment that journeys to "the deserts of Texas or the rugged uplands of Wyoming" had been rendered unnecessary by the simple expedient of transporting people who had lived in such places to an arena where they could be observed by anyone who paid the price of admission.[99] Both the exhibition of military technique by the modern British army and the performance of William Cody's collection of human relics, gathered in odd corners of the world and preserved as carefully as possible against the ravages of time, reflected Remington's latest predicament. In 1881, the artist had begun a quest for "new" experience that had captured the public attention only when it was rendered lurid by violence or romantic by distance. Since his quest had

97. Remington, quoted in McCracken, p. 76.
98. "Military Athletics at Aldershot," *Harper's Weekly*, September 10, 1892, p. 882.
99. "Buffalo Bill in London," *Harper's Weekly*, September 3, 1892, p. 847.

prepared him for youth rather than for currency, he now found both modern Europe and modern America unpleasant and impenetrable.

Remington returned to New Rochelle in time to see the September publication of his Aldershot and London sketches, which were followed two months afterward by a page of British and European military studies.[100] Except for the pictures he made for Bigelow's essays, which continued into 1895, and six grisly illustrations for an 1893 article written by Henry Stanley about the African slave trade, he left the ill-fated expedition behind him.[101] Bigelow styled the episode a "railway canoe cruise" and took inventory of its "net results" as "a wasted month, an empty pocket, a smashed canoe."[102] By not pursuing the matter of Africa and Europe further, Remington agreed that the expedition had failed, and the pictures he made to record it for the most part expressed the same quality that caused him to call one group of them "idle notes." Having gone to Montana at nineteen in search of energy and to Russia at thirty in search of currency, Remington surely sensed the poetic justice of now packing his tackle and going fishing at Cranberry Lake, near Canton. The energy he had found in Montana seemed wholly absent from the Wild West Show he had seen in England; the fashionable newness he had sought in Russia made what editors of the *Harper's* picture history had earlier called a "current live topic" but failed utterly to stimulate the seeker's imagination as Fort Thomas and Fort Grant—no longer current in the wake of Wounded Knee—had once done. Clearly, the only meaningful continuity between Montana and the Wild West Show and between Arizona and Russia was that provided by the artist as seeker. Since Remington did not yet realize that the energy and currency he sought derived their significance as art entirely from himself, however, his search seemed, for the time, wholly pointless.

The trouble was, of course, that energy ceaselessly changed locations and vehicles and that currency always refused to remain current. Remington would not arrive at even a partial solution to his dilemma until late in 1894, when he produced *The Bronco Buster*, his first bronze—even then, the solution stated by the *Buster* would frighten and perplex him. Yet, while Remington fished at Cranberry Lake in 1892, sixty-nine-year-old Francis Parkman at Boston addressed

100. *Harper's Weekly*, November 12, 1892.
101. "Slavery and the Slave Trade in Africa," *Harper's Monthly*, March 1893, pp. 613–632.
102. "Why We Left Russia," p. 306.

the dilemma directly in his preface to a new edition of *The Oregon Trail*, noting of the Remington pictures that illustrated the book—all made before the Russian excursion—that they were "as full of truth as of spirit" but observing that since the book's first appearance in 1849 events had occurred which significantly altered its character.[103] "Sons of civilization," he sadly wrote, had "thronged to the western wilds in multitudes which blighted the charm that lured them." In consequence, all that had drawn Parkman himself west in 1846 was now supplanted by the "agreeable society" he had sought to escape, and his book, in 1849 a chronicle of his transformation by the wilderness, had by 1892 been transformed into a relic Parkman hoped would help preserve the memory of a region whose "savage charms" had "withered." Obviously, the changes Parkman spoke of occurred in sequence; just as obviously, that which occurred *later* in the sequence changed the appearance of that which occurred *earlier*. Parkman's preface thus contained a suggestion of the difficult principle by means of which Remington would at last abandon the strategy that required him to paint and draw pictures that suggested the sequences of time and history—as well as a clue to Remington's next application of that same strategy.

The 1846 events in *The Oregon Trail* had, said Parkman, receded and diminished—with the result that the record offered of them had changed its function. The buffalo left only their bones behind them in 1892; the Indians had been "scourged" into an "ugly caricature" of their conquerors; even rattlesnakes, mountain lions, wolves, and grizzly bears seemed to have become "diffident and abated." In the face of such drastic and pervasive reduction of its subject's amplitude, Parkman's book could only become an elegy. It was thus not possible for Parkman to agree with Remington that either America or Remington's pictures of America were new—or even for him to indulge Remington's illusion of national youthfulness. The reason he thought Remington's pictures truthful and spirited was that they were the "work of one who knew the prairies and the mountains before the irresistible commonplace had subdued them." In one of its dimensions, such praise merely called attention to Remington's accuracy; in another, it suggested that the truth and spirit of Rem-

103. *The Oregon Trail* (Boston: Little, Brown & Co., 1892), p.

linked them with the pictured subjects in historical sequence than from the perceptual connection that linked them with an artist who could "know." If Parkman was right in saying that Remington had known his subjects, then Remington's pursuit of them had been transformed by the consequent pictures into pursuit of self.

Yet the habits of mind Remington had acquired as journalist and illustrator, which also informed his pursuit of "current live topics," caused him to confuse the pursuit of self with the pursuit of some subject outside the self—and, perhaps unfortunately, the preface offered this outside subject as well. Gloomy as Parkman was about the diminished West of the present, he admitted that the buffalo might vanish without immediately dissolving the prairie and that the "all daring . . . all enduring trapper" might recede into the past without leaving behind either gentility or a complete vacuum. To replace the buffalo, there were "cattle and fences of barbed wire"; filling the void the trapper left was the cowboy.[104] Since Remington had resolved to "do" America, and since he persisted in denial of the genteel but still affirmed the "new," he regarded the cowboy with increasing interest as a figure both marginal and current.

Marginality and currency together were also reflected in the popular interest focused on the cowboy as fictional and anecdotal figure. Owen Wister's first two western stories were published in August and December respectively, neatly bracketing the new printing of *The Oregon Trail* and pointing out the new emphasis of popular sentiment concerning matters western—for both treated cowboys rather than trappers or soldiers, and both identified cowboys as exotics.[105] Likewise, Theodore Roosevelt rummaged through his recollections of Elkhorn Ranch to produce a June 1893 essay called "In Cowboy Land," reiterating his faith in the "rude virtues" of the "border" and proceeding through a brief catalog of anecdotes intended to prove cowboys unique in their "relations to morality and the law."[106] Remington read Wister's stories with interest while he worked on illustrations for Roosevelt's essay and prepared for the first public exhibition and sale of his own work, held January 6 to 13, 1893, at the American Art Association gallery in New York. Shortly afterward, he departed for the town of Chihuahua,

104. Ibid., p. xvii.
105. "Hank's Woman" and "How Lin McLean Went East." The former story was published in *Harper's Weekly*, August 13, 1892, pp. 821–823. The latter appeared in *Harper's Monthly*, December 1892, pp. 135–146.
106. "In Cowboy Land," *The Century*, June 1893, pp. 276–284.

ostensibly to gather information about a band of insurgents reportedly terrorizing mountain communities near there.[107] The "insurrection," however, was wholly eclipsed by Remington's excitement at discovering the "puncher," his own appropriately named permutation of American youthfulness expressed by the designation of cowboy.

Sometime before, probably during his 1885 excursion into Sonora, Remington had made the acquaintance of Jack Gilbert, an American adventurer who rode south across the Arizona-Sonora border in 1882 to acquire a large tract of land in the vicinity of the tiny settlement of Los Ojos. Gilbert established a ranch at the abandoned Mission San José de Bavicora, a fortresslike adobe structure built in 1770 by Spanish Jesuits and vacant since 1840, when Apaches had murdered all its inhabitants. Old as it was, this ranch paradoxically epitomized Remington's notion of American newness, and he seized the occasion of his Chihuahua assignment to regain the focus he had lost in Russia.

Setting out by coach from Chihuahua, Remington noted "turquoise hills, dazzling yellow foregrounds," and "little adobe towns . . . which you must admire though you may not like them," further observing that the "palette of the 'rainbow school' is everywhere."[108] At night, he slept rolled in a blanket on the adobe floor of a "convenient" ranch house, stripping for a sponge bath in the open before the coach resumed its journey at dawn. Yet the routine soon began to pall, especially after the coach capsized one afternoon, throwing Remington from his seat and pinning his leg beneath a wheel, and he could not suppress a sense of relief when, five days after leaving Chihuahua, the coach encountered a group of Gilbert's punchers.

The punchers, said Remington, wore "terra-cotta buckskin, trimmed with white leather," and, as a precaution against bandits, were "armed for the largest game in the country."[109] His pictures of them revealed smaller men with bigger hats, better horses, and more carefully tended clothes than the northern plains cowboys he had drawn for Roosevelt's *Ranch Life* essays but, even more surely than shabby appearances had rendered Roosevelt's perception of the Elkhorn cowboys as potential patriots doubtful, the dandified air that hung about the punchers from Rancho San José de Bavicora hid a fractiousness altogether unrelieved

107. *Harper's Weekly*, December 30, 1893.
108. "Coaching in Chihuahua," *Harper's Weekly*, April 13, 1895, p. 348.
109. "A Rodeo at Los Ojos," *Harper's Monthly*, March 1894, p. 515.

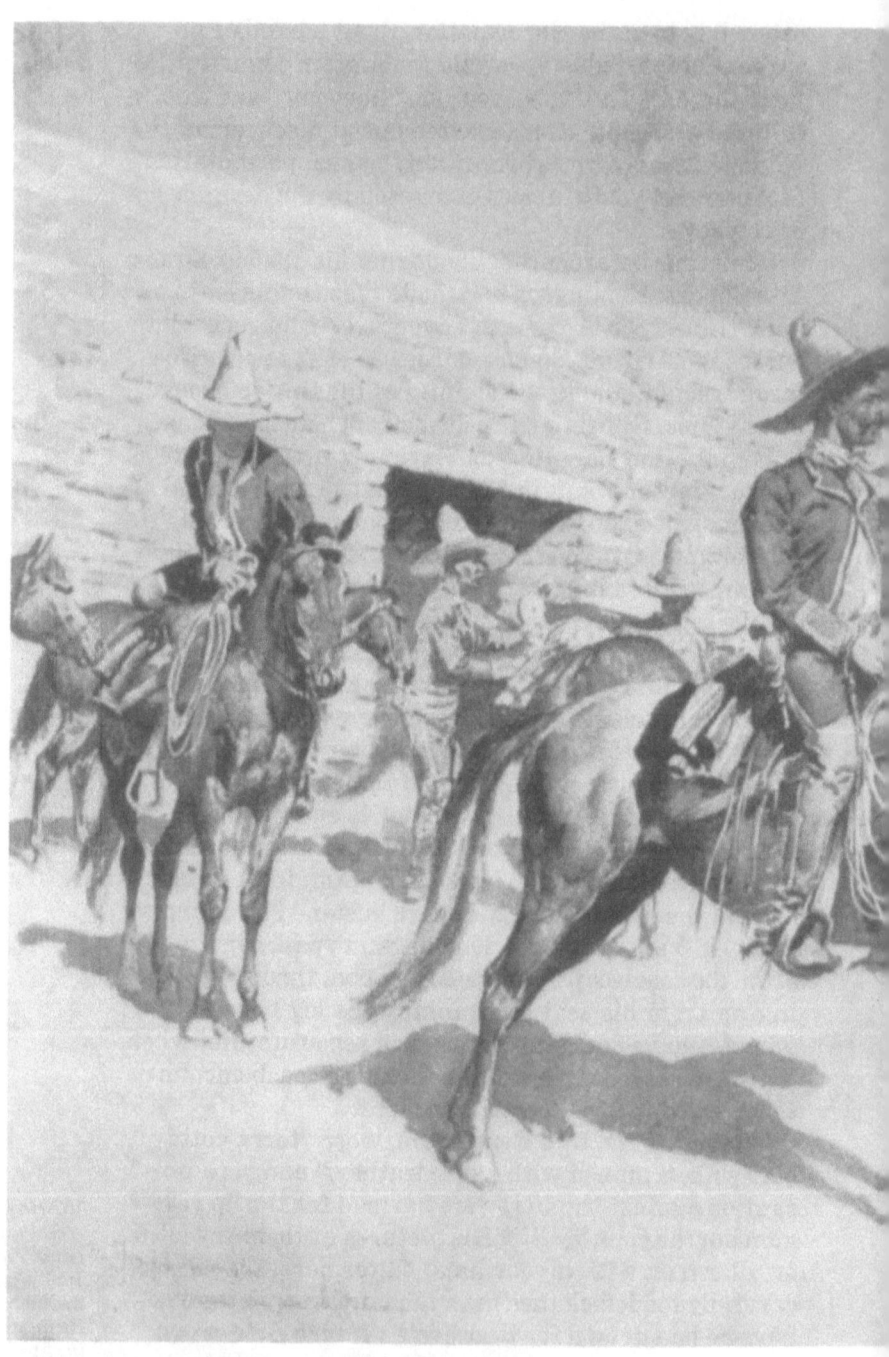

13. *"Punchers Saddling in the Patio."* Jack Gilbert's Mexican cowboys, whom Remington encountered in 1893, seemed to him to combine the best qualities of the northern plains cowboys and the Russian Cossacks.

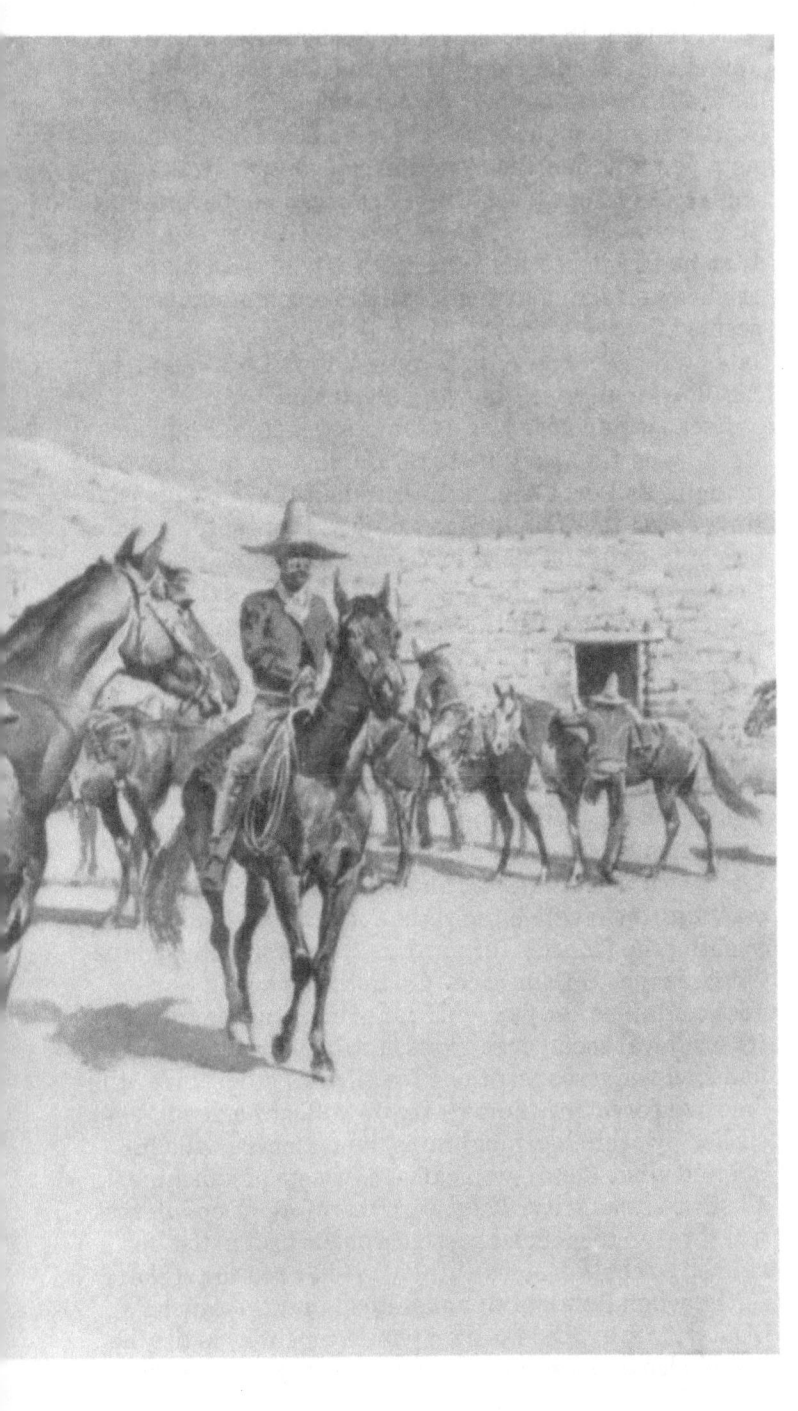

by any promise that it might someday become respectable. Indeed, the feudal context where Remington found the punchers kept him from speculating about how either they or their context might change, for Remington thought of punchers and context together as a combination that "carried one *back*" (italics mine). As he surveyed the refurbished adobe mission that served as Gilbert's hacienda, the dreary sequence that had replaced his tribe with a wild west show seemed to fade, and the irresistible commonplace seemed to lose its force. "Here, in the year of 1893," he later wrote, "I had rediscovered a Fort Laramie after Mr. Parkman's well known description."[110]

Because San José was a "long travel from Plymouth Rock"—as far away in 1893, Remington may have thought, as Fort Laramie had been in 1846—sequential time failed to affect it. Accordingly, Remington's elated perceptions of the place focused on ancient appearances that acquired their "newness" precisely by denying genteel currency. On the banks of a dry arroyo near the hacienda, "curious mounds" contained "adobe walls, mud plasterings, skeletons, and bits of woven goods" that testified to antiquity. The "curious broken formation of hills" that rose in the distance was likened by Remington to "millions of ruins of Rhine castles." A fiddler who played at the dance given in Remington's honor had been eroded by "weather and starvation" into a "ruin" Remington thought resembled the "ancient ape from which the races sprung." Instead of pushing the frontier forward, as Roosevelt believed the "grim pioneer of our race" did in the arid belt, San José contained the past without promising the future. Its medieval social organization, which brought two hundred vaqueros and their families together under the "motive force" of the patrón, its walled hacienda encircled by castlelike mountains, its punchers, who inhabited what Remington called a "waste of sunshine," all stated insularity. They were therefore of no interest whatever to the official presence of the first artist but seemed to contain some chthonic riddle for the seeker. Later, when Remington understood that the rancho's insularity mirrored his own temperament as artist, he would also understand that what he sought there was himself.

For now, however, returning north, he made another

110. "An Outpost of Civilization," *Harper's Monthly*, December 1893, p. 73.

discovery, hardly less valuable: if San José's insularity protected the rancho from the rest of the world, it also separated the rest of the world from San José. The isolated ranch looked more like an island of tranquility than what Roosevelt had called an "outpost of civilization" for, whatever Remington had aspired to become, the publication of his work in national magazines linked him with the urban and industrial rather than with the insular and feudal. Although he had described himself to Indians on the Oklahoma reservations as a "Kansas man," every account he wrote and illustrated of excursions into the wilderness identified him more thoroughly as a New Yorker. The city about which William Dean Howells had written *A Hazard of New Fortunes* in 1890—and where Stephen Crane, having completed *Maggie: A Girl of the Streets*, was beginning the works that would later appear in his *Bowery Tales* —was merely, for the seeker, the obverse of the experience that had elated him at San José.[111] Strikes, breadlines, and sleazy tenement districts teeming with poverty-ridden immigrants were less agreeable, less hospitable, and far more spectacular than the Jesuit mission turned hacienda turned Fort Laramie, and many New Yorkers understandably regarded the threat of riots at Manhattan with greater alarm than they did revolts in Mexico or eruptions of the Indian question in Montana or Dakota. Since Remington's enthusiasm for the puncher was directly related—to his dismay—to aspects of the urban social order, it was not surprising that he accepted, during the summer of 1893, an assignment that performed the important personal function of bringing the puncher into focus as anomaly.

 The insularity of San José de Bavicora was achieved by monolithic vastness, and Remington's account of the place accordingly emphasized extent, repeatedly utilizing images of the "vast plain" and the massive mountains capped with a "great blue dome" to suggest the unitary social structure and uncluttered style of the people who lived there, further intensifying the same impression with pictures that captured large, blank space and were printed without borders to frame them. Conversely, his next assignment—a study of indigence in what Melville called "your insular isle of Manahattos," undertaken with Julian Ralph—moved back

111. Most notable among Crane's Bowery tales are probably "An Experiment in Misery" and "An Experiment in Luxury," printed in the *Press* for April 22 and 29, 1894, and *The Men in the Storm*, printed in the October 1894 *Arena*.

and forth between cramped, dimly lit interiors and crowded exteriors to define the insularity of its subject as a matter of enclosure.

Ralph called his essay "The Shoe That Pinches," observing that "it does not need much distortion of either the map of New York or the mind that studies it to perceive a suggestion of a foot in the shape of Manhattan Island," proceeding to remark that the "poor of the town" covered the foot from the Harlem River to the Battery in a garment less protective than abrasive, concluding that this garment "is pinching the tender, sensitive foot that it encloses."[112] Strictly applied, the metaphor was somewhat less than snug, for it implied that the chief reason for attempting to relieve the ache of poverty surrounding Manhattan Island was to ease an itch that might soon be felt by the "well-to-do, brilliant, cleanly districts" within, but Ralph's sentiments were largely benevolent as well as largely self-righteous, and the essay, aided by Remington's pictures, made a point.

Several excursions into parts of the city unknown to the "average New Yorker" convinced Remington and Ralph that the tenement districts were heterogeneous, complicated, and connected with more affluent parts of town by numerous ties far from easy to define. In Mott Street the two investigators saw Chinese whom Ralph thought "foul and dirty" but whom Remington declined to draw, perhaps in penance for the "Chinese Coolies" of two years before. Greenwich and Cherry streets contained poor Irish settlements; Mulberry Bend, large families of poverty-stricken Italians; Ludlow Street, a colony of Polish Jews. Remington made a fine sketch of an Italian family, including with what may well have been ironic intent a small boy whose shoes obviously did *not* pinch.[113] The Jews, who reminded him of his recent visit to Warsaw, also attracted his pencil and—despite the mean streak of anti-Semitism that informed Ralph's remarks about these people— Remington drew them sympathetically, as they bargained for food at a sidewalk market on Ludlow Street.[114]

Wherever they had come from and however they looked, all the poor observed by Remington and Ralph were united in distress and, while Ralph managed to be both condescending and hysterical when he claimed that there was no reason to fear the poor, because the

112. "The Shoe That Pinches," *Harper's Weekly*, January 27, 1894, p. 83.
113. "A Sketch in Mulberry Bend: The Italian Quarter," p. 85.
114. "The Sidewalk Market, Ludlow Street," p. 86.

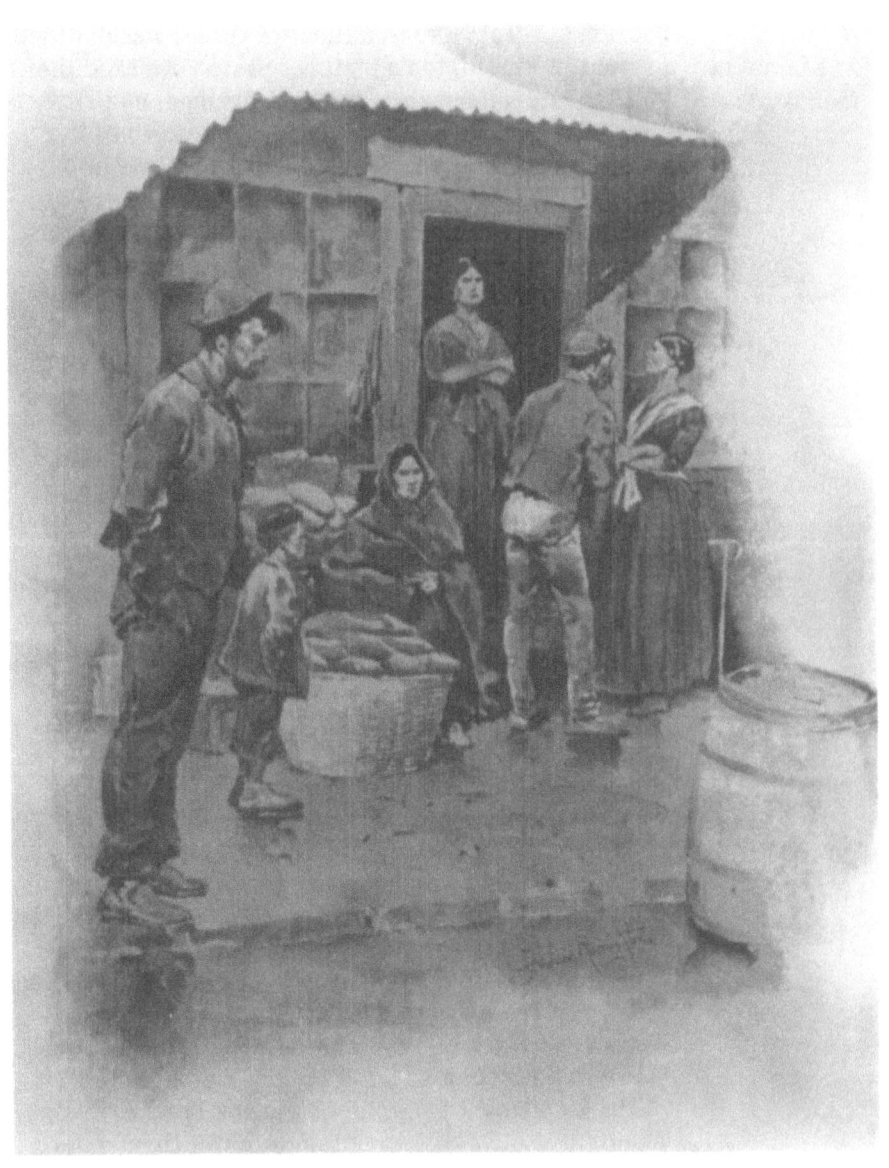

14. *"A Sketch in Mulberry Bend: The Italian Quarter."*
Remington's pictures of the Manhattan slums express the same sympathy and the same sense of threat depicted in his earlier works showing the hardships of life on the Indian reservations.

poor had useful virtues, a sense of threat was distinctly present in Remington's pictures. Ralph declared that "our brave policemen, our noble firemen, our letter carriers, our truck drivers, the plumbers who enter all houses, our butcher boys, the sweethearts of our servant-girls" were all either poor themselves or associated closely and repeatedly with the poor on a personal basis. Therefore, he argued, the poor had been proven harmless, and their poverty was an opportunity for charitable benefactors rather than a threat to the social order. Remington, however, saw most of all that the poor were numerous, and the act of drawing them constituted tactile experience of their capability for occupying space. For one who cherished magnitude and disliked multiplicity, they were menacing.

More than by the squalid Polish markets, which threatened only disease, or the hovels of Italian families in Mulberry Bend, which for Ralph at least were redeemed by both Christianity and motherhood, the menace of the poor was demonstrated by Oak Street Police Station, where race and religion fell away and misery stood up to be counted. Most New Yorkers, Ralph said, had no reason to know Oak Street. Tucked between Chinatown and the East River, with the Brooklyn Bridge towering overhead as though "striding over to Long Island," it had been bypassed long ago and, since it was not on the way to anywhere, it literally and metaphorically constituted a dead end. In daylight, one noticed the ironic presence of the Newsboys' Lodging House nearby, where Horatio Alger had until only recently worked at churning out juvenile success stories while he labored at a "serious" novel that was never published. At night, Ralph thought it a "bit of London—of the old 'City' near London Bridge." When he and Remington visited there, they walked down from brightly lit Pearl Street, entering a dark alleyway marked at its further end by the familiar green globes of the precinct house. Drawing nearer, they made out a queue of "lodgers" standing outside against a "dead-brick wall," waiting to be admitted for a meager supper and a night's shelter on the bare floor.

A policeman, whom Ralph described as a "stalwart, yellow-haired, pink-faced German, filling his uniform like a sausage in its skin," greeted them briskly and proceeded to take them on a tour of the premises,

laughing and grinning as he did so. Then, they watched as a group of tipsy women were admitted from outside and listened while a policeman called them the "happiest women in the world"—the full irony of which Remington captured in his suggestive sketch of "A Happy Female Lodger."[115] Finally, the file of hungry men Remington and Ralph had seen as they approached swept in from the darkness "like a great bat's wing," to be lined up in a crescent under naked lightbulbs that hung from the low ceiling of the station house basement, where a policeman strode from one to the other, barking "do you want to go 'way?" at each. If they answered yes and could prove their New York residence, they could go to the workhouse on Blackwells Island in the East River.

Remington's picture of the questioning showed seventeen nondescript indigents assembled before their questioner like recalcitrant recruits before a drill sergeant but, although they were all possible members of the army of unemployed Jacob Coxey would attempt to lead on Washington the next year, the men who lined the wall of Oak Street Station's basement expressed their threat not by demanding participation in society but by seeming to require that society manage them.[116] The potentially martial air they reflected in Remington's perception was therefore significantly modified by Ralph's remark that their characteristic formation was "Indian file" and his further declaration that a patrolman "charged with rounding them up" resembled a "cowboy among cattle." Just as supposedly genetic "stock raising" identified Roosevelt's cowboys, the presence of supposedly degenerate urban poor identified the police. The puncher had come a long way since Remington first drew him as Wyoming herdsman and *Harper's Weekly* first noticed him as Arizona desperado.

Ralph's simile of the policeman as cowboy in Manhattan ratified the assimilation of the cowboy by the state heralded but never developed in *Ranch Life*. If vacant land had given way to tenements, leaving the unemployed herdsman to supervise the channeling of displaced Europeans into colonies that were urban equivalents of Indian reservations, then what Roosevelt called his "abounding vigor and ... bold, restless freedom" had departed, and Parkman's gloomy estimation

115. "A Happy Female Lodger," p. 84.
116. "The Station-House Lodgers," p. 83.

of the irresistible commonplace seemed in error only by being overly optimistic. The sequence was nothing short of terrifying.

Indeed, Oak Street Station not only rendered Rancho San José de Bavicora anomalous, it also seemed to make the exoticness of the place less attractive, for the tactile experience of drawing poverty in Manhattan involved a threat analogous with that Remington had experienced aboard the Russian steamboat on the Niemen River, and his response was similar. In late summer, confessing to a period of unrest, he accepted a telegraphed invitation to join a hunting party bound for the "West" from Chicago.[117] When he arrived at Chicago's St. Paul depot, however, he was dismayed to find that the West where the hunting would take place was North Dakota and that the quarry would be ducks and prairie chickens. There was a private railroad car, hired especially for the occasion and fitted out with English setters, shotguns, ammunition, and all the regulation clothing. A brace of Harvard undergraduates, a regular army officer, two retired generals, and a phlebotomist from Pittsburgh made up the party, and all promised enthusiastically to teach Remington everything he needed to know about the venture, despite the "good natured contempt" he freely expressed for it.

Yet, after the private car had been towed north along the Great Northern Railroad to Devil's Lake, Remington remembered enough of San Carlos and Oak Street to call the shooting excursion a "gluttony," and an afternoon of killing ducks proved a "perfect revelry of slaughter" that left him wondering why "this pleasurable taste for gore" was so "ecstatic." He finally decided that "calm, deliberate shedding of blood" brought a "most surprising number of fellows" together, even when only ducks were slaughtered. "Doctors, lawyers, butchers, farmers and Indians not taxed," he thought, would all be interested in hearing tales about the hunt. This lame justification was rendered lamer still by Remington's confession that he fell asleep that night dreaming of "bad lands elk, soldiers [and] cowboys." It was true that riding about the country in a private car to kill wildfowl was a group activity, and it was true that many subscribers to popular journals like *Harper's* would read an account of the activity if it were put into their hands, but it was not true that either the activity or an account of it merited

117. "Stubble and Slough in Dakota," *Harper's Monthly*, August 1894, p. 452.

interest of the same sort that drew Remington away from the North Country in 1881.

Hoping to dispel his uneasiness by changing his location again, Remington elected to stay aboard the private car with its hunters and their paraphernalia when it was joined to an express train and towed west to Yellowstone National Park—and the change was salubrious. Spacious rooms at the Mammoth Springs Hotel were a welcome relief from the cramped quarters of the private car, and timbered, sweet-smelling mountains contrasted agreeably with the flat Dakota stubble fields. When a military uniform appeared among the tourists, Remington spotted it quickly and was soon engaged in earnest conversation with its owner, a young lieutenant named Lindsley on temporary assignment to the park from Remington's old, familiar friend, the Sixth Cavalry. The gluttony of bird shooting followed by feasts on Chicago beefsteak had sharpened Remington's appetite for headier fare, and he accordingly plied his new acquaintance for all the new acquaintance was worth.

There was no reason for Remington to expect anything more from Lieutenant Lindsley than some cheerful military gossip—perhaps, if he was lucky, a few remembered or vicarious accounts of Indian campaigns or fights with outlaws. Lindsley, however, flattered by Remington's interest and impressed by his earnestness, responded by inviting Remington and his party to accompany an expedition to the south end of the park, where there was rumored to be trouble involving a poacher in the buffalo herd. Remington avidly accepted the invitation and was glad when his party refused it. As he and Lindsley rode off into the mountains, he thought that "men who shoot chickens belong in a stage-coach—they are a 'scrubby wagon outfit,' as the cowboys say."[118]

The advantage offered Remington by the Oak Street Police Station and the North Dakota bird hunt was that they challenged his romantic perceptions of San José de Bavicora with realities that were unpleasant but decidedly immediate, and they did not require his loyalty or allegiance: his pictures and accounts made it clear that both the callous policemen and the gluttonous hunters were nasty but actual (if grotesque) expressions of the time and place where they existed. The innocent-looking ride with Lieutenant Lindsley was an

118. "Policing the Yellowstone," *Harper's Weekly*, January 12, 1895, p. 35.

altogether different and, finally, more sinister matter —as even the language Remington used to describe it showed. After being joined by Captain Scott, the park superintendent, he and Lindsley galloped off onto a range of "formidable-looking hills" to the south. Remington thought Scott's guide, a grizzled frontiersman named Burgess, who had served with the Sixth for nearly forty years, "contented with life, since he only wanted one thing—a war." Always vigorous, Remington's prose here turned somewhat more abrasive than usual. The unique environment of the park brought into sharp relief a condition that allowed Remington to blame someone else for the numerous frustrations he had encountered in the pursuit of his work.

One aspect of the park was expressed by its geysers and other geothermal oddities and by the hotels and restaurants established for the convenience of people who came to see such things. The other was the wilderness itself, which for Remington seemed drastically modified by the presence of people who came to see the geysers. As Remington related how he and his party encountered this latter aspect, he made sure to show that its principal characteristic was that of being rigorous. Large wastes of fallen timber blocked the party's path, an afternoon hailstorm pelted them, and the captain's horse was nearly swallowed up in a bog. While Remington called the expedition "generally monotonous, toilsome, and uneventful work," it obviously pleased him precisely because it was not convenient and because it therefore looked as though it might resist those who patronized hotels and restaurants. Yellowstone, he declared, was a "national treasure" that would not bear squandering, which meant that it should be guarded "jealously." Beneath his genuine impulse to leave the park unspoiled, there ran a strong feeling that his presence with Lieutenant Lindsley and Captain Scott as they looked for poachers confirmed his membership in an elite corps pledged to defend the wilderness.

Tourists who photographed Mount Moran from the top of Golden Gate Pass thus turned into nuisances as quickly and as surely as the Sioux who killed Lieutenant Casey had turned into a collective "hater of the United States"; the chicken shooters who came to look at Mammoth Hot Springs were rendered contemptible at the instant they encountered "Nature"—which at

Yellowstone became a Woman adorned with "boiling waters ... eternal snow, and ... pools like jewels," even possessing a "bosom" to suckle "beasts." Remington summed up tourists, chicken shooters, and elusive poachers as the "man from Oshkosh," who harbored a malicious compulsion to "write his name on Nature's sacred face" with a "blue pencil." Such a pervert, he asserted, should "spend six months where the scenery is circumscribed and entirely artificial." Whether he was thinking of the workhouse on Blackwells Island, the Oak Street Station, or one of the nearby Manhattan slums, where circumscription and artificiality had pinched Julian Ralph, did not really matter.

The anthropomorphic metaphor for Nature would not have occurred to Remington twelve years earlier, when he made his first visit to the Rockies, and it apparently did not occur to him now that his use of the metaphor measured the abyss between his first visit and the present one. The vacant land had become a lady —hopefully a virgin, probably genteel, and surely coquettish—and the wild riders had turned from heroic lawlessness in an apocalyptic garden to illegal poaching in a park. For the wilderness to be circumscribed, defined, and protected by law may have been necessary, but it was also debasing—while Remington did not mention it in his published account of his 1893 Yellowstone experience, he must have sensed this debasement as he thought about the difference between riding to the Rockies in a private car at thirty-two to hunt for poachers and drifting across them at nineteen in search of excitement. In consequence of both the debasement itself and his submerged awareness of it, Remington felt that the twelve years between 1881 and 1893 had consumed the energy that propelled the republic and himself. The hunter, supposed to absorb vitality from the wild game he ate, came out a phlebotomist when thoroughly digested by the establishment. The soldier, who cleared the land of Indians so that settlers could shoot the buffalo, became a gamekeeper to protect the buffalo from poachers when both buffalo and Indians were reduced to domesticity. When Remington was forced to choose between the phlebotomist and the gamekeeper for an ally and between hunting ducks and hunting poachers for a pastime, he could only reject them all. The desperado of 1881 had become the misanthrope of 1893.

Yet what waited in the hotel at the end of Remington's ride was an unexpected alternative. It was a fellow misanthrope in the person of Owen Wister, a lean, earnest Philadelphian, one year Remington's senior, who—beneath his rather dandified dress and manners—wore the same hair shirt of guilt and dismay that caused Remington to call the man from Oshkosh a latent rapist. Educated in fashionable preparatory schools and at Harvard University, Wister began preparation at the Paris Conservatoire in 1883 for a promising career in music, but financial considerations brought him back to the United States and put him to work as clerk in a Boston business house.[119] Two years later, he suffered a severe attack of neurasthenia and was sent to recuperate on a Wyoming ranch. His illness, his disillusionment with Boston, and his recognition that Wyoming's emptiness as accomplishment not only immunized it from a history of failure but freed it for an imagined future of unlimited success there combined to produce his notion that the West was a special landscape with curative powers that might be applied to the ailing body politic as successfully as they had been to his own disorders.[120]

Wister's subsequent study at Harvard Law School thus culminated not in a legal career but in stories where romantic Wagnerian themes, an empty and therefore hopeful geography, and a concern for the development and definition of the law made a pattern that was distinctly political. The political future Wister anticipated was far different from the apolitical past Remington remembered, but both had one vital feature in common: they were separated from a present time that looked disagreeable by contrast with either. If Remington and Wister together could cause these two disjunct times to truly intersect, it seemed possible that the artist and the writer might thus forge a continuum sufficiently powerful to challenge historical sequence and justify misanthropy by destroying in their common fiction the present upon which historical sequence turned.

Remington ended his ride with Captain Scott and Lieutenant Lindsley on the morning of September 8, after a sudden snowstorm, the season's first, had swept in from the north the night before. Wister, who came to Yellowstone with a party of friends after having visited the World's Columbian Exposition at Chicago,

119. See Vorpahl, *My Dear Wister*, pp. 12–13.
120. For a telling discussion of Wister, Remington, and Roosevelt, especially as their careers express political tendencies, see White, *The Eastern Establishment and the Western Experience*.

spent the night of September 7 shivering under inadequate blankets in a tent at the foot of Soda Mountain and arrived at the hotel before noon next day to find Remington still there. The two chatted amiably over lunch and continued their conversation through the afternoon. That evening they dined together and, by the time they retired, their common disgust with what Wister called the "way we Americans have been managing ourselves" had put them on a familiar basis. While both Remington and Wister made acquaintances easily but tended to resist the obligations attendant on lasting friendship, each was clearly attracted to the other in ways that were far from superficial. Each, furthermore, saw the advantages of a professional alliance. Only weeks before his chance meeting with Remington, Wister had signed a contract to write short stories for *Harper's Weekly* and *Harper's Monthly*, expressing delight with the provision that some of them would go to Remington for illustrations. Remington had read Wister's first two published western tales —both cowboy stories—in 1892, before visiting San José de Bavicora and its punchers. Wister saw in Remington an experienced, knowledgeable illustrator with an established reputation and what appeared to be a properly disapproving attitude toward national affairs. Remington saw in Wister a writer who, like himself, supposed that youth was new and who accordingly proposed to supplant a continuing and therefore steadily aging present time with a region of the country that permanently embodied youth and eternally promised the future, therefore abolishing the present and time altogether.

Remington probably recognized even then that what collaboration with Wister offered was precisely an opportunity to reassert the vision of the West that had first sent him out of Canton in a huff in 1881, and in 1893 he thought such an opportunity attractive. In fact, the seemingly attractive opportunity stated personal perils he would very quickly begin to discover.

Not since his initial meeting with Lieutenant Casey at Fort Keough had Remington encountered a potential ally at once so attractive and so dangerous for, while freedom from time seemed a viable alternative to Remington's now moribund strategy of sequence, achieving such freedom by means of an alliance with Wister required both a political alignment and a rigorous

geographical delimitation. Robbed of his tribe by the fight at Wounded Knee and deprived of artistic discrimination by his excursion into geographical typology, Remington now faced the prospect of trading his sometimes misguided but always vigorous sense of anarchy for sedate Republicanism with a Philadelphia lawyer. The fact that he remained unaware of how much he stood to lose did not diminish the risk, and Wister's 1893 designation of him as an "excellent American" contained the same unintentional irony that informed his own 1890 designation of the punchers who saved him from the Sioux as circus cowboys.[121] While the official first artist invited the title Wister's designation conferred, it acquired a hollow ring when applied to him; while the seeker after self might well deserve the title, the radical loneliness of his search would never allow him to accept it. During the following year, Remington's life and work were dominated by a complex response of each of these two roles to the other, producing at last a blend so thoroughly compounded that it simultaneously expressed them both.

[121] Undated entry in Wister's western journal for 1893, deposited in the Wister Collection at the Manuscript Division of the Library of Congress. Quoted in Vorpahl, p. 30.

5. Eternal Bronze

Remington found almost irresistible Wister's highly intellectualized if sometimes sentimental theory that the geographical region of the West, by being pressed into service as literature and art, could be made to accomplish political goals—chiefly because the theory counterpointed Remington's vivid and altogether nonintellectualized imagination, seeming to give it an order that was distinctly political and therefore at least ostensibly practical. That this apparent order was also wholly specious simply did not occur to him and, immediately after their 1893 Geyser Basin meeting, he began to urge Wister to collaborate in an ambitious attempt to define the puncher and place him at the center of a heroic alternative to gentility. By the time the two men parted at St. Paul, where they had ridden an eastbound Pullman together from Yellowstone, Remington thought he had found a way of annihilating the commonplace Parkman had gloomily recognized as irresistible. Instead of journeying east with Wister to Chicago, where Wister again watched Buffalo Bill's Wild West Show at the exposition, Remington thus headed south from St. Paul for Chihuahua, where he embarked again for another excursion among Jack Gilbert's punchers. On this occasion, he indulged no fantasies about Gilbert's hacienda and resisted his

impulse to marvel at the color of the sky or the configuration of the surrounding bluffs, for the sense of release that had informed his visit of the year before was replaced by a sense of purpose derived from Wister's politics. As a result, his awe at the extent of San José de Bavicora gave way to a study of its particulars.[122] Once the long coach ride to the ranch had been completed, there was a rodeo at one of the outlying camps and, following that, a week long pack trip into the mountains. At the center of both events was a puncher who, because he had nothing in common with Theodore Roosevelt's Elkhorn cowboys, did not threaten to turn into a policeman and whom Remington attempted to shape according to his own version of Wister's largely political misanthropy.

Whether Remington described the punchers as he saw them or saw them as he described them, his description made it clear that they possessed qualities Remington *wanted* to see. At one point, he gladly admitted that his imagination had "never before pictured anything so wild." At another, he lapsed momentarily but unobtrusively into the anthropomorphic vein to call them "children of nature." His pictures and prose consistently expressed one recognition concerning the punchers, however: the punchers stated a tacit but caustic criticism of what Wister had called the "way we Americans have been managing ourselves."

Remington thus avowed that a "man should for one month out of the year live on the roots of the grass, in order to understand for the eleven following that so-called necessities are luxuries in reality."[123] "Modern civilization," he asserted, often succeeded in "vulgarizing" people because it attempted to "educate them beyond their capacity." In contrast, the punchers possessed "chaste and simple minds" because they had been spared the baggage of "embellishments."[124] In the absence of a "certain flippancy which passes for smartness in situations where life is not so real," they were sustained by "the intelligence which is never lacking and the perfect courage which never fails." Neither Remington's prose nor his pictures were flippant, but both were surely embellishments and, however brave and bright the puncher was, describing him as a perfection of courage and intelligence who lived a "real" life—beside which actuality became a shadow—said more about Remington than it did about the puncher.

122. "A Rodeo at Los Ojos," p. 524.
123. "In the Sierra Madre with the Punchers," *Harper's Monthly*, February 1894, p. 359.
124. "A Rodeo at Los Ojos," pp. 523–524.

Specifically, Remington's distillation of Gilbert's Mexican cowhands into a single figure who personified heroic virtues stated the perilous condition of his career for, when Remington illustrated John Bigelow's Arizona diary with angular pictures that alternately mocked and elucidated the narrative or made sketches for the *Harper's* picture history that countered the prose they accompanied, he maintained an ironic stance by remaining in some sense part of what he drew—a subject which misguided writers might misunderstand as it pleased them and subscribers to periodicals might penetrate or not but which, in any case, possessed a discrete integrity that made it immune from being fundamentally changed by an act of distorted interpretation over which the artist had no control. When he took it upon himself to create a hero who would justify Wister's elitist politics, the hero he created still had to be spun from the strands of Remington's experience and was still susceptible to being regarded with distorted vision—but something curious happened to Remington's ironic stance for, in order to see the puncher as a hero, Remington had to look at him from the viewpoint of a New Yorker and, in order to identify with the puncher as a subject, Remington had to make him an antagonist of the genteel establishment that now so fully accepted Remington himself.

Having once mocked his genteel audience by representing subjects that challenged gentility, Remington suddenly found himself in a new relationship with these subjects. Because he assigned them elements of his own personality and wistfully represented them as what he himself might be like if only he were nurtured on enough "reality," the subjects were Remington. Because Remington acknowledged his presence among these subjects as a tourist, sent from a place where life was "not so real" to bring back a bundle of grass roots for his hungry fellows, he was the audience. In the space where the artist had stood between audience and subjects to confirm his disbelief in everything but his own vision, a clutter of bold, attractive pictures and vigorous, often ungrammatical rhetoric now proclaimed nothing so clearly as the artist's irony applied to the artist. Attempting to adopt and use Wister's sentimental politics, which ran absolutely counter to the current of his own imagination, could only cause Remington to mock himself.

Aesthetically, this surprising if inevitable condition promised far more than the enthusiastic but superficial observations that expressed it for, while it proceeded from Remington's confusion about what his own inclinations as an artist *ought* to be, it also began to prepare the way for his difficult and ultimately valuable inquiry into what such inclinations *had* been, freeing him at last from the illusion of objectivity that had caused him to pursue types over three continents. Personally, however, it made an incongruous spectacle. More important, it threatened to bring him face to face with himself in a confrontation that promised to be demanding and perhaps painful, and for this reason he rejected it. The aggressive, energetic adventurer who had looked for Geronimo in Arizona, become a celebrity in South Dakota, and penetrated North Africa and Russia in search of a currency kinetic enough to fit the model his imagination had devised not only still resisted self-knowledge but now professed as well, as a result of his enthusiasm for Wister, that Republican prudence might be just as good, if not better. In consequence, the adventurer seemed to disappear and fall away, leaving a defensive, usually patriotic isolationist who still transported himself across great distances but always, now, searched for simplicity and stasis.

In November, shortly after his return from insular San José de Bavicora, Remington thus set out again, this time with Julian Ralph, for a like region where Ralph claimed that time had "slumbered," producing the peculiar phenomenon he chose to call an "abiding place of genuine and pure American population, whose civilization has stood still for more than a century."[125] Ralph's designation might have been applied to the Wyoming Territory Wister put into his 1902 novel, *The Virginian*, and—if Jack Gilbert's punchers qualified as American—might even have been fitted to Remington's perceptions of San José. The place, however, was the Allegheny Mountains of northern West Virginia, where Remington made pictures of scenes and people that recalled his own youth in the North Country of the 1860s and 70s. Having grown weary of complicated kinesis as a subject, he now preferred a restful notion of American purity. There is no indication that subscribers to journals where his work appeared noticed the difference, but Remington would soon become painfully aware of it.

125. "Where Time Has Slumbered," *Harper's Monthly*, September 1894, p. 614.

Eternal Bronze

When he and Ralph found themselves stalled in Richmond, waiting for railroad connections, Remington indicated his new preference for stasis by remarking "I'm glad I'm here," adding that "my father tried for four years to get into Richmond, along with the rest of the army."[126] Far from attempting to settle his father's account with the Confederates, the amiable sketches he executed of schoolboys, loungers, and a vaguely military country colonel counterpointed Ralph's gushy veneration for the governors, presidents, and generals who hung in the portrait gallery of "famous Americans" at the old Virginia Statehouse, intimating that the glories recalled by portraits of the statesmen were both dimmed and tamed by shabby surroundings.[127] Unfortunately, the title Ralph chose for the piece fit the pictures perfectly: "How a Tourist Sees Richmond."

Giving up the inclinations of an artist in order to become a tourist was perhaps the worst thing that had ever happened to Remington. He began to realize how bad it was when he left Ralph in Richmond and went to Texas and New Mexico, where he accompanied General Miles and units of the Second Cavalry on an inspection tour and hunted grizzly bears in the mountains north of Albuquerque with Miles and a British rancher named Montague Stevens.[128] The only reason he could see for Miles' inspection tour was that it passed through a region where he supposed that "any war the Apaches or Navajos may make" might take place, if only there were Apaches and Navajos to fight it. The best justification he could think of for chasing bears with guns and lariats was that the method of the slaughter could be called "sportsmanlike."

Yet bears were so plentiful in this region that little sport was involved in shooting them. When Remington asked why Indian hunters had not previously reduced the numbers of bears, Stevens' cowboys told him that, until Miles' Indian reduction campaigns had achieved success, the bears had multiplied altogether unmolested because the Navajos and Apaches had invested them with supernatural powers as the "lost souls of the tribe." It suddenly occurred to Remington that Miles, come from Chicago to inspect the tribal structures he had ordered destroyed, engaged in a symbolic activity when he brought down a grizzly with a "tremendous thump" by putting a .50 caliber bullet through its brain.

Reduction campaigns, inspection tours, and sport all

126. Julian Ralph, "How a Tourist Sees Richmond," *Harper's Weekly*, February 24, 1894, p. 178.
127. Ibid., p. 180.
128. "Bear-Chasing in the Rocky Mountains," *Harper's Monthly*, July 1895, p. 251.

fused for Remington in New Mexico as they never had for Roosevelt in South Dakota, and the design they formed inspired pathos. When the Indians went down like buffalo at Wounded Knee, Remington had been quick to side with the soldiers. Now, as he watched Miles pursue the souls of the Indians killed in South Dakota by slaughtering bears in New Mexico, he wavered. If the imperial necessity of Indian campaigns preceded the sport of bear hunts, then the sport of bear hunts would appear to precede the triviality of chicken shoots. Drawn to both the soldier and the hunter by their "savagery," Remington at last began to see that the soldier and the hunter threatened to exterminate precisely the savagery that attracted him. He therefore responded to this threat with a lament for its victim, and his lament contained at least a partial recognition that, among the tribe of lost souls that haunted grizzlies pursued by soldiers turned hunters, his own lost soul made one: "He was a vampire; he was sacred. Oh Bear!"[129]

Remington had never before quite agreed with Francis Parkman's gloomy estimation of 1892 that both the West and the rest of the republic were doomed to an irresistible commonplace because, for just so long as he continued to regard the commonplace in its geographical dimension, it appeared to be a progressive malady susceptible to arrest, containment, and even remission—if only the patient could be induced to alter diet and habits. Now, however, Remington saw that the malady was instantaneous and terminal rather than progressive and curable and that its physical symptoms only obscured its spiritual cause. Indians, frontiersmen, and wild animals still inhabited vast wilderness areas that still occupied much of the continent, and San José de Bavicora still resembled Remington's imagined vision of a bygone Fort Laramie, but every vampire vanished at the instant that one vampire was regarded as a specimen. The significance of Miles' hunt was thus that it subjected urgency to triviality; of Remington's lament, that it identified an impotence.

When Wister arrived at New Rochelle in January 1894 for a conference over a story about the Ghost Dance, Remington bluntly informed him that "your text holds me down too close," commanding him to "write me something where I can turn myself loose" and employing what Wister remembered as "genial

129. Ibid.

profanity" to demand the "story of the cow puncher, his rise and decline."[130] Over a year before, Remington had returned from modern Europe with the brave hope of discovering in America a continuing strain of what he called " 'my people' . . . simple men—men with the bark on."[131] During the months that followed, a wide spectrum of American currency stretched all the way from the squalor of New York's Oak Street Police Station to the lordly hospitality of Jack Gilbert's Sonora hacienda but failed to reveal a plausible and continuing avatar of the antimodernism Remington sought—even though Wister had seemed to tell him at Yellowstone that the hopeful emptiness of the West might be capable of redeeming a history cluttered with apparent failures. However Wister might wish to romanticize him, the puncher, who still existed in Sonora and New Mexico, seemed to Remington a temporary survival of something old rather than a new permutation of frontier vitality. This angry perception culminated the self-mocking crisis begun with Remington's second visit to Gilbert's ranch, and Remington's bitter response to the ironic view of self the perception made possible was again to reject it, again turning his eyes away from himself and toward the puncher, whom he now wished not to preserve but to dispose of. To take this view of the puncher was to relegate him to the past, along with the soldier, the hunter, and the Indian. By banishing all the icons that had presided over his first interest in the West, Remington at once abandoned the new and acquired a new perspective on the current.

What immediately sprang into focus was a configuration of massive forms arranged in patterns that augured confrontation; precisely because it was both large and threatening, this configuration ratified Wister's discontent with American history far more powerfully than Gilbert's punchers had confirmed his hypothesis concerning the curative powers of American space. Unredeemed by Remington's previous notion that a diet of western grass roots could regenerate and transform any collective urban cluster into its component elements, the miserable tenement dwellers Remington had drawn at Manhattan melted into a single, ominous bulk that threatened to crush the "clean, wholesome and industrious" majority he had first recognized at Havana in 1891 even more thoroughly than the irresistible commonplace of that

Eternal Bronze

130. Owen Wister, *Red Men and White*, vol. 6 of *The Writings of Owen Wister*, 11 vols. (New York: Macmillan, 1928), introduction, p. ix.
131. In McCracken, p. 76.

majority had flattened out the once buoyant West. Remington's latest vision thus involved the transformation of Gilbert's "simple" cowboys into military supermen and of the exhilarating vacant land he had once associated with American newness into a potentially apocalyptic battleground. A March 1894 article for *Harper's Weekly* suggested the latter transformation by declaring the United States a "fool's paradise" and predicting, with Remington's usual disregard for syntax, that it was only a matter of time before the paradise developed a "political sore which can only be cut out with a sabre."[132] The former transformation seemed accomplished four months later, when the Seventh Cavalry, with whom Remington had stalked Big Foot in South Dakota, marched on Chicago.

In its early stages, Remington's assignment to the soldier of virtues he had come to think of in connection with the puncher seemed merely confused, as when he instructed his fellow New Yorkers to "blow a little" over the accomplishments of a New York paramilitary organization—begun in 1890 and christened "Troop A" by its organizer, a cavalry captain named Charles F. Roe—asserting that the exhibitions cheerfully conducted by this group of adolescents in the old New York Armory expressed something he called the "romance of war."[133] Later, the same confusion began to assume an unpalatable but perceptible order when Remington reported on an April 1894 visit to Fort Meyer, across the Potomac from Washington, D.C., in a garbled account that dissolved into enthusiastic nonsense. "Horses," he profoundly observed, "are horses, and are not made of wood, iron or by rule of thumb"[134]— but, beneath the befuddlement that allowed him to string such observations together in paragraphs that defied all logic, lurked a meaningful excitement. It was "altogether refreshing" to see Fort Meyer with its training facilities and its "four troops of cavalry which cannot be beaten"; General Guy V. Henry, who commanded the fort, and whom Remington styled its "creator," affected him as "positively exhilarating." What left Remington tongue-tied at Fort Meyer was a glimpse of the military sequence he had begun to suspect was irreparably shattered. He thought it a "grand thing" for young men who might only recently have graduated from Troop A to benefit from direct in-

132. "Troop A Athletics," *Harper's Weekly*, March 3, 1894, p. 206.
133. Ibid.
134. "A Model Squadron," *Harper's Weekly*, June 9, 1894, p. 541.

struction by "old veterans of the Civil War and the alkali plains." His enthusiasm for Fort Meyer derived from his conviction that the fort promised war. A visceral elation therefore mingled with his dismay in July, when Chicago began to look like the battlefield that would justify his estimation of Fort Meyer and Troop A.

In May 1894, Eugene Debs' American Railway Union began a bitter strike against the large Pullman works on the city's south side, spawning a number of sympathetic strikes by telegraph workers, engineers, and others in related occupations and resulting in snarled communication and transportation services throughout the country. After weeks without pay, some hungry workers resorted to looting in order to stay alive. Others, encouraged by the corporate management, attempted to cross picket lines set up by the unions. When violence erupted, units of the national guard were activated, and President Grover Cleveland —over strong protests from Illinois Governor John Altgeld—sent federal troops to the city on July 4, putting into effect an undeclared but fully operative state of martial law. Troop A stayed home to keep guard over Manhattan, and General Henry remained in Washington, but Nelson Miles was at Chicago even before the trouble started, and the Seventh Cavalry swept in from the West like an unusually early autumn. When the chancre Remington had prodded four months earlier reached the proper state of suppuration, there were sabers enough to perform the lancing, along with bayonets, small arms, dynamite, and even rapid-fire Hotchkiss cannon.

Remington arrived at the scene by rail, watching out the window with indignation and growing excitement while his heavily guarded train passed through what seemed "acres" of burned and burning cars. The St. Paul depot, where he had joined genial if stuffy companions in a private car only a year earlier, was boarded up and deserted. The great World's Fair, where Buffalo Bill's assemblage of cowboys, Indians, and Cossacks vied with dynamos, steam engines, belly dancers, and Frederick Law Olmsted's landscape gardening for gentility's attention, was closed. With expressive insight, Remington declared that the metropolis reminded him of Hays City, Kansas, "in the early

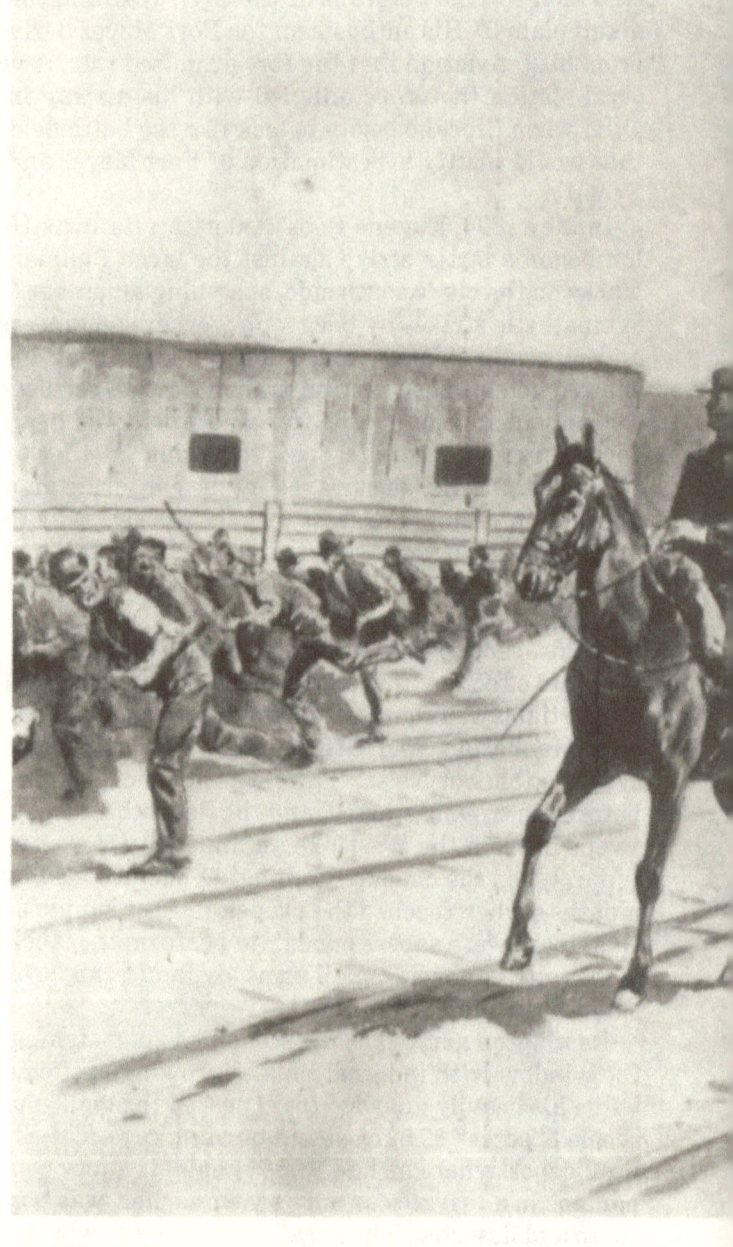

15. "The Chicago Strikes—United States Cavalry in the Stock-Yards." Civilians here flee a military column—probably a unit of the Seventh Cavalry, which Remington had last seen at Pine Ridge immediately following the Wounded Knee fight.

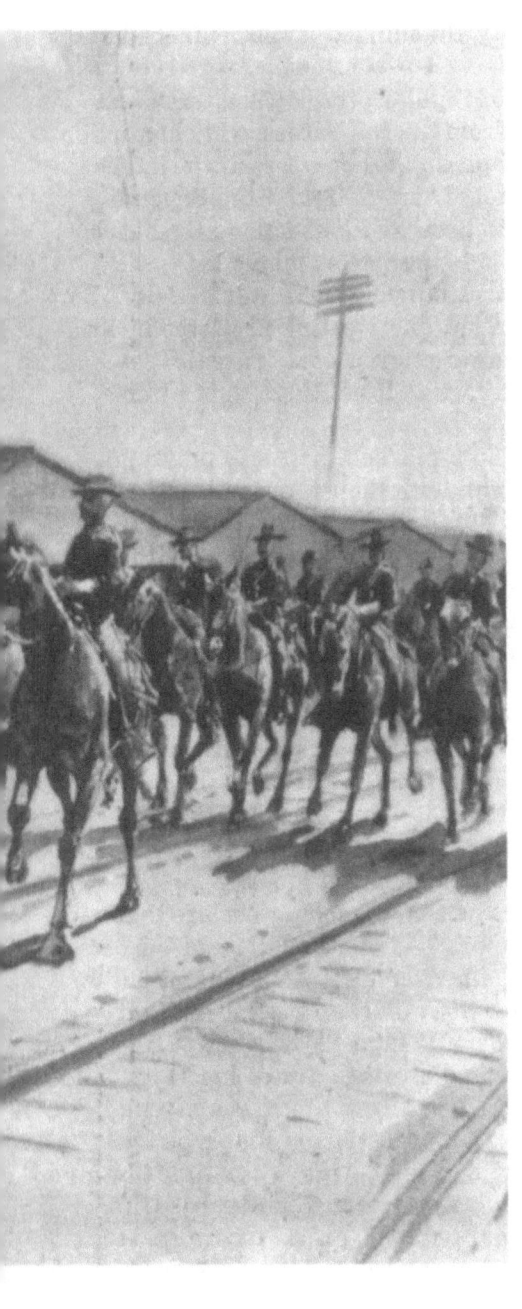

days" and, by calling it a "social island," pinpointed the painful insularity that linked it with pinched Manhattan.[135]

Three companies of regular infantry sheltered him as he made his way from the rail yards up Michigan Avenue to the lakefront and his quarters at the imposing Auditorium Hotel. There he found the Seventh Cavalry camped, with horses picketed along the beach, lighted Sibley tents glowing like so many Japanese lanterns, and campfires burning holes in carefully tended stretches of lawn. The greeting proffered by an officer named Capron was "as natural," he said, "as when I had last seen him at Pine Ridge, just after Wounded Knee."

Yet even Remington remarked the "gray buildings towering into the night, with their thousands of twinkling windows," and admired the contrast such a backdrop made between Chicago and Pine Ridge. Neither bizarre setting nor displaced participants suggested any but a very special category of the "natural," for Chicago, said Remington, had entered the final permutation of the fool's paradise to become a "state of anarchy," and the Seventh Cavalry had ventured away from its stronghold "pretty far up stream" on the Platte to penetrate the "middle of civilization," expressing as it did so something Remington called the "recreated spirit of Homer." Whether the soldiers—whom he described as "bronzed young athletes"—or the anarchists—of whom he heard a soldier declare that "them things ain't human"—embodied more of the *bête noire* he had stalked for over a decade, Remington celebrated their collision at Chicago as an event that promised a springtime of "Nature's dark side." His pictures of the event had all the vigor of his early southwestern sketches, and a festive strain enlivened his account—as when he confessed to "simple delight" at watching "howling mobs" of strikers contained by armed troops who could "hit a man at 500 yards with a Springfield" or remarked that it was "funny" to see frightened strikers breaking ranks before the orderly advance of the Fifteenth Infantry, newly arrived from Fort Riley, Kansas.

Despite his contention that troops "should never be made to associate with a mob, except . . . to get strategically near enough, and then shoot," he felt the crisis at Chicago as a mediated triumph, looking forward to

135. "Chicago Under the Mob," *Harper's Weekly*, July 21, 1894, pp. 680–681.

the time when the "unlicked mob" would again require to be "shot up a little" in the interest of "mental calm," observing that, since "the Indians are all travelling in the middle of the 'white man's road,' . . . what this government must see to now is that Chicago does not commit hari-kari."[136] Although his hopes for the Indian military corps had never quite worked out, the presence of western troops along the Lake Michigan waterfront confirmed even more dramatically than he had thought possible his facetious prediction of 1890 that soldiers might someday be called upon to control an outbreak of citizens in Deadwood or Helena. Still another dimension was added to the event by Remington's assurance that if Chicago wished to "make a Sumter" of nearby Fort Sheridan, where troops were temporarily stationed after their withdrawal from the city, there was "plenty of material left in the country to make an Appomattox of Chicago." The establishment seemed at last to have been jarred into motion, and the consequent imbalance favored Remington's hope for a large military conflict that would justify the Civil War and the Indian wars by showing that both had been campaigns in a grander conflict between kinesis and inertia.

Like many of Remington's hopes, this one proved mistaken. With the railroads working again by the end of July, Remington's notion that the riots might transform the city into a consolidation of Sumter and Appomattox resembled his equally wistful notion of almost two years before concerning the relationship between Jack Gilbert's ranch and Francis Parkman's Fort Laramie. Into the breach between bizarre accomplishment and lurid expectation Remington therefore threw his imagined version of what might have happened at Chicago if the mobs had truly been the insurgents he associated them with and if the Army had been freed of all restraints. "The Affair of the –th of July," as the violent fantasy was called when *Harper's Weekly* printed it in February 1895, comprised Remington's first venture into fiction.[137]

Remington prefaced the piece with the avowal that it had come to him as a letter from a "young military aide de camp," who wrote from firsthand experience and signed himself only Jack. Between the end of Remington's earlier account and the beginning of the events he chronicled through Jack, several important

136. Ibid., p. 683.
137. "The Affair of the –th of July," *Harper's Weekly*, February 2, 1895, pp. 105–107.

developments had occurred. First, the "big foreign population" of Chicago, of which Remington earlier observed that it "isn't American in any particular," had fallen prey to the "revolutionary tendencies" Remington warned against, plotting organized resistance against the military invasion and successfully demoralizing the police in a series of pitched battles. Second, the martial law Remington advocated from the outset had been declared, and a curfew had been imposed, including the provision that any civilian seen outside after seven P.M. would be shot on sight. Third, the military units that delighted Remington had been massively reinforced, and the "better class" of Chicagoans had fled to escape the disaster Remington called municipal hari-kari, leaving behind only the poor, the rebellious, and a few who wished to protect their property from the rebellious poor. In short, confronted with an event that failed to meet the requirements of his imagination, Remington constructed a fictitious event to replace it.

Had his ability as a writer been sufficient to represent the tangle of often contradictory impulses that crowded his imagination, Remington's "The Affair of the –th of July" might have shared in the skeptical perceptions of Mark Twain's *A Connecticut Yankee in King Arthur's Court*—or at least have achieved something like the scope of dramatic action that reduced New York to rubble in Ignatius Donnelly's *Caesar's Column*. As it was, a curious diffidence robbed the work of both the magnitude it probably deserved and the complexity it surely had in Remington's mind. Far from being destroyed by the violence and hate that swept over it, the remarkable city of the narrator's account managed only to be "exasperated." For all its noise and smoke, the disorder the narrator related burned out into only a riot instead of flaring into a civil war. As the moon set shortly after midnight, the narrator accompanied a cavalry column away from the burning rail yards and up Michigan Avenue, noticing that the sounds of battle had ceased. A few "vicious looking wretches" still roamed the side streets and even broke into substantial brownstone mansions when they could manage it—but apparently the wretches looked more vicious than they were, for all they ever did was smash glassware and swill warm champagne, pretty much as cowboys on a spree might have done at

Medora or Great Falls if champagne had been available.

Failing to note the parallel, however, a cavalry captain who resembled a "football rusher" ordered their summary execution. "Once comes daylight," he remarked, "I'll leave nothing of these rioters but their horrible memory." The eternal moment of apocalyptic chaos Remington was disappointed to have missed in history thus fell prey to sequence even when he imagined it, for only by relegating it to memory could Remington any longer regard it as possibility. When he reported on the Chicago riots firsthand, the city reminded him alternately of Pine Ridge and Hays City. When he fantasized, he merely enlarged and colored his firsthand account to produce a fiction bound by the limitations of historical narrative but unilluminated by the insights of historical study. His peculiar involvement with the West had fixed the angle of his vision permanently rearward, while his means for expressing such involvement swept him rapidly forward along the White Man's Road, up Michigan Avenue, and into places like the Auditorium Hotel. In consequence, the war between kinesis and inertia that never quite surfaced in "The Affair of the –th of July" paralleled a like conflict in the affair of the artist and his subject.

Shortly after leaving Chicago in July, Remington demonstrated how dangerous the subject of energy was by visiting Buffalo Bill's "camp" at Brooklyn—an enclosure of "thirty acres fenced in"—and there making "social studies behind the scenes" of what his partner, Julian Ralph, correctly called a "human hodgepodge."[138] Prussians rubbed elbows with Cossacks; Irish waiters brought plates of food to families of Blackfeet and Sioux, who sat across the table from each other without acknowledging the ancient hatred that set them apart; splendid Mexican vaqueros strutted oblivious past Apache warriors daubed with war paint. The page that recorded Remington's impressions even contained the anachronism of a potbellied Sioux brave to show how thoroughly lean rancor could give way to amiable ease. Under the circumstances, it seemed reasonable for Ralph to compare Cody's tent, where he saw "a telephone, curtains, bric-a-brac, carpets, pictures, desks, lounges, easy-chairs, an ornate buffet, a refrigerator, and all the furnishings of a cozy home," with a nearby Indian tepee improvised from

138. "Social Studies Behind the Scenes at Buffalo Bill's," *Harper's Weekly*, August 18, 1894, p. 776.

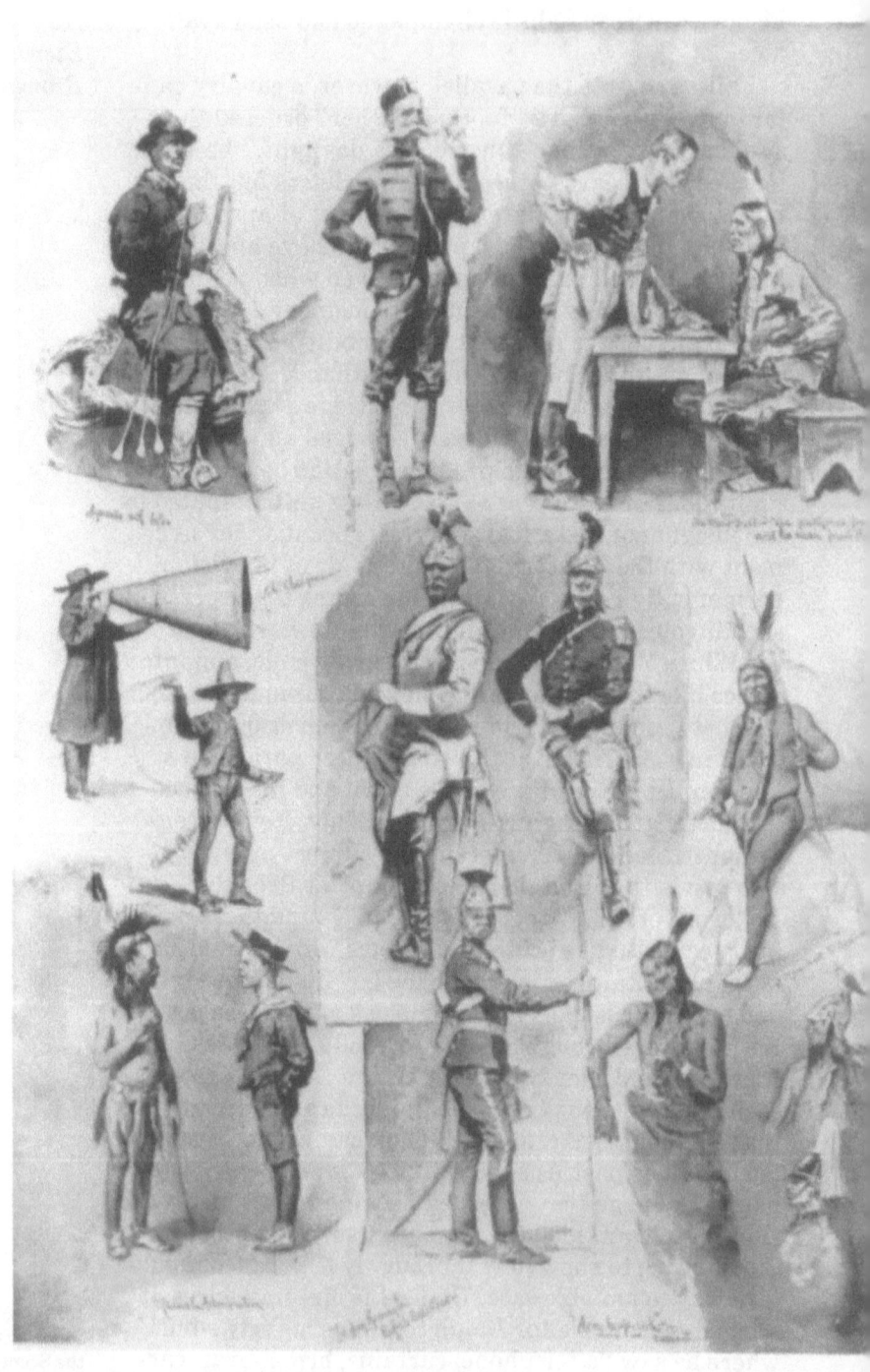

16. "Social Studies Behind the Scenes at Buffalo Bill's."
Remington's impressions of Cody's Brooklyn "camp" emphasize
his recognition of the Wild West Show as an anachronism.

white man's canvas—and it may even have been excusable for him to conclude from the difference that "by just so much have we advanced; by just so much has the Indian stood still"—but the canvas tepee with its wooden floor, the chubby warrior who gripped a lance with dimpled fingers, the cheerful mess hall with its common denominator of *bon appétit* showed Remington both that these Indians had not stood still and that their dubious progress in some sense measured his own. What attracted him from the beginning was energy, and both the Chicago riots and Buffalo Bill's Brooklyn camp demonstrated the manifold possibilities energy offered as a subject, but Remington no longer seemed able to make adequate distinctions among the forms before him.

How crippling his inability had become was shown that August, when he met Wister at Camp Crawford, near Gettysburg, to draw pictures of the Pennsylvania National Guard for, while some of the pictures he had made at Chicago would not have been appropriate as illustrations for Wister's Gettysburg essay, any of the Gettysburg pictures might have illustrated the Chicago pieces. Furthermore, Wister's prose linked the Gettysburg encampment not only with the Pullman riots but also with an 1877 railroad strike at Pittsburgh and the 1892 Homestead strike, declaring that all civil disorders were conducted by "domestic foes" Wister called "rats" and put down by wholesome, hard-working soldiers he called "real Americans."[139] If all strikes were riots and all riots were identical, it seemed reasonable to suppose that every man who elected to become a striker automatically gave up his identity and grew immediately interchangeable with each of his fellows in a "horde of vermin." Conversely, any upright citizen who joined the Army, or even the national guard, disappeared instantly into something Wister called a "soldier sea" that contained "beautiful straight lines drawn with horses and men as with ruler and pencil." The advantage of such collective subjects for Remington was simply that, since each of the units that comprised them presented much the same appearance as any of the other units, all the units invited treatment as actions rather than as individuals. The disadvantage was that such treatment, as Remington now practiced it, deprived him of meaningful judgment.

139. "The National Guard of Pennsylvania," *Harper's Weekly*, September 1, 1894, p. 824.

Indeed, it may be argued that his disastrous entanglement with Wister's politics deprived Remington of any judgment at all, for the judgments expressed in Remington's chronicle of the war between respectability and vermin seemed merely unintentional but visible parodies of Wister's. The rats wore only rags and an impudent sneer, just as Wister implied they should; the soldiers sported a thoughtful countenance and a carefully kept moustache, usually blond, and carried about various articles of military equipment. The pattern promised a graphic monotony so merciless that it could only collapse under the stress of its accumulated repeatability. Very shortly, it did so—not, however, until it had reduced Remington to a level of self-parody that made it impossible for him to ignore the ironic perception of self that had twice been set before him and had twice been denied.

Because military ordnance was the single variable in the desert of straight lines Wister had called a "soldier sea," Remington clutched at it with all the desperation of a drowning man. He crowed enthusiastically over a combined cape and ammunition belt designed by Infantry Colonel Edmund Rice in August and railed against impractical sabers and bulky duffle bags, later earnestly announcing the merits of a new combination blanket roll and knapsack containing a spring that made it easier to carry.[140] Remembering that the narrator of "The Affair of the –th of July" had ridden a bicycle to deliver messages, Remington even produced a fanciful tale concerning the adventures and accomplishments of a Colonel Pedal, who told a fellow officer named Ladigo that cavalrymen were only a "lot of jays on plough teams."[141] He may not have been aware that Mark Twain's Hank Morgan had been rescued from hanging by a special corps of bicycle knights but, while the tale had a good deal of Hank Morgan in it, it had nothing at all of the romance of war, and Remington's picture of three bicycle infantrymen purchased variety at the price of silliness. Keeping his eyes on the past made Remington passé, and wrenching them toward the present made him trivial. Buffalo Bill's Brooklyn sideshow, Colonel Rice's dandy ammunition carrier, and Colonel Pedal's bike corps swam into his vision and out again like figures in a dream, as transient and flat as paper dolls.

Nine years had been sufficient to exhaust the tribes-

140. "A New Infantry Equipment," *Harper's Weekly*, September 22, 1894, p. 905; "A New Idea for Soldiers," *Harper's Weekly*, May 2, 1896, p. 442.
141. "The Colonel of the First Cycle Infantry," *Harper's Weekly*, May 18, 1895, p. 455.

man's first enthusiasm for the West, and four years of tourism seemed enough to sate the clubman–sportsman–special correspondent with the stuff of currency. Yet, if the football forward could become a tribesman, and the tribesman could be swallowed up by a patriotic suburbanite who hobnobbed with Bear Coat Miles, then the logic of the situation ordained the suburbanite's elimination by yet another avatar of the artist for whom energy had always been the only proper subject and plasticity the only viable form. The football forward died with Seth Remington in 1880, four years after Custer's massacre at Little Big Horn; the tribesman was blown up at Wounded Knee in 1890 by a rapid-fire cannon; the suburbanite rode his bicycle out of the 1894 Chicago riots into a premature dotage that was soon mercifully over. Not since his 1881 sojourn in the vacant land of Montana had Remington been so alone as when he boarded a Chicago-bound train at New York in September 1894 and, from Chicago, set out for Arizona and New Mexico.

A striking feature of the 1894 southwestern trip was that Remington the seeker did not drag the corpse of Remington the correspondent along to record newsworthy details of movement and setting. Instead, he began a difficult investigation aimed at discovering the impulses that had sent him West thirteen years earlier and recognizing what they signified as art. The results were probably just as painful as Remington had feared they would be when his attempt to turn Jack Gilbert's punchers into heroes had allowed him to catch an ironic glimpse of himself, because the present trip provided him with a sudden understanding of why the punchers had attracted him in the first place —which, most simply stated, was that he had invested them with all the qualities of courage, original intelligence, and individual assertiveness which he himself admired and possessed but which his pursuit of popular success had caused him to mute and modify. Behind this realization, furthermore, lurked another realization both more luminous and more threatening: all the virtues with which Remington had invested the puncher were self-destructive—a thoughtless bravery that sought its possessor's annihilation, a mind ruled less by sequential patterns of the intellect than by the darker order of the imagination, a sense of self made possible only by the achievement of radical isolation.

The Law and the Prophets

The assertion of such virtues was Remington's response to the challenge with which Wister had, a year earlier, presented him at Yellowstone.

On his first visit to Montague Stevens' New Mexico ranch, Remington had hunted bears with Nelson Miles before the July riots at Chicago. Now, he came there from Fort Riley, Kansas, where he had talked with officers and men of the Fifteenth Infantry who had been sent to Chicago to disperse the rioters. Yet, even though the ranch was clearly associated for Remington with his own impressions of the riots and, perhaps, by means of Miles' presence there, with Wounded Knee as well, it resisted any identification in Remington's mind as either justification or denial of these conflicts. Neither, for that matter, did Remington regard it as an outpost of civilization like Roosevelt's Elkhorn Ranch or an insular survival of savagery like Gilbert's ranch at San José de Bavicora. The subtle but important reason was that he saw it as the already accomplished culmination of the event which, as he increasingly realized, had figured prominently—perhaps even centrally—in his career. In Remington's perception, the ranch was a wasteland where "the White race has given up the contest with nature." That it had been a battleground probably mattered far less than that it was the scene of a defeat.

For one thing, this meant that the people who lived on the ranch could be regarded as more natural than those who sought to preserve places like Yellowstone Park, where nature was put on display precisely because the white race had won dominion over it. For another, it indicated that a peculiar conjunction of events and location had at last allowed Remington to see in a new light his role as first artist and excellent American. By calling Stevens an "impossible combination" of "bonified Englisher" with American "horse sense" and "more *sand* than you could get in a freight car," he seemed to acknowledge the deficiency that haunted his own success. "I often wonder how *I* look," he admitted as he sketched a hasty profile of Stevens on a letter to Wister, and his afterthought that "every man sees with his own eyes" contained nothing less than the key to his own pressing dilemma.[142] He realized at last that what he sought was himself.

Remington had surely looked at himself before, sometimes even critically—as when he admitted to

142. Undated letter written in December 1894 in the Wister Collection, Library of Congress, quoted in Vorpahl, pp. 112–115.

gullibility in the 1887 "Coursing Rabbits"—and he had even drawn pictures of himself for publication in national magazines, but it now occurred to him that he had never searched deeply enough beneath the paraphernalia connected with the roles he played to discover whether any continuing impulse connected them. Comparing himself with Stevens' New Mexico cowboys, he discovered his own gentility and, looking back at the roles he had played, he found them reactions rather than actions.

His prominence as an illustrator of other people's texts, his involvement in such complicated combinations as the *Harper's* picture history, his repeated espousal of lost causes, even the abrasive irony that characterized much of his best work—all tended to define him as a sensitive but unpredictable observer who attempted to mask the narrowness of his creative ability by making a massive and immediate response to whatever he happened to observe. There was a shrillness about his denial of the artificial that finally suggested a denial of art, a hecticness about his pursuit of the new, the typical, and the geographical that, beneath the erratic energy that propelled it, expressed merely obsolescence.

Had Remington been a scholar, he might have studied the new view of himself formulated in New Mexico and come to some sensible conclusions about it. He was not, and the response of the seeker when confronted by the self therefore turned out to be boyish and unaccountable rather than mature and intelligent. Throughout the Chicago riots and the national guard encampments, the fantasies of bicycle warfare and the enthusiasm for new ammunition belts, Remington had entertained a hope that his accomplishments might gain him entry into a company he hyperbolically called the "Immortal band." Soon after his return from New Mexico to New Rochelle, he wrote Wister that "my oils will age old wasting . . . my water colors will fade away . . . I can't tell a red blanket from a gray overcoat for color."[143] Clearly, he missed none of the irony contained in the circumstance that, having gone to New Mexico to find a doorway into timelessness, he had come back convinced that time had rendered his journey pointless—just as clearly, he felt in the weight of such irony a crushing reproach, as when he confessed to Wister in the same letter that "I have simply been

143. Undated letter written in January 1895 in the Wister Collection, Library of Congress, quoted in Vorpahl, p. 158.

fooling my time away." Yet it would be a mistake not to recognize that, even though Remington's confession may have lacked verbal agility, it possessed another quality that to some degree compensated for this lack. It proceeded from the same buoyant if frequently wrongheaded logic that had generated the roles it rejected.

Once this logic is identified, its force is relatively easy to understand for, when Remington had looked at the Indians Lieutenant Bigelow found invisible and seen that they were horsemen, he immediately visualized them as a grand corps of elite cavalry; when he discovered Jack Gilbert's Sonora punchers and saw that they were not subjected to the same indignities as were immigrant Jews and Italians in the Manhattan slums, he concluded that the punchers were natural aristocrats. Likewise, when he finally turned his eyes on himself and perceived a thirty-three-year-old illustrator who had thrown himself into one pursuit after another but had garnered popularity for his efforts rather than greatness, he supposed himself a fool whose work contained neither meaning nor merit. His judgment of himself was therefore not only unfair and premature but of a piece with the judgments that formed his work. Its very vulnerability to criticism on intellectual grounds also elucidated its principal worth: like Remington's other judgments, it proceeded directly from the rigorous but undisciplined exercise of a wistful, romantic, and dangerous—above all, powerful—imagination.

For this reason, the despair Remington felt in the wake of his New Mexico sojourn was both as genuine as such matters ever are and remarkably free from signs of the paralysis they so frequently engender. Indeed, immediately after calling his previous work trivial, Remington promised Wister that his future work would "rattle down through all the ages," demonstrating as he did so his perfunctory rejection of sequential thought in favor of a thinking process that proceeded almost exclusively by means of leaps which instantaneously and lucidly established despair and exhilaration as two inseparable sides of the same complex phenomenon. "I," he proclaimed, "have got a receipt for being *great*." Although he tried to explain to Wister that the key ingredient in his receipt was bronze, he might have spared himself the trouble.

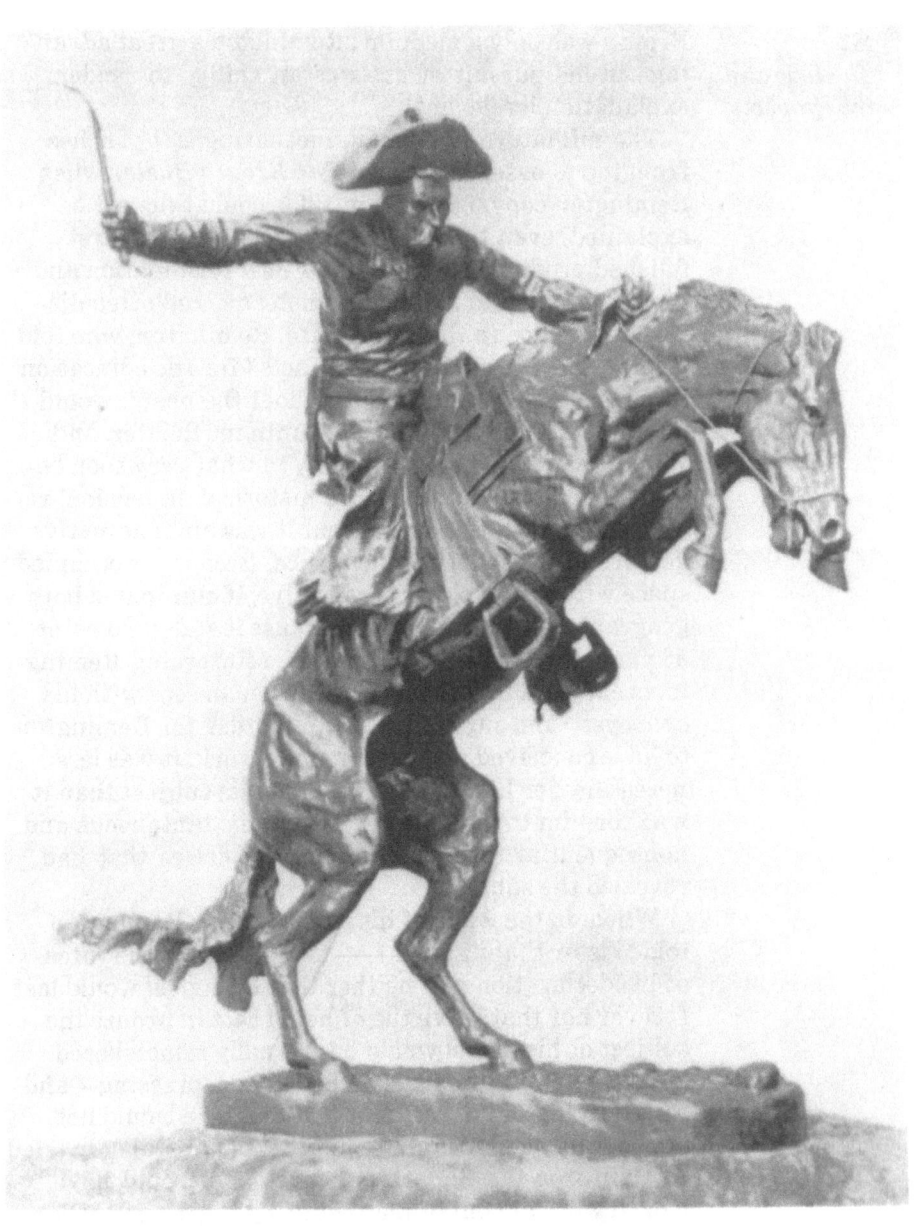

17. The Bronco Buster

Bronze was only a medium; Remington's great advantage in his pursuit of art was an ability to render explanation irrelevant.

The miniature horseman, measuring $23\frac{1}{4}$ inches from top to base, christened *The Bronco Buster* when Remington copyrighted it in 1895, could thus not be explained, even though it comprised both the first finished product of Remington's new formulation and the end product of a difficult, unsteady, and often distressing period in the artist's life. Remington, who told Wister that it would provide "facts" for the edification of people who "want to know about the past," would not understand its significance until much later, and Wister, who could regard it only in what very soon became its official and therefore historical dimension, remained incapable of seeing that it was an imaginative gesture of personal independence. Because it occupied space without invoking perspective, it eliminated both geography and chronology. Because it stated no point of view, it dissolved all alliances, reinforcing Remington's earlier admission that "every man sees with his own eyes" and suggesting that, in order for Remington to have conceived and executed the work, it was less necessary for him to have observed its subject than it was for him to have forged into an instantaneous and nonsequential form the sequence of crises that had revealed the subject.

When, in the wake of his achievement, Remington told Wister that "I am d—— near eternal," the force of his declaration was neither that his model would last forever nor that by virtue of being cast in bronze the subject of his model would be eternally remembered but that Remington had succeeded in expressing—and thus defying—the transient. Although he would not support the veneration Remington had mistakenly tried to claim for the Sonora punchers and would have looked woefully out of place hunting bears with Miles or chasing rioters in Chicago, the bronze homunculus perched on a bronco the size of a lapdog made up in energy what he lacked in scale. Since he was small enough to be seen in the mind, he was compressed enough to state the question that punchers, bear hunters, and rioters all merely helped identify: how did the artist seen with his own eyes look?

IV. Armageddon

1. Archaic Man

For Wister and Remington's other friends and associates, the question of how—and with what promise of meaning—the lean, precariously mounted miniature figure represented in *The Bronco Buster* constituted a projected self-image of the large, recalcitrantly aging artist was never resolved, because it only came up in oblique ways, as when such people offhandedly assigned to Remington the same patriotic virtues they associated with both the statuette and its putative subject, the cowboy. For Remington, the same question was a matter of great urgency and no little agitation—mostly because the condition of dynamic imbalance so vividly captured in the statuette reflected a like condition in the still erratic but rapidly accelerating logic of Remington imagination.

This condition was expressed by Remington's work in two ways during 1895: first, in a new concern with placement, which augured a new self-consciousness; second, in the record of an increasingly hectic series of diversionary pursuits, which unmistakably identified Remington's real difficulty in confronting the revelations of his new self-consciousness. Remington's conviction that neither art nor his own best interests had been served by his pursuit of currency did not therefore suffice to keep his work out of popular magazines,

and his growing awareness that he had missed profundity by recording multiplicity neither achieved his immediate penetration of a theme nor diminished the hecticness of his transcontinental search for themes he could quickly dispose of.

Indeed, his clay model of the *Buster* had hardly set before Remington was on his way to Florida in search of new types and, little more than a month after his February return to New Rochelle, he was on the move again—this time to Canada, where he made a backpacking and canoe trip north from Fort Tiemogamie with cronies much like those who had taken him duck shooting in North Dakota over a year before. In May, he dined with Roosevelt, Rudyard Kipling, and Wister in Washington, D.C. That summer, there was fishing, picnicking, and visiting in the North Country and, although preparation for a New York show featuring the *Buster* detained him at New Rochelle through the fall, he left on the day the show ended for shooting in Virginia, enthusiastic talk at San Antonio, and a quail hunt among the prickly pears of the West Texas desert. Having discovered that facts might be brought under his control, he mistakenly supposed that the way to achieve such control was to assimilate as many facts as possible, and his consequent gourmandising bore some resemblance to midday dinner at Roosevelt's Elkhorn Ranch.

Yet, even though Remington misunderstood the self-revelation promised by the revelation of bronze, his artistic misunderstanding contained a personal truth. From his schoolboy days onward, he had always resisted contemplation by asserting movement. His winters at school were relieved by summers at the racetrack; at Yale, football furnished him with a convenient substitute for study. When he was refused permission to marry Eva Caten in 1881, he promptly left for the Rocky Mountains; when financial disaster attached itself to him three years later at Kansas City, he quickly amputated it and departed for the North Country; threatened with professional failure in 1885, he left Kansas City for Arizona. Invariably, Remington responded to potential confrontations by fleeing from them, and the glimpse he had caught of himself in 1894 promised a confrontation more profound than any he had yet imagined. Arthur Hoeber's October 1895 review of the *Buster* stated the matter with keener

insight than Hoeber himself appears to have realized by calling Remington's new interest in bronze a "stampede" and supposing that it would surely take Remington tearing down "other roads."

To make the *Buster*, Hoeber said, meant "breaking away from the narrow limits and restraints of pen and ink on flat surface," and to make the *Buster* in three dimensions, complete with all the proper clothing and equipment, was to represent the "cowboy as he really was, divested of the nonsense of romance."[1] Remington's "profound knowledge" produced a "realism and intensity" about which Hoeber could say only that "every detail has been carried out," adding finally that Remington had "struck his gait" at last. Hoeber did not attempt to say what the collection of completed details signified or where Remington's erratic gait was likely to take him next but, if the statements he made in his review were correct, they made one point quite lucidly and very persistently, even though Hoeber would never have agreed with it: Remington was running away from something.

The key factor in the pattern of encounter and escape that his life increasingly expressed in 1895 was another fundamental change in Remington's perspective for, while he had earlier used point of view to indicate the nature and extent of his own involvement in the scenes he represented, an important consequence of bronze was that by eliminating point of view it demanded a variety of involvement that rendered the arrangements utilized in Remington's earlier work instantly meaningless. Before the change took place, a prescriptive viewpoint identified the artist's sketchbook with a camera lens and defined pictures in the sketchbook as sharply delimited segments in linear sequences. After the change was accomplished, even the inhibitions Hoeber called "limits and restraints of pen and ink on flat surface" did not suffice to keep flat pictures inside their square frames or to assign the artist a location in space at some point along whatever vectors his pictures established. Remington's new concern with placement was thus no mere technical advance which could be observed in some individual picture or series of pictures—it was a modification of the angle by means of which the artist measured his work in its totality. The point at which such modification occurred was a fulcrum between the fragmentary but

Archaic Man

1. Arthur Hoeber, "From Ink to Clay," *Harper's Weekly*, October 19, 1895, p. 993.

sequential record Remington's work made when regarded as history and the discrete, nonsequential arrangement the same work immediately became when regarded as creation.

Subscribers to popular magazines therefore surely recognized the familiar configurations of the Remington pictures published early in the year. The three final installments of Albion Tourgée's "factual" Civil War narrative, *The Story of a Thousand*, supplied Remington's martial illustrations with titles that both fit them perfectly and established their participation in the narrative they were designed to accompany.[2] Mounted soldiers "came up on . . . jaded horses" to march obediently past the artist's easel; infantrymen paused for "a halt on the march" just long enough for the artist to draw them; the "rear of the battery" faithfully represented what the artist might see if he looked toward the line of battle from the only position he might reasonably be expected to occupy—a point close enough to the fighting to sense its presence and far enough within Federal territory to be relatively safe. Throughout, there was the uninterrupted sense of a *line* toward which columns of mounted troops, files of foot soldiers, and batteries of artillery arrayed in rows moved with all the certainty of accomplished chronological progression. The presence of such a line and the artist's location adjacent to it were all that any of the pictures really communicated, and the picture called "Going Into Action" showed that the line was exactly the same as that Remington had put into his pictures of the Wounded Knee fight and the Chicago riots.[3] The line seemed to advance perpetually before the artist, who seemed compelled to follow it.

No restraints imposed by flat surface ordained such an arrangement; it was inflicted on Remington by an impulse that may only be called fearful. The line marked a frontier that might dissolve if it ceased to move and, if it dissolved, the conflict it stated would vanish, leaving the artist face to face with the question of why he was there. It was therefore an event of some importance when the May *Harper's Monthly* printed three of Remington's pictures with "La Tinaja Bonita," Wister's gloomy tale of star-crossed lovers in Arizona, for none of the three contained any indication of the lineality that had haunted Remington's work since 1890.[4]

2. "The Story of a Thousand," *Cosmopolitan*, January 1895, February 1895, March 1895.
3. "Going Into Action," February 1895, p. 495.
4. "La Tinaja Bonita," *Harper's Monthly*, May 1895, pp. 867–874.

The initial two pictures, both of which had been agreed upon by Wister and Henry Alden before Wister sent the manuscript to Remington, were largely of a piece. In the first, three figures, two of them male and one female, clearly stated an instance of the eternal triangle held eternally in equipoise by centripetal attraction. In the second, five frontiersmen similarly faced inward about an irregular circle—rather than bristling outward from an otherwise analogous circle, as in "The Last Stand," or being drawn up in columns to present the common enemy with a common front and the sympathetic artist with an even commoner backside, as at Wounded Knee and Chicago. The first picture utilized conventional figures set against a background as perfunctory as any Remington had drawn, and equally conventional figures appeared in the second picture, supported in wholly blank space only by blobs of shadow at their feet. Yet, in both cases, the arrangement of the figures seemed to promise some central secret that demanded discovery not by virtue of its accomplished historicity or its potential utility but for its own sake.

This promise was fulfilled by the third picture, which was Remington's own idea rather than Wister's or Alden's, in which the center designated in the first two pictures as a void was made to serve the radically modified sense of form and placement that accompanied Remington's efforts at sculpting three-dimensional clay models. Gone were the files of soldiers, the rows of artillery, and the implied or explicit edge of confrontation toward which they pointed and, since the edge itself had dissolved, sweeping away all the pointers by which it was defined, it was at last possible to see the center of the circle that the edge of confrontation had protected and obscured. The circular horizon, relieved only by a few small clumps of withered foliage, contained a flock of ravens circling above a dried-up water hole encircled by dead cattle. Within the pattern of concentric rings stood a single figure, his hat brim tilted at a peculiar angle to enclose his face in a dark halo. Readers of "La Tinaja" doubtless recognized the figure as Russ Genesmere, the story's hero, acting out the role assigned him—that of dying from thirst in the desert—but the logic by which Remington had arrived at the picture's execution identified the man in the middle as Remington himself.

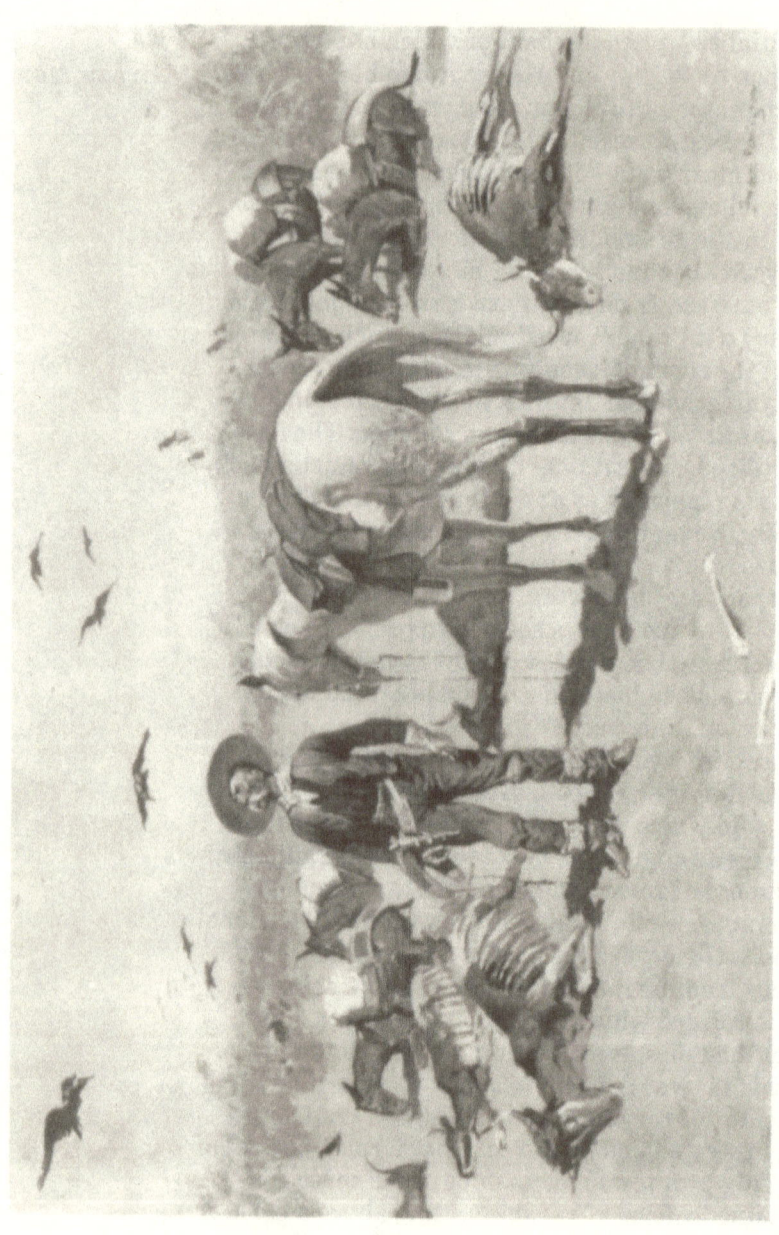

18. "You Don't Want to Talk This Way. You're Alone." This is the third picture Remington made for Wister's short story, "La Tinaja Bonita." Russ Genesmere, the hero, stands at the center.

Although the man in the picture looked lean and tough like Dan Gatlin and Montague Stevens' New Mexico cowboys, rather than large and fleshy like Remington, his isolation reflected Remington's suddenly acute sense of loneliness, and his emergence beyond the protective geometry that had sheltered many of his counterparts tallied with both Remington's foray into sculpting and his confrontation with the self-revealing theme that ran through nearly all his serious work. Remington had looked toward a whole series of distant places to imagine himself engaged there in some rewarding and finally significant activity. His travel, however, had only emphasized the disengagement he had feared, and the numerous friends and acquaintances he acquired while ranging so far vividly defined his own fundamental solitude. The protective geometry he had formulated was precisely a fortification against his own subjectivity.

When the fortification of collective enterprises built of straight lines and uniform surfaces crumbled under its own weight, and insight replaced objectivity, the solitary figure stated by the *Buster*, the man beneath the ravens, and many subsequent works emerged. Although he assumed various postures and costumes, there was never any doubt about his identity, because his condition was always the same. The space he occupied was always a void. He hung there momentarily, the embodiment of transience—an isolato perched at the brink of terminal crisis.[5] Before Remington had begun to wonder about the contours of his own temperament in 1893, he might have dismissed each permutation of this figure as a discrete segment of observed reality, supposing that his connection with each consisted principally in having recorded it. Now, he could not avoid the intimation that the figure was unitary rather than multiple and that his own involvement with it was less an act of observation than an attempt at exorcism.

Both Remington's tendency to run away from confrontations and the new freedom from lineality expressed in his otherwise more or less conventional picture of Russ Genesmere among the ravens were intricately involved in determining the form this attempt very shortly took. The former defined a tacit but persistent assumption that change of place could somehow effect change of mind and feeling; the latter pro-

5. I have used the term *isolato* to designate the figure of the isolated wanderer who appears in Remington's works as Indian, cowpuncher, and soldier. It is worth noting that this type occurs with some frequency in American literature of the nineteenth century. Perhaps the best articulations of it are Cooper's Natty Bumppo and Melville's Ishmael.

vided Remington with new insights into the ways in which place might be changed. The result was a dazzling demonstration of how exciting the new directions Arthur Hoeber called "other roads" might be for Remington, and it was also prophetic of the perverse but imaginative uses to which Remington would try to put such new directions. Ironically, however, the demonstration occurred in a context that linked it in important ways with the picture history Remington had pursued for *Harper's Weekly* a decade before, rendering it extremely difficult for his public to recognize.

In 1893, Remington had urged Wister to embark on a joint venture, conducted in both prose and pictures, with the aim of establishing the historical puncher's heroic qualities. Wister had found the proposal attractive but had also realized that Remington knew more about the subject than he did and, in consequence, Remington had soon begun to send him copious notes from which to write. By early 1894, however, Remington's view of the enterprise had subtly changed, so that he thought of it as quite another thing—a chronicle of the puncher's "rise and decline." The notes he sent to Wister therefore acquired a tone that was both curiously academic and breathlessly bewildered. Minute details concerning types of saddles and mounts, articles of clothing and equipment, and the origins of terms like "mustang" and "cayuse" dovetailed into fragmentary anecdotes of Arizona and New Mexico and hurried references to works of his own like "Horses of the Plains," giving the energetic, importunate letters he wrote to keep the project going the look of a final examination in some course aimed at encompassing the meaning of his western involvement.[6] Repeatedly and rather shrilly the letters declared the puncher significant, at the same time demonstrating Remington's inability to say what his significance was.

During the interval between the project's inception and its completion, however, Remington confronted the *Buster* and drew the man in the circle for "La Tinaja," in the process dispelling at least some of the confusion that had made it difficult for him to advise Wister about what the essay should contain. Meanwhile, Wister finished the essay itself, constructed largely from the variegated, piecemeal information in Remington's notes, and christened it "The Evolution of the Cow-Puncher," a title that both paralleled Reming-

6. See Vorpahl, pp. 47–55.

ton's demand for a discourse on the puncher's "rise and decline" and expressed his determination to fix the puncher's location in a thoroughly sequential scheme of things—where genetic traits, the social order, and even the face of the land were all subject to changes brought about by the passage of time. Since Remington's initial meeting with Wister in 1893 had coincided with the beginning of the cycle of personal unease that culminated in the *Buster*, the large, surprisingly "painterly" oils he made in 1895 to illustrate Wister's essay on the puncher's evolution constituted Remington's own history of the whole relationship.

"The Evolution" appeared in *Harper's Monthly* for September 1895, with Remington's five pictures distributed more or less evenly throughout its text. The first, an uneasily executed allegory entitled "The Last Cavalier," depicted the puncher's apotheosis. The second, "A Sage-Brush Pioneer," showed a more plausible horseman being chased by Indians across an arid plain. The third bore the unwieldy title "What an Unbranded Cow Has Cost" and depicted a carnage supposedly resulting from a dispute over the ownership of the animal in question. "There Was No Flora McIvor," printed fourth, depicted a puncher talking with two Indian women. In the fifth and last, two tired punchers—encountering a fence—demonstrated the principle that would soon inform Frederick Jackson Turner's frontier hypothesis and thus could be said to enact "The Fall of the Cowboy." Despite the titles, all the pictures were clearly superior, with the exception of "The Last Cavalier"—a work crippled by sentimentality—and even it showed a good deal of erudite technique. Yet the pictures, arranged in such a fashion and placed in such a context, looked wrong. One reason was that Wister's references to them in the text were almost always silly; the other, far more important, was that they in no way demonstrated any historic or evolutionary sequence. In addition, coming to them from the *Buster* was a distinct disappointment, for they were all somewhat cluttered: not one contained a permutation of Remington's newly discovered isolato when observed separately.

Whether or not readers thought of the picture history as they read Wister's quasihistorical text and looked at Remington's pictures, the two enterprises had common characteristics, and Remington's involvement

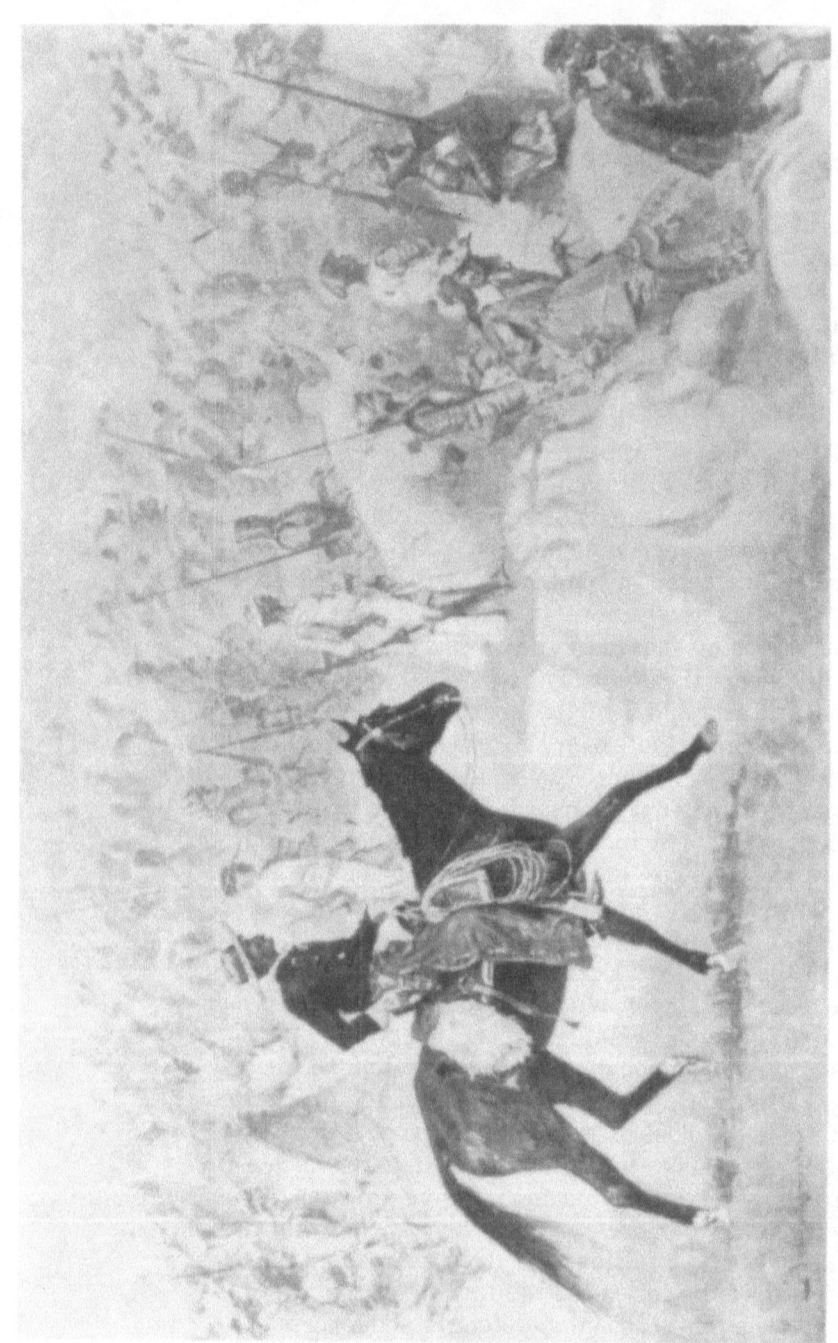
19. "The Last Cavalier"

20. "A Sage-Brush Pioneer"

in the second enterprise was analogous with his involvement in the first. In both cases, his pictures were treated as "historical" but refused to express the sequence associated with history and, in both cases, the relationship between text and pictures thus became perfunctory and contrived. Yet, even as early as 1887, Remington had arrived at an interesting, highly original, and—so far as readers of the picture history were concerned—nearly invisible way of dealing with such a situation.

The series of Indian pictures he made that year for *Harper's Weekly* had begun with a composite study, in which twelve sketches showing facets of Papago Indian life were welded into a single, harmonious design. Some half a year afterward, the same series had closed with a similar composite study, this time with a military focus—which, when placed together with the opening study, generated still another composite that both made its own statement and commented on the works that intervened. Remington had countered sequence with design, and the informing element in his ingenious maneuver was placement. Placement was likewise what made the design of his "Evolution" pictures invisible in *Harper's Monthly* and what made the invisible isolato of those pictures visible again, once the design was asserted. The whole was not only an exorcism, it was also an alternation between two very different varieties of order.

Viewed as they were printed in the text, Remington's five pictures failed to state a meaningful continuum; viewed as though they hung along a single wall, they exhibited a remarkable and meaningful symmetry that caused each to be significantly modified by the presence of the others. "The Fall of the Cowboy" on the right balanced "The Last Cavalier" on the left. The "Sage-Brush Pioneer" to the cavalier's right balanced the more serene puncher in "There Was No Flora McIvor," to the left of "The Fall." All four pointed to the central picture that defined them all. Indeed, it may be argued that Remington's pictures for "The Evolution" were not five separate works but were units which looked separate and distinct only when viewed in chronological sequence: when placed in proper spatial relationship, they became a single, composite work.

By itself, "The Last Cavalier" seemed a concession to Wister's sentimentalism—which it probably was. In

21. *"What an Unbranded Cow Has Cost"*

22. "There Was No Flora McIvor"

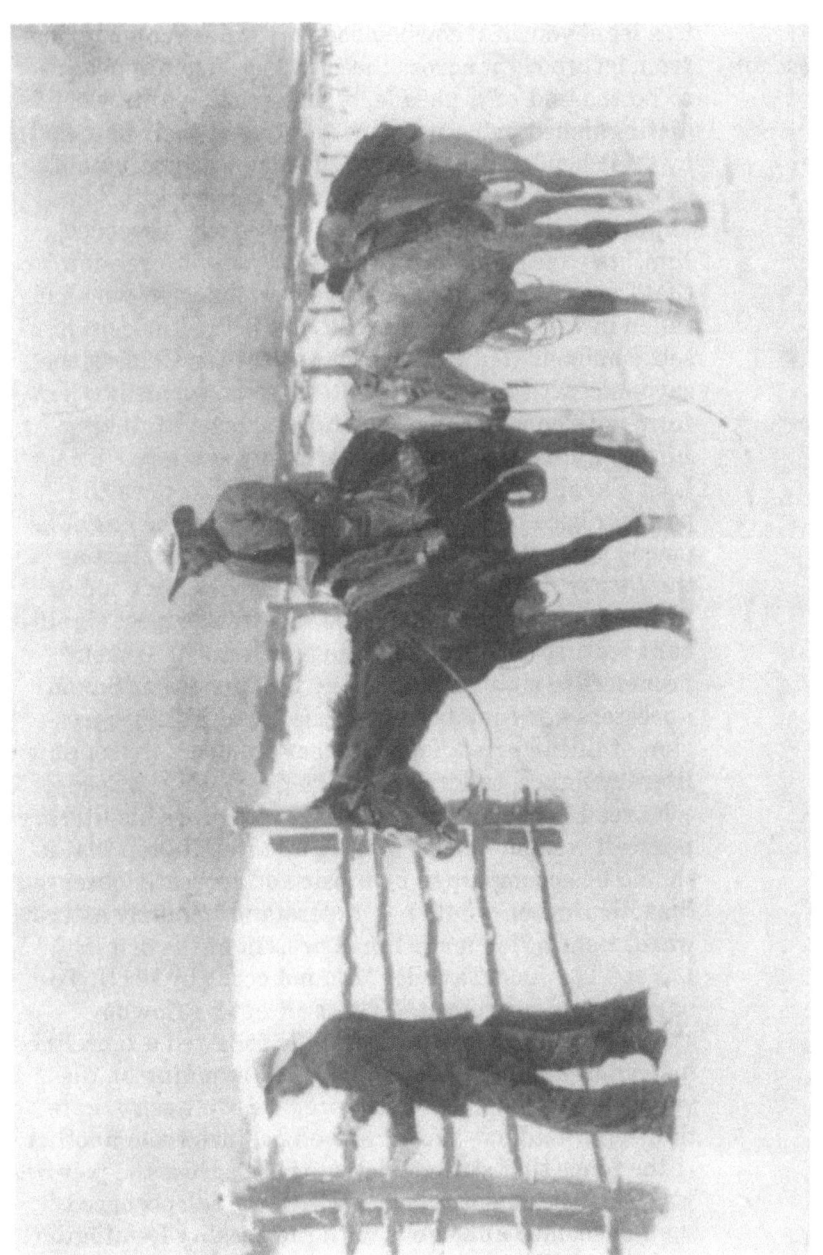

23. "The Fall of the Cowboy"

it, a lean, youthful cowboy rode his well-groomed pony from left to right across the canvas at what appeared to be the end of a parade, whose participants were distinguished principally by the style of their hair and by their headgear. Although the idea was presumably to suggest that the puncher would ride off into some happy hunting ground like the heroes who preceded him, its execution was imperiled by an impression that the cavalier might be merely an innocent who had fallen in with evil companions. While the innocent himself demonstrated Remington's talent for welding the sardonic with the graceful, Remington seemed to perform with considerable reluctance the act of linking him to a linear progression of foggy soldiers. "The Last Cavalier" by itself proved only that once the puncher became a creature of imagination he might be placed against whatever backdrop one chose, just as the *Buster*, being portable, might decorate a boudoir or a tearoom. Thus considered, the work's most significant feature was probably the puncher's movement from left to right, which linked him to neither Saxon ancestors nor romance but to the inexorable progression of linear print. This puncher seemed a thoroughly literary figure, tailored to fit the perceptions of people who read books and magazines. Just before his literary portrait was published, Wister told Remington that it should be accompanied by music and correctly observed that Remington would not understand.[7] Shortly afterward, Remington made him a present of the original.

Yet "The Last Cavalier" did not occur by itself. To balance and redeem it, "The Fall of the Cowboy" showed two ragged herdsmen who followed a fenceline instead of a parade and, rather than standing on the verge of glorious posterity, prepared to open a gate that separated one snow-covered pasture from another. If the fence that stretched diagonally across the picture was the instrument through which the fall occurred, the fall seemed analogous with the passing Remington had urged Wister to write about, but such lineality possessed a lasting stasis antithetical to the kinesis associated with a frontier or border. Furthermore, the two herdsmen and their mounts faced in the opposite direction from the opening puncher but toward the same center, thus establishing a central focus.

To reinforce this focus, "There Was No Flora McIvor" replaced the fenceline with a row of Indian

7. August 25, 1895, letter from Wister to Remington, in the Wister Collection, Library of Congress, quoted in Vorpahl, p. 75.

tepees confronted by a sturdy puncher who sat amiably astride a lively-looking pony. While the row of tepees in this picture corresponded to the fenceline in "The Fall," it was seen both from the other side and the other end, so that the puncher looked not forward toward the next in a series of compartmentalized units but backward, beyond two Indian women, at an image of which he and his mount appeared to be a permutation. Facing back at him from the right, like a reflection in a mirror, the picture of an Indian horseman echoed both the puncher and any one of the several figures who appeared behind him in "A Sage-Brush Pioneer."

There, an utterly blank sky hung above an arc of featureless horizon, from which a troop of Indian horsemen seemed to sprout as they mounted a rise in the middle distance. Leaping outward from the foreground as he rode obliquely across the canvas, a hatless white man fled a kinetic line of Indian warriors. The unmistakable resemblance both he and his pursuers bore to the Indian horseman painted on the tepee in "There Was No Flora McIvor" stated the new function all four flanking pictures acquired when placed on either side of the unfortunately named "What an Unbranded Cow Has Cost." The sagebrush pioneer and his more peaceful counterpart, the sentimental puncher of "The Last Cavalier," and the shivering herdsmen of "The Fall" all pointed to the central void established precisely by their presence, in which Remington's newly discovered isolato appeared as though by magic.

Two wounded men at the foreground inclined their bodies toward the single standing figure, and a rifle was aimed at him from the right rear, as well as a pistol from the middle distance, all confirming the posture of the man at the far left who pointed his revolver like an accusing finger. These gestures were more eloquent than words, although Wister wanted the scene to illustrate a story of "mediaeval . . . simplicity" he associated with Sir Walter Scott.[8] Unlike the various permutations of himself that flanked him, the central isolato was truly central and truly isolated. Along with the *Buster*, and Russ Genesmere among the ravens, he had come to the end of whatever past he may have occupied—into a place where no future could accommodate him. He was Remington's embodiment of the archaic, and formulating the incarnation he comprised

8. "The Evolution of the Cow-Puncher," *Harper's Monthly*, September 1895, p. 609.

was Remington's finest accomplishment to date for, in order to find out what the man in the middle looked like, Remington had been compelled not only to examine the seemingly discontinuous elements of his vision but to bring them under his control, discovering as he did so an order of imagination in which transience became permanent, sequence was replaced by symmetry, and time could be rendered meaningless by manipulating location.

The significance of this discovery for Remington's work can hardly be overestimated for, if even the sentimentality of "The Last Cavalier" could be redeemed by creating a context that transformed its function, nothing seemed beyond the reach of a like transformation. Beginning with the pentacle he had devised for "The Evolution," Remington set about the task of rearranging, and thus redeeming, what seemed to him a global, even a cosmic, mistake. For the next two years, he labored to construct a design that would subvert the sequence of historic events in the same way as his five pictures had subverted the sequence of "The Evolution."

2. Top of Speculation

Although Remington would probably not have identified it as such, the condition he regarded as a mistake —and thus sought to correct—was the condition ordained by entropy, or the tendency of all matter toward a simple, undifferentiated state. In his *Education*, Henry Adams associated this condition with historical "chaos," and E. L. Gombrich has more recently defined its relationship with art as involving both the fragmentation of "actual" order and the formation of an artistic counterorder which may itself suggest—or even cause to be repeated—the fragmentation that produced it. The problem that entropy presented Remington may be seen at a glance by looking at either the *Buster* or the central figure of the "Evolution" pictures. While the bronze buster can never be thrown from his bronze mount because both are parts of the same statuette, a "historical" rider put in the buster's place would immediately complete the fall already begun by the buster; although the standing puncher in "What an Unbranded Cow Has Cost" can never fall simply because the picture keeps him standing, a "historical" personage set in the same deadly center would be killed. Such perceptions, of course, would appear to involve little more than a commonplace distinction between historic process and artistic stasis and therefore do

not ordinarily cause much concern—yet Remington's assertive imagination consistently blurred distinctions between the historic and the artistic. Following the spectacular display of antihistorical order accomplished in his "Evolution" pictures, he accordingly embarked on another project aimed at establishing the same order on a larger scale: having been told for more than a decade by Bigelow, Wister, Hoeber, and others that his work was "historical," he began attempting to use his work to *remake* history, searching first the historical past of the West, then the personal past of his own experience, for some secret that would enable him to endow his formulation of the archaic with the future dimension required by historic sequence.

His attempt involved a decidedly complex combination of factors. One was the double relationship that linked the artist with his subject on one hand and his audience on the other. Another was the relationship among the works the artist produced in sequence but regarded as parts of a spatially arranged pattern. Yet a third was the relationship between such a pattern and the pattern of historical events that linked past, present, and future in sequential and supposedly irreversible progression. All three, however, achieved more or less lucid articulation in two events Remington touched near the end of 1895: the annual New York Horse Show at Madison Square Garden and Remington's own one-man show and sale at the American Art Gallery on Twenty-Third Street. Theodore Dreiser approached the first event obliquely and from a dizzying height when, signing himself "The Prophet," he admitted in a December essay that an order of importance was difficult to establish among such large historical concerns as the coming Advent season, corrupt New York City politics, and a fear that Europe might erupt in war—and therefore turned instead to the horse show at the Garden, where he found "wonderful proof of what society can do when it desires to put itself on exhibition."[9] Theodore Roosevelt matter-of-factly addressed the second event a fortnight later, when, having attended Remington's newly opened show, he confessed to Remington in an admiring letter that "I have never so wished to be a millionaire . . . as when you have pictures to sell."[10]

The horse show annoyed Dreiser because he noticed that a number of expensively attired women took ad-

9. Theodore Dreiser, "Review of the Month," *Ev'ry Month*, December 1895, pp. 2–3.
10. Quoted in McCracken, pp. 89–90.

vantage of the occasion to display themselves when they should have been doing something worthwhile, such as being "patrons of Remington and young Pollard." The whole affair, he thought, was an unfortunate demonstration of how history worked. History, he insisted, involved shifting patterns of fashion which might be expected to serve art but which art could not be ruled by. Art, on the other hand, expressed perceptions so intense they could never be truly fashionable. The two realms were altogether distinct. Yet Remington's show at the gallery emphatically contradicted the historic lesson Dreiser derived from the horse show, for oils, watercolors, and drawings there lined walls that became a hall of mirrors by virtue of having the bronze *Buster* placed at their center, demonstrating how supposedly factual representations of historic subjects were subtly and significantly altered when displayed in company with an avatar of the artist. In other words, the relationships that linked the artist with his subjects and his audience were blurred, the relationship among the artist's individual works was mostly unrecognized, and the relationship between the artist's work and history was persistently misunderstood. Wister was no help at all, because even though he venerated history he did not possess the insight that allowed Dreiser to see the horse show as historical—of the works exhibited at the art show, he preferred fondly consigning "The Last Cavalier" to a region he called the Past while ignoring the rest. Remington's other friends and associates had plenty of praise but very little enlightenment to offer, and his editors, understandably grateful for whatever Remington's exhibition as painter and sculptor might add to his prestige as illustrator, did not trouble themselves about the exhibition's significance. Of all the people who strolled through the Twenty-Third Street gallery, only Roosevelt—with his eye for utility and his politician's sense of the collective—appears to have made a sensitive and sensible response.

Like Dreiser and Remington, Roosevelt had been to both the horse show and the art show, seeing, furthermore, both history and horses at the former and, at the latter, both the *Buster* himself and the reflections of him bounced back by the surrounding equine combinations. Chances are that he even admired pretty women at both events—but his habits of mind made instantly

available to him the insight many others missed: placing himself in a room with the *Buster* to look at pictures of soldiers and punchers was "historical" participation in the aesthetic process stated by the pictures and the bronze; placement of the three-dimensional *Buster* among two-dimensional reflections of him paralleled the placement of a viewer who was subject to time among works in which time was frozen. In the letter he wrote to Remington, Roosevelt's identification of himself as a "literary man with a large family of small children and a taste for practical politics and bear hunting" therefore had a special force, as did his further confession that he wished to be a millionaire, for the identification and the confession together naïvely but lucidly defined the activity Remington's exhibition required of its viewers. The hall of mirrors on Twenty-Third Street was neither history nor the Past: it was a pregnant fantasy. Its chief function was not to record but to reflect.

Yet Remington's pictures mirrored not only the *Buster* and the imagined self-images of viewers who, because they were present, could more or less put themselves physically in the buster's place—they also mirrored the pages of periodicals, where they had been printed in quantities of thousands and displayed long before the art show opened, which in turn mirrored imagined self-images of viewers who could *imagine* themselves in the buster's place, much as spectators at the horse show might imagine themselves in the expensive clothing to which Dreiser objected. Thus, only a slight shift in ground was necessary to apply Roosevelt's penetrating confession to the thousands of Remington's admirers across the country who qualified as literary by virtue of subscribing to magazines and who expressed their taste for practical politics and bear hunting by reading about them. Most of these people probably wished they were millionaires, and all in some sense qualified as Remington's patrons. While such range and magnitude of patronage testified to Remington's success, they also established the popularity of his work as a distinctly historical phenomenon and threatened him with the very specter of fashion Dreiser despised. In other words, Remington's popularity—most especially his popularity in large national magazines—had a remarkable capability for demonstrably changing the whole body of his work.

An ironic consequence of the escape from two-dimensional lineality which had made the art show possible was thus that it not only made Remington's isolato fashionable, it also rendered Remington himself in some sense a model of fashion—which is to say that it required him to disavow the isolato's meaning. Immediately following the reappraisal that swept him into the void epitomized by his bronze and reflected in his paintings of concentric circles, he seemed to clutch at the mask of traveling correspondent again, as though to reestablish the surface order of objects and events that vanished when it was superseded by the order of imagination. The result was a counterexhibition that denied the art show on Twenty-Third Street—much as the show had denied the horse show—and that displayed the artist as an example of the curiosity then commonly known in genteel circles as a "D. F.," or "damn fine" fellow, conducted with the apparent intention of showing that he was not a rebel. Although it was a dismal farce, the counterexhibition was not without meaning. It expressed both Remington's desire to satisfy the tastes of his absentee patrons and his perception of what his patrons were like. In this sense, it was Remington's most savage assault on gentility to date, even though he did not intend it as one.

The D. F. made his first appearance on the Gulf coast as something Remington, in a May 1895 essay for *Harper's Weekly*, called a "Florida sportsman," who found fishing dull work but thought ducks "confiding birds"—he helpfully advised his readers that a "boat loaded with girls and grub and Scotch whiskey and soda can be sailed right up to them while the sportsman empties his shot-gun and fills his game bag."[11] Significantly, however, the account suggested that the respectability Remington achieved as the D. F. was less a matter of the sportsman's paraphernalia than it was of a meretricious refusal to recognize the tribesman, even when the tribesman stood before him. Two ragged cowboys he encountered in the Florida pine barrens therefore served to make his dissociation from the unfashionable tribe explicit.

These "crackers" had three negative characteristics which made his task relatively easy: they were not ambitious, they were not sociable, and they did not espouse currently accepted standards of moral conduct.[12] As inhabitants of a region of "ooze and rank grass"

11. "Winter Shooting on the Gulf Coast of Florida," *Harper's Weekly*, May 11, 1895, p. 451.
12. "Cracker Cowboys of Florida," *Harper's Monthly*, August 1895, p. 339.

where "dreary pine trunks line up and shut out the view," they were necessarily separated from the sportsmen and their boats and therefore invited Remington's designation of them as "lonely." What they did remained largely secret and, since it was secret, it seemed likely that it was also illegal. Most of them, Remington supposed, were "rustlers." Yet he could not help noticing that the crackers rode "emaciated Texas ponies" that resembled underfed versions of those the punchers used at San José de Bavicora, that they shared their poverty and loneliness with Montague Stevens' New Mexico cowboys, and that their putative addiction to cattle rustling was a trait he had previously regarded as an assertion of individuality rather than a symptom of moral weakness. Placement was obviously as important for the sportsman in Florida as it had been for the bear hunter and would-be millionaire at the art show in New York.

At first, Remington's account gave the impression that the crackers' placement in Florida was responsible for Remington's scorn. Yet the crackers' placement finally mattered far less than Remington's placement alongside his absentee patrons in an enclave from which he could observe that the crackers compared to their western counterparts in about the same way as a "yellow cur" compared to a "fox terrier" or that, "while some of the tail feathers were the same, they would easily classify as new birds." Boats, women, and whisky were all far less effective shields against the tribe than the expressed attitude that removed the D. F. so far from his subjects in order to bring him closer to his audience. Remington's abrupt maneuver had an immediate if conditional result: it reestablished the sense of a frontier and even rescued the artist from isolation.

The result was immediate because of the clarity with which it seemed to repudiate all the show on Twenty-Third Street had accomplished and to callously reject the self-perception Remington had achieved at such great personal cost; it was conditional because it augured an even more costly and perhaps ultimately more valuable self-perception and began the attenuated exhibition that could end only when it had wholly consumed the artist. This is to say that Remington's vision of himself as the sportsman was as accurate in its way as his vision of himself as the buster had been, as well

as being altogether more vulnerable to the lacerations his ironic habits of mind were capable of inflicting. Remington was clearly aware that the reemergence of a frontier within his frame of perception meant he had been momentarily successful in erecting another threshold in his protective geometry, and as he examined this threshold he became increasingly aware that it was also a *different* threshold from that which had separated him from the *Buster*. The threshold he had begun constructing after Wounded Knee had functioned temporarily to shield him from the *Buster*'s isolation; the one he now confronted seemed designed to protect the *Buster* from historic process. Remington's next account of himself as a sportsman contained evidence that he could now not only see himself but could also see himself performing a series of evasions to keep from confronting that which his art addressed: it was a muted but bitterly ironic recognition that the fragile subterfuge which kept the falling buster in his seat was wholly incapable of accomplishing the purposes his imagination had energetically but naïvely formulated.

Had it been written by Julian Ralph, Wister, or any of the other writers with whom Remington had worked, this account might have been innocent enough, for it purported to be merely a narrative of travel—and, even in Remington's telling, its incidents seemed still almost connected with the naïve excitement he had earlier managed to evoke from places like the Pine Ridge reservation or San José de Bavicora.[13] Shortly after returning from his Florida encounter with the crackers, Remington had set out for Canada. Two companions designated only as a "lawyer with eyeglasses and settled habits" and a "merchant ... in reality an atavistic Norseman" accompanied him, supposedly sharing his desire to find "lakes bigger than Champlain with unnamed rivers between them" somewhere in the vast stretch of country that extended north from the Canadian Pacific rail line and on to Hudson's Bay. Its boyish rhetoric aside, this kind of writing made a direct appeal to the imagination. The travelers who carried other and more potent identities beneath their sedate appearance, the blankness of the region they entered, and the prospect of uncovering secrets all stated the delights of possibility. Very soon, however, the pattern of the narrative underwent a sudden and drastic

13. "The Strange Days That Came to Jimmie Friday," *Harper's Monthly*, August 1896, pp. 410–419.

transformation, for what waited in Canada for the three adventurers from New York was not a new landscape but simply the obverse of an old one: instead of escaping even momentarily into the archaic, they found themselves in a situation resembling that of a socialite at the Twenty-Third Street art show.

Remington achieved the transformation of his narrative by leaving blank the undiscovered landscape that constituted its ostensible focus and concentrating instead on the points of view that made the landscape's discovery impossible. On one side of the central mystery, the three American clubmen regarded the wilderness hopefully but gingerly, supposing that it was indeed mysterious. On the other, a motley crew of tribesmen peered out of the same wilderness to find the clubmen incomprehensible. At the center loomed an unmapped country known to neither tribesmen nor clubmen and designated by Remington as "that awful beyond."[14]

Clubmen and tribesmen encountered each other at Bais des Pierres, a lumbering town on the Ottawa River, where an Indian who called himself Jimmie Friday joined the expedition as man of all work, two métis —or people of mixed French and Indian blood—were hired as guides, and a tall, burly Scots-Canadian was employed as cook, giving the entourage a genetic range that reached from the aboriginal American to the transplanted European. While such an appearance of continuity might be initially reassuring, Remington rendered it ambivalent and tenuous by linking it with a continuity of another kind. The awful beyond, he said, "for centuries has stood across the path of the pioneer, and in these latter days confronts the sportsman and the wilderness lover." The presence of an Indian and a lawyer with settled habits in the same expedition appeared to suggest the continuing availability of the archaic, but the successive presence of a pioneer and a sportsman along the same frontier suggested only the inevitability of diminishment and oblivion.

Again, placement was the key element in Remington's perception, for the awful beyond into which Jimmie Friday would someday disappear—as the pioneers had disappeared already—looked most attractive to the sportsman when viewed from New York, and the miniature buster, with his ability to eternally keep his

14. Ibid., p. 410.

precarious seat, looked less like history and more like art when seen from the distance of Jimmie Friday's wilderness. Remington's account of the Canadian venture allowed him another perception as well: by sighting along the same line, the archaic buster and the archaic Indian could be brought into view simultaneously. This meant that the angle of vision Remington established to perceive the archaic was no less a line than was the wall that separated him from the cracker cowboys.

Remington had previously made a sharp distinction between these two kinds of lineality, supposing that the latter might serve as protection in the present and that the former might carry him back to make a connection with the past, as it had at San José de Bavicora. A sense of the line as path informed the collection of his San José essays, published on April 3, 1895, under the title of *Pony Tracks*, a name that suggested fading signals left behind by a traveler into Remington's version of the place Mark Twain more decisively called the "Great Dark."¹⁵ The conjunction of Jimmie Friday and the buster, however, shifted the coordinates of the whole pattern, so that the line as path and the line as barrier suddenly looked the same, replacing Remington's lately reestablished sense of a protective frontier with the sense of another line that stretched neither across the region of the present nor back through time toward the region of the past but *in* through perceptual space. The development was both subtle and important, for it allowed Remington to ask a vital question: if the path named in *Pony Tracks* extended inward rather than backward, what prevented travel along it *outward*? Sportsmen notwithstanding, a new pattern had already begun to replace the system of confrontation and escape by means of which Remington had journeyed away from Canton's tangle of commitments, into the vacancies of the West, and toward the *Buster*'s freedom from allegiances.

A generation earlier, Walt Whitman had sketched this pattern in "Passage to India," asking "what is the present, after all, but a growth out of the past?" and proceeding to answer that "as a projectile, form'd, impell'd passing a certain line, still keeps on, / so the present, utterly form'd, is impelled by the past." Here, in fact, were *both* the lines that had occupied Remington's attention—the line of the chronological frontier

Top of Speculation

15. Remington, *Pony Tracks* (New York: Harper & Brothers, 1895).

and the line of the track that crossed it. Characteristically, however, Remington endowed the pattern with an emphasis of his own, translating his own past, which began with the Civil War, into a universal principle. The projectile that linked Whitman's "unfathomed retrospect" with the "secret of the earth and sky" Whitman expected the future to reveal thus appeared to Remington as a column of soldiers. Despite the popular notion articulated by Wister and others that such a column was steadily retreating into history, Remington insisted that it marched out of the past, through the present, and into the future. When Remington went to San Antonio that winter, he therefore thought he had found the prophet for a new religion in the person of Colonel "Rip" Ford, who had engaged in battle with Mexicans, Comanches, and white Texans like himself, both consecutively and simultaneously, since about 1836, for—sighting outward along the same line that reached inward toward the colonel's memories—Remington pictured vivid historical fulfillment of his own personal aspirations.

Colonel Ford was a "very old man" who had, nearly sixty years before, joined Captain Jack Hayes' company of Texas Rangers, accepting in payment the regulation dollar per day plus expenses. With a smile of "pleasant recollection" that occasionally gave way to a chuckle, he amiably complied with Remington's request to share some of the highlights of his career. These were horrific, bizarre, and lucid. In 1851, he said, he and six other rangers had encountered and killed fourteen Indians. In 1858, he had wiped out a village of some three hundred Comanches, noting as he returned from the affair that his Tauhauhaucan scouts carried severed limbs and "pieces of flesh" cut from the Comanche corpses to a "cannibal feast" held in his camp that night. An ancient Comanche woman who had survived the carnage somehow made her way to the fireside where her tribesmen were being cooked and eaten, emerging into the light to curse the participants. Although Ford remembered directing the scouts to "let her alone," he was not surprised to later discover "that that is just what they didn't do."[16] Even Remington acknowledged that the narrative might have been given rather different contours had it been told by someone "capable ... of more points of view than the Colonel was used to taking," but what he

16. "How the Law Got Into the Chaparral," *Harper's Monthly*, December 1896, p. 60.

called the "outlines of the thing" impressed him. The colonel's return from a "wild past" to tell stories of bloodshed, torture, and cannibalism in a smoke-filled room at San Antonio signaled a chronological expansion of the frontier Remington sought to construct as replacement for the lineality he lost in his encounter with three-dimensional bronze. It formed the basis for a hope that, since the Indian, the puncher, and the frontier trooper had exhausted geographical frontiers, the chronological region they now occupied might somehow invade the present.

Looking backward thus became an act of prophecy rather than an investigation of history and, as Remington performed this act in Colonel Ford's hotel room, he saw the "brave young faces of the hosts which poured into Texas to war with the enemies of their race."[17] At first, the imaginary company looked something like the parade of criminals that trooped across the canvas of "The Last Cavalier" ahead of a dandified cowpuncher but, instead of vanishing into the foggy region Wister had called the Past, they dashed out of it to fulfill the expectation contained in Remington's tenet that they were "impelled by Destiny to conquer." Having undertaken what Dan De Quille had six months before called a "jornada del muerto,"[18] they underwent an apotheosis in Remington's imagination that brought them back from the awful beyond and infected the present with the death they symbolized.

In consequence, Remington was able as never before to integrate his pursuit of the new and current with his corresponding pursuit of the archaic, but the synthesis he achieved remained unsatisfactory because he did not yet comprehend the meaning it held for his imagination. On one hand, he joined gentility for duck shoots, drew pictures of the New York Horse Show, and held forth in print concerning the merits of every new development in military ordnance and training as though he were a drama critic discussing the fine points of a current theatrical season. On the other, he found that the subjects he knew best rapidly sank away from the present into a past where intervening events threatened to obscure them. A book of his pictures, entitled *Drawings*, published in 1897, served the latter impulse, as did most of the essays and stories collected as *Crooked Trails* the year after, for the cast of both pictures and narratives was retrospective.[19] The for-

17. Ibid., p. 64.
18. Dan De Quille, "An Indian Story of the Sierra Madre," *Cosmopolitan*, June 1895, pp. 180–195.
19. *Drawings* (New York: R. H. Russell, 1897); *Crooked Trails* (New York: Harper & Brothers, 1898).

mer impulse pointed him away from subjects like the Apache warriors and bearded frontiersmen who had long ago accomplished their jornada del muerto toward subjects like New York City's Troop A, now become Squadron A, of which he remarked in 1896 that it was "about twenty-two years of age in the aggregate" and that it dreamed of the day it could "draw the fire of the audience."[20]

To put the matter most simply, the present refused to serve Remington. How stubbornly it resisted his efforts to forge it into a link that would connect and justify the twin eruptions of the archaic he imagined in the past and the future was shown whenever he addressed it, for his imagination kept pointing him elsewhere. During the same Texas trip that brought him into contact with Colonel Ford, for instance, he had watched units of the Twenty-Third Infantry perform "hasty intrenchment drill" but, when it came to writing an account of his observations, he found it impossible to focus on what he had seen.[21] His conviction that "hasty intrenching" must be learned by soldiers who occupied a present that contained no enemies derived from his antecedent conviction that they, like the rangers before them, would in the future fight new wars of conquest. What he anticipated was a military conflict over the control of Cuba or, as he put it in a letter to Wister, a "big war with Spain."[22]

Precisely because this conflict was *not* in the present, Remington could link it with the past, imagining that it would assert apocalypse on a scale like that of the Civil War and revitalize the same imperial destinies that afterward sent white men and black men to fight together against red men in the West. In addition—also because the war was not in the present—he could imagine that it would involve himself—perhaps even as the Civil War had involved his father and the Sioux wars had involved his hero, General Custer, and his friend, Lieutenant Casey. Enclosing a caricature of himself in field uniform, complete with the newly adopted duffle bag-blanket roll he had recently seen in Texas, he wrote to Wister that a war "with the Dagoes or the Yaps" would be "just our ticket for soup," concluding with a promise to "start in as a Capt. of Infantry" when the event occurred.[23] His enthusiasm for the Spanish war contained the same ambivalence that

20. "Squadron A's Games," *Harper's Weekly*, March 28, 1896, p. 295.
21. "Hasty Intrenchment Drill," *Harper's Weekly*, August 8, 1896, p. 788.
22. Undated letter written in April 1896, the Wister Collection, Library of Congress, quoted in Vorpahl, p. 221.
23. Undated letter written in June 1896, the Wister Collection, Library of Congress, quoted in Vorpahl, pp. 225–226.

marked his pursuit of Indians who vanished while he watched them and cowpunchers who dissolved into riot police almost before he could sketch them. Much as he wanted to believe with Whitman that past, present, and future were linked in a single harmony, he could never address supposedly historical subjects without leaving the center blank and there placing a Janus-faced image of himself.

This rather painful circumstance had a perverse virtue. Eventually, it required of Remington that he exert the power of his highly selective imagination to impose a unique order on otherwise random events. For now, it initiated a period of intense and varied activity founded both on his impulsive conviction that the future might be shaped to fit aesthetic rhythms and on his hopeful theory that such rhythms were less coherent with the present than with a past where they waited to be discovered. The *Harper's* picture history had decisively proven him no historian, but a book like *Drawings*—which Wister mistakenly called historical—demonstrated Remington's talent for capturing a sense of exotic antiquity in works where the tilt of the landscape, the arrangement of the figures, or the magnitude and configuration of the sky served as signals that the events represented were out of step with contemporary actuality. What Wister mistook for history in such pictures was largely a matter of integrity. They succeeded best when their elements were arranged in a discrete internal harmony that stated disharmony with the changed and changing external continuum beyond the frame. Remington's intense personal involvement with these pictures not only prevented him from adequately comprehending any historic sequence that included a present, it also compelled his engagement as artist of issues he had before been tempted as reporter merely to record.

While Remington waited for the future to ratify his expectations, he therefore searched the past for models of the form such ratification might take. The most serious problem involved in his endeavor was that of the present, which he had counted on to be disjunctive from the past and which he repeatedly ordained as disjunctive from a future he hoped would provide his pictures with a truly "historical" sense of continuity. Only one solution was possible. Given the values Rem-

ington assigned to past and future and the continuity he sought to forge between them, it was necessary to eliminate the present.

For an intelligence attuned to historical rhythms, such prestidigitation contained no challenge at all, for the business of coordinating events in a chronological progression depended upon an understanding that the present counted for something only before or after its occurrence. Dreiser, in the same truncated jeremiad he launched at socialites at the New York Horse Show, dismissed it, observing like the Preacher of Ecclesiastes that "everything seems doomed to pass away."[24] For Remington, however, who preferred the immediacy of perception to the profundity of reflection, the task was harder. Dreiser's dismissal of the present was accomplished by consigning it to the past; Remington's union of the past with the future was accomplished by replacing the uncontrollable present with a grid of intensely personal associations by which he was himself controlled.

The summer of 1896 therefore found him in Montana—the site of his earliest encounter with the West—observing the Tenth Cavalry—which he had first encountered at Fort Grant in 1885—perform maneuvers at Fort Assiniboine, a few miles from the site of Custer's disastrous fight with Sitting Bull. Even by itself, a setting so heavily weighted with symbolic possibilities might well have acted as a catalyst. As it was, the setting conjoined with the event to make what seemed to Remington exactly the harmony he sought, justifying on aesthetic grounds his preference for military subjects, his desire for war, and his wish to somehow formulate a scheme of things in which the present did not exist. Embedded in the inevitable clutter of martial details that ballasted his account of the Montana sojourn was the first pointed articulation of the method Remington had already begun to apply in his campaign against historic sequence.

Appropriately, the occasion was a war game designed to pit a small band of cavalry commanded by a lieutenant named Carter Johnson, whom Nelson Miles had called "one of the most skilful and persistent cavalrymen of the young men in the army," against a large force of infantry supplemented with horses and a "bicycle corps." Remington marched west from the fort with the infantry, in company with a Major Kel-

24. Dreiser, p. 3.

ley—whom he had known as a captain eleven years before in Arizona—listening to stories about palmy times when, as one old sergeant put it, "we used to have a fight every day." By late afternoon, the infantry reached a vast, grassy prairie just below a jagged line where the landscape slanted sharply upward at the base of the Bear Paws. For Kelley and his staff, this spot had the recognizable utility of a strong defensive position. For Remington, it reflected in geomorphic terms a graphic formula for the archaic interior.

"All about," said Remington, employing a rhetoric in which a sense of aesthetic effect mingled with an awareness of tactical possibility, "was an inspiring sweep, high rolling plains, with rough mountains, intersecting coulees and a well brushed creek bottom." The multiple associations, accumulated over a decade, which the scene contained for him were paralleled by its eclectic topography and the diverse perceptions it invited. Furthermore, all the multiplicities of the scene were available to him at once for, while the soldiers set up guard posts and defensive patrols, Remington and Kelley scaled a nearby "pinnacle of rock," where they sat "like two buzzards"—from above, the activities that went on below them appeared as a single pattern.[25] The landscape had become an arena. Substituting a sunken stage for the rugged upland had preserved the lucidity Remington associated with art but dissolved the prosaic minutiae that too frequently enfeebled his perception of the present.

Once the stage had been established, the actualities of terrain, equipment, and strategy no longer made any binding demands. During his Texas sojourn of half a year earlier, Remington had laboriously anatomized the business of trench digging and concluded that the realities of modern warfare made it a necessity. Now, he looked down from his aerie at the rows of entrenched infantry encircling the camp below and remembered a conversation he had overheard while the trenches were being dug. "How much dirt does a doughboy need for to protect him?" one weary soldier had asked, and another had replied that "there ought to be enough on 'em to protect 'em." Given its context, the joke was a signal that physical order had given way to imagination.

Correspondingly, the large, well-planned infantry camp which Remington thought would have been "per-

25. "Vagabonding with the Tenth Horse," p. 352.

fectly safe" under more mundane conditions suddenly became altogether vulnerable to Carter Johnson and his small band of horsemen, who "snapped" over the hills, "met the subtle approaches of his enemy at every point, cut off a flank of the defending party, and advanced in a covered way to the final attack." Remington's box seat provided a less dangerous perspective than the supply wagon from which he had touched the edge of the Wounded Knee fight in South Dakota. Johnson brought the event to a close that satisfied the artist's aesthetic expectations concerning what heroic fighting had been and what it might become:

> On he came, with yells and straining horses, right through the camp, individual men wrestling each other off their horses, upsetting each other over the tent ropes, and then in column he took off down a cut bank at least six feet high, ploughed through the creek with the water flying, and disappeared under our hill. In an instant he came bounding up, his squad in line, the horses snorting and the darkies' eyes sticking out like saucers.[26]

The maneuver, of course, had been wholly impossible, and the infantry camp did not surrender. Instead, a "festive" soldier lit a cigarette and remarked to Johnson that "your d—— band ought to be ready for burial long before now." Remington admitted that the drama had not been war but insisted that it *had* been "magnificent." It was, he concluded, the "sort of thing our militia should undertake."

Indeed, speaking from his new vantage point, Remington even confessed that the "stately march of the Seventh New York, or Squadron A, when it is doing its prettiest, fills my eye, but it does not inflate my soul." Although he attempted to justify this means of judging potential military effectiveness, arguing that "handling cavalry troops is an art, not a science," its subjectivity exposed the personal impulse he halfheartedly sought to hide behind a screen of expertise in matters military. If Squadron A and the Seventh New York looked "too deadly prosaic" when regarded from Fort Assiniboine, it seemed probable that Fort Assiniboine and the Tenth were poetic. Remington's facetious promise to quickly "burn or sell every barrack

26. Ibid., pp. 353–354.

in the country and keep the soldiers under canvas and on the move" if he were appointed secretary of war contained neither strategy nor loyalty but affirmed instead his pledge of allegiance to his own aesthetic principles. The impossible revolution the pledge urged was an invasion of politics and military policies by art. Dreiser would surely have recognized that Carter Johnson's cavalry charge at the foot of the Bear Paw Mountains had much in common with the horse show in Madison Square Garden; Remington's response to it contained the same identification and the same confession that the art show on Twenty-Third Street had elicited from Roosevelt. Placement of the artist at the archaic center of his own vision made history a mirror of the artist.

3. The Real Thing

The chaotic but curiously exhilarating order Remington glimpsed from his pinnacle in Montana expressed a number of possibilities, all of them equally alarming. First, by some grotesque turn of events, the boisterous make-believe of Carter Johnson's charge might be translated into terms that made it truly dangerous—which would be something like arming the bronze buster and his fellows at the gallery on Twenty-Third Street with real weapons and turning them loose on the would-be bear hunters and millionaires who came to have a look at them. Second, Remington's vision of himself as secretary of war, innocent enough as bluff hyperbole, might in the artist's vivid imagination acquire a force sufficient to generate visions more monstrous and less innocent, resulting at last in the trauma of discovering that such visions were illusory. Third, Johnson and his roughneck band of cavalry, for the moment so magnificently evocative of the heroic traits Remington ascribed to his archaic ideal, might harbor attitudes that identified them with gentility, made them susceptible to use for genteel purposes, or both. None of these possibilities could be fulfilled without importantly affecting Remington's career. All were realized before the end of 1898.

February 1897, when *Cosmopolitan* printed Rem-

ington's narrative of Johnson's Montana triumph, also saw the publication of three Remington drawings in William Randolph Hearst's New York *Journal*. One portrayed the execution of Adolfo Rodríguez, a young Cuban rebel, which had taken place some two weeks earlier on a barren, moonlit plain outside the town of Santa Clara. Another showed several Cuban women, one of them nude, being searched by Spanish troops aboard an American steamship. Still another, entitled "Spanish Cavalryman on a Texas Bronco," caught an astonished loyalist trooper in midflight as a horse pitched him from his saddle.[27] These and thirty-three more sketches of similar subjects in a series that began at the end of January 1897 and closed in the middle of August proceeded from Remington's first contact with the substance of that war he had hoped would fulfill the spirit of Lieutenant Johnson's breakneck charge. They were made from photographs, imagination, and whatever firsthand observation was allowed the artist during a whirlwind tour of Cuba he and Richard Harding Davis made during the closing weeks of 1896.

According to Davis' account, the two men saw dreary villages where deaths from smallpox and malnutrition occurred daily, strings of the tiny forts the Spanish had scattered about the countryside, and some twenty-five miles of "trocha," or fortified combat line, by means of which the Spanish forces hoped to contain and eliminate rebellion. Yet, while both Remington and Davis wanted the United States to enter the war on the side of the insurgents, and Davis' account strained hard to make the insurgents out as heroes, artist and correspondent were granted entry into Cuba at the pleasure of the Spanish government and were shown only what the government wished them to see. Remington's sketches of Spanish officers and troops thus had the same posed, wooden look that had afflicted his pictures of German and Russian soldiers four years earlier, and the peasants he saw eating at fondas or working in the fields of sugar cane looked more like the cracker cowboys he had seen in Florida than like revolutionists.[28] The dignified gentlemen in uniforms of immaculate tropical white who sat for Remington's portraits made a ludicrous contrast with the demons in handlebar moustaches who butchered innocent women and children in Remington's pictures of

27. New York *Journal* for February 2, February 12, February 28, 1897.
28. When Remington left Cuba, Davis was relieved, writing in a letter home that "he was a splendid fellow but a perfect kid and had to be humored and petted all the time." See Charles H. Brown, *The Correspondents' War* (New York: Scribner's, 1967), p. 78.

24. *"A Spanish Officer."* This is one of the pictures Remington made to illustrate Richard Harding Davis' accounts of the Cuban revolution.

"atrocities" he had heard of but was not allowed to witness. Although the magnificent charge he saw at Fort Assiniboine had not been war, the war he glimpsed at Cuba was certainly not magnificent. The squalor of the towns and cities, the petty graft in the military organization, the pompous self-righteousness of Davis' prose, and the hectic demands of Hearst's jingoistic New York *Journal* all conspired to plunge Remington into a depressed state that recalled the period of recrimination and self-doubt preceding his discovery of bronze.

This time, however, it was not himself that Remington doubted but, rather, the historic processes that repeatedly thwarted his attempts to discover some dimension of actuality that would fit the pattern his imagination had devised. Remington responded with a perverse but serviceable logic: if having projected himself into the bronze *Buster* had enabled him to call himself eternal, interpolating backward from Carter Johnson's charge at Fort Assiniboine might now create a line of progression that would somehow render the dreary circumstances of the Cuban revolution magnificent. Almost immediately after his return to New Rochelle in January 1897, he began to compose the series of narrative discourses that opened in *Harper's Monthly* that August with "A Sergeant of the Orphan Troop" and closed in November of the following year with "Sun Down's Higher Self," nine works which were neither wholly fictional nor wholly factual and which played an ironic, often wistful counterpoint to the martial rhythm of his journalistic pictures and articles appearing concurrently in organs like the *Weekly* and the *Journal*.[29]

The first narrative, which proceeded directly from Remington's Montana trip of 1896, reintroduced Carter Johnson as a sergeant stationed with his unit of the Third U.S. Cavalry at Fort Robinson, Nebraska, in 1879. Born in Virginia half a decade before the Civil War, wrote Remington, the sergeant was "refugeed out of Fredericksburg, with his family, before the Federal advance" and later—perhaps at about the same time Remington attended Highland Military Academy—graduated with honors from the Virginia Military Institute. From there, he went west to participate as a "private soldier" in the Arizona campaigns against Navajos and Apaches. The opening of Remington's

29. "A Sergeant of the Orphan Troop," *Harper's Monthly*, August 1897, pp. 326–336; "The Great Medicine-Horse," September 1897, pp. 512–517; "Joshua Goodenough's Old Letter," November 1897, pp. 878–889; "Massai's Crooked Trail," January 1898, pp. 240–246; "How Order No. 6 Went Through as Told by Sun Down Leflare," May 1898, pp. 846–852; "The Spirit of Mahongui," June 1898, pp. 53–59; "Sun Down Leflare's Money," July 1898, pp. 195–199; "Sun Down Leflare's Warm Spot," September 1898, pp. 588–594; "Sun Down's Higher Self," November 1898, pp. 846–851.

narrative found him on the bank of the North Platte River helping to round up herds of ragged Cheyennes for shipment to the Oklahoma reservations.

One significant feature of the narrative was that it provided Johnson with a past; another, the provisional nature of the past thus provided. Himself a refugee, Johnson's business was to join others much like himself in expediting the transportation of refugees. The troop to which he nominally belonged was appropriately christened an "orphan," because "no officer at that time seemed to care to connect his name with such a rioting, nose-breaking band of desperado cavalrymen." The Johnson of Remington's narrative thus became both one of the "real soldiers" Remington had heard about at Fort Assiniboine and one of the cavalry band that would have been "ready for burial" at the foot of the Bear Paw Mountains, had the charge Remington watched not been make-believe. His peculiar distinction, as Remington had it, was an ability to "act the others off the stage and sing them out of the theatre."[30]

Just as Johnson had redeemed the dull maneuvers at Fort Assiniboine by turning them into a game, Remington used Johnson to redeem history by turning it into a drama at Fort Robinson. The title Remington chose for the drama suggested its historical focus, for "A Sergeant of the Orphan Troop" designated the historic personage of Johnson, who was its chief actor, and the outlines of the drama matched the contours of the 1879 Dull Knife fight, a historic event in which Johnson and the Third Cavalry participated. Yet the conduct of the drama was less historic than aesthetic, and Remington brought to the narrative he had doubtless heard told by Johnson and others as "fact" his own intense concern for point of view.

As history, Remington's narrative of Carter Johnson and the Cheyennes was hopelessly romantic; as fiction, it flirted with important distinctions between individual and collective action but seemed incapable of developing them with any coherence, and the people who paid most attention to it were armchair strategists, who liked its military details, and juveniles, who read it as an adventure story for the same reasons they read Horatio Alger's dime novels. For Remington, however, it was probably a work of some personal importance, for it showed both that a certain kind of

30. "A Sergeant of the Orphan Troop," p. 327.

sense could be made from history by treating it with massive infusions of imaginative speculation and that fictional structures seemed to become more substantial when the weight of some historic event could be applied to them as ballast.

Like "A Sergeant," "The Great Medicine-Horse," next in the series of *Harper's* pieces, came directly from the 1896 Montana sojourn, where Remington had encountered a guide named in his accounts as "Sun Down Leflare." Sun Down's kinship with both Johnson and Remington was lucidly rendered in the truncated genealogy that fixed him as "cross bred, red and white, so . . . he never got mentally in sympathy with either strain of his progenitors."[31] Remington's treatment of the half-breed indicated that he was almost certainly an actual personage, and it hardly seems possible that in drawing him and writing about him Remington could have failed to recognize his affinities with Louis Riel, the colorful métis partisan executed at Quebec in 1885 for treason, but Remington used Sun Down as an interpreter of orphanhood rather than as an ethnic-historic type or the potential father of some brave new American state. In "The Medicine-Horse," he appeared as a translator who "knew about half as much concerning Indians as they did themselves, while his knowledge of white men was in the same proportion." Remington said that he had accompanied Sun Down to the lodge of an ancient Crow chieftain named Itsoneorratseahoos, or Paint, to hear the story of a "medicine horse" that had once lived among the Crows, but Sun Down's translation of the story often took the form of commentary and criticism, and Remington admitted that the "problem . . . was how to eliminate 'Sun Down' from 'Paint.'" Storyteller, translator, and reporter made a three-personed artist who—by virtue of his multiplicity—could insure that accuracy would be crowded out by imagination in whatever he produced.

Such fusion was readily recognizable as the same serviceable romantic technique that allowed Hawthorne to claim the collaboration of long-dead "Mr. Surveyor Pue" in *The Scarlet Letter* and made it possible for Melville to say that he had produced the poems in *Battle-Pieces* by placing "a harp in the window" and recording its vibrations. As Remington executed it, the technique permitted him not only a close

31. "The Great Medicine-Horse," p. 512.

identification with supposedly historical circumstances but also a calibrated scale along which such circumstances might be engaged.

So far as Itsoneorratseahoos was concerned, history appeared to be identical with myth, and he told his tale of the medicine horse as both an episode of family memoirs and an article of faith. Remington, however, as the white, urban reporter of the Indian's narrative, repeatedly emphasized the chasm that separated his own modes of perception from those that governed the narrative itself. First, the circumstances under which the narration occurred compelled his attention, for they could not be taken for granted like the hotel room where he had listened to Colonel Ford's gory reminiscences. Second, even if the "winter forest" Remington imagined inside the lodge could be traversed, another barrier still held him and his readers away from the Indian for, when Itsoneorratseahoos began to talk, Remington heard only a "heavy guttural click." Witnessing the Indian's redemptive history of the Crows was less like experiencing a millennial vision than it was like watching a man holding "an ounce of quicksilver . . . he did not want to swallow" in his mouth. From the reporter's angle of vision, the Indian's mythic history appeared impenetrable, and translating the mythic history only emphasized its impenetrability, for how could a reporter who had joined gentility and a reading public that had accepted the reporter's account of the Wounded Knee fight bring into sympathetic focus the notion of a horse who bred with both mares and women and promised an end to the dominance of genteel principles? The reporter regarded the medicine horse, the narrative that contained him, and the old Indian who executed the narrative as mere curiosities.

Between storyteller and reporter, however, stood the translator. It was he who bridged the gap between the Indian's faith and the correspondent's indiscriminate objectivity and, with the "Medicine-Horse" piece, he began to emerge as Remington's latest avatar of orphanhood. Remington later drew Sun Down as a frontiersman, dressed in the traditional fringed buckskins, for "Sun Down Leflare's Money" and "Sun Down Leflare's Warm Spot"; as an Indian, wearing breechclout, blanket, and headband, for "Sun Down's Higher Self"; and as a "washed and dressed up" citizen in store clothes for "How Order No. 6 Went Through"—

thus visually reinforcing the role of go-between verbally assigned the half-breed with his first appearance. Because he was himself neither white nor red, Sun Down regarded both white men and red men from the point of view of an outsider. His central presence in the "Medicine-Horse" transformed what might otherwise have been either a curiosity or a fragment of oral scripture into a fable that dimly prophesied the personal cost of the combination Remington sought to implement by coupling an objective view of events with vivid expectations that the events thus viewed would satisfy his imagination: "Never mind this thinking," the reporter at one point warned the translator, "it is fatal." [32]

Even as he composed the "Medicine-Horse" in 1897, Remington may have partially glimpsed the force of the reporter's warning to Sun Down, but if he applied the warning to himself he failed to heed it. Three works that did not directly concern Sun Down demonstrated how thoroughly Remington had been captured by Sun Down's "fatal" speculation. Taken together, they represented an attempt to anatomize and somehow explain the forces that brought red man, white man, and métis into peculiar conjunction around Itsoneorratseahoos' fire.

In "Joshua Goodenough's Old Letter," published in November, the Indian storyteller's role was taken over by a British colonist to New York, and reporter and translator joined hands to make an archivist who passed the storyteller's account along to the reader "because it is history." The piece related five incidents in the life of an eighteenth-century soldier of fortune who had participated as one of Captain Robert Rogers' famous rangers in the British conquest of the Old Northwest. Its connection with Remington's earlier narrative of Colonel Ford's recollections as a Texas Ranger nearly a century afterward seemed plain and meaningful, for the speculative line Remington had plotted between the conquest of Texas and the conquest of Cuba could achieve the sanction of history only if it were plotted into the past and, just as Remington claimed only to reproduce Ford's recollections, he now confided that he wished to faithfully transcribe the "letter" chiefly because it enumerated a few of "those humble beings who builded so well for us the institutions which we now enjoy in this country." [33] Linking

32. Ibid., p. 515.
33. "Joshua Goodenough's Old Letter," p. 878.

the names of otherwise unrecorded rangers like Goodenough and his fellows with heroes like Rogers in connection with events like the French and Indian War, and then making the linkage tangible as a document "yellow with age, and much frayed out at the foldings," was a way of objectifying imaginative expectation.

Dated from Albany, New York, in June 1798 and addressed to "my dear son Joseph," the account contained echoes of Crèvecoeur's *Letters from an American Farmer*, Benjamin Franklin's *Autobiography*, and the narrative of Remington's Montana wagon freighter, all of which may have been involved in its composition. Goodenough admitted that he was "getting on in years" and that tales he had earlier spun about his youthful exploits had been hyperbolized. Realizing that the letter might soon be "all that my posterity will have of their ancestor," however, he now vowed to represent "exact truth."

Because Goodenough, like Remington, disliked the drills and ceremonies connected with life in the regular army, he was glad to join Rogers' party of "rough borderers" in 1757. At Fort Edward, a log garrison on the Hudson River near the southern tip of Lake George, he was casually but thoroughly schooled in matters of the woodcraft and frontier warfare that Remington had to learn from books, and he prepared for what he called his "first adventure," an event that shared some elements in its macabre design with Carter Johnson's 1879 experience further west and Ah-we-ah's earlier encounter with terminal isolation in the Manitoba of "The Story of the Dry Leaves." This adventure involved the pursuit of hostile Indians who, as it happens, are killed by smallpox, the white man's most potent weapon, before they can be captured. Yet Goodenough's most important adventure occurred a year later, in the summer of 1758, which saw the mounting of a large British offensive, when Rogers took his rangers in tow as part of a force of fifteen thousand men under the command of General James Abercromby, charged with taking the newly built French fort at Ticonderoga on the northwest bank of Lake George.

Abercromby bungled the matter badly, and the assault was repelled by the Marquis de Montcalm's defending force of only 3,800 men. Montcalm had planned his defenses well, fortifying a low, even ridge beyond

the perimeter of the fort by felling hundreds of large trees so that their sharpened branches pointed toward the attackers. Instead of reducing this barrier with the ample artillery at his command, Abercromby chose to ignore it, ordering a series of disastrous frontal charges in hopes of taking the fort by storm. Consequently, the densely packed masses of British troops stalled among the pointed branches made an easy target for the French muskets and big guns. On the night of July 8, the British fled in disorderly retreat after two days of bitter fighting, leaving nearly two thousand dead behind them.

Goodenough's accurate account of the battle showed that Remington had done his research adequately, and the sense of involvement generated by the account demonstrated Remington's ability to project himself into historic situations, but it was Goodenough's retrospective response to the carnage that most merited attention, for it reflected Remington's anticipated response to something he later called a "big murdering" at Cuba. "I can remember nothing," said Goodenough, "but the fruit bourne by the tree of war, for I looked upon so many wondrous things that July day that I could not set them downe at all."[34] His amnesia was produced not by horror but by having witnessed wonders. The metaphor he casually chose to measure war recalled the Louisiana cornfield where Seth Remington was astonished to find that artillery sprouted between the rows, and he regarded the harvest of corpses with a complex emotion that contained both Melville's awareness of a "dark side" in "The Apparition" and Roosevelt's carnivorous relish at Elkhorn Ranch.

Remington's picture of "The Storming of Ticonderoga" made up in sentiment what it lacked in detail.[35] The French troops who fired down from the top of the ridge were represented as indistinct shapes, and only a few individual figures emerged from the jumble of hats and British uniforms in the foreground. True to Goodenough's description of the event, the ground in the picture was "covered deep with dying men," among whom Goodenough himself stood hatless and apparently at ease. While those around him flung themselves forward and were flung back by the bullets that struck them, he alone faced the top of the hill—in an attitude that resembled reverence. What appeared to occupy his attention were the beams of light Rem-

34. Ibid., p. 887.
35. "The Storming of Ticonderoga," p. 885.

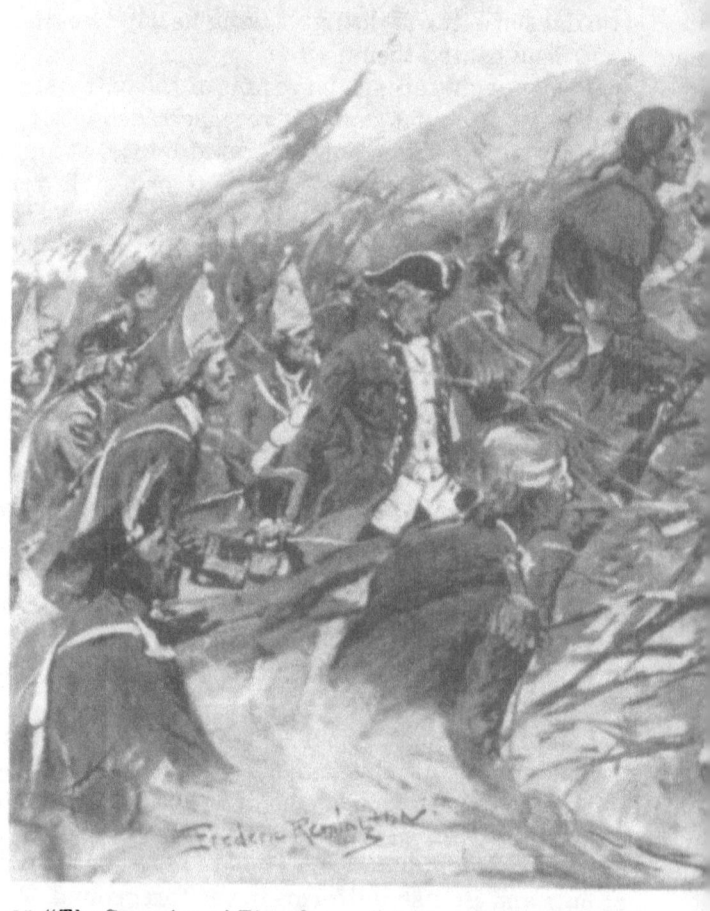

25. "The Storming of Ticonderoga." Joshua Goodenough is the standing figure in buckskin at left center. This picture bears comparison to Remington's later "The Storming of San Juan," plate 28.

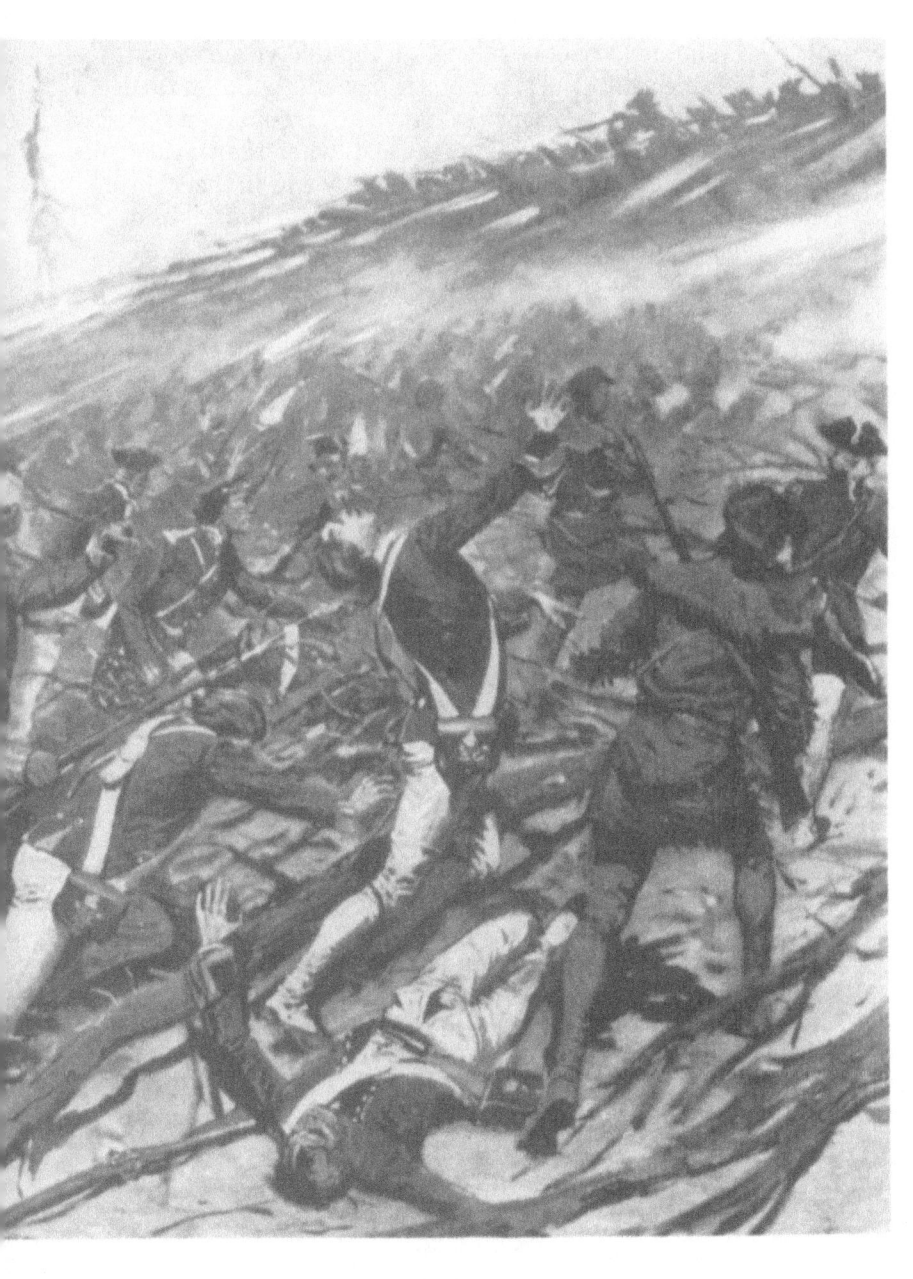

ington used to represent the fire emanating from the French positions. He looked like someone receiving an annunciation.

Whether or not Goodenough could have agreed with Melville about the apocalyptic power of a bullet to undeceive, the experience of battle at Ticonderoga served him as unique enlightenment and, when the war ended, he pursued "in the Western country and in the War of Independence" the vision that had transfigured him. He also promised to relate his later exploits in other letters, closing with the observation that "I served faithfully in what I had to do."

As fiction in the guise of history, Goodenough's letter made an interesting use of the epistolary sanctions utilized in Mark Twain's 1895 *Personal Recollections of Joan of Arc* and of the fictional documentation that had in 1889 framed Hank Morgan's account of his Arthurian adventures. Yet even more significant was Remington's implementation in the tale of a chronological sequence that linked it securely not only to the past but to the future. Goodenough himself moved from the deadly hollow at Ticonderoga to the dark and bloody ground of Kentucky to the perilous slopes of Bunker Hill, fathering along the way a son who might well have fought with General Hull at the Battle of Detroit or followed Jackson to New Orleans in the War of 1812, acquiring grandchildren who might serve the cause of war at places like Chickamauga and march with General Custer or (hopefully) Major Reno in Montana.

Furthermore, when *Harper's Monthly* subjected the letter to mass production in 1897, thus instantly enlarging the clan of Goodenoughs to include all patriotic Americans, the children of the colonist's grandchildren were poised to leap across the barrier that separated Tampa from Santiago. It required no special talent to see that periods in the genetic sequence where one generation of Goodenoughs followed another corresponded to a progression in time where all significant categories of distinction were marked by wars. What Goodenough called "the fruit bourne by the tree of war" was thus also at once the fruit of time and the fruit of the family tree of Goodenough. The soil and climate that fostered such plants were not discussed in the descriptions of the huge Louisiana Territory brought back to Thomas Jefferson by Lewis and Clark or in the

later journals of Dana and Parkman, but they occupied positions of rapidly increasing importance in the course of study that by 1897 had begun to look like Remington's own version of America's natural history.

Since the scope of the study was continental, and since Remington linked Goodenough's account of fighting the French with Itsoneorratseahoos' account of wars between the Crows and the Sioux in Montana, it put no strain on the peripatetic scheme to locate its next episode at Fort Apache, near the place where Remington had first encountered the variety of the atavistic of which Itsoneorratseahoos' narrative made a category. Remington's 1896 visit with the Tenth Cavalry in Montana had recalled his first visit with members of the same unit in Arizona some eleven years earlier, which in turn recalled his first encounter with Apaches in the foothills above Fort Thomas. "The ghostly Montana landscape," thought Remington, invited the tale of a "*bronco* Chiricahua" Indian named Massai, which was told to him in an army tent by a grizzled old trooper who had been chief of the Apache scout corps.[36]

Like Joshua Goodenough's crumbling letter, Massai represented an invasion of the present by the past and, like the medicine horse of the Crows, he stated that enigmatic promise Remington sensed at the center of American experience. Remington's story of him recounts his escape from a Florida prison, his trek back to the Arizona desert, and an episode—involving abduction, rape, and murder—of his subsequent life there. After Roosevelt read the story, he immediately wrote from Washington—where he was serving as assistant secretary of the navy—praising Remington and enthusiastically describing the Indian as a "revival in his stealthy, inconceivably lonely and bloodthirsty life, of a past so remote that the human being as we know him was but partially differentiated from the brute."[37] Remington touched another, equally significant facet of his meaning by calling Massai a victim of "homicidal melancholia."[38]

"Joshua Goodenough's Old Letter" allowed the reporter of the medicine horse narrative to glimpse the pattern of imperial thrust that had created Sun Down Leflare half-red and half-white and had deprived the Crows of the racial energy the narrative wistfully commemorated; "Massai's Crooked Trail" chronicled a

36. "Massai's Crooked Trail," p. 240.
37. T. Roosevelt to Frederic Remington, December 28, 1897, from E. E. Morison, ed., *Theodore Roosevelt*, 8 vols. (Cambridge: Harvard University Press, 1951–1954), I, 750.
38. "Massai's Crooked Trail," p. 245.

survival in recent times of racial energy the medicine horse narrative ascribed to "medicine" Sun Down despaired of explaining to the reporter. In between was the medicine itself, which Remington undertook to treat in "The Spirit of Mahongui." Like Goodenough's letter, this narrative was supposed to come from an "old document" and, like the "Crooked Trail," it concerned a merging of the human and the "brute." Remington declared that the source of his extract was the "memoirs of le Chevalier Bailloquet, a Frenchman living in Canada, where he was engaged in the Indian Fur Trade, about the middle of the seventeenth century."[30] Since the source was more ancient, the substance might be expected to be more atavistic than either Goodenough's or the chief of scouts' narrative, and such an expectation was amply fulfilled both by the archaic look of the chevalier's very imperfect seventeenth-century English and by the experience the chevalier remembered.

The extract began as the chevalier made his way from Quebec to Montreal by canoe with a party of friendly Hurons. As the group embarked after a night's camp, it was attacked by a large band of hostile Iroquois, who sank the canoes, bound the survivors, and proceeded up the river. That night they tied the leader of the Hurons to a tree and burned him alive, then cut the heart from his breast and devoured it. They also stripped the chevalier and tortured him by pulling out his fingernails. Horrified, the chevalier resolved to die, regarding himself as a Christian delivered by God "into ye power of Satan." Almost immediately, however, he was introduced to another point of view for, asking one of his captors why they had attacked him, he learned that the Iroquois regarded him not as a Christian abandoned to the devil but as one of the Frenchmen who had become enemies by violating their treaty with the Indians. The French, said the Indians, had set a pack of dogs on an old Iroquois woman, and the dogs had killed and eaten her. The Iroquois had responded by killing the dogs, then capturing a Frenchman who happened to be with Hurons, also enemies. When they reached their village, they planned to boil the Frenchman, the Hurons, and the dogs "in ye same kettle." This, presumably, was "medicine." Mahongui, who appears in the shape of a huge mastiff, saves the chevalier from death, and the chevalier, deeply shaken

39. "The Spirit of Mahongui," p. 53.

by his sudden exposure to primitive life, joins the Hurons.

Remington's rendition of the chevalier's narrative thus identified the obverse of the experience Remington had begun to explore at San Carlos in 1885: Indians confined by Europeans to reservations lost the sense of vitality that had given their medicine meaning; Europeans separated by Indians from the tools they used for measuring perception encountered a new dimension of experience. Some people, wrote Remington, would surely doubt the chevalier's account. "Out of their puny volition," he supposed, "they will analyze, and out of their discontent they will scoff." He enjoined such disbelievers to "go to your microbes, your statistics, your volts, and your bicycles." His own preference was for the "truth of other days."[40]

By the time the *Harper's Monthly* for June 1898 printed "The Spirit of Mahongui," Remington was feverishly seeking a similar spirit at Tampa, Florida. News of the *Maine* disaster in Havana Harbor had reached him at New Rochelle on February 15, the same day an unexplained explosion destroyed the American naval ship and killed 260 of its crew. Two months later, President McKinley sent his war message to Congress, and a joint resolution of the Senate and the House declared war on Spain just eight days afterward, on April 19. As soon as Tampa was designated port of embarkation for the invasion of Cuba, Remington joined the throng of correspondents that descended on the small city to mingle with the gathering troops, sip cool drinks on the shaded veranda of the ornate Tampa Bay Hotel, and exchange variations on the rumors that swept across the town like an endless succession of spring thundershowers. Richard Harding Davis was there, looking poised and clean-cut as usual, along with a number of Remington's other acquaintances—Caspar Whitney, Julian Ralph, and many more. There was a band concert every night, much pleasant, patriotic talk, and a great deal of merrymaking, all softened by the balmy spring weather and scented with profusely blooming oleanders and honeysuckle.

Cracker cowboys and duck shooters alike dissolved in such an atmosphere but, while Remington was excited by the bustle, he became increasingly distressed at the impulse that appeared to inform it. The frequent dances, with pretty girls hanging on the arms of spif-

40. Ibid.

26. "Prominent Officers Now at Tampa, Florida." Note the differences between the American officers and the German officer in plate 11.

fily uniformed young officers, looked like love's young dream, and another permutation of the romance of war expressed itself as a spasmodic flurry of activity in the city's brothels. Nowhere, however, was there anything that even remotely resembled an activity appropriate for descendants of Joshua Goodenough, Massai, or the Chevalier Bailloquet.

Disgusted, Remington left late in April aboard the battleship *Iowa*, bound for the coast of Cuba and the naval blockade that encircled the island. Yet the escape afforded him little relief, for life on shipboard was even more monotonous than life at the Tampa Bay Hotel, and steaming interminably up and down ten miles out from Havana Harbor caused Remington to declare the war that had been so long in coming "the murder of time and the slow torture of opportunity" once it arrived.[41] Hunting for Carter Johnson's naval equivalent, he explored "mile after mile of underground passages ... amid wheels going this way and rods plunging that, with little electric lights to make holes in the darkness," encountering only "grave, serious men of superhuman intelligence" who seemed to have "succumbed to modern science." The awesome machinery of the battleship neither attracted nor interested him, and in the sailors who bestowed "motherlike attention" on the valves and motors he sensed a "preoccupied professionalism" that alarmed him. The reason was that, while heroes like Joshua Goodenough entered a sacred grove to worship at a tree whose fruit was the mystery of fatality, the crewmen of the *Iowa* regarded a "dismal old bag of tricks" incased in fifteen inches of armor as "their hope and their home." Remington summed up the whole matter by deftly observing that "modern science does not concern itself about death."[42]

Because the *Iowa* was "unsinkable and unlickable," it also appeared to Remington as unthinkable and unbearable. When the torpedo boat *Cushing* crossed the battleship's bow one morning on its way to Admiral Sampson's flagship, the *New York*, he gratefully boarded it. A vertiginous ride across the Gulf delivered him to Sampson's large cruiser and the company of several excited correspondents, including Davis, Rufus Fairchild Zogbaum, and Stephen Crane, for the last of whom he had illustrated the 1897 "A Man and Some Others," first in a series of western stories.[43] The fra-

41. "Wigwags From the Blockade," *Harper's Weekly*, May 14, 1898, p. 462.
42. Ibid.
43. Stephen Crane, "A Man and Some Others," *The Century*, February 1897.

ternity of journalists was genial enough but was also competitive, for the ambition of each was to scoop the rest in the pursuit of news they all expected to break any instant, and Remington was humiliated to have seen nothing noteworthy aboard the *Iowa*, admitting of its crew members that "I was ready to die with them there, though I resolutely refused to live with them."

He also admitted to being "stiff with jealousy" when Davis and Zogbaum told him that they had had "some good sport the day previous shelling some working parties in Matanzas." Yet even in this jealousy he found the stuff of reassurance, for he matched his knowledge that war had been declared and that shots had actually been fired with his theory that "it takes more than one fight to make a war." The characteristic result was a vivid fantasy where anticipated future and half-imagined past joined forces to overwhelm the "appalling sameness" of a dreary present. "My homely old first love comes to haunt me, waking and sleeping," Remington confessed, adding that he ached to "get some dust in my throat, ... to kick the dewy grass, ... and to talk the language of my tribe."[44] After a separation of eight years, he felt that—from the deck of a warship named for his native state and cruising off the coast of Cuba—he might again glimpse the band of warriors he had first joined some thirteen years before in Arizona.

Meanwhile, the Fifth Army Corps' First Volunteer Cavalry had set up recruiting headquarters in Santa Fe, New Mexico, to begin assembling the regiment of cowboys, Indians, football stars, and socialites that soon acquired the popular name of "Rough Riders." While Remington languished in the Caribbean, the Santa Fe contingent was joined by others, including Theodore Roosevelt's troop of New Yorkers, at a bivouac in San Antonio. Remington, glad to get ashore again, returned to Tampa and, from there, hurried back to New Rochelle for a brief rest, writing to the honeymooning Wister, who had been married on the same day war was declared, of the "lovely scrap" he hoped to witness.[45] By the time the Rough Riders arrived by rail from San Antonio on June 4, Remington had returned to Tampa. Despite its heat and confusion, the scene he found there confirmed his hopeful expectation of the tenebrous dawn for, on the barren

44. "Wigwags From the Blockade," p. 462.
45. Undated letter written in June 1898, the Wister Collection, Library of Congress, quoted in Vorpahl, p. 233.

flats above the resort hotels and beaches, cowboys, Indians, and soldiers gathered for what might have been a final assault on gentility.

What followed, however, was so astonishingly brief and luridly surrealistic that he had difficulty in identifying it at all. On June 15, after several annoying delays, General Shafter's headquarters ship, the *Sequeranca*, steamed out of Tampa Bay heavily laden with troops and bearing a contingent of correspondents, including Davis, Caspar Whitney, and Remington. After a voyage which Remington hated, the ship arrived at Daiquirí Bay on June 20. There, Remington and the other reporters were allowed to go ashore after the invading troops had landed, and Remington "moved out" with the Fifth Corps toward Santiago. That night he cooked his supper over a "soldier fire" and slept among "sweaty men, mysterious and silent too," by the side of a road on the outskirts of the village of Siboney, where he saw the first American wounded carried back from the front lines the next morning.[46] John Fox, a cheerfully adventurous fellow correspondent for *Harper's Weekly*, ambled up, as though for a friendly chat, and the two decided that there would be no more fights of which they themselves were not a "party of the first part." Yet, after a day of marching up the road toward Santiago in the hot sun, the command to halt until supply lines could be established came down from General Shafter. Torrents of rain pelted the camp during the halt, while Fox and Remington, without tents, lived in the mud.

Malaria and dysentery took their dismal toll among the ill-prepared Americans but also allowed Remington the opportunity to purchase a horse from an "invalided" officer. On the night of June 30, ten days after the initial landing at Daiquirí Bay, Remington heard rumors that the waiting was about to end. Before dawn the next morning, he managed to steal a "good feed of oats" for his mount, and by evening he had witnessed the end of the famous battle at San Juan Hill. That night, he made his way back to headquarters. The next day, he tried to return to the front but found himself unable to do so, concluding fever had "finished" him. After drinking deeply from the dirty water in a nearby creek, he lay down by the side of the road and watched the machine of war grind on as reinforcements trudged past him toward the front. Then he

46. "With the Fifth Corps," *Harper's Monthly*, November 1898, p. 964.

limped back to camp. He had seen a charge like Carter Johnson's but, this time, with loaded weapons and altogether deadly intent. Although President McKinley had not awarded him a cabinet post, Remington had momentarily, in his own assertive fashion, appointed himself secretary of the war he recognized as a materialization of his own most lurid imaginings.

Remington's whole experience with battle had taken less than twenty-four hours, but he looked back at it from New Rochelle that summer with "awe," because for him it represented an intense conjunction of life with art, all the more dazzling for its brevity. At first, he remembered, the steamy Cuban landscape had a varnished, artificial look, and the men and weapons that moved across it seemed abstract and vaguely out of reach. Brigadier General Adna Chaffee of the Second Division, for instance, had a face Remington "used to sit around and study" because it did not "belong to the period" but appeared to come from some "remote" time, "when the race was young and strong."[47] Likewise, the artillery emplacements at El Poso Hill, outside El Caney, looked like a "picture such as may be seen at a manoeuvre." Yet, when one of the guns casually lobbed a few projectiles in the direction of Santiago, Remington's frame of reference vanished or, as he put it, "the manoeuvre picture ... underwent a lively change," for the air was instantly filled with "screaming shrapnel" from hidden Spanish positions. John Jacob Astor, having temporarily exchanged the splendor of his social position for the dignity of the Rough Riders, now put off dignity for the hope of a whole skin, leaping toward cover with great "jack rabbit bounds." As he followed suit, Remington probably did not consider that the scene he now occupied resembled the scene he had frequently imagined for—regarded from the battlefield—the dream of a jornada del muerto seemed both more exciting and less inviting than ever before.

Remington accordingly made haste to put the "manoeuvre picture" safely back inside its frame, where it belonged, gradually working his way among the prostrate bodies of "old friends" from the Tenth Cavalry to the top of El Poso Hill. There he found a "clubmate from New York, and sundry good foreigners," who engaged him in "expert artillery talk" and miraculously changed the lethal Spanish barrage into a game

47. Ibid., p. 966.

once more. Looking about him from the hilltop, Remington then noticed that "this hill was a point of vantage." In the scene that stretched below it, the "flat jungle, San Juan hills, Santiago, and Caney" appeared clearly and in miniature, as though shrunk to squares on a chessboard. Remington had delighted in experiencing the same phenomenon when he mounted a pinnacle near Fort Assiniboine in 1896 to watch Johnson lead a mock charge against a mock infantry camp but, while the previous dislocation had operated to make a game look like a battle, the present dislocation turned a battle into make-believe. "My art," he at last decided, "requires me to go down in the road where the human beings are . . . in the landscape which to me is overshadowed by their presence."[48] His decision was equivalent to being swallowed up by the verbal and graphic pictures he had made of fighting since the Apache campaigns.

What he hoped to find below El Poso was a colorful holocaust like that he had engineered for Joshua Goodenough at Ticonderoga; what he encountered was a bright green jungle where he seemed the only "human being," where the "roar of battle" he strained to hear had been subdued to "noises such as you can make if you strike quickly with a small walking stick at a very few green leaves," occasionally clustering together in bursts that reminded him of a "Fourth of July morning, when the boys are setting off their crackers." At the San Juan River, he watched medics set up a field hospital and felt his nerves "jump" when the wounded and dead were brought in, carefully noting all the while details of their mutilation, which "fascinated" even while they repelled him. The reason for his fascination may well have been that the casualties resembled the corpses that littered pictures like those he drew of Carter Johnson at the Dull Knife fight, for the next thing he looked for was a "line" by which the dead and dying might be explained.

No such boundary was in evidence, however, and he admitted that, although men were clearly being shot, "I could not find our line." Sounding something like Lieutenant Bigelow in the Arizona desert, he helplessly supposed that a man might "go through a war, be in a dozen battles, and survive a dozen wounds without seeing an enemy."[49] If his supposition expressed bewilderment, it also suggested that to participate in

48. Ibid.
49. Ibid., p. 972.

27. "The Temporary Hospital—Bloody Ford." Having gone to Cuba in hopes of finding war's romance, Remington discovered in the wounded and dying a demonstration of war's misery.

battle was not necessarily to comprehend its appearances. Without a point of vantage to measure it by, the battlefield became a chaos.

Eventually, Remington stumbled onto a road and, after having lost his sketchbook, walked down it until he arrived at the foot of a hill he would have readily recognized as one of the San Juans had he stayed with the observers at the top of El Poso. As it was, he made out the "white lines" of Spanish entrenchments through his field glasses but supposed that any assault of the position "would be unsuccessful." By the time he had crawled to a place where he could see the Spanish fort, the famous charge was over. Although he watched the American flag being broken out and displayed at the hilltop and heard the triumphant Rough Riders cheer, his response to the whole affair was muddled. A young officer tearfully embraced him after the firing had subsided and declared that the Twenty-Fourth Infantry had been reduced to a score of men; he noticed that the dead in the Spanish trenches lay in "curious attitudes ... mostly on their backs, and nearly all shot in the head"; an American officer urged his men forward "with gestures much the same as a woman makes when she is herding chickens." His emotions, Remington admitted, were "very unsettled."

Removing the frame from the picture and the artist from his point of vantage had the distressing effect of exposing the artist to the full force of the rigors he had imagined. So long as Remington attempted to counter gentility's appalling sameness with his art, he could wish for the dawning of a new age. Once he wandered down the road to find a battle, and the dawn seemed accomplished at last, the function of his art was instantly altered. For decades, Remington had dreamed of war and tried to capture its energy with his imagination. Now, he had actually experienced what he called the "tumultuous energy which accompanies the destruction of things by men in war" and seen the "greatest thing which men are called on to do"—finding, incidentally, that he had no stomach for it.[50] Not only did Chaffee, Roosevelt, and the other counterparts of Carter Johnson he had seen in Cuba serve a genteel cause, they also emphatically defined the genteel possibilities of his own imagination. Even as a hospital ship took him back across the Gulf to Tampa, this question must have occurred to Remington: what should a

50. Ibid., p. 962.

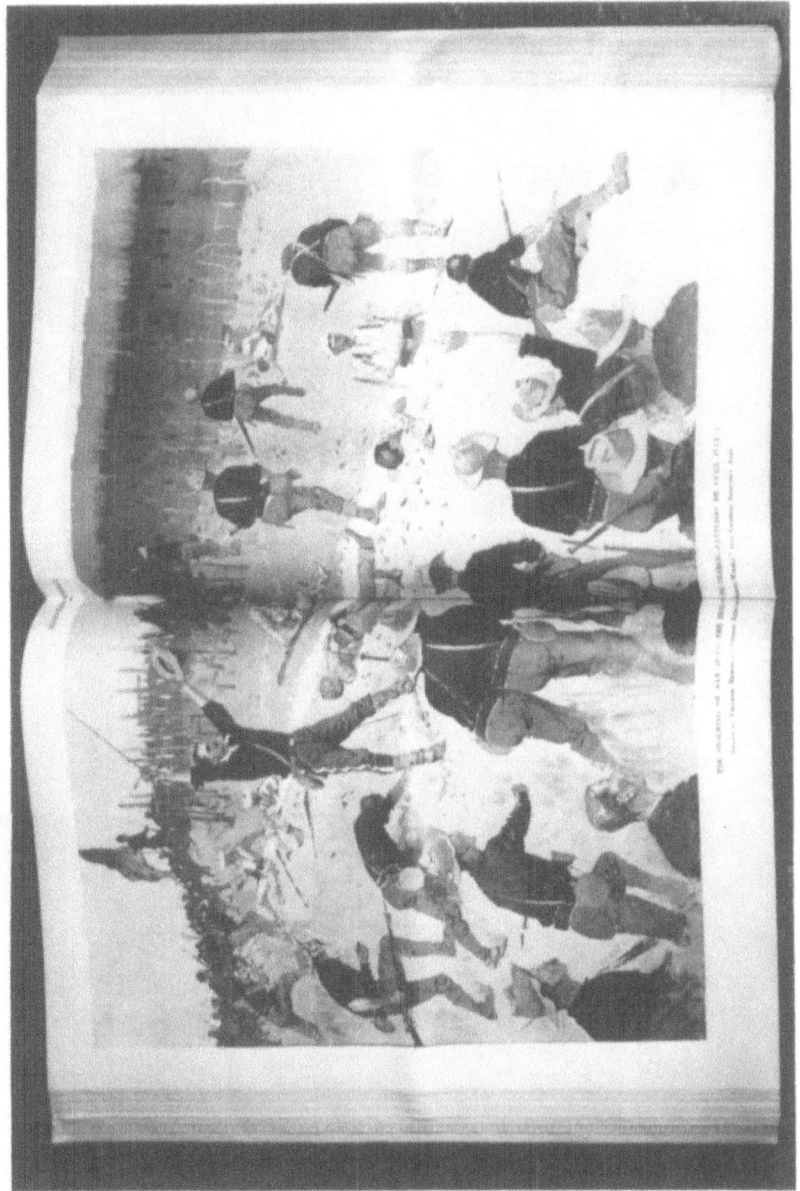

28. "The Storming of San Juan." Remington's picture of the charge manages to show both the defeated Spaniards and the triumphant Americans in frontal and side views, reflecting his newly powerful awareness that every victory requires a defeat.

man do if—after entering the sacred grove and tasting the fruit of the tree of war—he found himself gasping with nausea?

V. The Last Horseman

1. Letters from Another Country

For Remington, the most important result of the Spanish-American War was that he was at last compelled to investigate the origins and consequences of his own preference for violence as a subject. This enterprise, which would occupy him until his death in 1909, would have been well served had he been present on September 13, 1898, at Camp Wickoff, when the Rough Riders disbanded. On that occasion, Roosevelt was conducted by a committee of enlisted men to the parade ground, where he found the troops assembled about a pine table that supported something covered by a horse blanket. A trooper named William Murphy, who had been a justice of the peace in Indian Territory, made a brief, emotional speech, then lifted the blanket from the table to reveal Remington's *Buster*, a parting gift which, he told Roosevelt in what may have been an intentional paraphrase of the communion service, "will sometimes make you think of us, as we shall ever think of you."[1] Roosevelt replied at length, concluding at last that he would value the statuette "more than I do the weapons I carried through the campaign" —thus forging a bizarre but fitting link between the souvenir arms and the souvenir cowboy, both of which

1. For a full account, see Virgil Carrington Jones, *Roosevelt's Rough Riders* (Garden City: Doubleday, 1971), pp. 276–281.

had been transformed from anticipated possibility into remembrance. Very clearly and very forcefully, the incident demonstrated how the event of the war had changed the *Buster*'s function. As a result of the change, Remington could no longer regard the war as a hoped-for culmination of a continuum that included cattle drives and Indian campaigns. Instead, he turned his attention to another war he called, in a letter to Wister, "that old cleaning up of the West." [2]

In the several years before the Cuban war, Remington had produced a series of works that strained to forge a tangible link between events like the siege of Ticonderoga and events like the battle of San Juan Hill by using putative documents ascribed to an imaginatively satisfying past. The trouble was that, once the events he prophesied occurred, they invited the variety of attention he scornfully dismissed. Even when he wrote about his personal experience of the Cuban war itself, Remington admitted an inability to "add to the facts" already known about the conflict, promising to give an account of "my own emotions" instead for, as a prophet allowed to witness a fulfillment of his prophecy and as an artist whose vision of history at last seemed confirmed by historical event, he had discovered the negative qualities of fulfillment and confirmation. "War," he observed, "is productive of so many results, things happen so awfully fast, men do such strange things, pictures make themselves at every turn, the emotions are so tremendously strained, that what knowledge I had fled away from my brain, and I was in a trance." [3] Between his conviction that "he who has not seen war only half comprehends the possibilities of his race" and his confession to a "cheerful reader" that "you know, . . . I am not going to describe a battle to you" yawned a void that compelled his attention. Although Remington's articulation in his work of a sense of this void during the next four years was complex, the significance the void had for him in 1898 may be simply stated: he regarded the Cuban war differently after it was over because he occupied a different location in time; he realized, as his work almost immediately began to show, that what separated anticipation from memory was time—which was also what had prevented his art from building a bridge between past and future.

The new emphasis Remington's work acquired as a

2. Undated letter written in September 1898, the Wister Collection, Library of Congress, quoted in Vorpahl, p. 237.
3. "With the Fifth Corps," p. 970.

result was accordingly an emphasis on time and its effects. It seems highly likely that he was aided in establishing this emphasis by Stephen Crane, who had addressed the mystery of chronology from a rather different angle in a tale printed by *The Century* with one Remington illustration in 1897 and had repeated the performance a year later with "The Bride Comes to Yellow Sky."[4] The former tale, called "A Man and Some Others," culminated in a bloody battle between American squatters and Mexican outlaws in the desert, closing as the single American survivor watched the Mexicans withdraw and was incongruously reminded by their colorful serapes of the "cornucopia of childhood's Christmas." The latter and better-known story matched the "New Estate" emblemized by the marriage of a frontier sheriff and his waitress bride against the moribund order of an "old gang" that supported a saloon named the "Weary Gentleman," producing from the conflict a vision of the "plains of Texas pouring eastward" toward a cliff they would eventually catapult across, into the present. Both stories posited the notion that the present somehow *contained* the past, coinciding with Remington's fresh realization after the Cuban war that, if he was to have a viable past for his art, he would have to generate it from his own perceptions and reinforcing his new theory that, if a satisfactory future could not be materialized by imagining a past, then both past and present might be rendered imaginable by investigating the relationship they bore toward each other. Four new stories about Sun Down Leflare—each of which affirmed Remington's new awareness of the West as a place where what Crane called a "glimpse of another world" might be possible—were the result.[5]

In the first, "How Order No. 6 Went Through," Sun Down exchanged his former role of translator for the more important one of storyteller, and Remington characteristically framed the first-person story Sun Down told within a first-person narrative of his own. On the periphery of the frame was Remington's Montana trip of 1896. The opening of "Order No. 6" contained a campfire scene, where Remington and Sun Down gathered with hunting companions on a windy night, and Sun Down regaled the company with a history of events that had occurred twenty years before, when he was working as a scout for Nelson Miles at

Letters from Another Country

4. Stephen Crane, "A Man and Some Others," first printed in *The Century* for February 1897. "The Bride Comes to Yellow Sky" first appeared in the February 1898 *McClure's Magazine*.
5. "How Order No. 6 Went Through," "Sun Down Leflare's Money," "Sun Down Leflare's Warm Spot," "Sun Down's Higher Self."

Fort Keough. The colorful but undistinguished narrative of how Sun Down delivered a military document from Fort Keough to Fort Buford in subzero weather demonstrated the way Remington could compel the circumscribed plane surface of a scene to open backward like a tunnel into time, for the Sun Down who told a story in "Order No. 6" was the same middle-aged vagabond who translated the Crow myth in "The Great Medicine-Horse" and appeared in a picture at the end of "Order No. 6" as a sturdy, muscular figure attired in an ill-fitting suit of white man's clothing. The Sun Down who appeared in this figure's narrative, on the other hand, was a young man who lived with his "woman" at Fort Keough, drew seventy dollars government pay every month, and wore the fringed buckskin winter uniform of a cavalry scout.

Extending the same pattern, "Sun Down Leflare's Money," the next story in the Sun Down series, reached back to the edge of confrontation, where people who measured wealth in terms of pelts, dried meat, and ponies came into contact with the symbolic economics of paper currency and decks of playing cards. The story also conjured up an undomesticated Sun Down, who referred to himself and his companions as "us Enjun" and attempted to subvert the European order he came near dying for in "Order No. 6." Remington deftly reasserted chronology at the outset of the tale by picking up verbally where he had left off graphically in "Order No. 6"—that is, by beginning "Money" with a description of how Sun Down looked in the picture that showed him "washed and dressed up." Back from the pack trip where Sun Down had narrated "Order No. 6," Sun Down and Remington now sat on the steps of the flour mill at the Absaroke agency, talking about the difference between buying things and acquiring them in other ways.

From the vantage point of the flour mill steps, which also identified his narrative's chronological frame, Sun Down proceeded to explain how the time when the events of his narrative took place acquired its link with the time in which he related the narrative—which was also the equivalent of telescoping the present time backward into a time when the narrator experienced his first encounter with the forms and spirit of European civilization among the white prostitutes and cardsharps who frequented frontier gambling dens. "Back

yondair," he said, one could just see the juncture of old and new:

> De buffalo man she was come plenty wid de beeg wagon, was all shoot up de buffalo, was tak all de robe. Den de man come up wid de cow, un de soldier he was stop chasse de Enjun. De Enjun she was set roun de log pos', un was not wan' be chasse some more—eet was do no good. Den come de railroad; aftar dat bad, all bad.[6]

Although Remington remarked that he and Sun Down were "inclined to ... gaiety" as Sun Down's narrative opened, the story he told was an elegiac discourse on the loss of his own innocence.

Like the straight man in a vaudeville show, Remington at the close of the narrative supposed that "nothing came of all that enterprise," and Sun Down, dressed in store clothes and talking at the headquarters of an Indian agency with a man who made pictures and stories for national magazines, agreed that "not'ing" did. Yet it seems unlikely that Remington could have so quickly forgotten either that Sun Down called the arrival of the railroad "bad, all bad," or that the newly married sheriff in Crane's recently published story had announced the arrival of a train in Yellow Sky with "constricted throat and ... mournful cadence, as one announcing death."[7] The unstated but persistently implied assumption that pervaded the tale of Sun Down's brief prosperity was a conviction that life was "back yondair" among the buffalo herds and the rawhide tents of tribal villages and that death hung like a pall about the chronological foreground where money, military garrisons, and trains made it difficult to achieve a point of vantage.

Remington therefore set about discovering the difference between the vitality Sun Down happily remembered and the moribund spirit he identified with the railroad. In "Sun Down Leflare's Warm Spot," the next and penultimate tale in the series, he pursued the inquiry by measuring the meaning of the symbolic currency Sun Down won and lost again, the significance of the railroad train his erstwhile partner rode east, and the institution of marriage tested by Jack Potter at Yellow Sky against the Sun Down he characterized as an "exotic."

6. "Sun Down Leflare's Money," p. 195.
7. "The Bride Comes to Yellow Sky," p. 379.

Even among relatively tame surroundings, Remington suspected Sun Down of an "undomesticated mind," and a questioning confirmed the suspicion, revealing that the half-breed had fathered a "whole tribe" of children by no fewer than six women, none of whom he had married. The best, he confided to Remington, was a Gros Ventre woman he had acquired two decades ago in exchange for twenty-five ponies. Another, he had stolen from a young Crow brave whom he later killed. The latest, a white prostitute who had borne him a baby he now paid to have cared for at the Crow agency, had received her fee and departed. Besides a certain eccentricity which Remington found attractive, the pattern of encounters revealed a key to what Remington sought, for it traced Sun Down's progress from "weird past" to mundane present.

Sun Down characterized himself as "all same Enjun —fringe, bead, long hair" at the time of his involvement with the first two women, and Remington elsewhere wrote of him that, his French father notwithstanding, he had been "born and raised with the buffalo Indians." It was therefore appropriate that, although acquiring the Gros Ventre woman had involved an economic transaction, it had been a barter rather than a sale. The second woman, however, about whom Sun Down confided that "you see no woman at Billings Fair what would spleet even wid her," encountered him somewhat later, after he had gone to work as a fur trader at a post on the Missouri River, and Sun Down noted that "I tink she not straight bred Enjun woman." Such a woman could not be bartered for, and Sun Down simply stole her, informing her as he did so that "I am reech." The rather more complicated economics of this latter episode, characteristic of accelerated change, involved cards, money, and race rather than ponies. Three years afterward, Sun Down offhandedly sold the woman "for one hundred dollar to white man on de Yellowstone." Only a white man was likely to have a hundred dollars to pay for the woman, and only someone who played cards for money rather than bartering horses for women was likely to make the sale. The railroad that delivered Sun Down's gambling partner from the West also made it impossible for Sun Down to remain "all same Enjun."

Indeed, by the time Sun Down told his story to Remington, the half-breed woman he had sold to the white

man on the Yellowstone had doubtless borne children who resembled Indians very little, and the white woman the railroad had brought Sun Down had left him a "leetle baby," whom he was paying to have raised in a white home. That the pattern thus defined was neither flat nor unitary augured the awareness of multiplicity that emerged from Remington's new attention to time.

The last of the Sun Down stories, printed four months after the close of the Spanish-American War, accordingly contained signs that the artist who had for so long occupied himself with fragmentary impressions was beginning to achieve a sense of what the fragments meant when fitted together. Called "Sun Down's Higher Self," it presented several anecdotes concerning Sun Down's "medicine" in a sequence which was surely fragmentary but which also hung on a framework, whose main function was to define Remington and Sun Down in relation to each other. Its final sentence, which was also its most important, had the half-breed contemptuously call the artist a "white man" to identify the artist's newly intensified realization of the place he occupied in the mosaic his art had at once created and recorded. It was precisely at this point in Remington's new investigation of chronology that his old concern for point of view asserted itself with perturbing force.

Even though he had entered the white man's world, the Sun Down of the tale had once been an Indian. Indeed, he had been several Indians. Born in the Pembina River country of Manitoba to an Ojibway mother, he had traveled west to Montana as a young man to join the Piegans in their raids against the Crows, later joined the Crows in their disputes with the Cheyennes, and subsequently became part of the Cheyenne scout corps Miles employed against the Sioux. Remington, however, remained what he had always been—a European who suffered feverishly from alternate fits of admiration and hatred for Indians and the obscure meanings he sometimes assigned them. Sun Down's final definition of him as "white" therefore had the force of designating Remington a superficial observer. The artist's investigation of time had suddenly and surprisingly become an intensely personal investigation of self.

Sun Down allowed that Remington might be a "good man" but also observed of him that "you go run roun'

wid de soldier, go paint up deese Enjun, un den go back Eas'," further declaring that to learn the mysteries of the tribe by becoming a tribesman was an altogether more rigorous activity: "Enjun he go all ober de snow; he lie een de dark; he leeve wid de win', de tunder—well, he leeve all time out on de grass—night time—daytime—all de time."[8] The tribesmen Remington thought he had painted could hear voices in the wind that howled "roun' de tepee een de wintair night" and see "speerets dance un talk plenty een de lodge fire," where a white man could "see not'ing but de coffee boil." Because he incased himself in unnatural environments and indulged in unwholesome enterprises, or perhaps, as Sun Down had it, because he "don' 'pear know enough see speeret," the clubman who studied the tribesman deified his own ignorance, inviting Sun Down's abrasive judgment that "white man mak de wagon, un de seelver dollar, un de damn railroad, un he tink dat ees all dair ees een de country." In Sun Down's view, to be a white man was equivalent to being a blind man. If what Sun Down said was true, the artist who had pursued the subject of the frontier for nearly two decades had simply been missing the point. He had never known what the frontier was because, while he had followed along behind it, he had never explored beyond it.

Remington had seen enough of the frontier to know that—like any other boundary—it had two sides, and the appearance of Sun Down in Remington's stories signaled Remington's intention to invade the territory out of which Sun Down had emerged. Yet he must have known from the outset that there was no longer any possibility of setting up an easel there, for its chronological boundaries were more firmly fixed than its geographical boundaries had ever been. The same railroad that transported Remington west had long since hauled Sun Down's haunted prairies east, leaving the Indians and the spirits they worshiped as homeless as the white men who wandered about on the railroad and saw no spirits anywhere. Even Sun Down supposed that he would someday take his nearly white son "back Eas'," where he intended to "mak dat baby grow up where dar ees de white woman un de pries'" and "mak heem ave de farm, un not go run roun' deese heel on de damn pony."

The artist who had spent much of his life following

[8] "Sun Down's Higher Self," p. 846.

rail lines to their point of intersection with boundary lines that steadily retreated before them therefore now called the railroad "an institution which I wish from the bottom of my heart had never been invented."[9] He had supposed that the places where he sampled western grass roots were parts of a region that contained energy and invited art. Yet the Montana twilight—where spirits vanished and red men became white men who went east to live on farms and worship at churches—suggested something very different. It confirmed neither the *Buster*'s denial of sequence nor Joshua Goodenough's defiant assertion of a genetic sequence within which the archaic individual survived merely by being repeated in his offspring. Rather, it illuminated process, also establishing with a clarity to which recognition comprised the only possible response that the West was less a region than it was the direction in which the sun set—a well-worn but still forceful metaphor for death. Seen from his house at New Rochelle, where Remington returned after his brief experience of the Cuban war, the West of 1898 looked very different from the West of 1881.

Remington now began to see his subjects differently, not because the subjects had changed but because his latest recognition left him no recourse except to understand how he and his subjects were related. Even though he had just six years earlier, in 1892, come back from Europe to find the "new" in America, he now sensed in the same republic a persistent rhythm he had previously failed to recognize. Hunting for the new, he must have remembered, had sent him to Yellowstone, where he found only park rangers and Owen Wister; to Chicago, where he encountered civil disorders that failed to satisfy his taste for apocalypse; and to various deserts and mountains, where he got to know cowboys and soldiers. Now, he looked about him at the pleasant suburban clutter of New Rochelle, which was definitely new, and—instead of heading west to discover something even newer—he bought a wooded island of some five acres, complete with house and studio, in the St. Lawrence River's Chippewa Bay, about three miles from the Canadian border. By repudiating the West he had celebrated for its energy, and by turning his attention to the West he at last recognized as termination, he struck the somber keynote for his last and most instructive body of work.

9. Ibid.

As a social and economic transaction, Remington's acquisition of Ingleneuk, as he called his island summer home, was a sign of affluence and professional success; as a symbolic gesture, it signified Remington's shifting perspective. Partly because his large size and declining health no longer permitted him to travel as he once had, partly because sections of the West had been modified by settlement, the West was no longer available to Remington as "vacant land," and he made only two more extended trips there, one in 1899 and one in 1900. Consequently, even he sometimes thought of his island as a substitute for places like San José de Bavicora. If there was any truth at all in such thinking, however, it was of the most provisional nature for, as Remington's work increasingly demonstrated, the value of Ingleneuk was its capability for allowing the artist to understand what his perceptions of places like San José signified. Once Remington realized that his perceptions of the West objectified impulses that originated in himself, there was no urgent reason to return to the places he associated with them. His tiny wooded island in Chippewa Bay expressed his new insularity—it was a point of vantage from which he could peer into the weird past of the exotic Sun Down, recognizing the people, the landscapes, and the actions as identical with those he had passed as he made his way from Canton to Cuba but also seeing that their collective function was altered.

The reason for this alteration involved both location and identity, which together constituted point of view for, although Remington's work had always represented fading subjects, it had always done so principally to emphasize their novelty—even when he was most successful in evoking a sense of the tribe he wanted to belong to, his enthusiasm for the enterprise as "new" automatically branded him an outsider. With Sun Down, however, he had produced a character reared as an Indian, who had become progressively Europeanized, even though he had observed that white men died "pretty easy" and that Indians were conversely "pretty sharp" in their desire to live. The inference of such a configuration, which Remington asserted with some skill, was that—as Sun Down lost his youth and approached the end of his life—the qualities that distinguished him as "all same Enjun" simply faded away, presumably to vanish altogether at the moment

of his death, leaving him a white corpse rather than a red spirit. The perception of the self in time not only made possible a perception of the self's multiplicity, it also elucidated the essential harmony by which the buster, Joshua Goodenough, and all the other tribesmen were together governed. Each, by the position he occupied along a scale between redness and whiteness, stated an expressive tension between living and dying. The force that kept the buster in his seat and fed the family tree of Goodenough was therefore precisely the same as that which ordained an interval between Sun Down and Remington. Remington could meet the challenge posed by Sun Down only by exploring beyond the frontier Sun Down defined.

The task was far from easy. Even though the concurrent processes of bleaching and aging that carried Sun Down away from the morning of his life on the western prairies toward its evening on an eastern farm suggested this frontier, they still expressed continuity and thus did not fully satisfy the requirements Remington attached to the terminal conflict he called "that old cleaning up of the West." Indeed, before he finished the Sun Down stories, Remington probably began to suspect that he had never truly found war's "romance" at places like the New York Armory and Wounded Knee—or even at the base of San Juan Hill—because he had directed his attention principally to the warriors who survived, while the mystery he sought belonged only to those who suffered defeat. The special correspondent at Wounded Knee and the self-appointed secretary of war at San Juan Hill thus acquired a fresh sense of what his titles meant when he recognized that, behind the exotic locations where he had recorded energy, was an impulse he had been aware of only dimly.

Earlier, before his experience in Cuba had shown him the difference between anticipation and event, Remington had usually been content to relate his impressions, as when he wrote that entering the lodge of Itsoneorratseahoos had obscurely reminded him of a "stroll in the winter forest." Now, he sifted through the impressions he had recorded, puzzling, in what he wrote about them, at their collective significance. This was clearly a conscious process on his part, one in which his observation of scenes and subjects was modified by a conscious exercise of introspection. Describ-

ing a snow-covered woodland scene in a December 1898 *Harper's* essay, for instance, he not only made sure that his account was affective but located the particular affective focus of his last body of work:

> It had a soothing, an almost seductive influence, that muffle of snow. So solemn is it, so little you feel yourself, that it is a consciousness which brings unconsciousness, and the calm white forest is almost deadening in its beauty.[10]

Although he had executed numerous assignments for his editors and patrons, Remington now realized as never before what all the assignments together meant for him personally. Into each of them he had put something of himself, and as he thought about the snowy woodland he began to recognize a concern that held the assignments together. "The winter forest," he concluded, "means death."

So, for that matter, did the autumn forest where Ah-we-ah fought a losing battle with starvation in "The Story of the Dry Leaves," published in the *Harper's Monthly* for June 1899, and the summer forest that encircled San Juan Hill, which appeared as an irregular wall of livid green at the back of Remington's famous picture of the charging Rough Riders, printed in the April 1899 *Scribner's*.[11] When Remington turned to look behind him at the path of empire he had begun to celebrate in 1881 as vacant land, he found it littered with corpses that emphatically confirmed Sun Down Leflare's judgment concerning the principal difference between the white men who built the white man's road and the Indians the white men herded onto it:

> I see deese soldier stan' up, geet keel, geet freeze all up; don' 'pear care much. He die pretty easy, un de pries' he all time talk 'bout die, un dey don't care much 'bout leeve. All time deese die.[12]

Remington remembered how horses picketed near the field hospital at the San Juan River stamped "as though to get rid of a troublesome fly" when bullets struck them, then lay down "panting desperately" or "sat down like a dog."[13] He recalled stories of Indian agents who plotted to kill cavalry officers and cavalry

10. "The White Forest," *Harper's Monthly*, December 1898, p. 66.
11. "The Charge of the Rough Riders at San Juan Hill," *Scribner's Magazine*, April 1899, p. 421.
12. "Sun Down's Higher Self," p. 847.
13. "How the Horses Died for Their Country at Santiago," *Harper's Weekly*, July 15, 1899, pp. 698–699, accompanied by a brief text, p. 700.

officers who retaliated by collecting the severed heads of their attackers, a horrible permutation of the custom of taking scalps.[14] He even constructed a "romance" in which the love an American soldier felt for a pretty immigrant girl and the hate he felt for a Mexican rival were curiously mingled not only with each other but with the gratuitous killing of scores of Indians by means of coyote poison.[15] Persistently and with passionate attention, Remington followed the trail of his work backward to discover that, wherever the line of the white man's road encountered the line of a frontier, there was certain to be death.

Not surprisingly, the subject of death was intimately bound up with the twin conjoining mysteries of racial difference and sexual attraction which had figured so importantly in Remington's personal life, since his fatherless early childhood during the Civil War, and in his professional life, since at least as early as the time when the refusal of Eva Caten as a bride sent him west to inspect the battlefield at Little Big Horn. Furthermore—perhaps just as importantly—death, sex, and race were firmly linked with the geographical and chronological phenomenon of the West in the popular imagination Remington both formed and was formed by.

Sydney Cloman managed to communicate a sense of this linkage with a brief sketch, set at the Wounded Knee fight of 1890, in which a Cheyenne scout kills his Sioux sweetheart by mistake, subsequently stabbing himself to death when he discovers what he has done.[16] A more considerable tale by "Bucky" O'Neill—a sheriff from Prescott, Arizona, who joined the Rough Riders as captain only to be killed at Las Guásimas—also treated darker aspects of the racial tragedy that Roosevelt's grim pioneer pushed just ahead of him on his triumphal march across the continent.[17] O'Neill's story took place in 1861, at the Arizona Territory outpost of Fort Buchanan, when the First Infantry, called east to help preserve the Union, is ordered to abandon the fort, leaving behind the Papago woman and infant son of one of the white troopers, both of whom are stoned to death by the Indians. Neither Cloman's story nor O'Neill's succeeded very well as fiction. Both, however, utilized the same factors Remington combined but failed to bring to a satisfactory resolution in the narrative "A Desert Romance," printed in *The Cen-*

14. "Natchez's Pass," *Harper's Monthly*, February 1901, pp. 437–443.
15. "A Desert Romance," *The Century*, February 1902, pp. 522–530.
16. Sydney A. Cloman, "Walita: A Trooper's Story," *Cosmopolitan*, January 1898, p. 230.
17. "Bucky" O'Neill, "The Requiem of the Drums," *Cosmopolitan*, February 1901, pp. 401–405.

tury for February 1902, some nine months before the publication of *John Ermine of the Yellowstone*, his first novel.

Whether Remington fully realized it or not, the romance of his narrative was not a matter of hate or love or some combination of the two. It was a grand design of geographical tensions, in which the West figured both as an arena in which the two principals could demonstrate their rather trivial sexuality without offending readers and as an irresistible lure for the imagination, promising the darker consummation Remington identified, however innocently, when he wrote that "the West was fast eating up strong young men from the East."

That *John Ermine of the Yellowstone*, published by the Macmillan Company in November 1902, closed with a chapter entitled "The End of All Things" pointed to Remington's attempt to correct the unsatisfactory condition that had spoiled "A Desert Romance" and had, indeed, rendered it virtually impossible for any of his earlier fiction to treat termination as a theme.[18] One reason for the altered circumstance reflected in *John Ermine* was doubtless the form imposed upon Reminton by the genre he now attempted to employ for the first time for, while nearly all of Remington's other writing had been freehanded and sometimes strikingly if unsuccessfully experimental, *John Ermine* was by and large a conventional work in which plot and subplot came together at the end to resolve the action, just as authorities like Howells said they should, resulting in a decisive statement as readily recognizable as the finale in an opera. The plot concerned the progressive but incomplete Europeanization of the hero, a blond frontiersman born about 1856 and raised by a band of Absaroke Crows who ranged from Wyoming to Montana and South Dakota. The subplot was a love story that recalled the rigorous courtships of Sun Down Leflare.

Briefly, Ermine, named White Weasel by his Indian foster parents, is surrendered in his adolescence to a white recluse who calls himself Crooked Bear, whom the Crows regard as sacred. Renaming him, and recognizing him as a white, Crooked Bear teaches him reading, arithmetic, and rudimentary Christianity and sends him off—in the company of a half-breed named Wolf Voice—to join General Crook in his pursuit of

18. *John Ermine of the Yellowstone* (New York: Macmillan, 1902).

263
Letters
from Another
Country

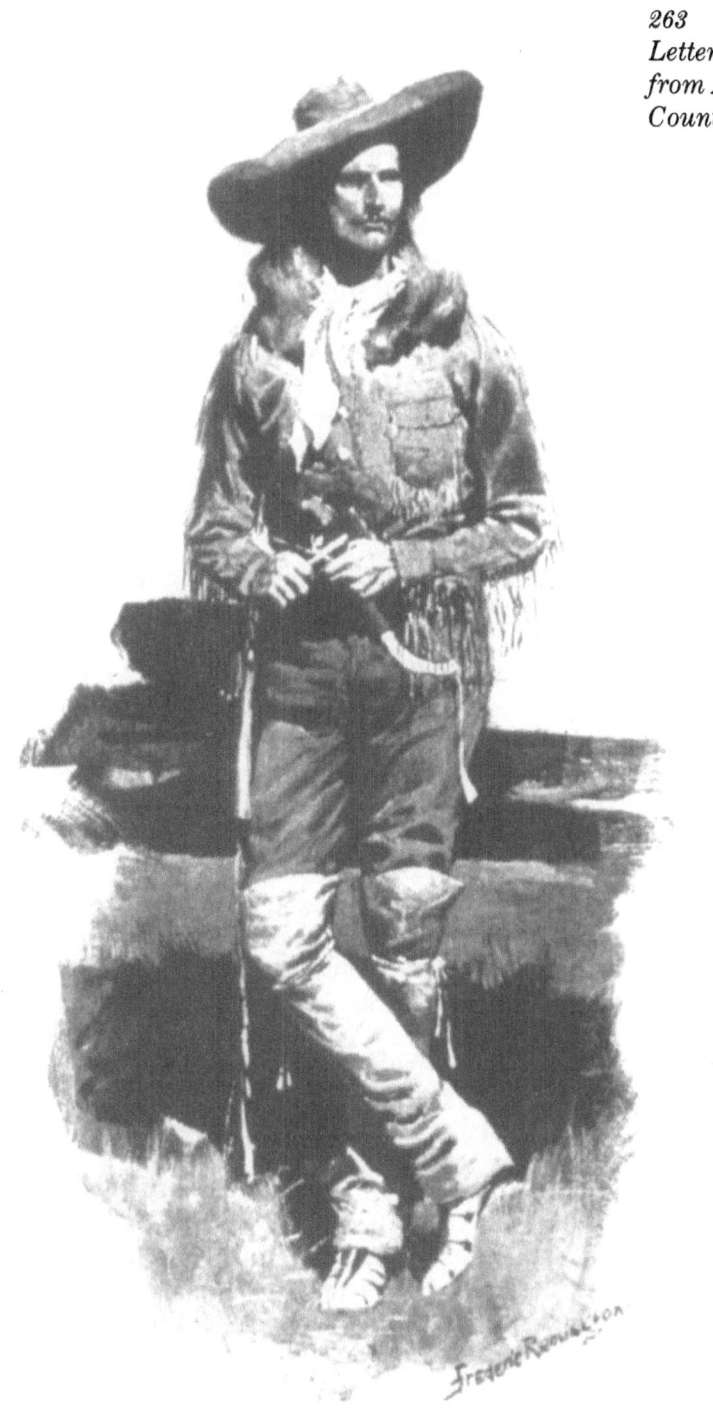

29. "John Ermine." The white hero of Remington's first novel was known as White Weasel by his Indian foster parents.

the Sioux and Cheyennes across Montana during the winter of 1876, immediately following Sitting Bull's triumph at Little Big Horn. Ermine excels at military pursuits, including fighting, card playing, horse trading, and getting drunk, but, when he retires with his unit to a position on the Tongue River in the spring of 1877, he falls in love with the coquettish daughter of an officer, proposing marriage, suffering refusal, and inflicting a gunshot wound on the girl's fiancé, a young lieutenant. He then flees to Crooked Bear's lodge in the mountains and there receives good counsel, which he finds himself unable to accept. Returning to the fort by night to steal the girl, he is shot and killed by a jealous Crow.

Such a plot might have served either an epic or a dime novel western. *John Ermine* was neither because, while the setting and subject of the story had epic possibilities, Remington did not attempt to exploit them—even though he had elsewhere flirted with the "Homeric" aspects of both Indian wars and civil disorders—and, while the plot and its execution were haunted by the ghosts of juvenile writers like Edward Wheeler, whom Remington had read as a boy, the book had an odd capability for rendering its formulaic tendencies irrelevant.

Instead, *John Ermine* was a personal testament. Its setting was the same region of vacant land into which Remington had wandered in 1881, just four years after the accomplishment of the events it narrated—which designated the difference between Ermine's age and Remington's—and the Little Big Horn battleground was at its center—which Ermine, like Remington, witnessed only secondhand as a "big surround" of "pony soldiers." Its hero, to whom Remington assigned the same "weird past" he had borrowed from Roosevelt's designation of Massai and given to Sun Down Leflare and who, like Sun Down, was described as "all same Enjun," was Sun Down's obverse. In a novel that bore the unmistakable stamp of speculative autobiography, Remington had responded to the historical European thrust—expressed as red men who wore white men's clothes and sired white children—with a counterthrust expressed by a white man who claimed to have a "Crow heart" and whom contact with whites only turned into an Indian. Clearly, this was the imagination's hopeful answer to Sun Down Leflare's medicine. In response to

Sun Down's stinging accusation that he was "white," Remington had simply evoked the whole canon of his life and work from his fatherless Civil War childhood onward.

Rather than merely repeating patterns from Remington's other works and manipulating thinly veiled accounts of the conditions of his life, *John Ermine* defined the value for the imagination of both life and works for, with all its flaws, it represented Remington's view, now unitary and retrospective, of the picture he had created piecemeal. Like the panorama Remington saw from the top of El Poso in Cuba, the retrospective prospect possessed a frightening lucidity. It revealed the column of Remington's heroes, a Gaul at one end and a métis at the other, with soldiers, punchers, and Indians filling the space between, and, while each of the heroes could be distinguished from his fellows, their features had a family resemblance. There was not one of them to whom Remington had not in some way applied the force of the remark Crooked Bear made about John Ermine: "I will give him the happiness which was denied me, and it pleases me to think that I can do this."[10]

Since each of the heroes epitomized by Ermine represented a partial surrogate of Remington, the man who included them all constituted a culmination. A blond, fair-skinned boy born in a place where he could be raised as an Indian, at a time that allowed him to march with Crook in the aftermath of Little Big Horn, he could only—that climactic experience behind him—die in his twenty-first year, the chronological point that marked the end of his boyhood. For all the signs of haste and clumsiness it exhibited, this pattern recalled Remington's first encounter with the tribe seventeen years before.

19. Ibid., p. 53.

2. Demons of the Night

Whether Remington's death in 1909, at the tragically early age of forty-eight, may be regarded as a function —or even a confirmation—of Remington's work remains an open question for a student of the artist's career. Clearly, however, the collective force of Remington's work does not allow his death to be regarded only as a cessation of vital signs, brought on, in his case, by years of self-abusive overindulgence. The possibility that Remington's life style and the multifaceted pattern of his work in its totality, so intricately interwoven, were actually or potentially suicidal is, of course, no more than a possibility. Nonetheless, the terminal event of the artist's death and the lifelong event of his art together express the same troubling symmetry that pointed to the central isolato of the "Evolution" pictures in 1895 and later produced Sun Down Leflare and John Ermine as negative images of each other. The principal value and great peril of this symmetry for Remington were its appeal to the imagination. During the last years of his life, Remington's work demonstrated nothing more surely or more powerfully than his imagination's capability for ordering, synthesizing, and thus re-creating whatever it touched. Since this same work—occupied almost exclusively with death as subject and theme—so thoroughly mir-

rors the event of Remington's death, it may be regarded by a student as having a literally "deadly" dimension. The nature of Remington's personal involvement with his work was clearly both exuberant and self-destructive.

A key feature of this intense involvement was casually and perhaps inadvertently identified by Orin Edson Crooker in the observations he made to accompany a page of Remington's early sketches and letters, presented in *Collier's Weekly* in 1910, little less than a year after the artist's death, as relics of his boyhood.[20] For anyone even vaguely familiar with Remington's subsequent work, it was not surprising to learn that Remington at fifteen drew sketches of Cossacks on horseback or that he wrote to an acquaintance asking for pictures of "cowboys, Indians, villains or toughs."[21] Crooker, however, concluded from the boyish notes and pictures not that they proved what everybody already knew about Remington but that they suggested something that most people had overlooked and that few of Remington's enthusiastic supporters were willing to admit. "It has been said of [Remington] since his death that he was one of those who have been 'formed by their experiences in life,'" wrote Crooker, "but back of this life experience in Frederic Remington's case were the yearnings and longings even in his boyhood to picture the very characters and scenes which afterward brought him fame."

The point was a modest one, modestly stated. Incorrectly paraphrased, it might even come out an aphorism asserting that Remington was "born and not made" an artist. Yet it also implied that the wistfulness and vigorous angularity that distinguished Remington's work—and were therefore commonly attributed to the subjects he treated—belonged not to the subjects but to Remington. What was thus suggested by the page of boyish notes and pictures presented by Crooker was no affirmation of Remington's lifelong interest in a geographic region but the boyhood those notes and pictures shared with their mature counterparts.[22] When Remington drew pictures of Cossacks and cowboys at Highland Military Academy, he did so chiefly because he wanted to be *in* them—and later proceeded, as a man, to hunt down corresponding Cossacks and cowboys to ratify his imagination. In the decade following the Spanish-American War, when he ex-

20. Orin Edson Crooker, "A Page from the Boyhood of Frederic Remington," *Collier's Weekly*, September 17, 1910, p. 28.
21. Remington letter quoted by Crooker.
22. Peter Hassrick, for instance, notes in *Frederic Remington* (New York: Harry N. Abrams, 1974) that, "in his efforts to portray the rigors of frontier existence, Remington's tense forms, highly articulated surface textures, and unbridled action remained in perfect sympathy with the overall Western theme." The statement is both accurate and misleading, because it suggests that Remington merely painted what he found in the geographical region of the West. In fact, Remington painted what he imagined, using what he found as ratification. Hassrick's mistake is a common one.

plored the theme of death in his own previous career, painting and writing to express what he found, he performed a clearly analogous activity. The capability of Remington's mature imagination to order, synthesize, and re-create derived from boyhood "yearnings and longings" forged at enormous personal cost into an expressive and finally merciless design, whose last and most personally urgent function was to receive the artist.

Remington's final involvement with the West thus brought about a personal and aesthetic culmination rather than a historical record and, although he thought until 1898 that his work concerning the American West in some sense recorded a geographical region, he told art critic Perriton Maxwell in 1907 that he was not interested in the region of the West, because the region of the West did not inform his art. Specifically, he said that the place was "no longer" the location of "picturesque and stirring events" and contrasted it with another place he called "*my* West" (italics mine), which had "passed utterly out of existence so long ago as to make it merely a dream."[23] The latter place, he declared, "put on its hat, took up its blankets, and marched off the board"; afterward, the "curtain came down" to allow the preparation of a "new act." Of course, what Remington probably intended in telling Maxwell that "I have no interest whatever in the industrial West of today" was that he had a great deal of interest in the romantic West of yesterday but, as late as 1900, he had told a newspaper reporter in Colorado that "I don't consider that there is any place in the world that offers the subjects the West offers"[24]—even when he tried to show Maxwell the relationship between the changing region of the West and the West represented in his art, which he seemed to imply was immune from change, he utilized a two-pronged metaphor of fantasy and drama to explain how the chronological progression had occurred. What he called "my West" was not a place where he had once been but a condition he presently imagined. Indeed, during the same 1900 trip in which he told the Denver reporter that the West offered more subjects than any other place, he also vowed that "I shall never come West again ... it spoils my early illusions." His vow affirmed both the value and the function of the state Crooker would identify as boyhood. As a mature artist, Rem-

23. Perriton Maxwell, "Frederic Remington: Most Typical of American Artists," *Pearson's Magazine*, October 1907; quoted in "Frederic Remington—A Painter of the Vanishing West," *Current Literature*, November 1907, pp. 521–525.

24. "Frederic Remington," Denver *Republican*, October 21, 1900, quoted in Hassrick, p. 39.

ington could acknowledge that "early illusions" were more important than history.

In consequence, he countered the historical pageant Maxwell called a "great Wild West drama" with a somber performance that represented his own temperament.[25] The knuckly, harshly outlined figures of Indians and soldiers who rode through his earliest works accordingly softened, and the great empty spaces they occupied were mellowed and deepened by means of the artist's increased understanding of color and shading. His bronzes were likewise marked by a new sense of complexity, as unitary compositions like the *Buster* gave way to works that represented multiple figures moving in fortuitous concert, like the band of drunken cowboys in *Coming Through the Rye*, and the roughly textured surfaces of his earlier works were replaced by the polished, gracefully executed curves of figures like *The Buffalo Horse*. In every scene of the counterdrama, however, the same imagination that had turned Remington's attention to "cowboys, Indians, villains or toughs" asserted itself with a vigor it had never before achieved, because Remington's imagination, turned in at last upon itself, enabled the artist to re-create everything the boy had always longed for. One way of describing the situation might be to say that the artist had gained control of his imagination; another, that the artist's imagination had succeeded in capturing the artist. The result was that the canon of the artist's work rapidly acquired its final resonance, its fundamental action, and its ultimate definition of the figure who occupied its center.

In the last works Remington wrote about the Spanish-American War, the place previously occupied by the buster and his ensuing permutations was entered first by Don Thomas Pidal, a homeless war refugee, then by a Corporal Oestreicher, an aged orderly in the Third Cavalry.[26] The former, said Remington, had been introduced to him by Sylvester Scovel, a correspondent for the New York *World*, in a Cuban fonda, where he eagerly told his story in exchange for the price of a meal; the latter, having faithfully attended his major from the Apache campaigns at San Carlos through the charge at San Juan Hill, was killed at Cabanatuan in the Philippines. Neither resembled the heroic figure Remington had once imagined as one of the buster's avatars, but both possessed qualities that made it pos-

25. "Frederic Remington—A Painter of the Vanishing West," p. 525.
26. "The Sorrows of Don Thomas Pidal, Reconcentrado," *Harper's Monthly*, August 1899, pp. 393–397; "They Bore a Hand," *Harper's Monthly*, April 1900, pp. 705–711.

sible to consider them types of the archaic. If they looked out of place in the central void Remington had fashioned for the buster's eternal triumph over gravity, it was simply because they fell, in the process encountering and crossing the frontier with which Sun Down Leflare taunted Remington by calling him "white."

Pidal, a prosperous farmer with a wife and five children, had been rounded up by Spanish soldiers who butchered his herds, destroyed his crops, and burned his house. He was put into a Havana concentration camp, where he watched the members of his family die one by one from starvation. Oestreicher, described as a "typical German of the soldier class," had been an "atom of humanity" in company with "thousands of armed countrymen" determined to "set the stars and stripes over the frontier and hold them there," unwittingly demonstrating that—whatever continuity might be expressed in the collective enterprise of military conquest—the individual participant always played a terminal role. Both figures were heroes because both had touched heroic enterprises, yet both were pathetic because each entertained illusions about the enterprises that touched him, as when Pidal puzzled about "why people who do not want war should have it," or Oestreicher told tales about how "he and the Major" took San Juan Hill. Together, they suggested how complex were the boyhood yearnings Remington's imagination now more and more actively engaged—and in doing so they also instantly endowed the buster and his fellows with another, final dimension: no one could look at the precariously seated buster without imagining him unseated. The values Remington associated with the archaic required that the archaic hero be destroyed.

Remington thus had to devise a means of allowing the archaic hero, whom he had always represented poised at the *brink* of terminal crisis, to speak from *beyond* that crisis. He accomplished this interesting feat in a simply plotted but deftly conceived and executed story called "When a Document is Official," also managing to show what the effect of the archaic's culmination would certainly be.[27] Here, William Burling, a thirty-year-old cavalry sergeant stationed at Fort Adobe during the 1870s, is told in confidence by an officer that he has been promoted to second lieutenant

27. "When a Document is Official," *Harper's Monthly*, September 1899, pp. 608–613.

and that his signed commission is on its way from Washington. Almost at once, however, the commandant sends Burling out to deliver a document to the commander of a unit in the field. This paper is subsequently stolen by illiterate buffalo hunters and, very quickly, recovered by Burling, who outdistances the pursuing hunters and camps in a wooded creek bottom. Smoothing the crumpled document he almost lost and thinking about the signed commission on its way from Washington, he fails to notice the restlessness of his picketed horse until a band of hostile Sioux has surrounded him. After a bullet strikes him in the hip, he crawls into a dense thicket, where the Indians kill him —since he is clearly one of Remington's prototypical men in the circle, he thus demonstrates the perils of his own centrality. Burling's death, however, at once marks the end of Remington's plot and the beginning of his more complicated formula for final culmination. Just as the chief personal function of the boyish sketches Remington drew at Highland Military Academy was to allow Remington to imagine himself in the place of the figures he drew, the function of the formula he devised in "A Document" was to establish the artist's location, as creator and participant, at the center of his own accumulated work.

What sets Burling most sharply apart from both Remington's earlier tribesmen and the Indians and buffalo hunters who pursue him is a susceptibility to the power of the symbols Remington employed in his formula. At the outset Remington identified one set of such symbols by noting that "Burling had for the last four years worn three yellow stripes on his coat sleeve," adding that previously "there were two years when he had only worn two." The lieutenant's bars Burling looks forward to are likewise symbols of the same order, the significance of which Remington located by observing that they represented "the 'clean-up' of Burling's assets." The bars were locked firmly into the same complex system that generated signed commissions sent out from Washington and sealed orders dispatched from Fort Adobe, and Remington pointedly remarked of Burling's progress toward acquiring them that "he had wrestled so sturdily with the books that when his name came up for promotion to an officer's commission he had passed the examinations." If they were not precisely literary symbols, the

bars were at least symbols of literacy. Burling's pursuit of them, like his reverence for the written order he must risk his life to deliver, was a badge of membership in the white man's club.

The buffalo hunters, however, were not impressed by Burling's military rank and took the written order only because they thought it might be worth money. As Remington characterized them, they were "men of iron endeavor for gain. They were adventurers; they were not nice ... There was an intellectual life—a scientific turn—but it related to flying lead, wolfish knowledge of animals, and methods of hide-stripping." What separated them from Burling was not that Burling could read and they could not but that they read different documents.

Indeed, it was to the buffalo hunters, of whom Remington remarked that "they do not say things ... that go for much," that he also ascribed the whole of the narrative of Burling's death. The hunters knew that Burling had camped in the creek bottom, that the Sioux had surrounded his camp, that Burling's horse had roused him from his reverie, and that Burling had then been shot and had rolled down a bank and dragged himself into the bushes, while his horse stamped and snorted but could not decide which way to run. They knew that a silent interval of several minutes had followed, during which the Sioux crawled closer. Finally, they knew that there had been a "bright little flare of fire" from Burling's hiding place, immediately drawing the Indians' shots from all directions. What the hunters read to learn all this were the signs Burling left behind him on the prairie rather than the texts he had wrestled with at the fort. To make sure no one missed the point, Remington equated the "footprints" the hunters deciphered with a "book." [28]

By insisting that the illiterate buffalo hunters could read, even though they could never qualify as clubmen, Remington thus showed that "A Document" contained at least four documents, in addition to being a document itself. First, there was Burling's signed commission, a document which both compelled and justified the soldier's conduct; next, there was the paper he carried out from Fort Adobe, recovered from the buffalo hunters, and burned at the last minute in accordance with his superior's command to "destroy that order if you have bad luck," also revealing his position to the

28. Ibid., p. 612.

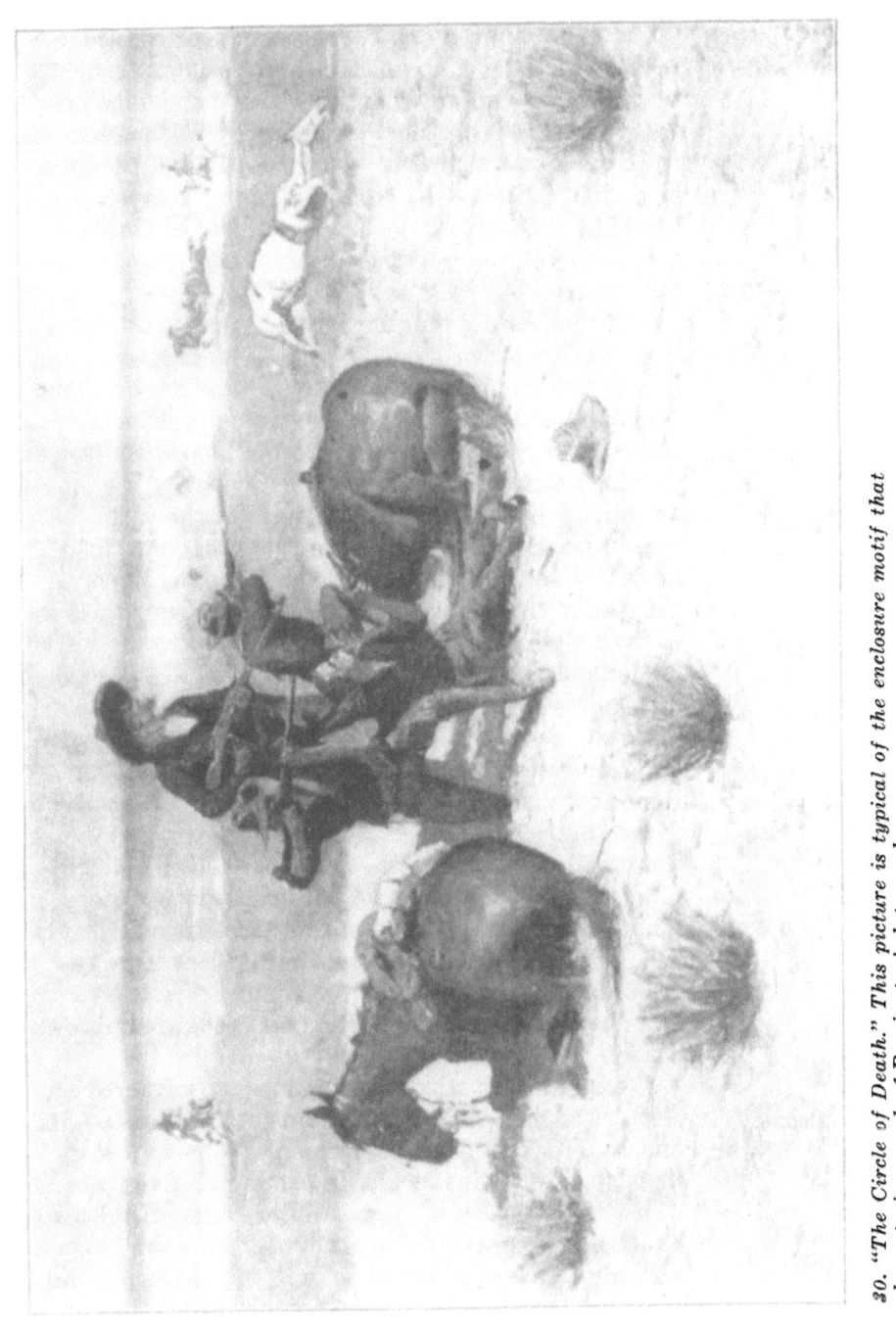

30. "The Circle of Death." This picture is typical of the enclosure motif that characterizes much of Remington's late work.

Sioux. After that, there was the open book of the landscape, which the hunters read from its outer perimeter inward to the center, where they found a riddled body with a small pile of ashes beside it. Even later, there were the hunters' narratives of the incident, passed on to an "old Indian" who, said Remington, relayed it to him. Each of the four documents clearly had symbolic force, and all were together involved in Remington's formula.

The question Remington raised by such multiplicity was thus the one of *which* document the title referred to, and the only possible answer was another question, ironically put, concerning the meaning of "official." Refusing to answer either question, Remington instead provided a clue to both questions by arranging the documents in a meaningful pattern. In the order of events employed by his story, a paper originating at an eastern office building generated another paper at Fort Adobe, which in turn generated the signs read by half-wild buffalo hunters, who told the story to an even wilder Indian. So far, the pattern looked like a vector descending along the scale by which Remington's story measured its characters but, when the Indian relayed an oral version of the document to Remington, and Remington wrote it down to be printed by *Harper's Monthly*, the vector became a circle. The man at the center was Remington, as it had been from the beginning. By putting himself so thoroughly in Burling's place, he demonstrated a unique perception of the way he and the imaginative pattern of his work were related. By devising a way for Burling's story to be told from beyond the terminal crisis, he prefigured his own death.

Two pictures, both completed in 1901, mirrored each element of the formula "A Document" articulated. In one, called "Rounded Up," a small cavalry unit made its last stand against encircling Indians; in the other, "The Circle of Death," four frontiersmen occupied an almost identical vortex, while almost identical Sioux horsemen dashed about its perimeter.[20] So lucidly did the latter work evoke its own unique kinesis that Frank Norris wrote a story about it, "A Memorandum of Sudden Death."[30]

Likewise, the same newly employed enclosure motif the next year gave *John Ermine of the Yellowstone* both its sense of the insular and its sense of relief from

29. "Rounded Up" is reproduced in Hassrick, pp. 139–140; "The Circle of Death" appeared in *Collier's Weekly*, December 7, 1901, pp. 20–21.
30. "A Memorandum of Sudden Death," *Collier's Weekly*, January 11, 1902, pp. 7–13.

insularity. Walls of one sort or another enclosed most of the novel's crucial scenes to indicate the presence of other, more important walls that effectively prevented the people in the book from communicating with each other, and the impression the book gave of the western landscape was that of a void of indeterminate size interrupted at infrequent intervals by tiny compounds rarely left by the people who occupied them. Even though the band of Crow Indians that adopts Ermine can leap from Montana to South Dakota with relative ease, Remington could also write of them that, having arrived, "they were shut in by impassable snow clad mountains." He reasserted the same pattern of enclosure by describing Crooked Bear's lodge as a "cabin made of logs set across the rock wall" high in the mountains that shut in the Crows and arranged matters so that, beyond the wall of mountains, Ermine appropriately encounters Crook with his columns of troopers who have come to build the walls of the Tongue River Cantonment, renamed Fort Keough in the year of Ermine's death for a captain who was walled in with Custer at Little Big Horn, just as the frontiersmen and soldiers are walled in in the many Remington pictures that resemble "The Circle of Death."

Similar lines of demarcation served a similar function in *The Way of an Indian*, Remington's final literary testament and a work dominated by the pathetic hero in his last, most fully developed avatar.[31] Asked about the book in 1907, two years after it began serial publication in *Cosmopolitan*, Remington nonchalantly said that his purpose was "to introduce people to the subjects I was trying to draw, paint and sculpt," that the work had been done "with the deliberate view of educating men and women, who knew not the West, up to a certain standard of appreciation for its beauties, its fascinations, its intrinsic worth."[32] For all its misplaced self-effacement, the statement was in some partial sense correct for, by the time he made it, Remington had decided that "I shall never write another word," preferring to pursue his vision in paintings, many of which were splendidly printed in *Collier's*, with whom he had signed an advantageous contract in 1903. While the statement may have been correct, however, it was simply not true, because the informational value of Remington's novel was no greater than that of

31. *The Way of an Indian* began serial publication in *Cosmopolitan* for November 1905. One installment appeared each month thereafter until its conclusion in the March 1906 number.
32. "Frederic Remington—A Painter of the Vanishing West," p. 523.

the graphic works Remington said it was supposed to introduce, and its formal qualities overshadowed its content in much the same way as shape transcended subject matter in those works.

If *The Way of an Indian* had been an educational treatise on the West, one might at the very least have expected it to be accompanied by pictures that showed what the West looked like. Instead, the sixteen pictures Remington made to illustrate his story represented only sixteen different views of the story's hero as he passed from youth to age. For all they said about the region of the West, they might have had plain, undecorated pasteboard for a backdrop, for in none of them did setting or background convey any information whatever. Ambrose Bierce, writing in the "Magazine Shop-Talk" section of *Cosmopolitan*, unwittingly touched the focus of both the pictures and the novel as he related how the pictures had been brought in for editorial inspection and "stuck up around our desks and leaned against our walls" before being prepared for the book. "You should have been here the other day," he gleefully remarked, adding in a sentence where the intimation of a personality superseded his perception of the paintings that "an express wagon was unloaded at our front door and the man brought Remington after Remington up."[33]

In other words, the subject and theme of *The Way of an Indian* were Remington's imagination, just as the subject and theme of *John Ermine* had been four years before, and—as though to emphasize their common focus—Remington set both books in approximately the same location and time. Yet there were both enough differences and the proper kinds of differences between the two to turn the threat of redundance into an aesthetically viable resonance. For one thing, even though *The Way of an Indian*'s protagonist began the story as White Otter, a name that resembled *John Ermine*'s White Weasel, and closed it by demonstrating his ability to see most clearly "just at sun down," he was neither white nor half-white and thus exhibited neither Sun Down Leflare's tendency to bleach out into a European nor Ermine's tendency to pout because he couldn't be an Indian. For another, the winter of 1876, when Ermine marched with Crook in the wake of Little Big Horn, marked both the beginning of Ermine's majority and the entrance into dotage of Fire Eater,

33. *Cosmopolitan*, February 1906, p. 244.

31. "He Looked on the Land of His People and He Hated All Vehemently." This picture represents White Otter, first avatar of the composite hero of The Way of an Indian, Remington's second and final novel.

White Otter's final avatar. Also, while *John Ermine* began in 1864 and spanned the remaining thirteen years of Ermine's boyhood, ending abruptly just inside the threshold of his maturity, *The Way of an Indian* began about 1824 with White Otter's initiation into manhood, spanned the fifty-odd years of his active life as a Cheyenne tribesman, and ended just outside the threshold of his death, a place characterized in the book's final sentence as the "spirit land where the Cheyennes of his youth were at peace."[34] The differences between *John Ermine* and *The Way of an Indian* were all complementary, because between them the two books represented both sides of the same phenomenon. Focusing on the Sioux war he had missed when he first went to Montana in 1881, Remington gave imaginative personification first to one party in the conflict, then to the other, producing a composite that expressed the sculptor's degree of vision in a literary dimension.

The opening episode of *The Way of an Indian* introduced White Otter as a young Cheyenne on the verge of manhood, making a solitary "medicine journey" from the Tongue River plains into the Big Horn Mountains to secure the blessing of the Good Gods by asking for a sign of favor. Such a sign comes to him in the form of a small bat which he catches and kills, later being told in a dream that it is medicine that will hear and answer all his questions, make him victorious in battle, protect him from spirits, insure his success with women, and finally in the fullness of time bring him safely to the "shadow land."

After carefully tanning and decorating the skin of his precious bat, White Otter sets out with another young brave into Absaroke territory, where they locate a Crow village in a creek bottom and are able to steal two ponies. On the same night, White Otter kills and scalps a young Absaroke lover who is waiting for his mistress by the river. Because of his success, he acquires the name of the Bat, and a series of triumphs follows as he achieves maturity. In one exploit, he leads a charge against frontiersmen who defend themselves with dynamite—and he thus earns the name of Fire Eater. Later, he becomes the sole Indian survivor of a raid he leads against an outpost of trappers. Unmanned by this defeat, he slinks off to join a party of Shoshones and, years afterward, reappears among the

34. *Cosmopolitan*, March 1906, p. 508.

Cheyennes, telling them that he is a reincarnation of himself.

In the summer of 1876, a party of cavalrymen attempts to overrun the village but is repulsed in a bloody battle that looks like a Cheyenne victory and thus brings back Fire Eater's confidence. That winter, Crook's troops attack again, this time with more success. Fire Eater seizes his rifle and joins the fighting, realizing too late that he has left his medicine bat behind him. Without his medicine, he feels powerless and frightened as he watches the soldiers burn the village, killing the women and children. He is able to save his infant son, whom he carries into the mountains. He soon notices, however, that the baby has become stiff, "like a stone image." Recalling—but in reverse—his initial journey to the mountains to ask the Good Gods for a sign of favor, and defining as he does so the most important of the differences between *The Way of an Indian* and *John Ermine*, he moans: "Oh Bad Gods! Oh, Evil Spirits of the night, come take my shadow!"

The first three chapters of *John Ermine* dealt with White Weasel's childhood in the Absaroke village. In the fourth he was taken up the mountain to the lodge of Crooked Bear, where he became John Ermine and prepared to join Crook. The last chapter saw Ermine's renunciation of Crooked Bear's counsel, which he called "white man's talk," and his permanent rejection of the white men, effectively transforming him into White Weasel again. The sense of continuity that threw Ermine's theatrical termination slightly off balance thus originated in the lodge of Crooked Bear, who had books, knew geography, history, and astronomy, and—most importantly—recognized the presence of a white boy in an Indian camp as a hiatus in the order he thought proper, an order founded almost exclusively upon material objects and dedicated to discovering and utilizing the relationships among them.

To Crooked Bear, it seemed inappropriate for a young Gaul to occupy the space reserved for a young Crow because, even though the young Gaul's foster parents—who judged him by his feelings and behavior —saw that he fit the Indian camp, Crooked Bear—who judged him by his appearance—insisted that his pale skin linked him more firmly with remote European ancestors than learned patterns of perception and be-

havior linked him with his brother Crows. White Weasel's conversion to whiteness was thus a triumph of physics over metaphysics, and John Ermine's final gestures of renunciation and rejection were denials that flew in the face of European materialism and rationalism—equivalent with the gesture one of the frontiersmen in "The Circle of Death" might make if he clambered over the protecting barrier of dead horses and walked toward the Indians who sought to kill him. Except for the thin opening and closing layers of concern with the good and evil spirits with which the Indians invested their surroundings, *John Ermine* was conducted at the center of the circle, safely beyond the reach of Indians like Fire Eater. Yet its containment between the mysteries that haunted its edges both confirmed Remington's perception of the West as a void and denied the popular notion of the West as a place, suggesting that even walled-in strongholds like the cantonment on the Tongue River and Crooked Bear's mountain cabin were sure to be engulfed by the shadows that surrounded them.

The most significant difference between *John Ermine* and *The Way of an Indian* was that the shadowy region at the edges of the former story was the region where the latter story happened. Ermine's denial of Crooked Bear's values was thus truly a denial, for it involved the rejection of a superficial way of seeing, but the failure of Fire Eater's medicine was no real failure, because it confirmed the final condition under which White Otter had received the medicine. The condition, of course, was that the bat would carry its owner *through* life rather than merely allowing him to think he had mastered it. Medicine required that its possessor pursue the journey all the way to its conclusion.

Indeed, *The Way of an Indian*'s opening scene clearly articulated the terms of the compact by means of which the trinity of White Otter, the Bat, and Fire Eater swept past triumph, achieving death and reincarnation, to stand in the final scene at the brink of apotheosis. At the beginning, White Otter sat at the rim of a bluff, contemplating his medicine journey and attuning his consciousness to "the mysterious demons of the darkness, the wind and the flames . . . the monsters from the shadows and from under the waters." The day before, he remembered, he and his father had

performed a ceremony, in which his father had "presented him with charcoal-ashes in his right hand, and two juicy buffalo ribs with his left." White Otter's subsequent choice of the charcoal was the ceremonial gesture prescribed by the rite, but the transparent symbolism designated the gesture as an acceptance of death's certainty and a denial of life's material illusions. Once he made such a choice, the seeker became a spectator at his own life drama or, as Remington had it, entered his shadow, "which was his other and higher self." [35] Remington's lifelong—and decidedly boyish—interest in "medicine" thus achieved final articulation as a mirror of the artist's belief in the power of his art. The transfiguring penumbra into which the artist had White Otter step in order to see himself was equivalent with the perceptual space that the artist's work in its totality constituted.

In addition, John Ermine's rejection of Crooked Bear's teachings and White Otter's acceptance of the charcoal were not only the same gesture but were finally the source and culmination of the energy that informed the single, Janus-faced whole of Remington's two novels. That it was also the central gesture of Remington's own life as artist sufficiently explained his decision to "never write another word" after completing *The Way of an Indian* for, having discovered that the gesture always had the same result, he could only accept its consequence, joining the tribe he now understood the meaning of, which his complicated, sometimes arresting, but often confused sequential prose could reduce no further. Remington was thus free as he had never been before to produce a dazzling array of paintings, all of which were "Remingtons" in precisely the same sense as were the pictures of White Otter, the Bat, and Fire Eater that Ambrose Bierce had called a triumph.

All represented shadows. In June 1906, three months after *Cosmopolitan* printed the last installment of *The Way of an Indian*, Zebulon Pike appeared at the mouth of a blue-shadowed Santa Fe street in *Collier's*, with a ragged column of faceless horsemen at his back; a month later, a Jedediah Smith who looked like an Old Testament prophet led a line of shadow people out of a pale yellow wilderness where the only imaginable history was apocalypse.[36] Likewise, the ghostly riders of "Downing the Nigh Leader" moved in a vacuum where

35. *Cosmopolitan*, November 1905, p. 37.
36. "Zebulon Pike," *Collier's Weekly*, June 16, 1906, p. 8; "Jedediah Smith," *Collier's Weekly*, July 14, 1906, p. 8.

it was unthinkable that any of their shots and yells could have made a sound, and the solitary frontiersman who peered out from "Benighted—A Dry Camp" inhabited a landscape that had not even the remotest connection with geography.[37] A remarkable feature of all the pictures was their lack of perspective, as though they represented a place where the farthest and the nearest points were exactly the same distance away and where all events occurred at the same instant and with the same intensity. The place, of course, was the West but, far more important, it was *Remington's* West. Although Remington had been to the Pacific, he had never been where these pictures happened—although even he lamented that his West had departed into the past, lending a veneer of credibility to the notion that he was a historian, the pictures had suddenly become prophetic.

A map to find the place the pictures represented was contained in a painting of three mounted tribesmen, who gazed in awe at a wisp of cloud suspended in a pale, blotchy, turquoise sky while the orange light of a sunset illuminated them and a hillcrest cast a shadow that cut across the picture at the level of their ponies' chests.[38] Measured against many of Remington's more lively works, the picture seemed serene, for it represented neither conflict nor violent action—yet, even though the figures in the picture were stationary, the picture itself nonetheless stated a variety of movement. This kinesis derived from the same symmetry that had informed Remington's work from the beginnning, surviving even the artist's confusion about politics and race and his enthusiastic pursuit of violence as a theme. Now, however, the symmetry was fully realized and articulated: the wisp of cloud seemed a distant echo of one of the tribesmen, who seemed to raise his hand, as though in greeting. "With The Eye of The Mind," as Remington called the picture, expressed the principal resonance of his career.

Twenty-three years earlier, in 1886, Remington's first signed, published illustration had depicted a party of Indian scouts and white frontiersmen supposedly pursuing an invisible Geronimo across a rocky desert, suggesting that Geronimo's absence from the picture was precisely what made his presence in the minds of his hunters possible. Since then, the artist had—like the hunters he pictured—wandered a long way in

37. "Downing the Nigh Leader," *Collier's Weekly*, April 20, 1907, p. 10; "Benighted—A Dry Camp," *Collier's Weekly*, March 4, 1911, p. 12.
38. "With The Eye of The Mind," *Collier's Weekly*, June 19, 1909, frontispiece.

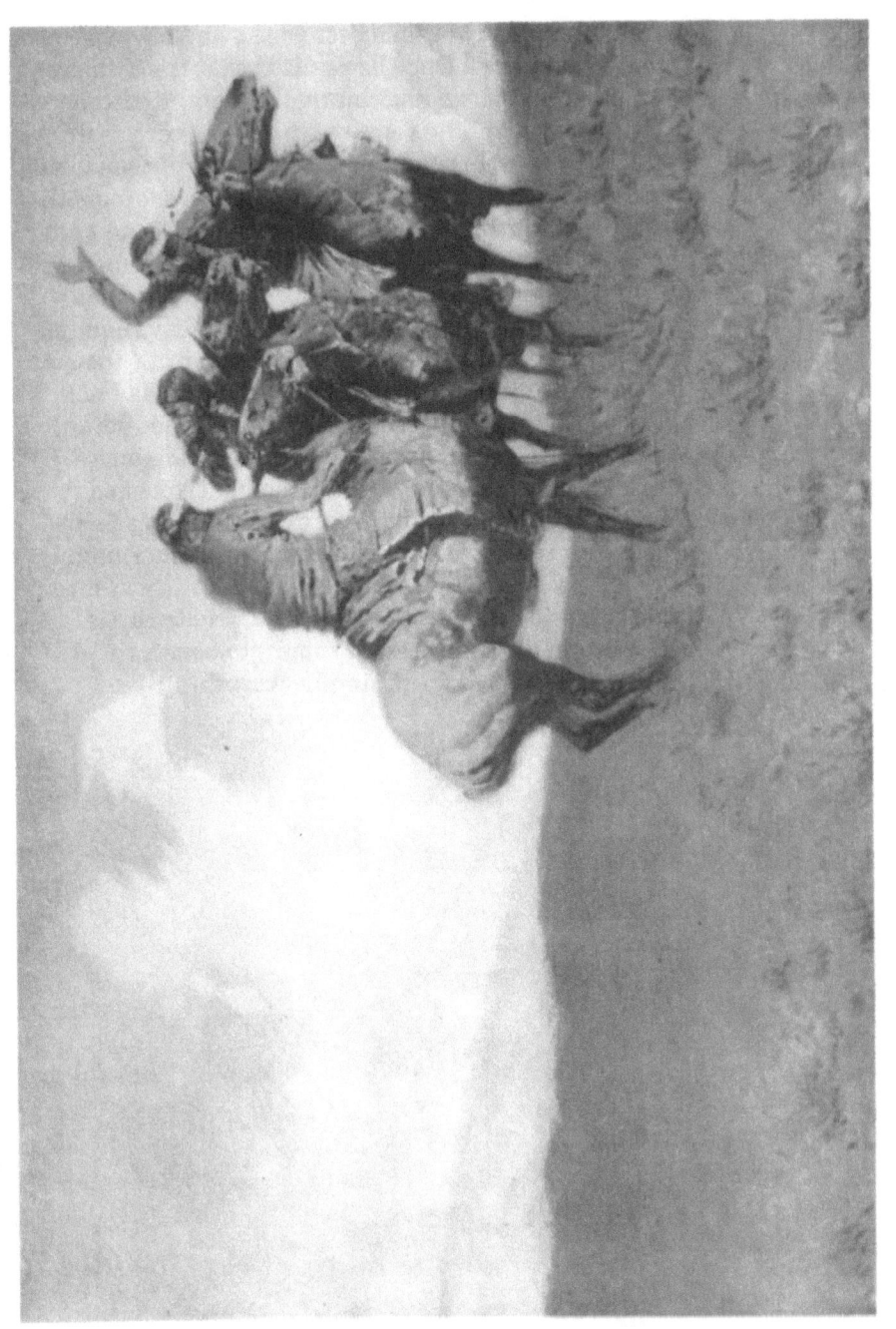

32. "With The Eye of The Mind"

search of subjects, but his best works had always represented chimeras. Once he realized that the chimeras he painted had more imaginative presence than the subjects he sought, he also saw that they were more real in still another way, because the best of them demonstrated that the eye of the mind could transform the most disappointing actualities, creating a shadow that expressed what was best in the artist. By the time the West he had first gone looking for at nineteen finally caught up with him when he was nearly fifty, Remington was therefore better prepared than any of the men in any of the circles he had painted—for he had not only seen the shadow creeping nearer, as the Indian who hailed the pale rider spurring his pale horse across the sky had done, he had known it, touched it, set it down in words and paint, executing with desperate, boyish courage a frontal charge his father might have appreciated. As history, the maneuver was meaningless, for it achieved at best only a problematical acceleration of the process it sought to penetrate. As imagination, it was quite simply everything.

Index

Abercromby, James, 228
Absaroke agency, 252
Adams, Henry, 47, 203
Africa, 162
Ah-we-ah, 16, 17, 18, 228, 260
Alden, Henry, 49, 53, 189
Alger, Horatio, 29, 150, 224
Algeria, 129–130, 133, 134
Allegheny Mountains, 162–163
Altgeld, John, 167
American Art Association, 142
American Railway Union, 167
American Water Color Society, 97
Apache Indians, 45, 74, 76, 78, 87, 92, 93, 102, 122, 125, 136, 143, 163, 173, 214, 223, 233; Apache War, xiii, xv, 36–44, 52–53, 58–61, 64–72, 241, 269
Arab military troops (Turcos), 129–130, 138
Arizona, 30, 35, 36–47, 48, 52, 53, 54, 57, 61, 65, 66, 68, 72–75, 79, 87, 92, 110, 120, 124, 129, 130, 134, 140, 143, 162, 177, 188, 192, 223, 233, 238, 241
Art Students' League, 50, 120
Astor, John Jacob, 240

Bailey's Wells, Arizona Territory, 67
Bailloquet, le Chevalier, 234–235, 237
Baird, G. W., "General Miles's Indian Campaign," 124
Bais des Pierres, Canada, 210
Bat, the, 278, 280, 281
Bear Paw Mountains, 217, 219, 224
Benton, Thomas Hart, 105
Bierce, Ambrose, 276, 281
Bigelow, John, 41, 42, 103, 121; *On the Bloody Trail of Geronimo*, 52–53, 67–72, 74, 78, 79, 87, 124, 161, 180, 241
Bigelow, Poultney, 46, 48, 51–53, 110, 128–139, 204; "In the Barracks of the Czar," 132; "Cossack as Cowboy, Soldier, and Citizen," 136; "French Fighters in Africa," 130; *Seventy Summers*, 21; "Sidelights on the German Soldier," 132; "Why We Left Russia," 129, 136, 138
Big Foot, xv, 100, 101, 102, 103, 107, 110, 166
Black Coyote, 101
Blackfeet Indians, 75, 76, 173

Index

Blaine, James G., 128, 137
Bourke, John, "General Crook in the Indian Country," 124
Brown, Charles H., *The Correspondents' War*, 221
Brown, Dee, *Bury My Heart at Wounded Knee*, 101
Bull Bear, 93
Bull Head, 99
Burling, William, 270–274

Camp, Walter, 21
Canada, 75–76, 129, 186, 209–211, 234
Canadian Mounted Police, 75, 76
Canadian Pacific Railway, 75, 209
Canton, New York, 4, 12–15, 18–20, 27, 28, 32, 33, 47, 50, 76, 140, 157, 211, 258
Capron, William, 170
Casey, William, 99, 100, 101, 102, 104, 107, 108, 110, 117, 126, 127, 154, 157, 214
Caten, Eva. *See* Remington, Mrs. Frederic
Caten, Lawton, 28, 29, 34, 49
Cather, Willa, xii
Centreville, Virginia, 4
Century, The, 79, 90, 116, 117, 125
Chaffee, Adna, 240, 244
Chevreuse, Jacquésson de la, 21 n. 34
Cheyenne Indians, 45, 93–96, 99, 102, 122, 129, 224, 264
Chicago, Illinois, 166–173; Pullman strike, xv, 167–173, 175, 177, 178, 179, 182, 188, 189, 257
Chinese, 120–121, 124, 148
Civil War, 3–11, 16, 48, 171, 188, 214; its impact on Remington, xv, 12–14, 18, 20, 21, 36, 47, 212, 261, 265
Cleveland, Grover, 167
Cloman, Sydney, "Walita: A Trooper's Story," 261
Cody, William (Buffalo Bill), 98, 99, 103, 139, 140, 159, 167, 173–175, 176
Cole, Thomas, 48–49
Collier's Weekly, 26, 267, 275, 281
Comanche Indians, 93, 212
Cooper, James Fenimore, 191 n. 5
Cornu, Sébastien, 21 n. 34
Courant (Yale), 21
Cowboys, 29, 30, 59–60, 88, 185, 187, 267; as cattle contractors, 94–95; compared to Cossacks, 135–137; derivation of name, 30 n. 5; as Florida crackers, 207–209, 211, 221, 235; as heroes, xiv, 143–146, 160–161, 162, 165, 177, 180, 182, 265; as isolato, 189–202; compared to Manhattan police, 151–152; as marginal figures, 142–143, 151, 158; as military supermen, 166; in Roosevelt's *Ranch Life*, 82–84, 88, 96, 124, 151; in Wister's "The Evolution of the Cow-Puncher," 192–193, 196, 200, 201; as Wyoming herdsmen, 29, 30, 151
Coxey, Jacob, 151
Cranberry Lake, New York, 140
Crane, Stephen: *Bowery Tales*, 147; "The Bride Comes to Yellow Sky," 251, 253; *Maggie: A Girl of the Streets*, 147; "A Man and Some Others," 237, 251
Crèvecoeur, J. Hector St. John de, *Letters from an American Farmer*, 35, 36, 228
Crook, George, 37, 52–53, 65, 97, 262, 265, 275, 276, 279
Crooked Bear, 262, 264, 265, 275, 279, 280, 281
Crooker, Orin Edson, "A Page from the Boyhood of Frederic Remington," 267, 268
Crow Indians, 75, 76, 225, 233, 262, 264, 275, 278, 279
Cuba, 120–121, 124, 165, 221–223, 235, 239–246, 258, 259, 265
Cushing (torpedo boat), 237
Custer, George, xv, 85, 93, 97, 98, 110, 125, 133, 177, 214, 216, 232, 275

Dana, Richard Henry, 233
Davis, Richard Harding, 221, 223, 235, 237, 238, 239; *The West from a Car Window*, 126
Debs, Eugene, 167
De Quille, Dan, "An Indian Story of the Sierra Madre," 213
Dodge, Theodore, "Some American Riders," 122–123, 124

Donaldsonville, Louisiana, 3, 4, 5, 6
Donnelly, Ignatius, *Caesar's Column*, 172
Doyal's Plantation, 4, 5, 6, 7, 8
Dreiser, Theodore, 204–206, 216, 219
Dull Knife, 94, 224, 241

Eleventh New York Cavalry, 3, 4
Elkhorn Ranch (Roosevelt), 85, 92, 103, 142, 143, 160, 178, 186, 229
Ermine, John, 17, 266, 275, 276, 278, 279–280, 281

Fairfax Courthouse, Virginia, 4–5, 6
Ferris, A. C., "Through California to Mexico," 125
Fifteenth Infantry, 170
Fifth Army Corps, 238, 239
Fire Eater (White Otter), 17, 276, 277, 278–279, 280, 281
Florida, 186, 207–209, 235, 238–239
Ford, "Rip," 212–214, 226, 227
Forsyth, James, 101
Fort Apache, 233
Fort Assiniboine, 216–219, 223, 224, 241
Fort Edward, 228
Fort Grant, 41, 42, 43, 45, 52, 67, 92, 130, 134, 140, 216
Fort Huachuca, 78
Fort Keough, 99, 100, 129, 157, 252, 275
Fort Meyer, 166–167
Fort Robinson, 223, 224
Fort Sill, 45, 47, 93
Fort Thomas, 37, 38–39, 41, 42, 44, 130, 134, 140, 233
Fort Tiemogamie, 186
Fox, John, 239
Franklin, Benjamin, *The Autobiography of Benjamin Franklin*, 228
Frémont, John, 122
French and Indian War, 228–232
Friday, Jimmie, 210, 211
Frost, A. B., 10, 116

Gatewood, Charles, 65, 66
Gatlin, Dan, 191
Genesmere, Russ, 189–191, 201
Genteel tradition, 48–50, 57–58, 60, 72, 74, 76, 89, 91, 95, 98, 105, 117, 121, 128, 142, 159, 161, 179, 207, 213, 220, 226, 239, 244
Germany: Berlin, 130, 132, 138; Prussia, 139; soldiers, 130–132, 134, 136, 221, 236
Gérôme, Jean Léon, 21 n. 34
Geronimo, 10, 36–39, 52–53, 59, 61, 65, 66, 67, 69, 72, 74, 162, 282
Gettysburg, Pennsylvania, 175
Ghost Dance, the, 97–103, 110, 117, 125, 164
Gilbert, Jack, 143, 159, 161, 162, 165, 166, 171, 177, 178, 180
Gilder, Richard Watson, 49, 91
Godfrey, E. S., "Custer's Last Battle," 126
Gombrich, E. L., 203
Goodenough, Joshua, 227–233, 237, 241, 257, 259

Hamlin, Cyrus, 5 n. 5
Hampton's Ferry, Louisiana, 5, 6
Harper and Brothers, publishers, 128–129
Harper's Monthly, 126
Harper's Weekly, 10, 30, 35, 53–54, 57, 58–61, 64–66, 72, 75, 76, 116, 117, 125, 192
Hassrick, Peter, *Frederic Remington*, 267 n. 22, 268, 274
Hawthorne, Nathaniel, *The Scarlet Letter*, 225
Hayes, Jack, 212
Hearst, William Randolph, 221, 223
Henry, Guy V., 166, 167
Highland Military Academy, xiii, 20, 116, 223, 267, 271
Hoeber, Arthur, 204; "From Ink to Clay," 186–187, 192
Hogarth, William, *Hogarth Moralized*, 75
Homestead (Pennsylvania) strike (1892), 175
Hough, Emerson, *The Settlement of the West*, 126
Howe, E. W., *The Story of a Country Town*, 19
Howells, William Dean, 15, 47, 51, 53, 262; *Criticism and Fiction*, 49; *A Hazard of New Fortunes*, 16, 147
Hull, William, 232

Indians: assimilation of, 43–

44, 85–89, 92–96, 98–103, 171, 225–226, 235, 251–256, 259, 260–261, 264; Remington's identification with, 36, 41, 43; as soldiers, 96, 100, 101, 102, 105, 130, 171, 255
Ingleneuk, 257–258
Iowa (battleship), 237, 238
Isham, Samuel, *The History of American Painting*, 48
Isolato, 191, 193, 196, 201, 207, 266
Itsoneorratseahoos (or "Paint"), 225, 226, 227, 233, 259

Jackson, Andrew, 232
James, Henry, 139
Jefferson, Thomas, xi, 105, 232
Johnson, Carter, 216, 218, 219, 220, 221, 223–225, 228, 237, 240, 241, 244
Jones, Howard Mumford, *The Age of Energy*, 48, 50
Jones, Virgil Carrington, *Roosevelt's Rough Riders*, 250

Kansas, xiii, 31–33, 47
Kansas City, Kansas, xiii, 32, 33, 34–35, 36, 72, 128, 186
Kemble, E. W., 116
Kicking Bear, 97, 100
Kipling, Rudyard, 186

Leflare, Sun Down, 17, 225–227, 233, 234, 251–256, 258, 259, 260, 262, 264, 266, 270, 276
Lewis and Clark, 232
Little Big Horn, battle of, xv, 30, 93, 99, 125, 133, 177, 261, 264, 265, 275, 276

Mabie, Hamilton, 93, 95; "Indians, and Indians," 92
McCracken, Harold, *Frederic Remington: Artist of the Old West*, 10 n. 17, 20, 32, 76, 165, 204
McKinley, William, 235, 240
Mahongui, 234
Maine (battleship), 235
Manhattan, 147–152, 155, 165, 170, 180
Manley, Atwood, *Frederic Remington In the Land of His Youth*, 13, 28, 29, 32, 57, 97, 129

Massai, 233, 237, 264
Maus, Marion P., "The New Indian Messiah," 99
Maxwell, Perriton, "Frederic Remington—A Painter of the Vanishing West," 268–269, 275
Melville, Herman, 7–8, 10, 11, 12, 13, 47, 147, 191 n. 5, 232; "The Apparition (A Retrospect)," 7, 11, 229; *Battle-Pieces*, 225; "The Conflict of Convictions," 7; "The March into Virginia," 7, 18; *Mardi*, 8; "Misgivings," 7; *Moby Dick*, xvi, 8; "The Portent," 7; "Shiloh: A Requiem," 8
Mexico, 45, 118, 120, 142–143, 147, 159. See also San José de Bavicora
Miles, Nelson, 53, 57, 64, 65, 66, 76, 98, 99, 102, 106, 107, 110, 118, 124, 134, 163, 164, 167, 177, 178, 182, 216, 251, 255; *Personal Recollections and Observations of General Nelson A. Miles*, 72
Montana, 233, 257, 264, 275; Remington's 1881 trip to, xiii, xv, 25–27, 28, 29–30, 31, 32, 33, 47, 61, 75, 76, 99, 108, 134, 136, 140, 147, 155, 177, 186, 264, 278; Remington's 1896 trip to, 216–219, 220, 221, 223, 225, 251
Montcalm, Marquis de, 228
Morison, E. E., *Theodore Roosevelt*, 233
Murphy, William, 249

Navajo Indians, 163, 223
New Mexico, xv, 75, 129, 163–164, 165, 177–179, 180, 192, 208
New Rochelle, New York, 25, 128, 140, 164, 179, 186, 223, 235, 238, 240, 257
New York, New York, 47–55, 57–72, 147–152, 155, 165, 170, 180, 186; Oak Street Police Station, 150–152, 153, 155, 165; Troop A, 166–167, 214, 216
New York (flagship), 237
New York Armory, 166, 259
New York Horse Show (Madison Square Garden), 204–206, 213, 216, 219
New York National Guard, Seventh Infantry Regiment, 118–120

Niemeyer, John, 21, 21 n. 35, 49
Noble, Louis Legrand, *The Life and Works of Thomas Cole*, 49
Norris, Frank, "A Memorandum of Sudden Death," 274
North Country, 12, 14, 19, 20, 22, 29, 31, 35, 50, 72, 128, 129, 140, 153, 162, 186, 257–258
North Dakota, 85, 93, 152, 153, 186. *See also* Elkhorn Ranch

Oestreicher, Corporal, 269, 270
Ogdensburg, New York, 19–20, 22, 47, 50
Oklahoma, 45, 46, 47, 93–94, 147
O'Neill, "Bucky," "The Requiem of the Drums," 261
Outing Magazine, 51–52, 67, 68, 69, 117

Pantagraph, Bloomingdale, Illinois, 18
Papagos Indians, 72–75, 76, 79, 196
Paris Exposition, 97
Parkman, Francis, 159, 164, 171, 233; *The Oregon Trail*, 140–142, 146, 151–152
Peabody, Kansas, 31, 32, 33, 128
Phisterer, Frederick, *New York in the War of the Rebellion*, 4 n. 1
Picture history (*Harper's Weekly*), 57–61, 64, 66, 75, 79, 82, 89, 116, 140, 161, 179, 192, 193, 196, 215
Pidal, Thomas, 269, 270
Pike, Zebulon, 281
Pine Ridge agency, Sioux reservation, 99, 100, 102, 106, 107, 108, 110, 117, 118, 123, 133, 168, 170, 173, 209
Pittsburgh railroad strike (1877), 175
Plain Dealer, St. Lawrence, 13, 14, 18–20, 28, 29, 32, 97
Poland, 132–133
Pullman strike, Chicago, xv, 167–173, 175, 177, 178, 179, 182, 188, 189, 257

Ralph, Julian, 126, 209, 235; "The Chinese Leak," 120; "How a Tourist Sees Richmond," 163; "The Shoe That Pinches," 148, 150–151, 155; "Social Studies Behind the Scenes at Buffalo Bill's," 173; "Where Time Has Slumbered," 162
Reason, Shorty, 36
Red Bear, 102
Red Tomahawk, 99, 100
Remington, Ella, 35
Remington, Frederic: and concept of family in his art, 16–18; currency in, 128, 136, 140, 157, 165, 179, 185, 213–214; death as subject in, 11, 177, 257, 261, 262, 266–267, 280–281; definition of the West in, xiii, xv, xvi, 27, 28–33, 75, 124–125; disjunction in, 10–11, 30, 38–39, 43–44, 47, 53–54, 57–61, 64–65, 68–72, 74–76, 78, 82, 89–96, 116, 193, 196, 200–202, 215; early years, 12–15, 18–22; energy as subject in, 46–47, 49–50, 53, 68, 105, 124, 130, 136, 140, 162, 171, 173, 175, 177, 200, 201, 244, 257, 259, 274, 281, 282; explains career, 25–27, 29; history and sequence in, xvi, 10, 11, 42–44, 105–107, 117–125, 127–128, 134, 136, 137, 141–142, 146, 156, 157, 165, 166, 172, 177, 179, 182, 185, 188, 193, 196, 200, 202–206, 209–216, 217, 219, 224–235, 250–257, 268–269, 282; landscape in, 39, 43, 46–47, 53, 58–60, 71, 189, 200–202, 210, 276; marginality in, 136; martial preoccupation in, xiv, xv, xvii, 10; parody in, 64, 65; point of view in, 11, 109, 110–121, 123–124, 130, 132, 133, 138, 173, 187–189, 208–209, 210–211, 225, 226, 227, 240–241, 244, 245, 255, 258, 282; self as subject in, xii, xiv, xv, 11, 15, 44, 110, 111, 116–121, 123–124, 127–128, 133, 140, 142, 146, 158, 161, 176, 177, 178–182, 185–188, 189, 191, 208–209, 215, 219, 223, 255, 257, 258, 260, 265, 267, 269, 271, 274, 284; sentimentality in, 124; sequence in, 105–107, 117–125, 127–128, 134, 137, 141–142, 146, 156, 157, 177, 182, 188, 193,

290 Index

196, 200, 202, 204, 215, 216, 232; social issues in, xiv, xvii; spatial relationships in, 82–83, 196, 204
—pictures and bronzes by: "Advance of Russian Infantry," 134; "The Apaches are Coming," 58, 60, 61, 66; "The Apache War—Indian Scouts on Geronimo's Trail," *9*, 10, 66; "The Arrest of a Blackfoot Murderer" (painting), 97; "Benighted—A Dry Camp," 282; "The Blue-China Cossack," *135*, 136; "In a Bog-Hole," 83; "A Bold Dragoon," 134; *The Bronco Buster* (bronze), 140, *181*, 182, 185, 186, 187, 191, 192, 193, 200, 201, 203, 205, 206, 209, 210, 211, 220, 223, 249, 250, 257, 259, 269, 270, 271; "Bronco Busters Saddling," 83; "The Buffalo Dance," 75; *The Buffalo Horse* (bronze), 269; "In the Cafe Tomboff," 133; "The Canadian Mounted Police on a 'Musical Ride'—'Charge!'" 75; "Captain Dodge's Colored Troopers to the Rescue," 124; "The Captive Gaul" (painting), 19, 27, 121, 134; "The Cavalry," 118; "Ceremony of the Scalps" (painting), 15; "The Charge of the Rough Riders at San Juan Hill" (painting), 260; "Chasing a Major General," 99; "The Chicago Strikes—United States Cavalry in the Stock-Yards," *168–169*; "Chinese Coolies," 148; "The Circle of Death" (painting), *273*, 274, 275, 280; *Coming Through the Rye* (bronze), 269; "Cossack of the Guard," 136; "Cossacks of the Amoor," 136; "Cossacks Scouting," 134; "The Coup" (painting), 123; "The Couriers," 66; "Cow-boys of Arizona: Roused by a Scout," 30; "A Dispute Over a Brand," 83; "Downing the Nigh Leader" (painting), 281-282; "Dragoons, Mount!" 134; "Drawing of a German Officer," *131*; *Drawings*, 213, 215;

"An Episode in the Opening Up of a Cattle Country" (painting) *80–81*, 82–83; "With The Eye of The Mind" (painting), 282, *283*; "The Fall of the Cowboy" (painting), 193, 196, *199*, 200–201; "A Fantasy From the Pony War Dance" (painting), 123; "Field Service in Arizona," 78; "Final Review of General Miles' Army at Pine Ridge," 110; "Gentleman Rider in Central Park," 125; "After Geronimo," 52, 126; "Going Into Action," 188; "A Hair-Cut in a Cavalry Stable," 134; "A Happy Female Lodger," 151; "He Looked on the Land of His People and He Hated All Vehemently," *277*; "Home, sweet Home," 74; "The Hotchkiss Cannon," 118; "How the Horses Died for Their Country at Santiago," 260; "The Indian Method of Breaking a Horse," 124; "An Indian Trapper," 123; "The Infantry," 118; "Jedediah Smith" (painting), 281; "John Ermine," *263*; "Kuban Cossack, Imperial Guard Corps," 134; "Ladrone," 125; "The Last Cavalier" (painting), 193, *194*, 196, 200, 201, 202, 205, 213; "The Last Stand" (painting), 97, 110, *112–113*, 116, 134, 189; "Lieut. Ross's Attack," 124; "In the Lodges of the Blackfeet Indians," 75; "Long-Tom Rifles on the Skirmish Line," 124; "Merry Christmas in a Sibley Tepee," 126; "Mexican Troops in Sonora," 61; "A Mexican Vaquero," 123; "The Midday Meal," 83; "In From the Night Herd," 66; "An old Man," 74; "One of the Czar's Body-Guard," 134; "One of the Czar's Pirates," 134; "The Opening of the Fight at Wounded Knee," 110, *114–115*, 116, 124; "The Outlying Camp," 83; "The Patient Pack-Mule," 124; "Prominent Officers Now at Tampa, Florida," *236*; "Pulling a Cow Out of The

Mud," 83; "Punchers Saddling in the Patio," *144–145*; "A Quarrel Over Cards," 75; *The Rattlesnake* (bronze), 15; "A Revolver Charge," 129; "A Rodeo at Los Ojos," 160; "Rounded Up," 274; "A Row in a Cattle Town," 83; "A Run to the Scout Camp," 110; "The Russian Military Gendarme," 134; "Saddle Up," 65; "Saddling a Pack Mule," 124; "A Sage-Brush Pioneer" (painting), 193, *195*, 196, 201; "Shoeing Cossack Horses," 134; "The Sidewalk Market, Ludlow Street," 148; "Signalling the Main Command," 61; "The Sign Language," 43–44; "The Sioux War—Final Review of General Miles's Army at Pine Ridge," 118; "Sir, They Are in Sight," *71*; "Sketches Among the Pagagos of San Xavier," 72, *73*, 74, 77; "A Sketch in Mulberry Bend: The Italian Quarter," 148, *149*; "Social Studies Behind the Scenes at Buffalo Bill's," 173, *174*, 175; "The Soldier's Song," 134; "Spanish Cavalryman on a Texas Bronco," 221; "A Spanish Officer," *222*; "The Station-House Lodgers," 151; "The Storming of San Juan," 230, *245*; "The Storming of Ticonderoga" (painting), 229, *230–231*, 232; "The Temporary Hospital—Bloody Ford," *242–243*; "There Was No Flora McIvor" (painting), 193, 196, *198*, 200–201; "Threshing Wheat," 74; "Training U. S. Troops in Indian Warfare," 76, *77*; "Types From Arizona," 61, *62–63*, 65, 122; "United States Cavalryman," 123; "Watching the Dust of the Hostiles from the Bluffs of the Stronghold," 110, *111*; "What an Unbranded Cow Has Cost" (painting), 193, 196, *197*, 201, 203; "The Wounding of Lieut. Hawthorn," 110; "You Don't Want to Talk This Way. You're Alone," 189, *190*, 191–192; "Zebulon Pike," 281

—prose by: "The Affair of the –th of July" (fiction), 171–173, 176; "Artist Wanderings Among the Cheyennes," 45, 93–96; "The Art of War and Newspaper Men," 99; "Bear-Chasing in the Rocky Mountains," 163; "Buffalo Bill in London," 139; "Chicago Under the Mob," 170; "Coaching in Chihuahua," 143; "The Colonel of the First Cycle Infantry" (fiction), 176; "Coolies Coaling a Ward Liner—Havana," 120–121; "Coursing Rabbits on the Plains," 31, 33, 90, 179; "Cracker Cowboys of Florida," 207; *Crooked Trails* (essays & fiction), 213; "A Day with the Seventh Regiment," 20, 118–119; "A Desert Romance" (fiction), 261, 262; "The Essentials at Fort Adobe," 20; "With the Fifth Corps," 239–245, 250, 251; "The Galloping Sixth," 20; "General Miles's Review of the Mexican Army," 118; "The Great Medicine-Horse" (fiction), 223, 225–227, 234, 252; "Hasty Intrenchment Drill," 214; "Horses of the Plains," 90–91, 122, 192; "How Order No. 6 Went Through as Told by Sun Down Leflare" (fiction), 223, 226, 251–252; "How the Horses Died for Their Country at Santiago," 260; "How the Law Got Into the Chaparral," 212–213; "On The Indian Reservations," 38, 45, 92–93; "Indians as Irregular Cavalry," 20, 100; *John Ermine of the Yellowstone* (novel), 15, 17, 262–265, 274–281; "Joshua Goodenough's Old Letter" (fiction), 223, 227–233, 234; "Lieutenant Casey's Last Scout," 104, 108; "Massai's Crooked Trail" (fiction), 223, 233–234; *Men With The Bark On* (fiction), 16; "Merry Christmas in a Sibley Tepee," 126; "Military Athletics at Aldershot,"

291

Index

139; "A Model Squadron," 20, 166; "Natchez's Pass," 260–261; "A New Idea for Soldiers," 176; "A New Infantry Equipment," 176; "An Outpost of Civilization," 146; "Policing the Yellowstone," 153; *Pony Tracks* (essays & fiction), 211; "A Rodeo at Los Ojos," 143, 160; "A Scout with the Buffalo-Soldiers," 41–44, 92; "A Sergeant of the Orphan Troop" (fiction), 223–225; "In the Sierra Madre with the Punchers," 160; "The Sioux Outbreak in South Dakota," 103, 107; "The Sorrows of Don Thomas Pidal, Reconcentrado" (fiction), 269; "The Spirit of Mahongui" (fiction), 223, 234–235; "Squadron A's Games," 214; "The Story of the Dry Leaves" (fiction), 16, 17, 228, 260; "The Strange Days That Came to Jimmie Friday," 209; *Sun Down Leflare* (fiction), 17; "Sun Down Leflare's Money" (fiction), 223, 226, 251, 252–253; "Sun Down Leflare's Warm Spot" (fiction), 223, 226, 251, 253–255; "Sun Down's Higher Self" (fiction), 223, 226, 251, 255–257, 260; "They Bore a Hand," 269; "Troop A Athletics," 20, 166; "Vagabonding with the Tenth Horse," 20, 217, 218; *The Way of an Indian* (novel), 17, 275–281; "When a Document is Official" (fiction), 270–274; "The White Forest," 260; "Wigwags From the Blockade," 237, 238; "Winter Shooting on the Gulf Coast of Florida," 207

Remington, Mrs. Frederic (née Eva Caten), xiii, 28, 32, 34–35, 36, 48, 50, 72, 76, 186, 261

Remington, Lamartine Zetto, 13, 20

Remington, Maria Pickering, 13

Remington, Seth Pierre, 4–10, 12, 13, 14, 18–22, 27, 163, 177, 214, 229, 284

Remington, Mrs. Seth Pierre (née Clara Sackrider), 13

Remington, Seth Williston, 13

Reno, Marcus, 232

Rice, Edmund, 176

Riel, Louis, 225

Rodríguez, Adolfo, 221

Roe, Charles F., 166

Rogers, Robert, 227, 228

Rogers, W. A., 10, 30

Rogers' rangers, 227

Roosevelt, Theodore, xii, 103, 106, 146, 147, 151, 160, 164, 178, 186, 229, 233, 238, 244, 249, 264; "In Cowboy Land," 142; on cowboys, 82–84, 88, 96, 124; definition of the West, 82, 83–84; on frontiersmen, 87–88; on Indians, 85–88; *Ranch Life and the Hunting Trail*, 76, 79–93, 95–96, 101, 116, 124, 125, 143; on Remington's Twenty-Third Street art show, 204, 205–206, 219

Rough Riders, the, 238, 240, 244, 249, 260, 261

Russia, 140, 143, 152, 162; Cossacks, 96, 134–137, 138, 144, 167, 173, 267; St. Petersburg, 128, 133, 136–138, 139; soldiers, 132–134, 136

Saint Gaudens, Augustus, 21 n. 34

Sampson, William T., 237

San Antonio, Texas, 212–214, 217

San Carlos Indian reservation, xiii, 37–38, 41, 52, 53, 67, 74, 93, 152, 235, 269

San José de Bavicora, 143–147, 152, 153, 157, 159–162, 164, 165, 171, 178, 208, 209, 211, 258

San Juan Hills (Cuba), 239, 241, 244, 250, 259, 260, 269, 270

Santayana George, *The Genteel Tradition at Bay*, 48

San Xavier del Bac (mission), 74–75, 76, 78

Scott, John S., 6, 7

Scott, Sir Walter, 201

Scott's Nine Hundred, 3, 4

Scovel, Sylvester, 269

Second U.S. Cavalry, 163

Seely, Howard, "The Jonah of Lucky Valley," 123

Sequeranca (headquarters ship), 239

Seventh U.S. Cavalry, xv, 99–

102, 104, 105, 107, 108, 133, 166, 167–170
Shafter, William, 239
Singleton, F. J., 49
Sioux Indians, xv, 97–103, 104, 105, 106, 108, 110, 120, 125, 154, 158, 173, 214, 233, 264, 271, 272, 274, 278
Sitting Bull, 98, 99, 100, 101, 116, 125, 133, 216, 264
Sixth U.S. Cavalry, 101, 153–155
Smedley, William, 10
Smith, Jedediah, 281
South Dakota, 97–107, 110, 118, 120, 121, 126, 129, 134, 147, 162, 164, 166, 218, 275
Spanish-American War, xiv, xv, 16, 96, 120, 214, 221–223, 227, 229, 235–246, 249–250, 251, 255, 257, 267, 269
Stanley, Henry, "Slavery and the Slave Trade in Africa," 140
Stevens, Montague, 163, 178, 179, 191, 208
Stuart, J. E. B., 4
Sumner, E. V., "Besieged by the Utes," 125
Swain, James B., 4, 5

Tenth U.S. Cavalry, 61, 216–219, 233, 240; K Troop, 41–45, 52, 61, 65, 67, 69
Texas, 45, 129, 139, 163, 214
Texas Rangers, 212–213, 214, 227
Third U.S. Cavalry, 223–224
Thoreau, Henry, xii, xiii, xv, xvi, xvii, xviii; *Walden*, 16
Thulstrup, T. de, 35, 60, 61
Ticonderoga, 228, 232, 241, 250
Tourgée, Albion, *The Story of a Thousand*, 188
Tribe of Remington, the, 35–36, 41, 44, 47, 61, 102, 107, 127, 129, 130, 134, 146, 158, 164, 165, 176–177, 207, 208, 238, 258, 259, 265, 281
Turner, Frederick Jackson, 193
Twain, Mark, xi, 18, 19, 20, 47, 139, 211; *A Connecticut Yankee in King Arthur's Court*, 172, 176, 232; *The Gilded Age*, 18; *Huckleberry Finn*, 19, 72; *Personal Recollections of Joan of Arc*, 232
Twenty-Fourth U.S. Infantry, 244
Twenty-Third Street art show, 204–207, 208, 210, 219, 220
Twenty-Third U.S. Infantry, 214

Vancouver, British Columbia, 120
Van Valkenberg, Walter, 20, 27, 28
Vorpahl, Ben Merchant, *My Dear Wister: The Frederic Remington–Owen Wister Letters*, 51, 156, 158, 178, 179, 200, 214, 238, 250

Warner, Charles Dudley, *The Gilded Age*, 18
War of the Rebellion, The, 4, 5, 6
Waud, W. H., 13
Weasel Bear, Louise, 101
West, definition of, xii, xiii, xiv, xv, xvi, 27, 124–126, 257, 268–269, 280, 282
Wheeler, Edward, 264
White, G. Edward, *The Eastern Establishment and the Western Experience*, 31, 156
White Otter, 276–279, 280–281. *See also* Fire Eater
White River massacre, 122
White Weasel, 262–265. *See also* Ermine, John
Whitman, Walt, 47, 48, 215; *Leaves of Grass*, 16; "Passage to India," 106, 211, 212
Whitney, Caspar, 235, 239
Whitside, Samuel, 101
Wildman, Edwin, "Frederic Remington, the Man," 15
Wister, Owen, xii, 51, 156–158, 159, 160, 161, 164, 165, 175, 178, 179, 180, 182, 185, 186, 189, 192–193, 204, 205, 209, 212, 213, 214, 215, 238, 250, 257; "The Evolution of the Cow-Puncher," 192–193, 196, 200, 201; "Hank's Woman," 125, 142; at Harvard University, 156; "How Lin McLean Went East," 142; "The National Guard of Pennsylvania," 175; at the Paris Conservatoire, 156; in Philadelphia, 156; *Red Men and White*, 165; "La Tinaja Bonita," 188–192; *The Virginian*, 162; in Wyoming, 156
Wood, Leonard, *Chasing*

Geronimo; the Journal of Leonard Wood: May–September, *1886*, 72
Wounded Knee massacre, xiii, xiv, xv, 100–101, 102, 103, 105, 106, 107, 108, 109, 110, 111, 112, 115, 117, 119, 121, 122, 124, 125, 127, 132, 133, 136, 140, 158, 164, 168, 170, 177, 178, 188, 189, 209, 218, 226, 259, 261
Wovoka, 97–98, 106, 125
Wyoming, xiii, xv, 30, 32, 33, 35, 47, 139, 156. *See also* Yellowstone National Park

Yale University, 20, 21, 27, 28, 33, 49, 186
Yellow Bird, 103
Yellowstone National Park, 153–158, 159, 165, 178, 257
Yvon, Adolphe, 21 n. 34

Zerowski, 133, 137
Zogbaum, Rufus Fairchild, 116, 237, 238

www.ingramcontent.com/pod-product-compliance
Lightning Source LLC
Chambersburg PA
CBHW020729180526
45163CB00001B/162